SCULPTORS AND DESIGN REFORM IN FRANCE, 1848 TO 1895

Challenging distinctions between fine and decorative art, this book begins with a critique of the Rodin scholarship, to demonstrate how the selective study of his oeuvre has limited our understanding of French nineteenth-century sculpture.

The book's central argument is that we need to include the decorative in the study of sculpture, in order to present a more accurate and comprehensive account of the practice and profession of sculpture in this period. Drawing on new archival sources, sculptors and objects, this is the first sustained study of how and why French sculptors collaborated with state and private luxury goods manufacturers between 1848 and 1895.

Organised chronologically, the book identifies three historically-situated frameworks, through which sculptors attempted to validate themselves and their work in relation to industry: industrial art, decorative art and objet d'art. Detailed readings are offered of sculptors who operated within and outside the Salon, including Sévin, Chéret, Carrier-Belleuse and Rodin; and of diverse objects and materials, from Sèvres vases, to pewter plates by Desbois, and furniture by Barbedienne and Carabin.

By contesting the false separation of art from industry, Claire Jones's study restores the importance of the sculptor-manufacturer relationship, and of the decorative, to the history of sculpture.

Claire Jones's research centres on nineteenth-century French and British sculpture and the decorative arts. Formerly Curator of Furniture at the Bowes Museum, and Postdoctoral Research Fellow, University of York. Claire is currently writing a new monograph on Victorian sculpture.

For Jacqueline, Arthur and Amanda

Sculptors and Design Reform in France, 1848 to 1895

Sculpture and the Decorative Arts

Claire Jones

ASHGATE

Published by
Ashgate Publishing Limited
Wey Court East
Union Road
Farnham
Surrey, GU9 7PT
England

Ashgate Publishing Company
110 Cherry Street
Suite 3-1
Burlington, VT 05401-3818
USA

www.ashgate.com

British Library Cataloguing in Publication Data
A catalogue record for this book is available from the British Library

The Library of Congress has cataloged the printed edition as follows:
Jones, Claire (Claire Bethsedia)
 Sculptors and design reform in France, 1848 to 1895 : sculpture and the decorative arts / by Claire Jones.
 pages cm
 Includes bibliographical references and index.
 ISBN 978-1-4724-1523-3 (hardcover) 1. Sculpture, French--19th century. 2. Decorative arts--France--History--19th century. 3. Art and design--France--History--19th century. 4. Art and society--France--History--19th century. I. Title.
 NB547.J66 2014
 730.944'09034--dc23

2014000525

ISBN: 978-1-4724-1523-3 (hbk)

Printed in the United Kingdom by Henry Ling Limited, at the Dorset Press, Dorchester, DT1 1HD

Contents

List of Illustrations *vii*
Preface *xiii*

Introduction: The False Separation of Fine and Decorative Sculpture:
Problems with the Rodin Scholarship for the Study of French
Sculpture, 1848–1895 1

1 Sculptors and Industrial Art, 1848–1870 17
 The Professional and Legal Position of Sculptors in 1848 19
 Salon Sculpture and Industry: Pradier's *Standing Sappho* 31
 The Diffusion of Renaissance Sculpture in Barbedienne's
 Furniture 40
 Ornamental Sculpture and its Sculptors 54

2 Decorative Sculpture and the Third Republic, 1870–1889 89
 Sculptors and the State in the 1870s 89
 Carrier-Belleuse and the Revival of Sculpture in Ceramics,
 1875–1887 91
 A Reconsideration of Rodin's Involvement in Design Reform 109

3 Decorative Sculpture and the Fine Arts, 1890–1895 133
 The *Objets d'Art* Section at the Annual Salon of the Société
 nationale des beaux-arts, 1892 133
 Desbois's Pewter Ware 140
 Chéret's Posthumous Exhibition at the Ecole des beaux-arts
 1894 152

Conclusion: The Limits of Decorative Sculpture 179

Appendix 1: Contract between Constant Sévin and
Ferdinand Barbedienne, 1855 193

Bibliography *195*
Index *215*

List of Illustrations

Colour Plates

Plate 1 Victor Paillard and James Pradier, *Clock Garniture of the Standing Sappho by Pradier* (1848), silvered and gilt bronze on a black marble base, 71.5 × 44.5 cm. Paris, Musée de la Vie Romantique. Photo credit: Musée de la Vie Romantique / Roger-Viollet.

Plate 2 Lapeyre & Cie, designed by Wagner, *Décor 'Style de la Renaissance'* or *Chasse et Pêche*, wallpaper, hand painted and printed, 286 × 323 cm. Les Arts décoratifs – Musée des Arts décoratifs, Paris. Photo credit: Les Arts décoratifs, Paris / Jean Tholance.

Plate 3 Ferdinand Paillet, *Rodin* (1884), watercolour in 'Album de portraits-charges de personnages de la Manufacture'. Sèvres, Cité de la céramique. Photo credit: © RMN-Grand Palais (Sèvres, Cité de la céramique) / Martine Beck-Coppola.

Plate 4 William A. Wellner, 'Der neue Styl', in *Lustige Blätter* (1899), vol. 14, no. 17, pp. 8–9. Photo credit: Jeffery Howe.

Introduction: The False Separation of Fine and Decorative Sculpture: Problems with the Rodin Scholarship for the Study of French Sculpture, 1848–1895

I.1 Choisy-le-Roi, Albert-Ernest Carrier-Belleuse and possibly Auguste Rodin, *Titan Vase Pedestal* (ca. 1879–1880), glazed earthenware, 38.5 × 31 cm. Musée Rodin, Paris. Photo credit: Musée Rodin, Paris / Christian Baraja.

I.2 Mathias Ginsbach and Auguste Rodin, *Bed* (1882), photograph annotated and authenticated by Rodin ca. 1912, published in Mathias Morhardt, 'Rodin ébéniste', *L'Art et les Artistes*, vol. 1, n.s. (no. 1–9) (1920), p. 349. Les Arts décoratifs – Bibliothèque des Arts décoratifs, Paris. Photo credit: Bibliothèque des Arts décoratifs, Paris / Suzanne Nagy-Kirchhofer.

1 Sculptors and Industrial Art, 1848–1870

1.1 Anonymous, 'Victor Paillard's Stand at the International Exhibition in London' (1851), engraving, published in *The Art Journal Illustrated Catalogue: The Industry of All Nations, 1851* (London: George Virtue, 1851), p. 289. Photo credit: © Victoria and Albert Museum, London.

1.2 François-Désiré Froment-Meurice, James Pradier and Jules Wièse, Bracelet, *Two Women with a Vinaigrette Coffer* (1841), silver, silver gilt, gold, enamel, pearl and ruby, 7.4 × 8 cm. Les Arts décoratifs – Musée des Arts décoratifs, Paris. Photo credit: Les Arts décoratifs / Jean Tholance.

1.3 Jules Desfossé, designed by Edouard Müller, called Rosenmuller, *The Garden of Armida* (central panel) (1855), block-printed wallpaper, 390 × 340 cm. Les Arts décoratifs – Musée des Arts décoratifs, Paris. Photo credit: Les Arts décoratifs – Musée des Arts décoratifs, Paris / Laurent Sully Jaulmes.

1.4 Claude-Aimé Chenavard, *Study for the Vase Chenavard called Vase de la Renaissance* (1833), watercolour, pen and ink on paper, 60 × 41 cm. Sèvres, Cité de la céramique. Photo credit: © RMN-Grand Palais (Sèvres, Cité de la céramique) / Martine Beck-Coppola.

1.5 Ferdinand Barbedienne, *Bookcase* (1851), engraving pasted in the scrapbook *Exhibition London 1851, Illustrations*, vol. 6, France and Belgium. Victoria and Albert Museum, London. Photo credit: © Victoria and Albert Museum, London.

1.6 Walter Goodall, *Part of the French Court, No. 1 (Sèvres)* (1851), watercolour and gouache over pencil on paper, 28 × 37.5 cm. V&A, London, purchased with the assistance of the Art Fund, the Friends of the Victoria & Albert Museum and the Royal Commission for the Exhibition of 1851. Victoria and Albert Museum, London. Photo credit: © Victoria and Albert Museum, London.

1.7 Ferdinand Barbedienne, *Bookcase* (1862), in John B. Waring, *Masterpieces of Industrial Art and Sculpture at the International Exhibition, 1862* (London: Day and Son, 1863), vol. 3, Plate 268. Les Arts décoratifs – Bibliothèque des Arts décoratifs, Paris. Photo credit: © Bibliothèque des Arts décoratifs, Paris / Suzanne Nagy-Kirchhofer.

1.8 Denière, *Tobacco Jar*, engraving in *Magasin Pittoresque* (1855), vol. 23, p. 340. Photo credit: © Victoria and Albert Museum, London.

1.9 Ferdinand Barbedienne, Constant Sévin and Albert-Ernest Carrier-Belleuse, *Mirror* (1867), reproduced in *The Art Journal: The Illustrated Catalogue of the Universal Exhibition, Paris, 1867* (London: Virtue, 1867), p. 172. Photo credit: The Bowes Museum.

1.10 Ferdinand Barbedienne, Constant Sévin and Albert-Ernest Carrier-Belleuse, *Mirror* (1867), patinated, gilt and silvered bronze, 208 × 133 cm, detail of metal chasing on fruit. The Bowes Museum, Barnard Castle. Photo credit: The Bowes Museum.

2 Decorative Sculpture and the Third Republic, 1870–1889

2.1 Manufacture nationale de Sèvres, Albert-Ernest Carrier-Belleuse and Auguste Rodin, *Saigon Vase, Les Limbes et les Syrènes* (c. 1888), porcelain, 24.7 × 13.3 × 13.3 cm. Musée Rodin, Paris. Photo credit: Musée Rodin, Paris / Christian Baraja.

2.2 Manufacture nationale de Sèvres, Albert-Ernest Carrier-Belleuse and Auguste Rodin, *La Nuit, urne pompéienne* (1881–82), porcelain, enamel, gilding, 31.8 × 22.7 × 22.7 cm. Musée Rodin, Paris. Photo credit: Musée Rodin, Paris / Christian Baraja.

2.3 *Study of a Group of Children after Fragonard* (1866), in Emile Reiber, *Bibliothèque portative des arts du dessin* (Paris: Ateliers du Musée-Reiber, 1877), Plate 42. Les Arts décoratifs – Bibliothèque des Arts décoratifs, Paris. Photo credit: © Bibliothèque des Arts décoratifs, Paris / Suzanne Nagy-Kirchhofer.

2.4 Manufacture nationale de Sèvres, Albert-Ernest Carrier-Belleuse and Auguste Rodin, *Saigon Vase, Les Eléments* (1879–1880), porcelain, H 19 cm. Sèvres, Cité de la céramique. Photo credit: © RMN-Grand Palais (Sèvres, Cité de la céramique) / Martine Beck-Coppola.

2.5 Manufacture nationale de Sèvres and Larue Jean-Denis, *Vase commémoratif de la nouvelle manufacture* (1867–77), porcelain with pâte-sur-pâte decoration, H 97 cm. Sèvres, Cité de la céramique. Photo credit: © RMN-Grand Palais (Sèvres, Cité de la céramique) / Martine Beck-Coppola.

2.6 Manufacture nationale de Sèvres and Albert-Ernest Carrier-Belleuse, *Vase Delafosse* (1880), porcelain. Musée d'Orsay, Paris. Photo credit: © Musée d'Orsay, Dist. RMN-Grand Palais / Patrice Schmidt.

2.7 Manufacture nationale de Sèvres, Albert-Ernest Carrier-Belleuse, Auguste Rodin and Suzanne Estelle Apoil, *Buire de Blois* (1883–84), hard-paste porcelain with enamel and gilt decoration, 42 × 27 cm. Les Arts décoratifs – Musée des Arts décoratifs, Paris. Photo credit: Les Arts décoratifs, Paris / Jean Tholance.

2.8 Camille Alaphilippe, *Woman with a Monkey* (1908), polychrome and glazed earthenware, gilt and patinated bronze, 184 × 78 × 96 cm. Petit Palais, Musée des Beaux-Arts de la Ville de Paris. Photo credit: Claire Jones.

2.9 Mathias Ginsbach and Auguste Rodin, *Wardrobe* (1878), in Mathias Morhardt, 'Rodin ébéniste', *L'Art et les Artistes*, vol. 1, n.s. (no. 1–9) (1920), p. 348. Les Arts décoratifs – Bibliothèque des Arts décoratifs, Paris. Photo credit: © Bibliothèque des Arts décoratifs, Paris / Suzanne Nagy-Kirchhofer.

2.10 Auguste Rodin, Cuvillier and Parfonry & Huvé Frères, *Grand Dresser for a Dining Room* (1889), various marbles. Reproduced in Victor Champier, *Les Industries d'Art à l'exposition universelle de 1900* (Paris: Bureau de la Revue des Arts Décoratifs, 1903), vol. 3, Plate 30. Les Arts décoratifs – Bibliothèque des Arts décoratifs, Paris. Photo credit: © Bibliothèque des Arts décoratifs, Paris / Suzanne Nagy-Kirchhofer.

3 Decorative Sculpture and the Fine Arts, 1890–1895

3.1 Adrien-Aurélien Hébrard and Jules Desbois, *Femmes et centaures* (1892), pewter, D 33.7 cm. Musée d'Orsay, Paris. Photo credit: © RMN-Grand Palais (Musée d'Orsay) / Hervé Lewandowski.

3.2 Jules Desbois, *Pot en étain* (1892), in *Les Arts du Métal* (September 1893), p. 1. Les Arts décoratifs – Bibliothèque des Arts décoratifs, Paris. Photo credit: © Bibliothèque des Arts décoratifs, Paris / Suzanne Nagy-Kirchhofer.

3.3 Adrien-Aurélien Hébrard and Jules Desbois, *La Treille* (after 1890), terracotta, 19.5 × 6.9 cm. Musée d'Orsay, Paris. Photo credit: © RMN-Grand Palais (Musée d'Orsay) / Hervé Lewandowski.

3.4 Maison Bréant & Coulbeaux, Joseph Chéret and Emile Gallé, *Vase Mounted in Silver with a Garland of Fine Gold and Enamel* (1889), in 'Les Industries d'Art à l'exposition universelle de 1889', supplement to *Revue des Arts Décoratifs* (September 1890), p. 105. Les Arts décoratifs – Bibliothèque des Arts décoratifs, Paris. Photo credit: © Bibliothèque des Arts décoratifs, Paris / Suzanne Nagy-Kirchhofer.

3.5 Albert-Ernest Carrier-Belleuse, *Le Printemps (vase et support)* (before 1884), in Albert-Ernest Carrier-Belleuse, *Application de la figure humaine à la décoration et à l'ornementation industrielle* (Paris: Goupil, 1884), Plate 2. Les Arts décoratifs – Bibliothèque des Arts décoratifs, Paris. Photo credit: © Bibliothèque des Arts décoratifs, Paris / Suzanne Nagy-Kirchhofer.

3.6 Joseph Chéret, *The Quiver* (before 1885), in *La terre cuite française. Reproductions héliographiques de l'œuvre de Joseph Chéret, sculpteur à Paris* (Paris; Liège: C. Claesen, 1885), Plate 7. Photo credit: © Victoria and Albert Museum, London.

3.7 Joseph Chéret, *Sleep* (before 1885), in *La terre cuite française. Reproductions héliographiques de l'œuvre de Joseph Chéret, sculpteur à Paris* (Paris; Liège: C. Claesen, 1885), Plate 23. Photo credit: © Victoria and Albert Museum, London.

3.8 Jules Chéret, *Students' Gala Ball* (1895), colour lithograph, H 124 cm. Minneapolis College of Art and Design, Minneapolis. Photo credit: Minneapolis College of Art and Design, Minneapolis.

3.9 Joseph Chéret, *Le Vase aux Masques* (1892), in *Revue des Arts Décoratifs* (July 1892), p. 8. Les Arts décoratifs – Bibliothèque des Arts décoratifs, Paris. Photo credit: © Bibliothèque des Arts décoratifs, Paris / Suzanne Nagy-Kirchhofer.

Conclusion: The Limits of Decorative Sculpture

4.1 Rupert Carabin, *Display Cabinet for Objets d'Art* (1895), walnut, 238 × 243 × 184 cm. Petit Palais, Musée des Beaux-Arts de la Ville de Paris. Photo credit: Claire Jones.

4.2 Henri-Auguste Fourdinois, Hilaire, Pasti and Néviller, *Cabinet on Stand* (1867), ebony, partly veneered on oak, with inlay and carved decoration in box, lime, holly, pear, walnut, mahogany and hardstones, marble plaques and figures in box, 249 × 155 × 52 cm. Victoria and Albert Museum, London. Photo credit: © Victoria and Albert Museum, London.

4.3 Rupert Carabin and Albert Servat, *Bookcase* (1890), walnut and forged metal, 290 × 215 × 83 cm. Musée d'Orsay, Paris. Photo credit: © RMN-Grand Palais (Musée d'Orsay) / Hervé Lewandowski.

4.4 Rupert Carabin, *Display Cabinet for Objets d'Art* (1895), walnut, 238 × 243 × 184 cm. Detail of Stone. Petit Palais, Musée des Beaux-Arts de la Ville de Paris. Photo credit: Claire Jones.

Preface

This book was originally inspired by my time as a curator at the Bowes Museum, which brought me into contact with its extensive collection of French Second Empire decorative arts, and set me thinking about the interrelationship between the various arts.

I would like to thank the Arts and Humanities Research Council for supporting my doctoral research, and for providing me with additional financial assistance for research in Paris. I would also like to thank the Henry Moore Foundation for generously supporting my research and the publication of this book, and the Tom Ingram Memorial Fund for a grant towards research.

This book would not have been possible without the help of the following people. Adrian Jenkins for enabling me to initially embark on this project part-time; Howard Coutts for early conversations; Martina Droth for her encouragement throughout the project; David J. Getsy for his helpful comments and enthusiastic response to an early outline; and Amanda Lillie for her advice and guidance. I would also like to thank Adrian, Howard, Martina and, in particular, Antoinette le Normand-Romain, for supporting an exhibition on Rodin as a decorative artist that I began curating in 2004. Although unrealised, these early discussions were pivotal to the conception and development of this book.

I would especially like to thank Jason Edwards (who was my doctoral supervisor at the University of York) for his constant encouragement of my research, and for his thoughtful and incisive guidance throughout. The support of my examiners, Michael Hatt and Michael White, was invaluable in taking this forward to publication.

I am also grateful to those who have made my research visits so productive. Particular thanks go to Catherine Chevillot at the Musée d'Orsay for sharing her research on the Réunion des fabricants de bronzes, and Laure de Margerie for helping me navigate its invaluable documentation centre; Antoinette le Normand-Romain and François Blanchetière at the Musée Rodin; Dominique Morel and Amélie Simier at the Petit Palais; and Olivier Gabet for early

conversations. The interest and help of archivists and librarians has been invaluable, and I would particularly like to thank staff at the Bibliothèque des Arts décoratifs and the Archives nationales, Anne Gros at the Musée Bouilhet Christofle, Tamara Préaud at Sèvres – Cité de la céramique, as well as staff at the Musée Rodin archive, the Bibliothèque Forney, Bibliothèque Historique de la Ville de Paris, the British Library, the National Art Library and the University of York library. I would also like to thank Melissa Hamnett at the V&A and Catherine de Bourgoing at the Musée de la Vie romantique for getting objects out of store for me; Martin Rodda at Rupert Harris Conservation for discussions regarding the Barbedienne mirror and an impromptu tour round the bronze foundry; and colleagues and friends across institutions and departments for thoughtful and helpful conversations over the years. The opportunity to present ideas and to receive feedback at conferences, seminars and study days has been invaluable.

I would like to thank Ashgate, and particularly my editor Margaret Michniewicz, for having faith in this project, and for guiding it so efficiently through to publication. Every attempt has been made to obtain permission to reproduce copyright material. If any proper acknowledgment has not been made, copyright holders are invited to inform the author of the oversight.

Finally, this project would not have been possible without the love and support of family and friends. Special thanks go to my parents, Jacqueline and Arthur; and to Amanda Burgess and Dale Robson, for always having such belief in me.

This book is dedicated to the makers of the works that I have had the privilege to examine and study throughout the course of my research.

Introduction
The False Separation of Fine and Decorative Sculpture: Problems with the Rodin Scholarship for the Study of French Sculpture, 1848–1895

The study of nineteenth-century French sculpture is dominated by autonomous, figurative and monumental fine art sculpture, and by issues of style and single authorship. This follows the high status of such works within the Académie des Beaux-Arts – whose role was to set standards for the fine arts in France – as the pinnacle of artistic and technical achievement; ideas that were promoted through its annual art exhibition, the Salon, as the preeminent forum for accessing the latest developments in contemporary sculpture. The study of decorative, ornamental and collaborative sculpture has by contrast received less scholarly attention. The involvement of sculptors such as Albert-Ernest Carrier-Belleuse, James Pradier and Auguste Rodin with a variety of manufacturers, and in a broad range of mediums from cameos to ceramics, while acknowledged, is generally regarded as incidental to their more 'important' endeavours in the fine arts. Similarly, sculptors such as Constant Sévin who did not exhibit at the Salon, but who worked almost exclusively within the luxury goods industries, are markedly absent from the scholarship.

This book seeks to redress this imbalance by examining the conceptual, professional, economic, legal and artistic status and interests of a broad range of sculptors who worked within the decorative arts, and who operated within, and outside of, the Salon. It brings to light the neglected and significant ways in which they created and theorised sculpture through their involvement with design reform, and challenges the current prioritisation of those sculptors, manufacturers and works which support a linear understanding of nineteenth-century sculpture as a precursor to modernism, by demonstrating how the partial and selective study of nineteenth-century sculpture (and of Rodin's *oeuvre* in particular) has limited our current understanding of French sculpture between 1848 and 1895. By bringing new archival and documentary

material, objects, sculptors and theoretical debates to bear on the existing scholarship, this book opens up new lines of enquiry into the complex intersections of sculptors, manufacturers and the State, and demonstrates the hitherto neglected importance of these relationships to changing discourses on, and practices of, sculpture.

I wish to make it clear from the outset that my aim is not to extend the study of decorative sculpture as a distinct category within the history of French sculpture. Rather, it is to argue that the history of sculpture must make room for the decorative arts. This was not simply an alternative site for sculpture, but a central field of sculptural activity which facilitated and challenged particular approaches to sculpture. Cross-fertilisations between sculpture and the decorative played a vital role in the formal practices and aesthetics of what we might still be inclined to think of in the exclusive terms of either 'sculpture' or 'the decorative'.

Despite the profusion of the decorative arts in France between 1848 and 1895 and the key role of sculptors in their design and manufacture, profound conceptual divisions between scholars of 'sculpture' and 'decorative art' have meant that the intensely productive relationship between the two has largely been ignored or obscured. This book presents a more comprehensive understanding of the practice and profession of sculpture in mid to late nineteenth-century France. It reconstructs a more precise history of sculpture in this period by demonstrating how sculptors operated fluidly (and achieved success) both 'in' and 'outside' the Salon through their involvement with state and private manufacturers.

So why, despite the importance of sculpture to the French nineteenth-century luxury goods industries, has this area of sculpture been neglected as a field of art historical enquiry? Central to an understanding of this is the problematic nature of the Rodin scholarship for the study of nineteenth-century French sculpture. This is almost exclusively underpinned by discourses prioritising a linear narrative towards modernism and an 'artisan to artist' chronology, both of which have generated a limited consideration of the diverse nature of sculpture during this period. Positioning Rodin as the 'father of modern sculpture' has required and generated a particular approach to Rodin's life and work which integrates and rejects elements of his life and work dependent on their compatibility with his supposed modernity as a sculptor.[1] This selective process preferences the 'authentic' qualities identified in his 'unworked' surfaces; his use of plaster as a creative medium, particularly through assemblage and the fragment; his use of the *non-finito*; and his exploration of the (tortured) human condition. Rodin's apparent rejection by a reactionary and official art world (despite the importance of state commissions to his career) and his subsequent recognition by an enlightened avant-garde are seen as testament to his status as an independent and autonomous artist. Such readings are partly the result of, and a

continuation of, Rodin's own myth-making, and set Rodin in opposition to the highly worked 'fini' of Salon sculpture and its mythological or heroic subject matter, to artisanal and collaborative production, and to the 'whole' or 'finished' object. In consequence, these elements are thereafter perceived as being incompatible with both modernity and his own *oeuvre*.

Herein lies the problem: positioning Rodin as the 'father of modern sculpture' has marginalised not only those aspects of his work that do not express this 'modernity', but has largely excluded them from broader sculptural discourse. And while the study of 'modernity' and 'modernism' has significantly developed over recent years to recognise its own history and complexity, the scholarship on Rodin and, by extension, on modern sculpture more broadly, remains entrenched in a relatively reductive and binary conception of what 'modern' sculpture might mean. The particular understanding of 'modern' sculpture adopted by Rodin scholars has led to a partial and selective study of his work, and this has impacted on the position and status of decorative sculpture and the decorative arts more broadly within the current history of sculpture. If one of the problems facing the study of nineteenth-century sculpture today is that it is overshadowed by the figure of Rodin, then that shadow reaches beyond our understanding of fine art Salon sculpture to encompass the decorative arts.[2]

While research on Rodin has been comparatively extensive and furthers our knowledge of his sculpture and artistic practice to incorporate his drawings, photographs, plasters, monuments and his role as a collector, the study of his decorative work has been fragmentary and favours those works that can be integrated within the rhetoric of progress and modernity that dominates the Rodin scholarship.[3] When such works are considered, the scholarship centres on questions of attribution rather than interpretation or contextualisation within a broader historical, sculptural or decorative discourse. For example, the 2009 exhibition 'Rodin, Les Arts décoratifs', jointly curated by the Musée Rodin in Paris and the Palais Lumière at Evian, focused on Rodin's work for the National Ceramic Manufactory at Sèvres in the 1880s, and his relationship with 'avant-garde' patrons and designers such as Baron Joseph Vitta, Maurice Fenaille and Félix Bracquemond.[4] While this exhibition presented new and welcome research, particularly for Sèvres, its selection of works concentrated on those areas which support rather than challenge or disrupt the standard narrative of progress towards a 'modern' sculpture. Rodin's decorative sculpture continues to remain an anomaly, languishing in museum stores or studied as isolated works.[5]

Central to the marginal status of Rodin's decorative work is the representation of the artist in a linear trajectory of advancement from artisan to artist. Rodin's career is broadly separated into two distinct periods: the 'early' years before 1880 when he earned a living working for manufacturers and sculptors such as Carrier-Belleuse; and his 'independent' career from 1880 onwards when

the State first purchased his work at the Salon and commissioned *The Gates of Hell*. His decorative work has been similarly separated into two interrelated distinct groups: early unsigned work produced through economic necessity; and later 'autonomous' artistic decorative work produced for enlightened patrons once his fine art career had taken off.[6] Neither is yet fully integrated within his broader *oeuvre*.[7]

One reason for this is that Rodin's formative years took place during the Second Empire (1852–1870) and the first decade of the Third Republic (1870–1946). The decorative arts of this period are generally identified with serial production, bourgeois bad taste, and an overreliance on historic models.[8] Rodin's work in this period is therefore thought to hold similar connotations. As the Rodin scholar Albert Elsen notes,

> From the time of [Rodin's] apprenticeship, which lasted until he was almost forty, all his decorative work in furniture, jewellery, ceramics, mantelpiece or table ornament, and architectural sculpture was identifiable with antique or Renaissance motifs. On the beds, he carved appropriately tender amors: his bases were braced by bacchic idylls; balconies were supported by caryatids; fountains were flanked by huge masks of sea gods; pediments were crowned with allegorical figures representing Fame or the continents.[9]

Such a generalised reading of Rodin's early decorative work could be partly excused by a lack of surviving documentation and extant objects, which prevent their closer analysis. However, from Elsen's quotation above, one can identify the figures modelled for a bed by Mathias Ginsbach (private collection), supports for balconies for the Villa Neptune in Nice, masks for the Trocadéro fountain (now at the Musée des Arts décoratifs, Paris) and pediments for the Brussels Academy.[10] Elsen's decision not to study these works in any detail suggests an implicit dismissal of their intrinsic value to our understanding of Rodin and (because of Rodin's dominance) to the development of French sculpture more broadly. The essential character of this work – its subject, form and style – is seen to be incompatible with Rodin's later modernity as a sculptor, as it is composed of allegorical figures, amors and bacchii that 'people' beds, fountains, balconies and pediments.[11] These are interpreted as predictable, derivative and stylistically reliant on historic models. With these issues in mind, Chapter 1 questions this reductive analysis of historicism and the sculptor–manufacturer relationship through a study of the integration of Renaissance sculpture in furniture produced by the bronze founder Ferdinand Barbedienne during the 1850s and 1860s, and its significance for contemporary sculptors. Chapter 3 addresses 'playful' sculpture in closer detail, in relation to the work of Joseph Chéret.

The critique of Rodin's decorative work from within a narrative of progress has not only impacted on the reception of his own work, but has also proved problematic for those sculptors (and their sculpture) who remained

within, rather than transcended, the 'artisanal' tradition. I highlight these shortcomings in Chapter 1 through a study of Constant Sévin's ornamental work for Barbedienne, and the concerns raised and discussed in two reports written by delegations of sculptors to the International Exhibitions of 1862 and 1867. These also demonstrate that the phrase 'artisan to artist' is in itself inaccurate and misleading. Rodin was not an 'artisan' as understood in terms of *making* craft objects; his 'artisan to artist' trajectory does not represent a shift from manual to artistic labour, but movement within different artistic labours. He formed part of one (or more) categories of sculptors who supplied *models* for manufacturers (and other sculptors). His career reflects the broad range of professional distinctions in sculpture addressed by this book; from the ornamental sculptor providing models of decorative vases for bronze founders to the *statuaire* (literally, statue maker) undertaking ideal sculpture for the (apparently) less commercial arena of the Salon. It would therefore be more precise to identify Rodin's professional transition as one from modeller to sculptor, or from one type of sculptor to another type of sculptor (and back again; as will be seen, he continued to supply models for manufacturers well into the 1880s).

The Rodin narrative is equally problematic for those sculptors who, like Rodin, succeeded in progressing along the different sculptor categories. Their early decorative work is rejected or diminished because of the greater value placed on the (perceived) higher degree of autonomy in their 'independent' artistic works, in contrast to their 'economically driven' work for industry. This demonstrates art history's still uncomfortable relationship with the economics of art, whereas this book considers financial matters and economic imperatives to be central to understanding sculpture during this period, and the needs and aspirations of its sculptors.

Furthermore, the 'artisan to artist' narrative leaves scant opportunity for the study of the interrelation and interdependence of fine and decorative sculpture over a sculptor's career or for the integration of apparent 'anomalies' in a sculptor's *oeuvre*. To illustrate this point, I examine the relationship between Salon sculpture and industry, notably in the case of Pradier in Chapter 1, and bring new evidence to bear on Rodin's continued involvement in design reform in the 1880s and 1890s in Chapter 2. While Rodin himself strategically emphasised his transition from artisan to artist, he simultaneously appreciated and valued, at least in retrospect, the variety of skills, objects, materials and techniques that his 'early' work furnished him with:

> In addition to sculpture and design, I myself have worked at all sorts of things. I've cut down marbles, and pointed them; I've done etching, and lithography, bronze founding and patination; I've worked in stone, made ornaments, pottery, jewellery – perhaps even too long; but it all has served. It's the material itself that interested me. In short, I began as an artisan, to become an artist. That's the good, the only, method.[12]

Rodin's education 'outside' the 'system' – attending evening classes and lectures, visits to galleries, zoos and botanical gardens, working in the studios of established sculptors – echoed that of the majority of sculptors within the period: skills were accumulated via an ad-hoc mixture of guided and self-guided instruction and practice.[13] In 1854 Rodin entered what is commonly referred to as the 'Petite Ecole', the state-funded art school for industry.[14] Alongside these classes Rodin explored the Louvre and the Print Rooms of the Imperial Library.[15] In 1857 he left the Petite Ecole with the intention of entering the Ecole des beaux-arts, the official School of Fine Arts, but was unsuccessful after three failed attempts.[16] The standard interpretation of this is that Rodin thereafter militated against, or at least remained outside, fine art academic and administrative institutions.[17] This is despite the fact that Rodin actively sought to enter the official fine art world, and was later to do so successfully. Ironically, it is the state purchase of the *Age of Bronze* and the aforementioned commission of *The Gates of Hell* in 1880 that are seen to mark his 'arrival' as a sculptor.

With the fine art academic route closed to him, Rodin supported himself by taking on sculptural work outside the fine arts, namely within architecture and the luxury goods industries, while privately pursuing his own artistic projects.[18] This experience of working in industry and architecture had a significant formative influence on Rodin's sculptural development and on 'modern' sculpture more broadly. While Rodin's use of assemblage and fragments can be understood as a radical transformation in the practice and conceptualisation of fine art sculpture, such techniques were common currency in the decorative arts. Given the role of sculptors in industry, Rodin would primarily have carved and modelled sections rather than whole objects, a process which would have trained him to conceive and produce work as a fragment.[19] This training perhaps also impeded his own ability to create and complete entire works, most notably *The Gates of Hell*.

Certainly, Rodin's work for manufacturers opened him up to particular ways of seeing, understanding, interpreting and adapting sculpture which differed to the approaches he would have been exposed to if pursuing a uniquely fine art career. In his role as a sculptor in industry Rodin came into contact with a broad variety of materials, techniques, surface finishes, skills and disciplines (including wood, furniture and enamelling) as well as with practitioners, including goldsmiths, chasers and sculptors, notably Carrier-Belleuse, Antoine-Louis Barye and Constant Simon. Rodin would also have acquired high level administrative and organisational skills working for manufacturers and sculptors such as Carrier-Belleuse, where he would have observed the logistics of working concurrently on a range of projects.

If these artisanal years have been somewhat neglected by the scholarship, the manner in which Rodin's artistic development and autonomy have been assessed in relation to them is equally problematic to our understanding of

his sculpture. These are predicated on the degree to which Rodin is perceived to have developed and maintained a personal and unique style within the parameters (understood as limitations) set by his employer. Thus, in the following quotation, Frederick Lawton interprets Rodin's 'deviation' from Carrier-Belleuse's original sketches as a mark of artistic maturity:

> What would be interesting, if possible, would be to see some of the sketches given him by Carrier-Belleuse, and to compare them with the finished production, in order to find out how far his own individuality was maintained or altered. It may be presumed that the incessant carrying out of designs not his own affected his style, at least for a time. For such a deviation to become permanent, his character would have had to be of more commonplace type, largely yielding to circumstance. Ultimately, he came to see the defects of what he copied – even those that were most hid – and, by his natural reaction against circumstance, the liability to be influenced by them ceased.[20]

Here, Rodin is seen to be blessed with an innate gift for sculpture and an inner strength which enabled him to rise above the role of 'mere' copyist to develop an original and personal style. Although Lawton goes on to acknowledge the positive influence of Rodin's experience in Carrier-Belleuse's studio on his technical and formal development, notably the opportunity it afforded him to study effects in grouping, the theme is consistent: working for others inhibits and stifles personal creative development.

This prioritisation of early decorative works by Rodin that are seen to express his personal 'signature' is taken up by subsequent scholars. The first extensive analysis of a piece from Rodin's 'early years' is an article by the art historian Horst Janson.[21] Janson examines extant terracotta versions of figures for the *Titan Vase* (Fig. I.1), a salt-glazed earthenware bowl on a stand incorporating four male figures, produced by the ceramic firm of Choisy-le-Roi from around 1879. Janson records the figures as being definitively by Rodin. This is despite the original design and the various and distinct examples of the vase being signed 'Carrier-Belleuse'.

As Janson argues,

> Carrier-Belleuse himself, on the evidence of this drawing, did not conceive the Titans as tormented beings. Their poses have the fluidity and easy grace characteristic of all the Application designs.[22] Rodin, on the contrary, seized upon and exploited the tragic implications of the theme. His Titans, unlike those projected by Carrier-Belleuse, do not form a coordinated 'team'; ... [they] reflect inner struggle and despair rather than the effort to sustain a heavy burden ... In essence, the Maryhill maquettes are four individually conceived and self-contained creations, each enveloped in its own mood. To stress their solitary character, Rodin has placed them on separate mounds whose irregular shape harmonises with the poses of the figures. He thus anticipates an important aspect of *The Thinker*.[23]

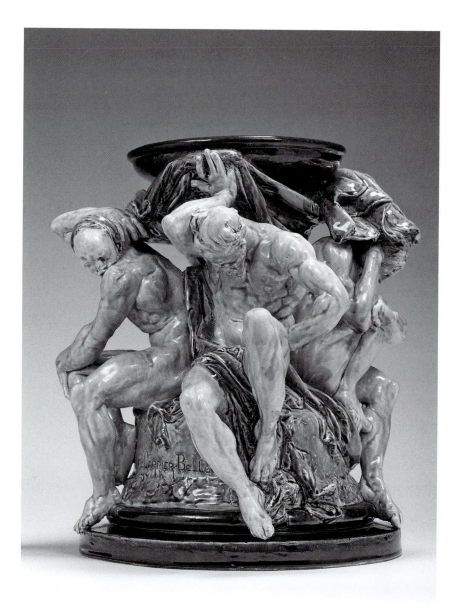

I.1 Choisy-le-Roi, Albert-Ernest Carrier-Belleuse and possibly Auguste Rodin, *Titan Vase Pedestal* (ca. 1879–1880), glazed earthenware, 38.5 × 31 cm. Musée Rodin, Paris.

Rodin's figures for the vase are here understood as precursors to the 'profundity' of Rodin's later independent sculpture; their (inner, psychological) 'mood' is valued more highly than Carrier-Belleuse's (outer, decorative) 'grace'.[24] While Janson's study is a rare example of art historical analysis applied to a decorative work by Rodin, the vase itself is largely incidental: Janson focuses on four figurative maquettes rather than the figures as applied to the vase, extracting the figures from their decorative context. Similarly, although different versions of the vase are known, these have yet to be explored as a group or considered in terms of the relationship between each of their elements.

I do not take issue with the fact that Rodin may have modelled the figures, as it was common practice for more established sculptors to sign a work irrespective of the contribution of hired sculptors, but it *is* fundamentally important to reassess the criteria and assumptions by which such attributions are made, to consider such works as whole objects, and to examine both their fine *and* decorative contexts.

Lawton and Janson's studies reveal a further problem with the Rodin scholarship: an emphasis on those works which conform to our current understanding of what constitutes 'a Rodin' excludes those which do not. On the figures for the *Titan Vase* for instance, Janson concludes that 'stylistically, their attribution to Rodin is incontestable'.[25] Herein lies the difficulty: Rodin's decorative work does not necessarily present as consistent or sustained an aesthetic as his sculpture 'proper', and is therefore almost impossible to identify without accompanying documentation. The problem is exacerbated by the fact that the decorative arts are generally less documented than the fine arts, particularly as regards the survival of manufacturers' records. As Rodin's documented early work does not 'look' like a Rodin, but includes the qualities of historicism and sentimentality, stylistic themes of children and playfulness, the ornamental and domestic, the 'finished' surface, the non-autonomous and collaborative work, these do not sit easily within the more recognised Rodin aesthetic of rough surfaces, the fragment, the *non-finito* and representations of the tortured human condition. These qualities consequently get excluded from the Rodin scholarship, and are thereafter devalued within the broader study of sculpture.

Take, for example, a bed by the furniture maker Mathias Ginsbach (1882) (Fig. I.2), which I discuss further in Chapter 2. At first glance it appears to be an unexceptional example of mid to late nineteenth-century furniture, encapsulating negative associations with decorative arts of the period, notably a reliance on earlier styles and the use of ubiquitous cherubs. Rodin modelled the figures for this bed in 1882, two years after he is seen by most biographers and art historians to have abandoned decorative and architectural work following his first state commissions in 1880. Yet despite the bed being a rare example of Rodin's work for wood, and a unique piece

untainted by the problems of reproduction that surround much of Rodin's sculpture, it seems that the reintegration of this work within Rodin's *oeuvre*, most visibly through its acquisition or display by a museum, requires more than the identification of authorship.[26] It needs, as is the case of the *Titan Vase* (whose attribution is in contrast not documented) to exhibit Rodin's *stylistic* signature as a 'modern' sculptor. As I demonstrate in Chapter 2, on closer analysis Rodin's 'cherubs' *could* be integrated within the dominant narrative of Rodin as the 'father of modern sculpture'. So why have the figures on the bed not yet been the subject of considered study by Rodin scholars? Has the bed got in the way? Do the figures, like those associated with the *Titan Vase*,

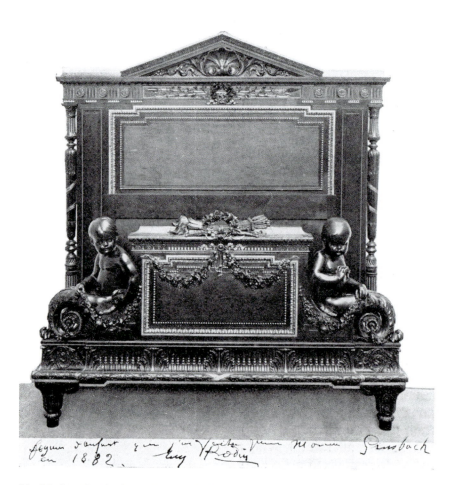

I.2 Mathias Ginsbach and Auguste Rodin, *Bed* (1882), photograph annotated and authenticated by Rodin ca. 1912, published in Mathias Morhardt, 'Rodin ébéniste', *L'Art et les Artistes*, vol. 1, n.s. (no. 1–9) (1920), p. 349. Les Arts décoratifs – Bibliothèque des Arts décoratifs, Paris.

need to be detached from their decorative context in order to be incorporated within art historical discourse? Are 'sentimental' children and cherubs simply not worthy of study?

Without Rodin's success in the fine arts it is likely that he would have remained as obscure as Hiolle, who carved the figures he modelled for Ginsbach's bed. While this book is in part a contribution to Rodin studies, its larger aim is to redirect attention towards the neglected position of decorative sculpture, both in relation to Rodin and more broadly within the study of sculpture. This opens up the question of how perceptions towards sculpture have been subsequently and selectively shaped through distinctions between particular types of sculpture, sculptors, materials, techniques, subject matter and patrons. Questioning how and why certain 'decorative' aspects of Rodin's work have been marginalised opens up new areas for the study of sculpture and for the decorative arts, which requires a reconsideration of art history as a discipline.

This book suggests how a re-examination of mid to late nineteenth-century objects, writings and sculptors can generate a more subtle and comprehensive understanding of the practice of sculpture during this period. Approaching sculpture from within the context of decorative art reveals how associated concepts such as authorship and the handmade are historically specific and changing constructs. Detailed and contextualised investigations of specific works and sculptors challenge a linear and progressive history from industrial art to Art Nouveau, and present an inclusive and object-centred approach to our understanding of both sculpture and the decorative arts of this period. This historical and object-based approach considers the values and meanings ascribed to artists, objects, materials and techniques to be flexible and changing, and to be determined, at least in part, by their contexts and consumers, be they sculptors, manufacturers, artisans or state representatives.

It must also be noted that these objects were predominantly created by men, commissioned by men, and critiqued and evaluated by men. Women sculptors appear to have been comparatively rare within fine art sculpture and I am as yet unaware of women sculptors working in the luxury goods industry of the period.[27] While I hope that my study will generate much-needed research into the role and position of women practitioners, its focus is almost exclusively on the dynamic between the (male) sculptor, state, manufacturer and critic. An important exception here is women as subject matter. Figurative sculpture in the decorative arts in this period is by and large represented by women, babies and children, a continuation of their historic significance to the decorative, notably eighteenth-century precedents by sculptors such as Etienne Falconet and Claude Michel (known as Clodion).

In terms of class, the sculptors examined were working class, as was typical of sculptors in France for the period. By introducing new material on these individuals, from their reports at the international exhibitions to research on

now obscure sculptors, I expand the current focus on professional art criticism to encompass the 'voices' of a broad range of sculptors (and manufacturers). This brings new evidence to bear on their technical, political, economic and aesthetic concerns, through their own writings and activities.

A survey of the decorative arts produced between 1848 and 1895 suggests that sculpture was perhaps the most visible and accessible of artistic forms of the period. It is certainly the art form most commented on by contemporary critics and most sought after by manufacturers. The term 'art' is therefore to be particularly identified with sculpture. As the century progresses the adjectives 'industrial', 'decorative' and 'objet' are successively added to the term 'art', giving 'industrial art', 'decorative art' and 'objet d'art'. This terminology has received little analytic attention to date, and tends to be used interchangeably.[28] In the course of this book I restore specificity to these terms by mapping how they signal distinct period-specific constructs, which reveal complex and nuanced relations between fine art and other objects.

Some objects, such as Sévin and Barbedienne's mirror of 1867, are unique and handmade and defy pejorative associations between 'industrial art' and mechanical reproduction.[29] Others, such as Desbois's pewter ware, were produced under the aegis of 'objet d'art' as a strategic means of distancing their work from 'manufactured' products, but were intended to be made by manufacturers in numbers accessible to a particular spectrum of society. Crossing conceptual and stylistic periods in this way allows greater scope for embracing contradictions, continuities, problems and inconsistencies. Thus, while some objects included in this study can be understood within the context of the avant-garde (Carabin's *Display Cabinet for Objets d'Art*, 1895), fine art sculpture (Pradier's *Standing Sappho*, 1848), or ornamental sculpture (Sévin's design for a mirror by Barbedienne, 1867) they can also be understood collectively as objects, as sculpture, and in terms of materials and techniques and associated concepts such as the handmade and surface effect. These case studies are thus designed to be exploratory rather than necessarily paradigmatic, and to counter unhelpful dichotomies such as the handmade versus the industrial, the reproduced versus the unique object, and the defining of alternatives to modernism as resistant to modernism rather than simply as different creative expressions.[30]

The overall organisation of the book is chronological. However, rather than follow existing retrospective categories based on stylistic or political distinctions such as Second Empire or Art Nouveau, it presents a new conceptual model for understanding sculpture and design of the period 1848 to 1895. I identify three discrete yet interrelated and nonexclusive dominant trends in design reform: industrial art (1848–1870), decorative art (1870–1892) and objet d'art (1892–1895). These are historically situated and understood terms, and reflect the changing dynamic between sculptors, manufacturers and the State. And although these terms are broadly aligned with particular

political periods, I do not wish to imply any monocausal political determinism. Rather, these terms were primarily a response by sculptors, manufacturers and the State to economic conditions which coincided with radical changes in political leadership as well as to democratic trends and the rise of the private art market.

Sculptors were not bystanders in contemporary design reform, but actively and significantly contributed to the theorisation and development of industrial art, decorative art and objet d'art as a means to improve their artistic, legal, economic and professional status. Sculptors were actively involved in defining these core terms of industrial art, decorative art and objet d'art as they sought to simultaneously benefit from, and assert their independence from, manufacturers and the State. A broad arc of increase in the visibility of sculpture in the decorative arts is discernible from 1848 to 1895, firstly within the context of industrial art, then through state intervention, and finally through the partial integration of the decorative arts into the fine arts. By thus avoiding stylistic categorisations, this new framework allows for the reintegration of marginalised and neglected practitioners and types of sculpture into our understanding of what constituted sculpture in this period, and provides a context for a more accurate study of the conceptual, professional, economic, legal and artistic concerns of its sculptors.

Notes

1 Albert T.E. Gardner, 'The Hand of Rodin', *The Metropolitan Museum of Art Bulletin*, n.s., vol. 15, no. 9 (May 1957): pp. 200–204; Ruth Butler Mirolli, 'The Early Work of Rodin and its Background' (Ph.D. dissertation, New York Univ. 1966); Albert E. Elsen, *Rodin* (New York, 1967); Ruth Butler, *Rodin: The Shape of Genius* (New Haven and London, 1993); Penelope Curtis, *Sculpture 1900–1945: After Rodin* (Oxford, 1999). Jon Wood, David Hulks and Alex Potts (eds), *Modern Sculpture Reader* (Leeds, 2007) still insists on the definition of a 'new' sculpture, as identified with Rodin.

2 On the crisis of influence within fine art sculpture following Rodin, see Catherine Chevillot (ed.) *Leaving Rodin Behind? Sculpture in Paris, 1905–1914* (Paris, 2009).

3 On Rodin's plasters see Leo Steinberg, 'Rodin', in Leo Steinberg, *Other Criteria: Confrontations with Twentieth Century Art* (New York, 1972), pp. 322–463; on his works on paper, Catherine Lampert, *Rodin. Sculpture and Drawings* (London, 1987); and on his use of photography in his studio practice, Albert E. Elsen, *In Rodin's Studio, A Photographic Record of Sculpture in the Making* (New York and Oxford, 1980). While these works have largely separated out Rodin's work by material, medium and subject matter, David J. Getsy's *Rodin: Sex and the Making of Modern Sculpture* (New Haven and London, 2010) provides a more cohesive conceptualisation of Rodin by identifying sex and sexuality as an interrelated performative strategy that integrates his work, practice and identity as a sculptor. However, Getsy still insists on a progressive linear narrative towards modern sculpture, with Rodin as its driving force.

4 François Blanchetière and William Saadé (eds), *Rodin. Les Arts décoratifs* (Evian and Paris, 2009). The exhibition took place in Paris in 2010 under the revised title 'Corps et Décors, Rodin et les Arts décoratifs'. Jean-Paul Bouillon, 'Baron Vitta and the Bracquemond/Rodin Hand Mirror', *The Bulletin of the Cleveland Museum of Art* (November 1979): pp. 298–319.

5 See for example the emphasis placed on the *Titan Vase*, while Rodin's models for the unrealised commission for a fireplace for Matías Errázuriz have only recently been displayed, and in an exhibition rather than as part of the permanent collection. Blanchetière and Saadé, *Rodin*.

6 Judith Cladel, *Rodin* (London, 1936); Butler, 'The Early Work'; Butler, *Rodin: The Shape of Genius*; Blanchetière and Saadé, *Rodin*. Rodin's 1902 collaboration with Bracquemond on a hand mirror for Baron Joseph Vitta has been interpreted as an enlightened, progressive commission, and is thus incorporated within Rodin's autonomous artistic production; Bouillon, 'Baron Vitta'.

7 Exceptions here are the early Musée Rodin catalogues which include Rodin's paintings, decorative work, plasters, photographs and drawings. Georges Grappe, *Catalogue du Musée Rodin: essai de classement chronologique des œuvres d'Auguste Rodin* (Paris, 1931).

8 On historicism as a reflection of bourgeois insecurity see Debora L. Silverman, *Art Nouveau in Fin-de-Siècle France, Politics, Psychology and Style* (Berkeley and London, 1989). On the bourgeoisie as consumers and the types of objects they purchased see Whitney Walton, *France at the Crystal Palace, Bourgeois Taste and Artisan Manufacture in the Nineteenth Century* (Berkeley, Los Angeles and Oxford, 1992).

9 Elsen, *Rodin*, 1967, p. 15.

10 A rare study that documents Rodin's decorative work is Cécile Goldscheider, *Rodin, vie et œuvre, tome I, 1840–1886, catalogue raisonné de l'œuvre sculptée* (Paris, 1989).

11 While these types of objects date from the ancien régime, some, such as balconies, were important features of Baron Haussmann's modernisation of Paris from the 1850s onwards and are central to paintings by the likes of Gustave Caillebotte and Auguste Renoir.

12 Victor Frisch and Joseph T. Shipley, *Auguste Rodin, a Biography* (New York, 1939), p. 191.

13 For a useful analysis of a sculptor's education at the Petite Ecole and the Ecole des beaux-arts, and additional opportunities for study and practice see Anne M. Wagner, *Jean-Baptiste Carpeaux, Sculptor of the Second Empire* (New Haven and London, 1986).

14 Renamed the National School of Decorative Arts (Ecole nationale des arts décoratifs) in 1877, the 'Petite Ecole' or 'small school' (a reference to its status alongside the prestigious Ecole des beaux-arts), originated from the Royal Free Drawing School (Ecole royale gratuite de dessin) founded in 1766 by the painter and Director of Sèvres Jean-Jacques Bachelier to develop arts-related professions for industry. The curriculum focused on drawing geometry, the human figure and ornamentation. Alumni include the architects Eugène Viollet-le-Duc, Charles Garnier and Hector Guimard; and the sculptor Jean-Baptiste Carpeaux. Ulrich Leben, Renaud d'Enfert, Rossella Froissart-Pezone and Sylvie Martin, *Histoire de l'Ecole nationale supérieure des arts décoratifs, 1766–1941* (Paris, 2004).

15 Théodore Reff, 'Copyists in the Louvre, 1850–1870', *The Art Bulletin*, vol. 46, no. 4 (December 1964): p. 557.

16 The EBA emerged from the teaching function of the Royal Academy of Painting and Sculpture (Académie royale de peinture et de sculpture), founded in 1648. It was renamed the Ecole des beaux-arts in 1863 when Napoleon III granted its independence from the Academy. The basis of its teaching was the art of ancient Greece and Rome as well as anatomy, geometry, perspective and life classes.

17 David J. Getsy suggests that Steinberg's work on Rodin's plasters (1963) set a pattern for the subsequent Rodin scholarship 'in which the heroic narrative of the individualistic, anti-Establishment artist would again become a central theme', David J. Getsy, 'Refiguring Rodin', *Oxford Art Journal*, vol. 28, no. 1 (March 2005): p. 132.

18 Although presumably, even if Rodin had gained entry to the EBA his family's poverty meant that he would still have had to support himself by undertaking similar work.

19 Claire Jones, 'Rodin: la formation d'un sculpteur' in Blanchetière and Saadé, pp. 10–15.

20 Frederick Lawton, *The Life and Work of Auguste Rodin* (London, 1906), p. 31.

21 Horst W. Janson, 'Rodin and Carrier-Belleuse: The Vase des Titans', *The Art Bulletin*, vol. 50, no. 3 (September 1968): pp. 278–280. Janson focuses his study on the maquettes at the Maryhill Museum of Arts.

22 This refers to Carrier-Belleuse's published designs, *Application de la figure humaine à la décoration et à l'ornementation industrielle* (Paris, 1884). The *Titan Vase* features as no. 173 *Les titans (Vase faïence et terre cuite. Piédestal pierre et bronze)*.

23 Janson, 'Rodin and Carrier-Belleuse', p. 279.

24 On Rodin and modern sculpture see Claire Black McCoy, '"This man is Michelangelo": Octave Mirbeau, Auguste Rodin and the Image of the Modern Sculptor', *Nineteenth-Century Art Worldwide*, vol. 5, no. 1 (Spring 2006).

25 Janson, 'Rodin and Carrier-Belleuse', p. 278.

26 The Musée Rodin has neither acquired nor exhibited the bed.

27 Women (and children) were employed in areas such as metal polishing and painting ceramics.

28 An exception to this is Patricia Mainardi's study of the Public Exhibitions of the Products of French Industry, which identifies changes in definitions related to the decorative arts between 1879 and 1851. Patricia Mainardi, *Art and Politics of the Second Empire, the Universal Expositions of 1855 and 1867* (New Haven and London, 1987).

29 Barbedienne produced a second (entirely gilded) version for the 1878 International Exhibition in Paris, now in the collections of the Musée d'Orsay.

30 Bridget Elliott and Janice Helland (eds), *Women Artists and the Decorative Arts 1880–1935: The Gender of Ornament* (Aldershot, 1992) positions women decorators and the domestic interior in part as resistors to modernism, industrial materials and technology.

Sculptors and Industrial Art, 1848–1870

In Paris, in the months following the 1848 Revolution, unemployment reached 56 per cent of the total number of employed workers, ranging from 20 to 75 per cent depending on the industry; 300,000 Parisians received state benefits.[1] Unemployment was highest in those areas of the economy that provided work for sculptors: the building, furnishing and luxury trades.[2] On 25 February 1848 the Provisional Government guaranteed work to all male citizens and permitted the equivalent of trade unions. On 1 March, what came to be known as the Luxembourg Commission first met, with the specific remit of improving the conditions of the working class. It reduced the legal working day to 10 hours in Paris and 11 hours in the provinces and abolished the practice of 'marchandage' or subcontracting. To combat unemployment the Commission established the Paris National Workshops, public work projects which generated a daily wage of one franc fifty, an amount insufficient even for unskilled day labourers.[3] Nevertheless, over 100,000 registered for the scheme, mainly artisans. The National Workshops were short lived, however, due to lack of funds. Their closure was the immediate cause of the June Days uprising and the consequent victory of the Republican Right. The new constitution of 4 November 1848 upheld the principles of Family, Work, Property and Public Order. Although it recognised that the State should provide public works for the unemployed, it no longer guaranteed the right to work.[4]

Following the political and economic crisis of 1848, sculptors became increasingly reliant on the success of private industry for employment opportunities. As Pradier's biographer Gustave Planche has noted, the 1848 Revolution led to the loss of aristocratic patronage, as had its predecessor in 1789.[5] And while there might be a market for more financially accessible items such as statuettes in plaster, terracotta or bronze, life-size Salon sculpture was too large and expensive for all but the grandest of homes. Neither was the State in a financial position to undertake vast decorative or monumental schemes. One exception was the preservation of France's national (formerly

royal and imperial) heritage.[6] On 24 February 1848 precautions were taken to protect the art treasures in the Louvre and the Tuileries Palace. On 22 March a credit of 500,000 francs was allocated to the conservation of the Louvre, the Tuileries, the Palais National, and the former royal and imperial palaces of Versailles, Trianon, Saint-Cloud, Fontainebleau and Compiègne, generating specialist employment for the luxury goods industries, including sculptors.[7] Heritage assets also funded the new Republic; the decree of 29 February 1848 confiscated and melted down royal silver, with the exception of items classified as 'objet d'art'.[8]

The former royal and imperial manufactories were also threatened with closure by the new Republic. In March 1848, the Higher Council for Perfection (*Conseil supérieur de perfectionnement*) was established with the remit to investigate and consider the continued viability of the national manufactories of Sèvres (for ceramics), and Beauvais and Gobelins (for tapestries and carpets).[9] These state-funded industries survived by positioning themselves as national centres of artistic and scientific innovation, 'coming to the aid of private industry by furnishing beautiful models and in making public improvements in manufacturing processes'.[10] They would again be threatened with closure with the fall of the Second Empire in 1870. As Gustave Flaubert noted, 'every trade, every industry expected the government to find a radical solution to its wretchedness'.[11] In 1848 the Provisional Government established consultative chambers to conduct enquiries into the state of France's industry and commerce.[12] Without the financial resources to act, however, the development of industrial art was largely the result of initiatives by private manufacturers.

Given the troubled economic situation it could be claimed that sculptors became engaged in industrial art simply out of financial necessity. Such an argument could be substantiated by the fact that sculptors appear to increasingly distance themselves from industrial manufacturers as the century progresses, in favour of state and private patronage. However, as the series of case studies in this chapter demonstrate, sculptors literally shaped industrial art, both through their active engagement in the design and modelling of manufacturers' products, and through their involvement in associations organised to promote industrial art. Sculptors' designs and models proved central to the development of the all-important 'exhibition' piece at the international exhibitions, to the extent that the 'art' in 'industrial art' could be said to be synonymous with sculpture. As such, sculptors were central to, rather than adjuncts to, the development of 'industrial art'. This raised the profile (and income) of the manufacturer *and* of the sculptor (when named; authorship was, as we shall see, a contentious issue between sculptors and manufacturers). It could also offer sculptors significant creative opportunities in comparison to the restrictions of the fine art system. It is therefore crucial to consider who these sculptors were.

The Professional and Legal Position of Sculptors in 1848

THE PROFESSIONAL STATUS OF SCULPTORS

Sculptors, even those now most recognised as working within the fine arts such as Rodin or Pradier, largely emerged from working class, often artisanal, backgrounds.[13] Many such workers had been politically radicalised by events in the years preceding the 1848 Revolution: high food prices, falling living standards, wage cuts, unemployment and famine caused by bad harvests and an economic slump.[14] The number of industrial disputes reached high levels in 1845–1847. A proliferation of societies emerged following the relaxation of anti-union legislation in 1848, the speed of activity suggesting that informal networks were already, to a degree, in operation. Sculptors and related workers were evidently eager to mobilise themselves as professional bodies. A report by sculptors, commissioned as part of the delegation of French workers to the 1867 International Exhibition in Paris, noted that nearly 300 sculpture-related societies were formed between 1848 and 1851.[15] However, in 1849 worker and employer associations were banned, and strikes remained illegal until 1864 unless authorised by the State.[16] By 1867 only 16 of the nearly 300 sculpture-related societies were still in operation. This included the Association of Masons, which between 1864 and 1865 had 5,000 members.[17]

While the radical fall in the number of sculpture-related societies may be accounted for in political and legal terms, it is perhaps the inherent specialisation (and therefore fragmentation) of the practices of sculpture which was most detrimental to their long term sustainability. The abundance of societies in 1848 reflects the diversity of professional distinctions between sculptors, and the variety of work available to them. For example, in 1851 the Paris trade directory *Almanach-Bottin* listed sculptors under three distinctive headings: *sculpteurs statuaires*; *sculpteurs, ornemanistes, mouleurs, stucateurs, etc.*; and *sculpteurs sur bois*.[18] The first implies a specialism in modelling and producing figurative and related sculpture. Fine art sculptors tended to be known as *statuaires*, suggesting that they were purely occupied with the representation of the human form and perhaps also had a less direct role in the carving and casting of their work. The next category, *sculpteurs, ornemanistes, mouleurs, stucateurs, etc.*, suggests a different knowledge of sculpture, including ornamentation and plaster casting, presumably for the luxury goods, architectural and building industries; while the third, sculptors in wood, was presumably most allied to the furniture and ecclesiastical trades.[19]

These professional distinctions in part recall the hierarchies of the fine art training system, in which the creation of freestanding figurative sculpture was the end product of an intensive programme of drawing and finally modelling the human form. Yet the diversity and ambiguity of professional categories

of sculptors and sculpture also reflect changes in the definition of art itself towards more artisanal and commercial associations. As Patricia Mainardi demonstrates in her study of the Public Exhibitions of French Industrial Products, held between 1798 and 1849 and the precedents for the international exhibitions that were to dominate the latter half of the century, by 1849 the word *artiste* (associated with Academic art) was virtually absent from official publications and had been replaced by the terms *fabricants* (manufacturers) and *ouvriers* (workers).[20] This represents a radical reassessment of the division between the fine and other arts in the post-Revolutionary period, by which the fine arts were reclassified as 'useful arts' and were reoriented to include such products as wallpaper and furniture.

A further shift occurred in 1851, at the first International Exhibition. This was held in London, at what has become known as the Crystal Palace. The success of France's displays there was attributed to the 'artistic' nature of its products, and this prompted the French state to restore fine art to its traditional definition as a distinct category incorporating sculpture, painting and architecture. Nevertheless the blurring of divisions between object categories and hierarchies continued, and is particularly evident in the emerging context of industrial art. Critics incorporated industrial art workers within a national history that simultaneously championed the artist as worker and elevated the status of the worker to that of an artist. For example, from the late 1840s to the 1870s the Renaissance sculptor and goldsmith Benvenuto Cellini was associated by critics (and workers) with metalworkers, particularly chasers. His works were defined as seminal to the histories of both the decorative and fine arts and praised for collapsing the distinction between both. Furthermore, he had created his famous *Salt Cellar* (1543) for Francis I of France, which enabled him to be appropriated within the French artistic canon as a predecessor to contemporary sculptors and metalworkers.[21]

This fluidity was reflected in the divisions between fine and decorative sculpture and between industries such as bronze manufacture and cabinet making, which appear to have been unregulated and comparatively flexible. As is evident in the careers of the sculptors examined in this book, sculptors worked in a variety of areas throughout their careers, sometimes simultaneously combining 'high' art and 'low' art careers, sometimes changing involuntarily because of external forces.[22] It is important to assert that decorative work was not, as is so often explained in the writings on Rodin for example, necessarily a stepping stone for those who aspired to the Salon and the potential state commissions that that entailed. Through their active role in the development of industrial art, sculptors could attain equally important government positions (in teaching or in state manufactories); receive awards such as the Legion of Honour and medals at exhibitions; as well as benefitting from state commissions.

For some sculptors, working in the luxury goods industry from 1848 onwards represented long term, secure and financially rewarding employment. Some manufacturers developed a particular and distinctive aesthetic by working closely with a specific sculptor, as is explored in the study of Sévin, Barbedienne's head designer. Positions such as these came with a strong degree of artistic freedom as novelty and innovation were imperative to maintaining market lead. Permanent and contractual employment such as this, however, appears to have been relatively rare. In his lifetime a sculptor may have had various vocational identities; produced work for a variety of manufacturers; and made a precarious living, with little steady or permanent employment.[23] In 1851, three years before he won the Prix de Rome which enabled him to study in Italy, Carpeaux was unsuccessfully approaching manufacturers in the hope of gaining lucrative contracts for his original models:

> I've made a few little objects which I've not yet disposed of because the manufacturers are not risking new expenses for models, added to which the selling season is too close to use to undertake new manufacturers.[24]

A sculptor's life was precarious. And despite the importance sculpture was to attain in the context of industrial art, sculpture always remained *a part* of a given work, which was composite and produced by a number of different hands. The names of the sculptors (and others) involved are largely unrecorded. This reflects and demonstrates the ultimate balance of power in favour of the manufacturer in the sculptor–manufacturer relationship. Where the sculptor is named, this is usually in association with high quality, artistic projects, to add artistic credibility to the piece and the firm for which it was commissioned. These works do not always bear the signature of the sculptor but contemporary press reports may mention the sculptor's name and role, presumably from information provided by the manufacturer. The issue of authorship is a recurring point of contention between sculptors and manufacturers.

The conception and production of works was predicated on the existence of distinct professional categories which in turn were dependent on the division of labour. The French luxury goods industries did not adopt mechanisation until the twentieth century, instead relying, at almost all levels, on manual labour.[25] And while a Marxist analysis of the division of labour can in part be applied to industrial art, brought about by the increasingly segregated and alienated nature of the production process, this book resists assumptive associations between the division of labour and the deskilling of labour. A defining characteristic of industrial art is its emphasis on perfection of execution. This required the development of a specialised workforce which could, for example, recognise visually the exact point at which molten metal was ready for pouring or perform the intricate chasing of the surface of a cast

bronze. Much of the work was to an extent repetitive, but each new model required individual assessment as to how it was to be cast in plaster, turned into a mould, cast in bronze, assembled, chased, finished and mounted. This applies to the production of candelabra as much as it does to the reproduction of Salon sculpture, if not more so, as the former is more likely to have extensive undercutting and intricate detailing compared to the smoother and broader surfaces of a female or male nude. And while workers were separated by the degree of skill they attained, some developing unique exhibition pieces and others contributing to bronze statuettes in their thousands, the workforce was nevertheless highly trained overall.

Furthermore, the development of specific skill sets did not necessarily imply the down-skilling or alienation of labour. Sculptors, plaster casters, mould makers, metal founders and chasers needed to be aware of the separate processes involved in each stage of production and of the relationship of their particular contribution to the next stage, in order to facilitate the most economical route (in terms of labour, time and finance) to the finished product. Take, for example, the case of Barbedienne. In 1886 the American journalist and art critic Theodore Child wrote an article on the firm for *Harper's New Monthly Magazine*.[26] This was evidently the result of a prolonged visit by Child to its manufacturing premises at 63 rue de Lancry, accompanied, at least in part, by Barbedienne himself. Child notes that the manufactory is a 'sort of Republic' in which Barbedienne 'leaves his ministers and his collaborators free'; 'each man is his own master, and each department is independent', with the freedom to determine the means and methods of execution.[27] Child first presents a history of the firm, followed by a visit through its workshops. Employing some 450 workmen, this is 'the most complete establishment of its kind in France', comprising the following departments:

> ... all the branches of the bronze industry, from the formation of the alloy in ingots to the gilding and burnishing of the finished metal, and its application to the rational adornment of cabinet-work – reduction, moulding, casting, chiselling, turning, mounting, bronzing, gilding, galvanoplasty, marble-cutting, glass-engraving, *cloisonné* and *champlevé* enamel, photography, designing[28]

Child takes the reader through the various stages of bronze production via Antonin Mercié's *Gloria Victis* (1872). Accounts of visits to studios and workshops often describe the processes involved, without reference to their human element; this can erroneously suggest that bronze reproduction was a relatively quick, mechanised and unskilled activity using the sculpture reduction 'machines' invented by Barbedienne's collaborator Achille Collas, among others.[29] Child, however, recognises the knowledge and skills of the employees concerned. When the plaster model enters the reducing department he notes that the foreman caster, foreman mounter and foreman of the reducing department all consult together to determine how the plaster

model should be divided in the manner best advantageous to all. Each model, be it the *Gloria Victis* or a copy of an antique vase, cannot be treated following a standard formula, but requires individual thought and assessment in order to take it through to the next stages of the production process; it is thus assessed and discussed at an inter-departmental level as it progresses through the manufactory. Furthermore, the reducing 'machine', despite its name, was not automated, but required great skill and delicacy of touch to cut and sculpt the block of plaster corresponding to each section of the original model. It also took time – two months to create a 3/5 reduction of the *Gloria Victis* if five or six men were working at it simultaneously. These sections would then be cast in order to create a mould for casting in plaster or bronze.

Each operation is specialist, distinct, yet interrelated and interdependent. Child also suggests a hierarchy in this division of labour, based on the degree to which the worker is closest to understanding and fulfilling the needs of the sculptor. Hence, the mould makers are 'rough-looking men', 'unpolished in their manners compared with the chisellers and mounters', but nevertheless 'do astonishingly delicate work with their enormous hands and thick fingers'.[30] Barbedienne employed nearly 200 'chisellers' (chasers), who operated in six rooms named after Republican and sculptural references such as the Senate, Belvedere and Campana. According to Child, these bronze chasers are the most closely aligned to the art of the sculptor, as they revive and preserve the 'true accent' of the work, developing its expression and fulfilling the sculptor's intentions, even creating details and effects that would be difficult or even impossible for the sculptor to produce within the original clay. Chasing is here recognised not as a mere mechanical activity – the removal of rough areas from the casting process – but as a skill requiring artistic understanding on a par with that of a sculptor.

Barbedienne's particular approach to chasing was seen by contemporaries to have had a fundamental impact on French sculpture. Rather than the overcharged minuteness of early nineteenth-century bronzes, Barbedienne was seen to have respected the sculptor's intentions and the materiality of the work, thus increasing the artistic value of the reproduction and attracting contemporary sculptors to the potential of bronze as a sculptural medium. Specialised skilled labour was crucial to the high degree of creative and technical innovation required by manufacturers such as Barbedienne, and sculptors (and those with what might be termed a sculptural sensibility, such as chasers) were a central element in this collaborative, or at least combined, process.

THE LEGAL POSITION OF SCULPTORS AND SCULPTURE

In the period covered by this book, sculptors' rights of authorship were not yet protected by law. This generated numerous disputes between sculptors

and private manufacturers over copyright, reproduction rights and the right to modify a sculptor's work. 'Work' is here defined as a three-dimensional model (*modèle*) as supplied to and purchased by a manufacturer. Some sculptors attempted to control their production by editing their own sculpture, for example Barye, Emmanuel Frémiet, Carpeaux and Carrier-Belleuse. These, and others, also sold their models to bronze founders; sometimes to more than one.[31] Others entered into formal contracts with a manufacturer, as first instigated between Susse and Charles Cumberworth in 1837.[32] This new contract system enabled sculptors to specify all or partial relinquishment of copyright, for example retaining the right to produce a Salon sculpture in marble. Without specific mention, however, a sculptor had no recourse should the manufacturer decide to modify his model or incorporate it as an element in another object such as a clock or an inkstand.[33]

Until 1902, artistic copyright was governed by the Decree of the National Convention of 19 July 1793. This ruling framed all legal matters relating to artistic matters during the nineteenth century. It recognised the exclusive rights of artists to their productions but omitted to name sculptors specifically:

> Authors of writings of any kind, composers of music, painters and draughtsmen who shall cause paintings and drawings to be engraved, shall throughout their entire life enjoy the exclusive right to sell, authorize for sale and distribute their works in the territory of the Republic, and to transfer that property in full or in part.[34]

In order to establish their rights of authorship, artists and authors were required to deposit two copies of their work at either the National Library or Print Room. For sculptors, these locations suggest that this involved the submission of designs on paper rather than three-dimensional models, necessitating a degree of skill at drawing, which all sculptors may not have had. Copies of works printed or engraved without the formal written permission of their authors could be confiscated or requisitioned by officers of the peace, and the law set out specific indemnities for infringement of copyright. In 1814 the Court of Cassation's ruling in the Robin vs. Romagnesi case attempted to bring sculpture in line with the 1793 law by stating that 'the counterfeiting of a work of sculpture is an offence like the illegal copying of a text or an engraving'.[35] Despite this, the legal position of sculptors remained tenuous and disputed until 1902 when sculptors, including ornamental sculptors, were added to the list of artists cited in the 1793 law, whatever the merit or destination of their work.

Nevertheless, between 1848 and 1895 various legal and professional rulings on artistic copyright directly and indirectly influenced the status of sculptors and the types of sculpture they could produce. For example, although the State purchase of Salon sculpture was beneficial to the careers of nineteenth-century sculptors, a legal ruling in 1839 established that a work of

art acquired by the State became public property and, as such, could be freely reproduced by manufacturers.[36] From a financial and artistic perspective, the State acquisition of a sculpture therefore had its disadvantages as well as its more publicised advantages of state patronage and official recognition. An artist automatically lost his or her rights of authorship and reproduction for that particular model, and so could no longer exploit, control or financially benefit from its reproduction. This ruling could have played a significant and to date unrecognised role in Rodin's non-completion of *The Gates of Hell*; while it remained a work in progress he successfully sold bronze and marble reproductions of its individual components, through his contracts with manufacturers such as Barbedienne.

Legal rulings also affected the nature of the sculpture produced. Broadly speaking, from the late 1840s onwards the sculptural element of decorative objects becomes increasingly three-dimensional compared to the prevalence of low relief in the first few decades of the century. This was, in part, a response to court rulings regarding the reproduction of Salon paintings in low relief bronze. Catherine Chevillot has drawn attention to the confusing legal position regarding this process in the early part of the century.[37] In 1844 a new court ruling determined that paintings and engravings were no longer freely available as models for sculptors and manufacturers unless they were in the public domain; permission was hereafter required from the artist or engraver.[38] This limited the practice of transposing a two-dimensional work into relief sculpture, as in a clock dating from around 1815 whose front panel is directly taken from Anne-Louis Girodet's 1792 painting *Hippocrates Refusing the Gifts of Artaxerxes*.[39] Although the degree to which this practice was employed is not known, it must have been common enough to require legal action. Furthermore, if new models had to be sourced there was little reason to limit them to relief sculpture. The 1844 ruling may therefore have directly benefited sculptors as it gave manufacturers a greater incentive to turn to them for original models, and to experiment with a greater diversity of three-dimensionality in sculpture. For example, while furniture mounts in the late eighteenth and first quarter of the nineteenth century are largely in relief, following neo-classical precedents, as the nineteenth century progresses the range of historic and stylistic influences expands, as do the thematic, formal, stylistic and material opportunities available to sculptors working within the decorative. The 1844 ruling was thus instrumental in creating new economic and creative opportunities for sculptors, and potentially stimulated the proliferation of three-dimensional, particularly figurative, sculpture in the decorative arts from the mid-century onwards.

The demand for new models did not necessarily improve the balance of power between manufacturers and sculptors in favour of sculptors, as manufacturers continually sought new ways to control their exclusive rights to the sculptors' models. This is documented in the proceedings of the Réunion

des fabricants de bronzes (hereafter the RFB), a society founded in 1818 to further the interests of bronze manufacturers, and which arbitrated disputes between its members and between its members and sculptors. For example in 1845, following a dispute after the separate sale of a plaster model and its wax original, the RFB encouraged its members to ensure possession of the original maquette as well as the definitive model from the sculptor, in order that the sculptor could not sell the same model to another manufacturer.[40] Given the cost and time of procuring new models, disputes were often resolved through modification, rather than in full remodelling. In 1846 Graux-Marly brought a case against Weiswald for imitating a light fitting with models of children after the sculptor Sayer; the RFB ruled that Weiswald had to replace the figures of kneeling children with those of women or other motifs.[41] Similarly in 1847, in the case of Vittoz vs. Royer, a clock by Royer with figures of children reading was deemed to imitate too exactly an example by Vittoz, and Royer was ordered to change specific aspects of his model, notably the books, one of the children's arms and some accessories.[42] Questions of artistic and industrial copyright were thus a central element of competition and differentiation between manufacturers, and one in which the sculptor's rights and concerns were rarely considered unless they directly affected the manufacturer.

It is significant that copyright disputes such as these were assessed and resolved through detailed object analyses. Seemingly innocuous components of an ornamental clock, from the position of a child's arm to the addition or suppression of a book, are approached seriously, minutely, individually. This is in stark contrast to the often generic way in which these types of objects – particularly 'sentimental' ones peopled with children – are largely considered today. The RFB's close deliberation over these objects restores specificity to the wealth of objects produced by its membership.

Manufacturers were evidently keenly observing works produced by their competitors. Detailed knowledge of individual works was central to litigation and defence when potential infringements of copyright were brought to arbitration. While some cases ordered the removal of counterfeit goods and the destruction of their models, the cases outlined above suggest a subtler intervention, in which a thorough understanding of modelling and the manufacturing process enabled the RFB to identify small but significant changes in the composition and configuration of the contested model. This acknowledges the expense and effort of creating new models for industry and the process of addition, subtraction and modification that the design process entailed. Furthermore, it underscores the fragmented nature of the work that sculptors undertook during this period, from the modelling of a child to the remodelling of the position of one of its arms. This significantly predates the practice of the 'fragment' and 'assemblage' later associated with Rodin's fine art sculpture. It also suggests that for manufacturers, the model produced by the sculptor, be it a figure for a handle of a vase or the vase itself,

was a valuable and essential component in their productions that could be adapted and changed as required by circumstance and application. This does not necessarily lessen or demean the sculptor or the model, but was simply part of established creative and economic practice; rather like Rodin's later assemblages of plaster casts from his own models create new works from pre-existing components, except that the (same) sculptor is not necessarily in control of the process and outcome.

Bronze manufacturers also expanded their catalogue by acquiring models owned by other manufacturers. In 1862 for example, *The Art Journal* noted that G. J. Levy was successor to the 'long famous firm of Vittoz & Co.', whose 'large collection of works of varied order' included 'the productions of Pradier, Cumberworth, Duret, Schoenwerck, Carrier &c, the principal designers of works of that class'.[43] Levy ceased to operate as a company in 1876, and the subsequent four-day sale of 450 bronze models (*modèles en bronze*) clearly states that they were sold with full reproduction rights.[44] This indicates that their value lay in their reproductive potential for industry rather than as saleable single items for the general public. Published catalogues of this kind are possibly the most extensive source for identifying the names of specific sculptors with particular models and with specific firms. The archive of the RFB includes an important collection: Levy frères (1876), Romain, successor to Victor Paillard (1879, two), G. Servant (1882), C. Pickard (1882) and E. Sevenier (1884).[45] However, these are also problematic in that the relationship between the sculptor and the manufacturer remains unclear; the presence of a particular model in a firm's catalogue does not guarantee that it was commissioned by that firm, as the model may have been resold by another firm.

In June 1879 Romain's first sale took place over nine days at the Parisian auction house Hôtel Drouot, and included reproductions of Salon sculpture in decorative objects and on a domestic scale: a bronze statuette *Fileuse* (32 cm high) and a bronze garniture (clock and candelabra) entitled *Fileuse*, both after (*d'après*) Mathurin-Moreau, whose marble *Fileuse* had been acquired by the State when it was exhibited at the 1861 Salon.[46] Romain's second sale took place in his studio, over eighteen days, and included over a thousand bronze art and furniture models and unedited plaster models (*modèles de bronzes d'art et d'ameublement, modèles en plâtre (non édités)*) divided by category, from groups by Carrier-Belleuse, Piat and Robert to clocks, candelabra, lamps and plaster models by Carrier-Belleuse, Clodion, Feuchère, Piat, Mathurin Moreau, Yon, Liénard, Klagmann, Sauvegeau, Combetti and Hayet.[47] This sale also included studio materials, tools and equipment. Its location in Romain's studio rather than in a public auction house again suggests that models were intended for purchase by the bronze industry.

The fact that these catalogues so carefully document who produced which model is thus explained by their value to industry. The majority of

disputes regarding copyright in the bronze industry were brought by manufacturer against manufacturer; keeping a track of your catalogue was a necessary measure in preventing future confusion and defending any potential disputes.[48] The sale of models with full reproduction rights favoured manufacturers rather than sculptors. The sculptor, having sold his model to one manufacturer, had no further control over its application or ownership and no economic remuneration from its resale and use by a subsequent manufacturer. The association of a sculptor's name with a particular model also demonstrated the artistic credentials of the firm in question, the type of work to be expected, and contributed to the status and value of the model itself.

While copyright issues thus largely concerned manufacturers rather than sculptors, sculptors producing models for industry were faced with an additional legal problem. The earlier court ruling of 1814 protected sculptural works of an artistic nature, yet the means of identifying what constituted an 'artistic' model was a recurring and unresolved issue which held significant implications for sculptors in the context of decorative art. Under what criteria (if one wishes to do so) can one classify a vase as fine art sculpture, as a utilitarian object or as a decorative object? The copyright law of 18 March 1806 protected a model if an artist or industrialist registered it in the form of objects or drawings with the Ministry of the Interior's Industrial Tribunal. However, it was up to the individual court to decide whether that model was 'artistic' or 'industrial', and therefore whether its copyright lay with the sculptor or the manufacturer.

The ambiguity and elasticity of these legal definitions is evident in legal cases throughout the nineteenth century, which reveal the difficulties inherent in distinguishing artistic from industrial models. In 1866 the RFB petitioned the Senate to repeal the 1806 law as expensive and, more importantly, unworkable due to the inherently three-dimensional and composite nature of their productions. The RFB outlined the problem as follows:

> For anyone with a practical mind, industrial sculpture is also not suited to the system of [copyright] registration, not only because of the [number/size] of some objects, but also because of the countless variety of models and the different uses to which they can be put. Thus, a piece of furniture, a light fitting, a vase, a candelabra, are often composed of a large number of ornaments which, taken separately, serve other purposes, and the very fact of being able, with the help of modifications and arrangements, to make a new model with ornaments which have already been used, constitutes in our eyes a true art form which can be compared, in principle, to the art of Piranesi, creating a now famous candelabra from the fragments of Antiquity … For an object in the round, a drawing or a photograph can only present the foreground of one of its sides; and anyway they give neither the general colour of the sculpture, nor its quality, nor the meaning of the model, nor the exact height of the reliefs, nor the combination of lines and ornaments which are found on the interior of a light

fitting, on the reverse side of a cup, on the sides or the back of a clock, etc. etc. (Let us say that counterfeiting extends to the whole or part of an object). And as unsatisfactory as the system of registration by drawings might be, it would require yet another outlay of time and money, [which would be] ruinous for the manufacturer.[49]

This passage underlines the complexity of decorative objects and their close interrelation with sculpture. The identification of decorative models as 'industrial sculpture' is apposite, as the concerns raised regarding the inability of a two-dimensional design to represent a three-dimensional model, including its surface effect, could be equally applied to fine art sculpture. The passage also highlights difficulties inherent in identifying an 'artistic' object from an 'industrial' object. Given the intrinsic three-dimensionality of sculpture, even in very low relief, how does one distinguish a 'sculpture' from a three-dimensional 'object' that is sculptural?[50] Legal definitions of 'artistic' or 'industrial' sculptural models – be they for a full design for a vase or an element of a piece of furniture – were unstable and ambiguous and depended largely on intention of use and application, and on who was applying for the copyright. This ambiguity was particularly pertinent, prevalent and problematic within the context of industrial art, in which objects by their very nature were intended to defy categorisation as either 'industrial' or as 'art', but rather to represent a synthesis between the two.

INDUSTRIAL ART

In 1848 the luxury goods industry was both a continuation of, and distinct from, the ancien régime model. Since the Middle Ages a system of specialist guilds had developed in France, which controlled the production and sale of luxury goods. Every trade, from gilders to cabinet makers, was represented by its own guild and the system regulated the tools and materials available to each guild member, ensuring that a craftsman could only produce work within his specialised field.[51] For example, the statute of the guild of sand casters, established in 1752, lists the types of objects members were permitted to cast in brass, copper and bronze, from church crosses to ice moulds, and specifically disallows moulding or casting in gold or silver unless at the specific request of a Parisian goldsmith.[52] The guild system thus created a fragmented, yet interdependent working practice, in which the production of an object required the input of numerous guilds, all separately involved in the manufacturing process. The work was invariably managed by a *marchand mercier* or luxury goods merchant, one of the few professions permitted to trade in luxury goods.[53] In contrast, the system in England entailed the operation of a number of specialist workshops under one roof, as in the case of the furniture maker Thomas Chippendale.[54] In France, this alternative system was only available to the privileged few granted royal protection at the Louvre

workshops. Thus, Louis XIV's cabinet maker André-Charles Boulle conceived, designed and produced furniture in its entirety, experimenting with a variety of materials (the turtleshell and brass combination of marquetry now synonymous with Boulle) and techniques (such as bronze casting, gilding, marquetry and joinery).

Following the Revolution, the 1791 Le Chapelier Law abolished all guilds, opening up the luxury goods industry to free enterprise. Artisans, unlike their forbears, could now control the production, exhibition and sale of their products. Without the royal patronage of the Louvre workshops, significant creative endeavours were now at the artisan's personal expense. An exception is the State's support of the now national manufactories of Gobelins, Aubusson and Sèvres. The leading private artistic and innovative manufacturers of the period 1848–70 – notably Barbedienne in bronze; Christofle in silver; Froment-Meurice in gold; and Fourdinois in cabinet making – developed their enterprises following the model of the Louvre (and English) workshops, incorporating a broader variety of materials, skills and techniques than would have been permissible under the ancien régime's guild system.[55] Today, Barbedienne is almost exclusively known for his bronze editions of freestanding figurative and animalier sculpture.[56] However, as my study of the firm demonstrates, Barbedienne's intellectual, technical and creative commitment to his decorative works far outstripped that for his fine art editions and actively created opportunities for sculptors to experiment, study and extend the boundaries of sculpture.

In their bid for novelty and market lead, manufacturers embraced new technologies, materials and techniques, such as galvanoplasty and aluminium. The latter was developed in France from 1854 onwards and for a short period redefined the category of precious metals.[57] In 1855 it had a value equal to that of gold, and gold and silversmiths were among the first to work the material, producing prestigious items such as a centrepiece presented by Christofle to Napoleon III in 1858.[58] The success of leading manufacturers lay in their ability to embrace, without apparent contradiction, a multitude of contemporary interests: tradition, modernity, industry, art, free enterprise, democracy, luxury, affordability, craftsmanship, technology, uniqueness and serial production. This complexity is central to understanding their success and the effectiveness of the term 'industrial art' more broadly.

The development of industrial art has long been associated with the State's official support of the value of art to industry following France's success at the Crystal Palace in 1851.[59] While this was undeniably important, I suggest that the success of the term lay in its ability to avoid a single coherent definition. This enabled it to appeal to a diverse range of interested parties: artists, manufacturers, collectors, politicians and art critics took up the idea of industrial art. For those interested in the return of the ancien régime it represented an opportunity to assert the concept of (a single) good taste led

by an enlightened elite.[60] For others, the 'art' in 'industrial art' was seen as a powerful force in the democratisation of what had been an elitist prerogative.[61] For those whose income and earnings depended on the sale of luxury goods it provided new opportunities for defining and marketing their products. This in turn generated, and was generated by, the increasingly active interest of art critics in the decorative arts. Industrial art pervades the design literature of the period, which suggests that it held significance for all these groups. This is further borne out in the proliferation of the term at an international level, in the literature related to the international exhibitions, at a time when the European revolutions of 1848 posed a serious threat to the established order. Industrial art's ambiguity was ideally suited to its historical moment and enabled it to encompass and dissolve broader struggles and oppositions within society.

Salon Sculpture and Industry: Pradier's *Standing Sappho*

The Swiss sculptor and painter Jean-Jacques, known as James Pradier (1790–1852) began his career as an apprentice to a jeweller-horologist in Geneva, where he learnt engraving on metal.[62] In 1807 he moved to Paris. In 1809, under the protection of Joachim Lebreton, Secretary of the French Académie des beaux-arts (1803–1815), he was awarded a ministerial grant of 900 francs a year to pursue his artistic training in Paris.[63] The city of Geneva was expected to supplement this income. A surviving letter from Lebreton to the Société des arts de Genève reveals how Pradier was to be educated:

> I have already arranged everything for the latest's [Pradier's] education. Mr Lemot, sculptor, will teach him to model, Messrs Jouffroi and Galle will teach him to engrave medals and precious stones, because those are two arts which can and ought to go together.[64]

This letter suggests an awareness of the diversity and interconnectedness of sculpture practice and education on the part of the government, and a certain pragmatism. If Pradier did not reach the summit of fine art sculpture through success at the Salon, he would nevertheless be able to pursue a respectable career within medal and fine stone engraving. His training thus reveals a greater diversity in fine art training than can be generally assumed from the extant scholarship, which has focused on the training of sculpture in the round at the Ecole des beaux-arts and in an Academician's studio.[65]

Entry to the Ecole des beaux-arts was achieved either, as in Pradier's case, by registering with the studio of an Academic sculptor, or on the recommendation of a patron.[66] The teaching regime involved modelling for two hours a day and students were required to sit various examinations, including the drawn figure, figures modelled after the antique or from life,

heads of expression and historic composition.[67] The ultimate examination, the Prix de Rome, was open to all Frenchmen aged between 15 and 30, and was judged by the Académie des beaux-arts. Those awarded the *Premier Grand Prix*, as Pradier was in 1813, received a five year placement at the Villa Médici in Rome, funded by the Académie de France à Rome.[68] There, sculptors had to undertake various projects including a copy after the antique. The final assignment was a life size model of a figure in marble: a sculptor was ultimately judged on his ability to produce figurative sculpture in the round. Pradier's adherence to the academic tradition is demonstrated by his success at the Salon from 1819 onwards. In 1827 the Institut de France elected him as a member, and he joined the Ecole des beaux-arts staff; in 1828 he was awarded the Legion of Honour.

In 1848 the Revolution generated radical measures to democratise the fine art system. On 24 March 1848 the Palais du Louvre was renamed the People's Palace (*Palais du peuple*), and was to house an exhibition of paintings, an exhibition of industrial products (*produits de l'industrie*), and the national (formerly the royal) library. A few days earlier, on 21 March, the Salon system was modified when a hanging committee, elected by the artists themselves, replaced the traditional jury. The traditional prizes of medals were replaced with Sèvres porcelain vases, perhaps, in part, given the economic crisis, because Sèvres, as a national manufactory, could provide 'free' and 'instant' prizes to the newly established Republic. The highest award at the 1848 Salon was conferred on Pradier, for *Nyssia*, a full scale marble neoclassical figure in the round. He received a vase worth 1,700 francs and the figure was purchased by the State.[69]

Alongside *Nyssia*, Pradier exhibited a half-size bronze, *Standing Sappho*. In his review of the 1848 Salon, the art critic Théophile Gautier commented that the *Standing Sappho* represented a radical departure for Pradier, as its head and body were treated distinctly.[70] While the body adhered to classical notions of ideal beauty, the head was imbued with a personality and sentiment found neither in Antique sculpture nor in Pradier's previous work. For Gautier, this new combination of individuation and ideal beauty was not problematic, although he firmly aligns *Standing Sappho* with Antique sculpture, perhaps pre-empting this criticism from others.

The figure of Sappho is accompanied by a number of elements that help establish her identity. She holds a lyre (the attribute of Poetry) in her left hand and her right hand rests on an upturned bowl of foliage, possibly an offering to Aphrodite. Beneath the bowl is a partially unwound section of a scroll inscribed in Greek with the last stanza of Sappho's 'Ode to Aphrodite'. At the foot of the plinth are a pair of doves, a reference to Aphrodite's 'two swift companion birds' in the same poem, which drew her chariot through the skies to meet with Sappho on earth. Between the plinth and Sappho stands a ewer. The figure itself is embellished with jewellery and an elaborate hairstyle.

In terms of scale, *Standing Sappho* was created for the Salon as a half-size work. The original is probably the bronze inscribed 'J. Pradier 1848, Lebeau Fdeur', now at Osborne House, height 89 cm.[71] Its scale reflects Pradier's interest in the statuette during the 1840s, when he produced unique small scale pieces and reductions of larger works. The *Standing Sappho* was reproduced in various dimensions and materials by different manufacturers. This suggests that Pradier may have entered into contracts with manufacturers for the exclusive rights to specific dimensions and materials. In 1850 a Salvator Marchi, who had purchased two plaster statuettes from Pradier, brought a dispute against the porcelain makers and dealers Duchemin, Verry and Jouanneaux Dubois for copyright infringement.[72] A polychrome biscuit version and an alabaster version by Masi are also known.[73] This reflects the shifting hierarchies within materials, as an integral element of, and contributor to, the increasing porosity between the fine and decorative arts.

Significantly, manufacturers chose *Standing Sappho* over *Nyssia*, despite the fact that *Nyssia* had received the highest award at the Salon and been purchased by the State, which meant that it was freely available as a model for manufacturers. Considering Gautier's aforementioned critique of *Standing Sappho* as diverging from ideal sculpture, it could suggest that manufacturers (and their potential audiences) were more receptive to modern works than the State. Its clothing may also have played a role in their decision. Although *Standing Sappho*'s drapery partly accentuates rather than detracts from the presence of Sappho's body beneath it, it was perhaps thought more appropriate for the domestic interior than the naked figure of *Nyssia*. Sappho had also become an increasingly popular subject for authors, sculptors and artists from the turn of the century onwards and could therefore have appealed to specific, educated consumers.

In terms of class and professional distinctions, a sculptor, chaser, collector or art critic may have approached the *Standing Sappho* in interrelated, yet distinct ways. A sculptor may have focused on its modelling, and assessed it in terms of his knowledge and practice of sculpture, and its relationship to his own work. A chaser, gilder or patinator may have been more receptive to and critical of its surface treatment, and the distinct effects resulting from different combinations of patination, chasing and gilding. A collector or art critic may have assessed its quality, uniqueness and economic value against his or her knowledge of related artefacts and the broader art market. Domestic consumers would have acquired it either as a freestanding statuette, as in the case of Queen Victoria and Joséphine Bowes, founder of the Bowes Museum in England, or integrated within domestic objects such as a mantelpiece clock. Bowes purchased the only version produced in solid silver, weighing 3.86 kg at a cost of 9,000 francs, the equivalent of a middle class annual salary.[74] It was originally cast in 1849 by the founder Simonet using the lost wax technique, and was offered as the first prize for the *Loterie des artistes* where it was valued

at 25,000 francs.[75] Gautier was present at its casting and described the process in an article, stating that, 'this statute was of bronze, today it is in silver, so that the material can be worthy of the work'.[76] This alignment of base with precious metals was to become a central feature of industrial art, and the additional ingredient of art – in particular sculpture – was fundamental to this process.

Through industrial art, Pradier's *Standing Sappho* entered the domestic sphere in a variety of materials and objects. An engraving of the bronze manufacturer Victor Paillard's stand from the 1851 International Exhibition (Fig. 1.1) includes the *Standing Sappho* as a freestanding statuette to the extreme left of a number of sculptural objects from candelabra to a painted and mounted vase.[77] Paillard produced *Standing Sappho* in a number of finishes: bronze, oxidised bronze imitating silver, silvered bronze, and silvered bronze with gilt highlights. Despite this richness in surface decoration the transition of the original model to a reproduction involved the inclusion or removal of all or some of its more 'ornamental' or narrative elements, including the pair of doves, the inscription on the scroll and the ewer. This may have been an economic decision on behalf of the manufacturer, or contractually based, with Pradier keeping the rights to the most complex Salon version.

1.1 Anonymous, 'Victor Paillard's Stand at the International Exhibition in London' (1851), engraving, published in *The Art Journal Illustrated Catalogue: The Industry of All Nations, 1851* (London: George Virtue, 1851), p. 289.

Paillard also incorporated Pradier's figure into a variety of clocks. Historically, clocks have been important sites for sculpture in the French decorative arts, particularly from the late seventeenth century onwards. Central to this is the relationship between bronze and sculpture, as many of the most sculptural examples were designed and modelled by sculptor-bronziers. These include the application of historic as well as contemporary sculpture; Michelangelo's *Night* and *Day* appear to have been first used on clocks by Boulle in the early 1800s.[78] Surviving versions of Paillard's application of the *Standing Sappho* to clock designs show the figure in different dimensions (45.5 cm and 41 cm high) placed directly on a clock case, as if the clock itself were a socle, and with or without the incorporated plinth which features in the original.[79] In at least one example the clock is cast by Barbedienne, demonstrating a cooperation between founders, and potentially retailers, which has yet to be fully understood.[80]

Paillard produced one particularly complex version, which forms part of a 'garniture de cheminée', now in the Musée de la Vie romantique in Paris (colour plate 1).[81] The silvered and gilt bronze figure of Sappho (45.5 cm high) is signed and dated, and stands on a black marble base that incorporates the clock's movement and its dial. A pair of six-light candelabra, 78 cm high, flanks the clock, providing light to read the time and illuminate the figure of *Standing Sappho* as well as the candelabra themselves. The candelabra incorporate two individually modelled figures of women, their contrapposto pose, classically inspired drapery and precise modelling echoing that of the *Standing Sappho*. The candelabra and clock bases/plinths incorporate further sculptural elements in the form of gilt and silver-gilt columns, high relief medallions of male and female heads and three-dimensional female figures in neoclassical dress. The undulating movement of their hips mirrors that of *Sappho*, while their quick, loose modelling provides a counterpoint to its more precise modelling. Each candelabra figure is stamped 'HP'; it is unclear whether they were modelled by Pradier or another sculptor. Other candelabra signed by Pradier are known, and the modelling of the versions at the Musée de la Vie romantique, which appear to be unique, suggest that they were created specifically by Pradier for this garniture. The modelling of the smaller figures on the clock particularly resembles Pradier's known figures for jewellery.

Pradier collaborated with the leading goldsmith François-Désiré Froment-Meurice on a number of pieces from at least the mid-1840s, including the ring *Les Nayades* (1844 Salon) and the bracelet *Two Women with a Vinaigrette Coffer* (Fig. 1.2) of which five variations are known.[82] Michèle Heuzé's research on Pradier's jewellery and cameos usefully draws attention to this little-known field of Pradier's sculpture, although he notes that his jewellery is 'very conventional, using the models of the period; his talent, therefore, does not come through'.[83] Closer examination of these works, however, reveal that they

were a significant departure for a successful fine art sculptor known for his adherence to neoclassical sculpture. The references to Renaissance sculpture, such as Michelangelo's *Night* and *Day*, are striking, as is the looseness and vitality of their modelling, similar to those found on the clock garniture.

Pradier's interest in Renaissance sculpture had begun on his journey to Rome in 1813, when he visited Milan and Florence, not leaving Florence until he had drawn the 'entire works' of Luca della Robbia, the Renaissance sculptor renowned for working in polychrome tin-glazed earthenware.[84] Pradier's subsequent experiences curtailed this then rather unusual pursuit. Once in Rome, his artistic activity was dominated by the current taste for neoclassicism. As his friend and biographer the sculptor Antoine Etex noted, while in Rome Pradier associated with the painters Jules-Robert Auguste and Théodore Géricault, and it is probable that he socialised with Jean-Auguste-Dominique Ingres and visited the studios of the leading

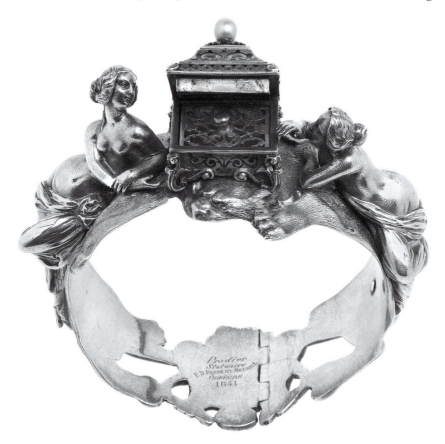

1.2 François-Désiré Froment-Meurice, James Pradier and Jules Wièse, Bracelet, *Two Women with a Vinaigrette Coffer* (1841), silver, silver gilt, gold, enamel, pearl and ruby, 7.4 × 8 cm. Les Arts décoratifs – Musée des Arts décoratifs, Paris.

sculptors Antonio Canova and Bertel Thorvaldsen.[85] It was through his later collaboration with Froment-Meurice during the 1840s and 1850s that Pradier was able to resume his earlier interest in Renaissance sculpture. The decorative arts thus offered him, and potentially other sculptors, an important avenue for pursuing artistic interests other than the classicism sanctioned and promoted by the Academy.

In 1851, for example, Froment-Meurice and Pradier produced *Leda and the Swan*, a statuette in ivory, silver, gold and turquoise.[86] The work does not bear Pradier's signature, as is typical of such collaborations, even high-end artistic ones such as this. More recently, Froment-Meurice has been described as Pradier's 'assistant' for this work, suggestive of the secondary importance placed on manufacturers by art historians.[87] While Pradier's involvement in this piece is not fully known, he was at the forefront of fine-art experimentation with materials, colour and scale. His contribution to the 1845 Salon included a marble figure of the Greek courtesan *Phryné*, which was also later shown at the 1851 International Exhibition in London. The figure wears gilded jewellery and a draped cloth trimmed with painted decoration, and originally wore custom made earrings in copper gilt.[88] This reflects a contemporary interest in polychrome sculpture, either as applied colour, as in the case of Pradier's *Phryné*, or, as in the Academic sculptor Pierre Charles Simart's monumental chryselephantine *Minerve du Parthénon* (château de Dampierre, 1846 and exhibited at the 1855 International Exhibition in Paris), through the juxtaposition of differently coloured materials. Pradier experimented with both types of polychromy, although he tended to reserve applied colour for his freestanding figures, and the use of composite materials for his collaborations with goldsmiths; both were exhibited at the Salon.

Exploration such as this in surface treatment, composite objects and polychromy was central to the decorative arts, an area more traditionally associated with a greater variety of materials and techniques than Salon sculpture. Furthermore, colour was largely determined by the materials themselves, such as gold, silver and ivory, than by a search for realism and naturalistic colour as in John Gibson's *Tinted Venus* (c. 1851–1856). Pradier's polychrome works, both at the Salon and for luxury goods manufacturers, were part of a broader debate regarding polychromy and the interrelation of the fine and decorative arts during mid-century. His collaboration with Froment-Meurice on high-end exhibition pieces, and his work for the Salon, enabled him to explore this in ways which would have been impossible had he restricted himself to Salon sculpture alone. At the very least, the separate skills necessary to produce a work such as *Leda and the Swan* would have been outside his own range of expertise, while the concentration of craftsmen within a goldsmith's studio made the conception and execution of such works possible.

A study of the ways in which Pradier's Salon sculpture was appropriated and adapted by industry, and new models commissioned for unique and reproduced works by manufacturers, thus challenges assumptions regarding the absence of creativity in a commercial, industrial context. It also recasts the extent to which an original artistic model is necessarily diluted or devalued through its reproduction and dissemination. Nevertheless, as Jacques de Caso has observed, the extent to which sculptors could exercise control over their work in their relationships with industry is profoundly questionable:

> As many artists of his time who, by taste or by necessity, created for the commercial world, Pradier must have known the difficulties that collaboration between artists, industrialists and dealers entail; sculpture created in the 19th century for serial production is directed and controlled in its subjects and forms by industrialists concerned with its profitability. Did he take their suggestions into account? Moreover, the statuette, similarly to a bearer bond, and in the same manner, alienable by the artist and by the industrialist, is entirely subject to the *jus utendi* [the right to use property, without destroying its substance] and to *jus abutendi* [the right to abuse property, or having full dominion over property] exercised by the buyer who modifies or adapts it: the incidents of the romantic clock and paperweight are evidence of this fact. Pradier, like others, found himself caught in the speculation of the industrialists, risking a lawsuit for counterfeiting when, seeking an added profit by exploiting a popular work whose rights were already sold, he makes a variation and finds himself accused of counterfeiting.[89]

This passage clearly identifies an imbalance of power between sculptor and editor, in which the 'industrialist' exerts legal, financial and creative control over the sculptor and the reproduction of his work, and the modification or adaptation of sculpture into 'the romantic clock and paperweight' is understood as an abuse of this power.

Nevertheless, despite such potential restrictions and limitations, Pradier's involvement with manufacturers simultaneously expanded the entrepreneurial and fine art possibilities of sculpture. As a critic noted in 1853, 'it no longer is an art reserved for the few; thanks to Pradier, the masses now like sculpture'.[90] He incorporated non-traditional materials and surface effects into his Salon sculpture, from real jewellery to tinted marble; permitted his Salon sculpture to be reproduced in a number of scales, materials and applications, from the statuette to the statuette-cum-clock; and modelled specific works for industry, which allowed and encouraged him to apply and expand his skills and interests in ways which diverged stylistically and technically from the prescriptive guidelines set by the Academy.

This blurring of distinctions between fine and decorative art is vividly embodied in a design by the painter Edouard Müller for the wallpaper

manufacturer Jules Desfossé, which features at its centre Pradier's statue of Pandora (Fig. 1.3).[91] This exceptional work forms the central panel of a three-part tableaux and frieze and was awarded a first class medal at the 1855 International Exhibition in Paris. It represents and simulates the primary categories of fine art – sculpture, painting and architecture – through block printing on paper, thus muddying the division between two-dimensional and three-dimensional works and the hierarchies between the fine arts and manufacture. Significantly, sculpture is placed at the very centre of this work.

1.3 Jules Desfossé, designed by Edouard Müller, called Rosenmuller, *The Garden of Armida* (central panel) (1855), block-printed wallpaper, 390 × 340 cm. Les Arts décoratifs – Musée des Arts décoratifs, Paris.

The Diffusion of Renaissance Sculpture in Barbedienne's Furniture

By the late 1830s, the 'style de la Renaissance' was well established in the decorative arts, at least at the high end of luxury production. This was partly due to the contribution of the ornamentist Claude-Aimé Chenavard (1798–1838) during the 1830s until his death in 1838.[92] It possibly made its first appearance at the 1831 Salon, when Chenavard exhibited a novel series of designs for 'vases, in the Renaissance style, for the Royal Manufacturer Sèvres' (Fig. 1.4).[93] In the following year he presented a fully realised vase, *Vase 'de la Renaissance'* at the Exhibition of Royal Manufactures. Pierre Ennès's research on contemporary reviews of these exhibitions reveals the excitement generated by Chenavard's new designs, and their significance as a novel departure in the arts; the handles in particular, with their three-dimensional figures in the round, were seen as a bold variation from the 'timidity' then current in relief porcelain.[94]

The emergence of the 'Renaissance style' in nineteenth-century decorative arts was part of a shift from the 1810s onwards, in which the term 'la Renaissance des arts' (denoting an evolution of a particular branch of the arts) was gradually replaced by 'la Renaissance' (understood as a period with broad social and cultural associations, specifically identified with fifteenth-century Italy and sixteenth-century France).[95]

A key text here is Jules Michelet's *Histoire de France au seizième siècle: Renaissance* (1855), in which Michelet identifies the political significance of the Renaissance as a study of intellectual and political emancipation.[96] For Michelet the Renaissance represented a reaction against the Royalism and Catholicism he saw as inherent to the Gothic revival, and he denounced the fashion for medievalism in mid nineteenth-century France as 'bizarre et monstreux' (bizarre and monstrous).[97] In the decorative arts, this 'current fashion for medievalism' dated from the late 1820s, when Sèvres began experimenting with the 'Gothic' (*gothique*) style.[98] The monarchy and aristocracy were significant patrons.[99] For others, such as Chenavard, the Renaissance also represented a significant alternative to the dominance of neoclassicism in the arts. As Ennès explains,

> The 'Renaissance style' vase represents, without any doubt, at the dawn of the reign of Louis-Philippe, the manifestation of a new art. In spite of its weaknesses ... noted by its contemporaries, the decorative power of Chenavard's style led a whole generation, which was trying to escape from the sterile path of neo-classicism, into new directions.[100]

The Renaissance style thus in part represented a reaction against neoclassicism and the Gothic revival, although it would be misleading and inaccurate to suggest that this necessarily represented a neat correlation with particular political affiliations, such as those expressed by Michelet.

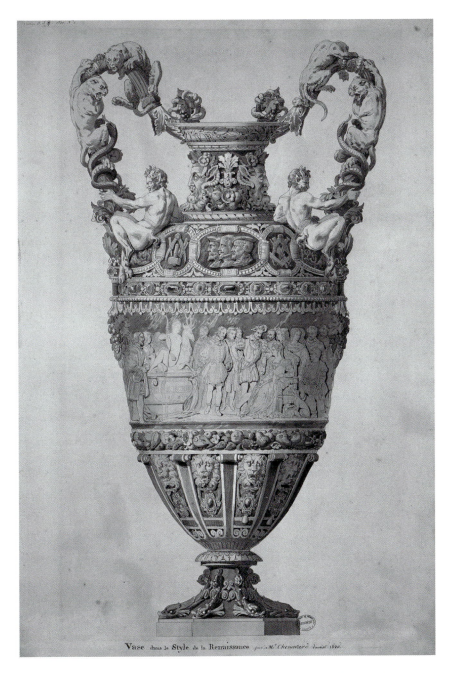

Vase dans le Style de la Renaissance par Mr. Chenavard dessiné 1833

1.4 Claude-Aimé Chenavard, *Study for the Vase Chenavard called Vase de la Renaissance* (1833), watercolour, pen and ink on paper, 60 × 41 cm. Sèvres, Cité de la céramique.

Nevertheless, it influenced even those entrenched in the more established historically inspired variants of neoclassicism and the Gothic revival. For example, in 1832 the neoclassical painter and sculptor Alexandre-Evariste Fragonard (son of the painter Jean-Honoré Fragonard) produced a neoclassically inspired *Vase de Phidias* for Sèvres, with whom he collaborated regularly. This was ridiculed by critics, and in 1835 he created a *Vase 'dans le style de la Renaissance'* which prompted one critic to comment that Fragonard 'wants to do the Renaissance, as the Renaissance is in fashion'.[101] The vase itself is a strange hybrid of neoclassical and Renaissance elements, the former particularly evident in its almost two-dimensional handles and their accompanying snakes.

It is significant that these sculptors decided on vases to experiment with new (historic) styles. Historically, vases are one of the most important of sculptural forms in France, and have played a significant role in architecture, interiors, landscapes and paintings, as evidenced in Louis XIV's commissions for Versailles. During the late eighteenth century archaeological excavations in Italy revived interest in antique vases. In 1807 the French State's acquisition of part of the Borghese collection from Rome listed the *Borghese Vase* and its pedestal, alongside the *Gladiator*, in its seven exceptional works.[102] These entered the Louvre, and surviving engravings of its antiquities galleries show vases displayed alongside figurative sculpture, the latter set primarily against the walls with vases occupying a more prominent (and fully accessible) position towards the centres of the rooms. As the century progressed vases became increasingly prominent in both private and public museums, such as Félix Ravaisson's Greek Museum (1860).[103] They were considered as artistic works in which the 'free and spontaneous activity of true artists is revealed in every line'.[104] By the mid nineteenth century historic vases such as the *Borghese Vase*, the *Albani Vase* and the *Townley Vase* were widely available as reproductions in a variety of materials and dimensions, simultaneously fuelling and supporting the development of a canon of sculptural vases. The Greek origins of many of these examples were central to their status alongside, rather than subordinate to, figurative sculpture. Manufacturers such as Barbedienne expanded this repertoire of antique vases to include copies of Renaissance and eighteenth-century examples.

Renaissance-inspired sculpture was also represented in two-dimensional form. In 1839 the wallpaper manufacturer Lapeyre & cie produced *Chasse et Pêche*, also known as *Décor 'style de la Renaissance'* (colour plate 2). Like the wallpaper featuring Pradier's *Pandora* referred to in the last section, this is a trompe l'œil relief, which places sculpture at centre stage.[105] *Décor 'style de la Renaissance'* merits close analysis as it incorporates the primary elements that would characterise the 'Renaissance style' in the French decorative arts during the Second Empire: an architectural, symmetrical composition; a combination of ornamental, figurative and animalier sculpture; lion's heads

and paws; garlands of fruit and flowers; children, including motifs of pairs of children, often placed back to back; medallions of heads with appropriate Renaissance headwear; and female figures on plinths and in niches arranged within narrow linear columns, similar to those found on Medieval and Renaissance cathedral doorways. The women represented in this wallpaper design, particularly the two external figures accompanied by dogs, are reminiscent of French Renaissance representations of Diana the Huntress; the drapery is distinctly not neoclassical. The coloured pigments used to depict the sculptural elements evoke stone, marble and gilt bronze, and reflect the colour combination of silver, gold and 'bronze' that would characterise the surface treatment of bronze throughout the nineteenth century. All of these elements are integral to the 'Renaissance' aesthetic developed in France in this period.

After Chenavard's death, the Renaissance style was continued by Salon and non-Salon sculptors alike, perhaps most notably Jules Klagmann (1810–67) who had collaborated with Chenavard on a Renaissance-style dessert service for the duc d'Orléans, completed in 1840–42. This Renaissance revival inspired, and was fuelled by, an increasing documentation and awareness of Renaissance sculpture and its sculptors. By the late 1840s a survey of the contemporary decorative arts literature, including exhibition catalogues and reports, indicates that the most referenced historic sculptors in the luxury goods industry for the period 1848–95 are Renaissance: Goujon, Cellini, Michelangelo and della Robbia. Individual works by sculptors are also cited, for example Germain Pilon's *The Three Graces* (1561–65) and Lorenzo Ghiberti's *Gates of Paradise* (1425–52), which were also disseminated by being reproduced as stand-alone works, and integrated into domestic objects such as clocks and bookcases. The decorative arts thus presented a different, yet parallel canon of historic sculptors and seminal works to the established fine art system, which continued to favour neoclassical ideal sculpture.

FERDINAND BARBEDIENNE (1810–1892)

After an unsuccessful apprenticeship as a saddler, Barbedienne developed a career as a wallpaper designer, establishing himself as one of the preeminent wallpaper manufacturers in Paris in 1833.[106] Following near bankruptcy, in 1838 he entered into a partnership with the inventor Achille Collas, which resulted in one of history's most lucrative, sustained and creative enterprises in sculpture. In 1836 Collas had deposited a patent for a sculpture reducing machine. While this was not the only machine of this type developed in the period, the success of Collas and Barbedienne's entrepreneurial partnership has led to its being the most renowned.[107] From its inception, the firm was involved in producing plaster and bronze copies of historic European

sculpture, and by at least 1845 was marketing these 'in reduced size' specifically for museums, academies, schools, studios and private galleries.[108]

While plaster casts of historic sculpture presented a lucrative, copyright-free resource for manufacturers, making them was a complex, labour intensive and expensive undertaking, particularly for large scale projects *in situ* outside Paris. According to the practical instruction manual for plaster workers, Roret's *Nouveau manuel complet du mouleur* (1849), it took three men nearly four months to make a piece mould of the Laocoon.[109] Barbedienne actively sought out fresh examples of freestanding, architectural and ornamental sculpture and organised and paid for plaster casts to be taken of them. For example, in 1870 the sculptor Ferdinand Levillain, who was travelling through Lyon, acted as an intermediary between Barbedienne and the *mouleur* (plaster caster) L. Gustini to execute casts of bronze antiquities in Lyon Museum.[110] These casts were then transported to Barbedienne's workshops, where his own workmen would have produced the plaster moulds from which plaster or metal casts could then be made.

Barbedienne sold these bronze and plaster casts as freestanding works, to art schools, museums, and private collectors, as well as to other manufacturers. What is less known, is that he also integrated them within his decorative art production. The current paucity of research on the firm's decorative output might suggest that this was a marginal area of activity compared to its more widely known interest in sculpture reproduction. However, this was an important element of the business, and potentially its most creative and significant, not least because it made Renaissance sculpture accessible to sculptors and others in unprecedented ways. Barbedienne's decorative productions also contributed to the success of the French luxury trades throughout the second half of the nineteenth century, thus creating employment opportunities for sculptors and other artists and artisans during this economically challenging period. Between 1847 and 1848 the Paris furniture trade lost a hundred million francs in turnover; and three quarters of its workers were unemployed.[111] Its success at the 1851 International Exhibition in London was crucial to its survival.

Given the economic climate, only 1,740 French manufacturers exhibited compared to the 5,000 that had shown at the Public Exhibition of French Industrial Products in Paris in 1849.[112] Nevertheless, in 1851 the highest honour – the Council Medal – in Class 26 (decorative furniture and other articles) was awarded to three French companies: Liénard, for a clock case and other articles; Fourdinois for a carved walnut sideboard; and Barbedienne for an ebony bookcase mounted with bronze.[113] Overall, the French received 41 of the highest awards, compared to England's 35.[114] France's success at the Crystal Palace was largely the result of its successful synthesis of sculpture and design, as exemplified by Barbedienne's bookcase. As Nikolaus Pevsner observed a century later, the exhibition cemented the place of sculpture in

industry as it was more integrally connected to its materials and mechanical processes than painting.[115] France's victory over England was thus not only a political and national triumph, and an urgently needed boost to the economy; it also placed sculpture at the centre stage of design reform.

Before examining Barbedienne's bookcase in further detail, it is worth noting that Barbedienne also exhibited a half-size bronze of Ghiberti's *Gates of Paradise* at the Crystal Palace.[116] An entry from Barbedienne's 1878 catalogue suggests that he commissioned casts of the *Gates of Paradise* in such a way that it was reproducible as an entire work and as stand-alone fragments. The catalogue lists prices for a half size reduction and ten individual low reliefs of the original door panels. Further sections could be purchased separately, including twenty-four heads sculpted in the round, the figurines in the niches of the doorframe, and the friezes depicting leaves and fruit. Barbedienne thus exploited every available component of the doors, understanding that in its fragmented state it held potential wide appeal to museums, schools, manufactures and the general public.

The bookcase he exhibited in 1851 demonstrated how these fragments from the *Gates of Paradise* could be integrated within the domestic interior, in decorative arts objects produced either by his firm or by other manufacturers who might purchase his bronze reproductions and use them within their own compositions. As this contemporary engraving illustrates (Fig. 1.5), the bookcase incorporated elements from the *Gates of Paradise* within the bookcase itself, and as freestanding elements on its shelves. These jostle for space alongside a range of statuettes and objects, including a candelabra and a clock surmounted by a figure. The dense, 'unordered' display is suggestive of a collector's cabinet or an antique shop; it infers that these could be authentic treasures, while their historic and stylistic range demonstrates Barbedienne's encyclopaedic knowledge of art and design. The display also represents an eclectic density appropriate to the domestic interior. Potential purchasers are encouraged to imagine the bookcase and/or its contents within their own homes, displaying their books or a variety of objects as seen here.

Unlike the half-size copy of the *Gates of Paradise*, which was exhibited on Barbedienne's own stand in the French section, this bookcase was displayed by Barbedienne's London representative, the cabinet makers Jackson and Graham (Fig. 1.6).[117] This was an astute move, as the bookcase received positive and extensive criticism from both the French and English press:

> Here, in a completely new direction, is the beautiful application of mechanically worked bronze to furniture, with which it could almost be said to dissolve, rather than to be content with decorating it.[118]

It also meant that the bookcase was eligible for prizes in both national sections.

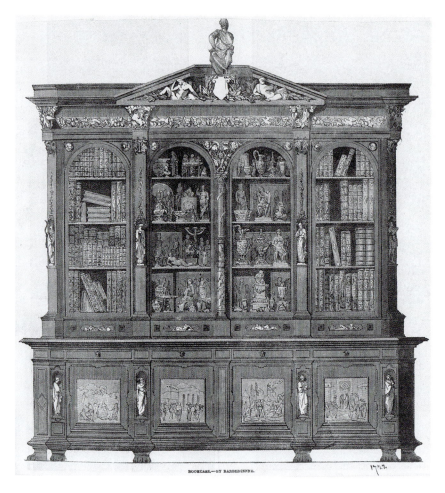

1.5 Ferdinand Barbedienne, *Bookcase* (1851), engraving pasted in the scrapbook *Exhibition London 1851, Illustrations*, vol. 6, France and Belgium. Victoria and Albert Museum, London.

The architectural composition of the bookcase facilitates the integration of fragmented sculptural elements within a rational, ordered scheme. At the top of the bookcase, above a broken cornice, sit reproductions of three works by Michelangelo: *Lorenzo de Medici, Night* and *Day*. These reflect, in part, the original setting of the sculptures in the Medici Chapel. These sculptures similarly featured in Barbedienne's catalogue and were available to purchase in a range of materials and dimensions. The main body of the cabinet is divided vertically into four glazed shelved sections, with figures to each dividing upright. Flanking the tops of the doors are high relief roundels, and below each door is a small horizontal relief. Four relief panels are displayed in the lower section, presumably as part of door fronts, interspersed with Ghiberti's

1.6 Walter Goodall, *Part of the French Court, No. 1 (Sèvres)* (1851), watercolour and gouache over pencil on paper, 28 × 37.5 cm. V&A, London, purchased with the assistance of the Art Fund, the Friends of the Victoria & Albert Museum and the Royal Commission for the Exhibition of 1851. Victoria and Albert Museum, London.

figures of Noah, Joseph, Abraham, Solomon and Sheba. Although elements of the friezes of fruit and flowers are undoubtedly after Ghiberti, some, notably those behind the central figures, were most probably by the contemporary sculptor Auguste Clésinger, who is recorded as having 'executed' the bronzes for this bookcase.[119]

A successful Salon sculptor, Clésinger entered into contract with Barbedienne in 1851, selling his rights to all works for life, in all dimensions and by all means.[120] In a visit to Barbedienne's workshops in 1858, Gautier commented on a section of the Parthenon frieze which had been restored by Clésinger (date unknown), and reduced in scale so as to be cast as part of a clock:

> This group, which has been reduced by the infallible Collas process and cast in bronze or in silver, will recline on the onyx marble plinth of a monumental clock. And what! A clock? You will say: Oh profanation! Oh sacrilege! Oh decadence! – Not at all. Where is the harm in learning about beauty while learning the time? – passing from the Parthenon on to a chimney? Perfectly. Under the pretext of respecting art, do not chase it from our homes, and let us thank Mr Barbedienne for having let it enter in all its forms.[121]

Here, similarly to the bookcase, the sculpture is at once integrated within, and separated from, its object in a number of ways. Firstly, it is differentiated through materials. The sculpture is in bronze (or in this case also silver), attached to an ebonised body or set on an onyx marble plinth. Secondly, in terms of architectural composition, *Lorenzo de Medici* and the element of the Parthenon frieze are both positioned at the highest and most central point of each piece. The clock and the bookcase thus function as a type of plinth, simultaneously distinguishing the figurative sculpture from, and integrating it with, its 'base'. The position of *Lorenzo de Medici* and the frieze also partly conforms to the triangular composition favoured by the Academy, with the lower two corners of the triangle provided by the outer edges of the base of the clock and the bookcase.

While the 'monumental' nature of the clock described by Gautier might seem at variance with the domestic interior he alludes to, the scale of the object would seem to have a bearing on its legitimacy as a vehicle for historic and canonical sculpture. The height of the bookcase is unrecorded, but, from the watercolour of it on Jackson and Graham's stand it must have extended to around four metres. It is a substantial piece of furniture. Furthermore, its symmetrical and ordered composition suggests that much thought has gone into the selection and positioning of the sculpture within the piece; this is not the intervention of an accidental, playful or irreverent mind, but of a learned, rational and skilled man. These issues – scale, materials, positioning, rationality and order – are central to the development of industrial art in this period, legitimising and making possible an incredible diversity of interventions between sculpture and object.

At the London International Exhibition of 1862 Barbedienne displayed a further bookcase in the Renaissance style (Fig. 1.7), although this time he designed one with specifically French Renaissance sculptural references. A pair, with gilt bronze decoration, survives in the Peterhof Palace outside St Petersburg. The bookcases incorporate truncated copies of Michelangelo's *Slaves*, their legs 'resolved' in a manner more typical of caryatids in architecture and furniture. The *Slaves* had entered France during Michelangelo's lifetime, and the Louvre in 1794, where they consequently became better known to artists, historians, collectors and manufacturers, and assumed something of a French identity despite the nationality of their sculptor. The Louvre's plaster workshops first produced casts in 1819; Barbedienne is recorded as having purchased a cast of the *Dying Slave* in 1859, but must have purchased casts at an earlier date from the same or other sources.[122] The Ecole des beaux-arts also progressively demonstrated an interest in Michelangelo's work, in particular his paintings; between 1830 and 1840 it dedicated an annexe to Michelangelo's work, and in 1833 commissioned a copy of the *Last Judgment* from the painter Xavier Sigalon.[123] These copies of Michelangelo's works were taken up by

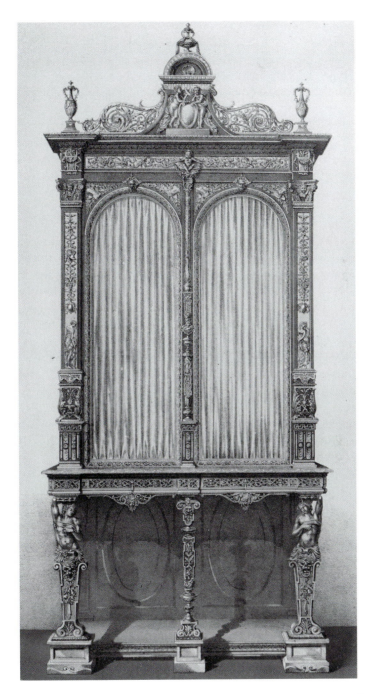

1.7 Ferdinand Barbedienne, *Bookcase* (1862), in John B. Waring, *Masterpieces of Industrial Art and Sculpture at the International Exhibition, 1862* (London: Day and Son, 1863), vol. 3, Plate 268. Les Arts décoratifs – Bibliothèque des Arts décoratifs, Paris.

manufacturers as copyright-free models, as inspiration for new works, and were published as designs for sculptors and industrialists.[124]

Reinforcing the peculiarly French connection with Michelangelo through the *Slaves*, the 1862 bookcase also incorporated reduced copies of the low relief panels by the French Renaissance sculptor Jean Goujon from the *Fountain of the Innocents* in Paris. This monument, originally conceived as a triumphal arch for Henri II's entry into Paris in 1549, was reconstructed as a fountain in 1787. The five standing nymphs hold vases, their tall, elongated bodies, small breasts, strong legs and intricate, plaited and curled hair, typical of the Mannerist or Fontainebleau school of French Renaissance sculpture. The upper section of the bookcase displays possibly a further work after Goujon, an angel blowing the Roman *tuba*. This is similar to a relief in the Musician's Gallery at the Salle des Cariatides at the Louvre, named after its four female figures by Goujon.

Barbedienne's 1862 bookcase thus demonstrates how a particular French manufacturer attempted to produce a decorative work within a broadly definable 'Renaissance style', and positioned and particularised this within a distinctly 'French' Renaissance. This nationalist element was particularly relevant to the context of the international exhibitions, in which national rivalry was partly played out through references to national heritage as well as through contemporary works. On a visit to the 1862 International Exhibition in London, a delegation of French workers visited the Crystal Palace in Sydenham, where the original building had been moved to in 1854 and housed an extensive collection of plaster casts.[125] The delegation noted, with pride, that the Renaissance rooms included casts of French works from François I to Clésinger.[126] Back at home, in 1865 the Union centrale des arts décoratifs, a society combining the interests of design theorists, manufacturers and workers, curated an exhibition on the French and Italian Renaissance, further demonstrating the importance of the French Renaissance to an emerging definition of a French history of sculpture.[127]

An important site in the construction of this Renaissance sculptural canon was industrial art. This presented sculptors, workers, manufacturers, critics (and the public), with a broad variety of Renaissance sculptural references. Significantly, it included mixed media and decorative art as well as 'fine art' sculpture. For example, della Robbia's work in majolica was influential in the revival of salt-glazed earthenware, notably at Minton's in England from 1851 onwards where sculptors, including French sculptors such as Carrier-Belleuse who had moved temporarily to England following the 1848 Revolution, played a significant role in developing new models that reflected della Robbia's subject matter, modelling and colour palette.[128]

Questions of reproduction, materiality and originality were therefore not necessarily problematic at this moment in time, but demonstrated a manufacturer's skill, education and taste, as well as that of his potential

public. At the 1855 International Exhibition in Paris, the bronze founder Denière displayed a tobacco jar (Fig. 1.8) cast after an ivory depicting the *Combat des Lapithes et des Centaures,* then attributed to Michelangelo. The tobacco jar merited a three-page entry in the *Magasin Pittoresque*, examining by turns the subject matter, Michelangelo's 'vigorous style', the transposition from ivory to bronze (which was not seen to have diminished the forms or expressions of the figures) and the successful creation of additional figures for the jar's lid in the same style and character as Michelangelo's.[129] Denière's choice of a decorative work attributed to Michelangelo as inspiration for a new object intended for the domestic interior is illustrative of the conflation of distinctions between the arts and industry in this period, and of historic

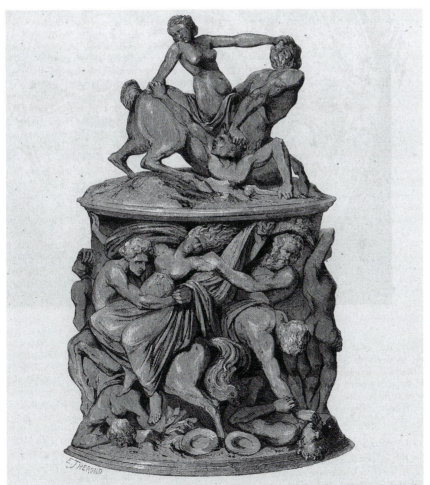

Exposition de l'Industrie. — Pot à tabac, par Denière, d'après un ivoire attribué à Michel-Ange. — Dessin de Thérond.

1.8 Denière, *Tobacco Jar*, engraving in *Magasin Pittoresque* (1855), vol. 23, p. 340.

and contemporary sculpture. It also reveals a less reverential and perhaps more creative approach to sculpture than one might expect in the fine arts. In a decorative context, Michelangelo's work was not above 'improvement' and adaptation.

The industrial arts thus presented an important site for experiencing and creating sculpture that diverged from neoclassical Academic sculpture. Sculptors could view these works in shop windows and in exhibitions of industrial or fine art (Chenavard's designs for Renaissance vases were first exhibited at the Salon). They would also have come into immediate, tactile interaction with Renaissance sculpture or copies of Renaissance sculpture in the studios of manufacturers (Barbedienne 'lived above the shop' and had a museum that his workers and collaborators had access to).[130] And while Renaissance sculpture was increasingly disseminated through engravings and photographs in contemporary art and design journals and histories of art and design, the reproduction of works by manufacturers presented a unique opportunity for studying these works in three dimension. This was particularly invaluable for the study of works located outside of Paris, or indeed outside of France.

Barbedienne's incorporation of Renaissance sculpture into objects such as his bookcases also demonstrated to contemporary sculptors how historic sculpture could be fragmented, repositioned and integrated within new works, and suggested ways in which they could similarly pursue this approach in their own creative practice. Rodin's positioning of *The Thinker* in *The Gates of Hell* is not dissimilar to that of Michelangelo's *Penseroso* in Barbedienne's 1851 bookcase, as is Rodin's inclusion of relief and sculpture in the round within an architectural framework. Furthermore, Barbedienne encouraged a new generation of sculptors to experiment in the Renaissance style by commissioning new works. In 1867, he paid Paul Dubois and Alexandre Falguière 7,500 francs each for the 'composition and execution in plaster of a torchère, Renaissance woman, with full reproduction rights'.[131] This is an unusual, but not unprecedented commission, in that a pair, traditionally associated with symmetry and single authorship, is here explicitly composed of works by different sculptors. Barbedienne produced the pair in four dimensions, from the original 200 cm high version priced at 8,500 francs the pair, to a 77 cm high reduction at 1,800 francs the pair.[132] Two years previously, Barbedienne had cast an immensely popular and critically admired 'Renaissance-style' statue by Dubois, his *Florentine Singer of the Fifteenth Century* (1865). Unusually, this was produced as a silvered bronze statue (now at the Musée d'Orsay) thus accentuating the slippage between Salon sculpture and industry and of bronze casting with goldsmithing. Barbedienne produced reproductions of this model in various sizes and finishes into the twentieth century.

Barbedienne was thus committed to financing and popularising a variety of Renaissance and Renaissance-style sculpture: reproductions of stand-alone historic examples; new models by contemporary sculptors which reflected the style and subject matter of Renaissance examples; and new ways of fragmenting, combining and displaying historic and contemporary sculpture, either separately or in the same piece, as in his 1851 and 1862 bookcases. Given this new research, the popularisation of Renaissance sculpture through industrial art must now be considered as an important, and even preeminent, factor in the development of neo-Florentine sculpture in France during the 1850s. In contrast to Pradier, who channelled his interest in Renaissance sculpture through his collaboration with goldsmiths and bronze manufacturers rather than in his independent Salon work, by the time Carpeaux was awarded the Prix de Rome in 1854 the beaux-arts system had become gradually more receptive to a Renaissance aesthetic, and Carpeaux's *Fisherman with a Shell* (1858 Salon) was hailed as a welcome and novel departure in Academic sculpture. While *Fisherman with a Shell* drew on relatively recent French precedents, notably François Rude's *Petit Pêcheur napolitain* (1833), it demonstrates Carpeaux's particular affinity to Renaissance sculpture, that he was to develop further, in works such as *Ugolin* (1857–60).[133]

The integration of Renaissance sculptors into the history of sculpture via industrial art also extended the definition of sculpture. It provided sculptors and critics with mechanisms for understanding and positioning the sculptor as other than a Salon artist, reintegrating their decorative work into the sculptural canon, and for considering Salon-quality sculpture as something other than white marble. Cellini was particularly central to this process. His skills as a goldsmith were an important factor in the professional and critical status of metal chasers in the bronze industry, and of the position of the bronze industry in relation to fine art. In an unpublished manuscript written in homage to his employer Barbedienne, the chaser Charles Cauchois-Morel noted that 'just as the name of Cellini is identified with goldsmithing, art bronzes will evoke the name of Barbedienne'.[134]

The revival of Renaissance sculpture in the French industrial arts from the 1830s onwards thus played a significant role in both the fine and industrial arts, to the development of a greater fluidity between both, and to its increasing influence within fine art sculpture. As such, the 'Renaissance revival' cannot be simply dismissed as an example of nefarious capitalist enterprise which reproduced original works for pecuniary profit while simultaneously removing them from their temporal, physical and historical contexts. These reproductions, fragments and variations presented tantalising new sources and opportunities for sculptors. It predated and contributed towards the integration of Renaissance sculpture within French Academic sculpture and to an expansion of the sculptural canon. Further research in this field requires a fundamental shift in art historical discourse, to challenge entrenched divisions

between art and commerce, manufacturers and sculptors, art and industry, tradition and the avant-garde, and between historical and contemporary sculpture.

Ornamental Sculpture and its Sculptors

The main players in French design reform by the early 1860s were the State and private industry. Each represented a divergent but not necessarily incompatible position on design reform. In his influential publication *De l'Union de l'art et de l'industrie* (1857), written as a response to the Crystal Palace in 1851, the curator and design reformer comte Alexandre de Laborde advocated a centralised, elitist approach, favouring state intervention in design education and manufacturing. Laborde believed that State, rather than private, manufacturers held the key to the revitalisation of France's luxury goods industries. The result, he hoped, would be twofold: international supremacy in luxury goods which would benefit the economy as a whole; and consumer reform through the production of suitably designed products that would educate the populace in matters of good taste.

Manufacturers, wary of state intervention, advocated private initiative, and in 1857 founded the Society for the Encouragement of Industrial Art (Société d'encouragement de l'art industriel), alongside design reformers and artists. The society had similar aims to Laborde – the union of art and industry – but emphasised the importance of private enterprise to this project. In 1863 the Society disbanded for reasons which are not fully known, and reformed as the Central Union of Fine Arts Applied to Industry (l'Union centrale des beaux-arts appliqués à l'industrie).[135] The Central Union's articles of association underlined its intended role in uniting art and industry, prioritising the 'dissemination of the most essential knowledge for the artist and worker who wants to unite the beautiful and the useful', and the staging of exhibitions to 'present for study the beautiful applications of art to industry'.[136]

Despite these points of difference between the democratisation of the arts and an aristocratically led elitism, or between private and state enterprise, design reform in the 1850s and 1860s revolved around the central concept of the positive union of art and industry. The numerous reports, articles and exhibitions produced by the State, private societies and individual design reformers, foregrounds their role as active participants and leaders in this debate. Recent scholarship has followed a similar path, focusing on the opinions of the dominant voices in contemporary nineteenth-century design reform: industry and the State.[137] The role and views of artists, artisans and workers have been largely overlooked.

In 1852 the sculptor Jules Klagmann submitted a report to the future Napoleon III. The report (now lost) outlined the specific problems facing

industrial artists – exclusion from fine art exhibitions and a loss of artistic identity when exhibiting at industrial exhibitions.[138] His report was supported by contemporaries, including the sculptor Jean-Jacques Feuchère, the painter Auguste Couder, the designer Jules-Pierre-Michel Dieterle (Head of Art at Sèvres) and the architect Viollet-le-Duc. The dominant position in design reform at the time advocated the union of art and industry by harnessing the arts to the benefit of industry, and/or in encouraging the fine arts to be more receptive to the decorative. In contrast, Klagmann proposed a third way. He distinguished industrial art as a separate category, independent of the broader concept of the union of art and industry and not as aspirational to fine art. He called for exhibitions in which industrial artists could stage their own work, as industrial artists. This was an option favoured by some of the profession's most vulnerable and low profile members: sculptors working exclusively within industry. This represents a distinct struggle for professional and personal identity within the fluid and changing dynamic of art-industry relations.

THE REPORT OF THE DELEGATION OF SCULPTEURS-ORNEMANISTES AT THE INTERNATIONAL EXHIBITION IN LONDON, 1862

The report of the delegation of *sculpteurs-ornemanistes* to the 1862 International Exhibition in London forms part of a larger report by Parisian workers who attended the exhibition.[139] Their visit was partly financed by the State. Each profession elected its own delegates, and the report overall includes entries on cabinet making, marble, ivory, joinery, bronze and marquetry, each of which, given the pervasiveness of sculpture throughout the luxury goods industries, touches on matters relevant to sculptors and sculpture.[140] Most revealing here for the study of sculpture is the 16-page report by the *sculpteurs-ornemanistes*.

The report is signed 'F. Combarieu, Heingle and Monjon'. The former most probably refers to Frédéric-Charles-Félix Combarieu (1834–84), who learnt to sculpt wood at the luxury furniture makers Guéret frères. At the time of the report, Combarieu had only recently embarked on a fine art career, having entered the studio of the sculptor Justin-Marie Lequien and enrolled at the Ecole des beaux-arts in 1861.[141] I have yet to source biographical information regarding Heingle and Monjon, and it is unlikely that Combarieu would be documented if he had not pursued a fine art career.

The report begins with a historical reference, situating ornament within the very core of fine art sculpture: Greek and Roman Antiquity. It identifies ornamental sculpture at that time as a specific yet interconnected category from either statuary or architectural sculpture. The report highlights the significant contribution of ornamentists and ornamental sculptors to the buildings of Antiquity, and, more recently, to France's international standing in the industrial arts. And as with Klagmann's earlier report, it does not

advocate a 'top down' approach from fine to decorative art or from fine art to architecture:

> We shall not try to prove that Phidias chased small items of jewellery in order to get away from the admirable colossus that he created, nor that Callimaque invented the Corinthian capital; perhaps many generations each brought, not only stone, but their leaves to this edifice.[142]

This passage partly challenges the emerging discourse in design reform that drew attention to the decorative and architectural work of 'great' sculptors such as Phidias and Cellini as a means of establishing the artistic and historic credentials of industrial art. In contrast, the report distinguishes ornamental sculpture as an important and distinct category of sculpture, with its own artistic and historic precedents. It then examines the contemporary situation, stating that the sculptor-ornamentist's skills are undervalued within an increasingly fragmented system of sculptural practice:

> By continuing this unfortunate system [of ignoring the contribution of the sculptor-ornamentist], we have seen the rise of sculptors of hair, of noses, and everything else, often sacrificed as being of secondary importance, become the work of another specialist, the ornamentist of today, who in turn subdivided the work and created specialisms in his specialism. Let us remark, in passing, that specialisation can work faster, but never better, and that it only serves to break the unity of creation and production, which gave such a particular cachet to the works of the Ancients.[143]

Here, the authors identify the interrelationship between the low status accorded to the sculptor-ornamentist, the 'secondary importance' of the work they execute, and the increasingly fragmented nature of their work and profession. It indicates the dangers of this for the profession as a whole, as the speed of execution required by industry generates greater subdivision in skills; without redress, ornamental sculptors would end up just carving noses or hair for a living. The report clinches its argument with a reference to Antiquity, identifying the importance of 'unity of creation and production' to successful ornamental sculpture. As proof of this, the authors examine the work of more recent ornamental sculptors whose knowledge, taste, skills and inventiveness have contributed to France's preeminent position in ornamentation:

> It is to Klagmann, J. Feuchère, Combettes, Liénard, Auguste Lechesne, etc., and only recently to Constant Sévin and to Pyat, that we have, until now, owed our superiority in ornamentation over other nations. We find in their works elegant proportions, audacious designs, feeling, good taste in arrangement, confidence in the forms of the figures, flawless drawings, incessant research for a new style: everything points to them as our models; they have preached by example and have done more for artistic decoration than many architects and specialised artists.[144]

Unusually, this passage identifies a canon of sculptors which is specific to ornamental sculpture. This is a significant alternative to the more common rhetoric found in the contemporary industrial art literature, which tends to position ornamental sculptors in direct, but subordinate, relation to the fine arts, which remains the paradigmatic point of reference. It is therefore worth considering this canon of ornamental sculptors in closer detail.

Neither Combettes, Liénard, Sévin or Pyat feature in Stanislas Lami's dictionary of nineteenth-century French sculptors. Both Feuchère and Klagmann came from artisanal backgrounds and pursued successful careers in industrial and fine art, exhibiting at the Salon and on the stands of manufacturers at national and international exhibitions. Their Salon entries include all aspects of their work – architectural, decorative and statuary sculpture – suggesting that 'sculpture' was then a much broader and more inclusive term than one might perceive today from the subsequent scholarship. Klagmann's Salon entries include *Principal models for a sword* offered to the Count of Paris by the City of Paris in 1841 (1842 Salon), chased by Antoine Vechte; and a model for a silver vase (1844 Salon) given by the Duke of Orléans to the Goodwood racecourse in England. Feuchère and Klagmann also received government commissions and recognition, including the Legion of Honour. In 1848, Klagmann was appointed Council Member of the Superior Council of Perfection (Conseil supérieur de perfectionnement), which supervised the work produced by the national manufactories Gobelins, Beauvais and Sèvres.[145]

Feuchère produced Renaissance-inspired shields that were so 'authentic' that his collectors thought them to be genuine.[146] He was himself an important collector who devoted his income to acquiring all manner of fine and decorative artworks, partly through which he developed his knowledge of the arts. On his death in 1852, the contents of his studio reveal an early interest in the acquisition and study of historic art:

> His studio was full of ancient art objects, paintings, drawings, medals, furniture, marbles and bronzes, which he had gathered over the last twenty years. Passionate amateur, fervent collector, he used all the money he earned through his work to satisfy his taste for the works of centuries gone by, an investment which, at the time, did not have the success it has today.[147]

Whereas the sculptor-ornamentists could have emphasised the fine art and official credentials of, say, Feuchère and Klagmann in their report, it is significant that they do not. Their aim was to assert the distinctness of ornamental sculpture, not to bring it 'up' to the standard of fine art. This framework facilitates a separate category of sculpture in which sculptors do not pursue a linear trajectory from *sculpteur-ornemaniste* to *statuaire* but could, as will be seen in the case of Sévin, develop a successful career within ornamental sculpture, and attain the same official recognition as that of Salon

sculptors, such as the Legion of Honour. The report distinguishes between a *statuaire* and an *ornemaniste* as follows: the former is skilled at drawing, modelling the human figure, and has an extensive iconographical knowledge. The ornemaniste, in contrast, has no interest in figurative sculpture:

> As to statuary, our ornemanistes have no idea of what, in workshop terms, we refer to as a *little man* (figure or figurine), and if, by chance, they introduce the shadow of one in their foliage, nothing motivates its apparition.[148]

These are powerful explanations for the current art historical disinterest in ornamental art. Iconographical analysis is a central methodological approach in art history and the coexistence of historic, contemporary, geographical and stylistic references in ornamental art is difficult to address when it is not thought to hold any 'deeper' meaning than the creation of a 'novel' and 'harmonious' (saleable) object. Even when opportunities allow for the transfer of iconographical skills to the study of industrial art – such as in the case of Pradier's *Standing Sappho* – the current prioritisation of the fine over the decorative has meant that this is hindered by the clock on which it sits. This situation is exacerbated in the case of ornamental sculpture, in which the perceived lack of iconographical meaning is even greater. Alternatively, I suggest that there are *different* types of meanings other than the iconographic or narrative to be found within ornamental objects.

The 1862 report highlights the interrelation of professional status and artistic creativity. It argues that the inferior professional position of the sculptor-ornamentist means that he (I have yet to find references to women in this trade) has little opportunity for self-improvement. Low wages and irregular work requires him to work long hours and consequently have little or no time for personal study. As remedy, the report advocates replacing private entrepreneurs with worker associations to combat the long hours, low wages and unemployment rife within their industry.[149] This echoes the more radical proposals of the early Second Republic in 1848, and highlights the particularly precarious and vulnerable position of the sculptor-ornamentist. The report also proposes a formal pay structure and a minimum hourly or daily rate which would compensate the sacrifices made by a sculptor-ornamentist and his family for his career and continued education.[150]

Time lost seeking work (and waiting for it) was a further problem, particularly within the building industry.[151] The report advocates the creation of a type of job centre, a *Maison d'appel*, which would allow sculptors to make more productive use of their time than job hunting. It also singles out the apprenticeship system as a particular candidate for reform. Its proposed solutions reveal the problems faced by apprentices: lack of regulation, low wages, poor training, exploitation and the need for a system for dealing with disputes. Design reform in England is referenced as a positive model,

suggesting that the delegates took the opportunity not only to examine the exhibits at the 1862 International Exhibition, but that they also met with and conversed with their English colleagues. The report calls for a training system similar to William Dury's School and Library-Museum established in London in 1833; and an end to piece work which, surprisingly, they state as being non-existent in England.[152] Education is seen as not only important in terms of professional training, status and design reform, but also as a means of personal creativity and fulfilment. The sculptor-ornamentists seek to express their place in the modern world, stating that while the sterile observation of historic styles may be relevant to restoration projects, 'by limiting oneself to slavishly copying known styles, one is no longer *oneself*'.[153]

This thirst for creative expression on the part of ornamental sculptors was impeded by manufacturers' preference for repeating historic designs rather than commissioning original work. This was a significant problem for all branches of sculpture. It was also raised in a report by the French delegation of ceramic workers to the 1862 International Exhibition.[154] This report particularly singled out Sèvres for criticism:

> We deeply regret that the Sèvres manufactory exhibited only old models of soft-paste porcelain, which for a long time have been copied by manufacturers in Saint-Amand-les-eaux, Tournay, and even by English manufacturers. We are sure that Sèvres possesses artists of a superior talent, who, we are convinced, could have produced something new. Therefore we do not understand why these products did not take another character: to reproduce what our fathers did is to fall asleep in routine; not to create is to show inertia.[155]

This report by ceramic workers presents a rare insight into the situation and opinions of workers in the luxury goods industry. It was, after all, they who developed new models, techniques and materials; Sèvres's reliance on its back catalogue threatened their livelihood and its own survival. Creative and technical developments were required for it to compete successfully against foreign manufacturers in an increasingly international market. Sèvres was an expensive enterprise and had been threatened with closure in 1848. To this end, the ceramic workers call for the mandatory signature or mention of a maker's name on a work; for a corporate association to protect employment and develop the industry; for the development of Sèvres into a ceramic school (Haute école de céramique); and artistic freedom in all the firm's workshops.[156]

These radical suggestions do not appear in other ceramic reports and critiques written in response to the 1862 exhibition. Rather, contemporary critics acknowledge the contribution of decorative artists and workers such as sculptors and metal chasers, while simultaneously maintaining the superiority of the manufacturer or/and of 'art'. Problems regarding worker–manufacturer relations are simultaneously circumvented and acknowledged

by incorporating the worker within a heroic history of industrial art, as in Alfred Taylor's official report on the 1862 exhibition:

> In consequence of this constant practise of using bronze [since the sixteenth century], there has always been kept alive in France, not only a school of artists, but also of workmen, for designing and executing works of art in that material; and the magnificent objects now produced in Paris are the noble results of widespread and long continued preparations. No stimulus, however violent and exacting, can suddenly produce the highest excellence in any school of art. High perfection in art must be the result of long study and the accumulated labours of men who have been masters in their respective pursuits. A constant succession of sculptors of great power has not for centuries been wanting in France, and it must not be forgotten that they have always trained workmen for the mere mechanical part of the process, who have had both knowledge and feeling for the production of works of art. These remarks apply not only to the production of objects exclusively of fine art, but equally to those which we are considering, which are more particularly intended for useful purposes; such as clocks, vases, candelabrum etc. We may add that there is no branch of industry which is more frequently recruited by fresh blood, as it were. Depending for success on taste, enterprise, and technical knowledge, rather than on amount of capital or established reputation newcomers are continually found[157]

Here, revolution is negated in favour of tradition ('no stimulus, however violent and exacting, can suddenly produce the highest excellence in any school of art'). 'Noble' attributes are art, tradition, perfection, hard work and long study. The 'workman' (although subordinate to the 'sculptor') is identified as a heroic figure; he is a trained, not an untrained labourer; he is possessed of an emotional sensitivity and a knowledge of art that enable him to transcend the purely mechanical to create a work of art. Taylor's final comment shows the importance of 'fresh blood' to the bronze industry. Here, in contrast to later negative associations between fine art and commerce, serial sculpture and industrial art, capitalism is acknowledged as a stimulant rather than as a barrier to creativity.

The 1862 reports by ceramic workers (who would have counted modellers and sculptors among their numbers) and sculptor-ornamentists both call for greater recognition of their roles within industry – as named artists and artisans; through better professional security, representation and training; and via increased opportunities for creative expression and experimentation. The 1862 report by the sculptor-ornamentists culminates with a threat to 'interested parties' (government, citizens, amateurs of art, shopkeepers, industrialists, sculptors of all specialisms). It warns that if measures are not taken to improve their situation in France they will be forced to seek work abroad. This in turn will have a detrimental impact on France's international reputation for luxury goods. As everyone was well aware, England had made immense progress in industrial art, notably in goldsmithing and ceramics, since the International Exhibitions of 1851 and 1855, and this was partly due

to the efforts of French sculptors who had moved to England following the events of 1848. The report ends with a nationalist clarion call, arguing that the nurturing of France's sculptural talents for France must be regarded as a matter of urgent national importance:

> We do not think we are wrong in saying that we will always have the best sculptors in France, if they earned enough to live on and to study; but if they cannot get the basic necessities of life because of the meanness, the mistaken economic views of some and the greed of others, they will go elsewhere to produce the tasteful and artistic objects, whose sale brings in easily-earned millions to Parisian businesses, and who will in turn lose out; everybody will regret, but too late, seeing us go down to the second or third rank, when, by the means of a few francs, it was so easy to remain in first place.[158]

Despite such threats, and its suggestion of ways to improve ornamental sculpture and its sculptors, the 1862 report was ultimately unsuccessful. Its plea for ornamental sculpture to be recognised as a distinct but interrelated category alongside architecture and statuary was not heard (or was ignored) by the fine art establishment and by state and private manufacturers. Its calls for greater professional recognition and reward were not met. While the union of art and industry *could* benefit *some* sculptors both economically and creatively, the balance of power was highly weighted in favour of the manufacturer, and the position of the majority of sculptors working within industry remained a vulnerable one. By 1867 the position of sculptor-ornamentists had little improved.

THE REPORT OF THE DELEGATION OF SCULPTEURS AT THE 1867 INTERNATIONAL EXHIBITION

The report by the delegation of *sculpteurs* at the 1867 International Exhibition in Paris was one of a hundred reports compiled by 315 delegates of workers to the exhibition, published in three volumes by public subscription and organised by the Commission for Encouragement (Commission d'encouragement).[159] Each report was required to comment on the following:

> The origin and history of diverse professions, appreciation of the objects exhibited, comparison of arts and industries in France and abroad, an exposé of the wishes and needs of the labouring class, and the various social considerations of interest to workers.[160]

As in 1862, a number of these reports provide insights into sculpture and sculptors in various industries. This includes detailed descriptions and critiques of furniture with sculptural elements after models by Carrier-Belleuse, Joseph Chéret, Goujon and Michelangelo.

The 20-page report by sculptors (*rapport des sculpteurs*) is particularly useful for the study of sculpture as it expresses the everyday reality, needs

and aspirations of its sculptors. It is signed by Porlie, modelling and plaster (*modelage et plâtre*); Vigoureux and Antony Debon, wood sculpture (*sculpture sur bois*); Demessirejean and Bertheux, marble and stone sculpture (*sculpture sur marbre et sur pierre*); and Lege fils, petitioner (*délégué suppliant*). Debon (d. 1901) is the only sculptor recorded in the standard dictionary of French sculptors as he worked in both industrial and fine art, exhibiting at the Salon in 1878 and 1892, including a wooden bust *La Folie* (1892). He was also a member of the Sociéte des artistes français, established in 1881 to administer the annual Salon.[161] Details of the other sculptors are obscure, as they worked exclusively outside the Salon. The report is entitled 'report by sculptors' but written by what are largely ornamental sculptors. The State, if it was responsible for the title, may have wanted to distance itself from the militancy of the 1862 report by sculptor-ornamentists; signal the importance of all branches of sculpture to the success of industrial art; or/and highlight the integration of previously 'lower' forms of sculpture into the definition of sculpture itself.

The report begins with a historical overview of the place of ornamental sculpture in France. From its minor role in the First Empire (1804–14/15) and the Restoration (1815–30), it states that it was 'not until 1835 or 1840 that ornamental sculpture saw a rapid development, by shaking itself from the routine in which it had become entrenched', presumably a reference to neoclassicism.[162] For the 1867 International Exhibition, the report singles out sculpture in wood (*sculpture sur bois*) as particularly worthy of praise, notably through its 'propitious choice of the Renaissance style'.[163] The report then analyses various objects exhibited in 1867, followed by an overview of the 'material and moral condition of sculptor-workers (*ouvriers sculpteurs*) and the different means of improving them'.[164] Each section raises specific issues of relevance to sculptors.

One of the central issues regards authorship. The report is critical of the fact that the names of sculptors (particularly ornamental sculptors) are rarely signed on a given work, and supports this statement with evidence gathered during the delegation's visit to the exhibition:

> At Jules Allard sons and Chopin, of Paris, we noticed two large torchères composed of a bacchante and a faun holding a child. The whole is well arranged; the execution, carried out by Mr Combarieux (senior) from Party's models, is supple and well modelled. The low relief of game forming part of a dresser is also a good sculpture, executed by Ligeret from Arson's model. As to the console in lime wood, in the Louis XVI style, some parts do not lack quality; such as, for example, the small caryatids making up the feet in the foreground … but not enough consideration has been given to allowing for the repose which is so necessary to decoration; it would also appear as if this console has been conceived in parts, considering the lack of unity in its composition.[165]

By identifying those involved in the production of a specific piece within their report, the delegates attempted to redress the absence of their name on the

objects themselves. How they got hold of this information is not revealed; they may have viewed or been party to the work during its production; been provided with information by the manufacturer at the exhibition; or examined the piece in the presence of the sculptors involved. In the eighteenth century, it was not unusual for cabinet makers to display an important piece in their workshop for the benefit of their peers before it was carried in public procession to its buyer; a variant of this practice might still have been in operation by the mid-nineteenth century. The above passage demonstrates a close examination by the delegation of the works on show, which, considering the number of manufacturers and objects on display in the context of an international exhibition, was no mean feat. The sculptors are not concerned with iconographic meaning but with the form and execution of individual details and the successful transmission of a 'unity of composition'. Professional distinctions are also detailed: ornamental sculptors provided the model while a different specialist executed the work. The model would have been in clay or plaster, similar to fine art sculpture practice, and in wax for particularly intricate models. If one wished to distinguish an artist as 'conceiver' from the worker as 'executor', this should therefore be equally applied to the ornamental as well as to the fine art sculptor.

The report's section on the 'material and moral condition of sculptor-workers (*ouvriers sculpteurs*) and the different means of improving them' introduces one of the report's key issues: the perceived need for sculptors to associate as a profession, with the aim of raising the profile of sculptors and facilitating better working and legal rights. As has been noted previously, between 1848 and 1851 nearly three hundred societies were constituted, of which only sixteen were still in operation around 1867.[166] No new associations were formed between 1851 and 1863, presumably as part of the Second Empire's control over freedom of association. The report outlines the benefits of association. Although sculpture was seen to be 'exerting a greater presence day by day', sculptors were not seen to be sufficiently represented in industrial tribunals due to intimidation from manufacturers: those that brought a case to tribunal were rarely employed by that firm again.[167] Whatever the legal position of sculpture, the balance of power was clearly weighted in favour of the employer. In the previous year, in a well-documented court proceeding, Clésinger had unsuccessfully brought a case against Barbedienne for producing unauthorised reductions carrying his signature.[168] The court declared that the loss of artistic rights was outweighed by the financial benefits of his relationship with Barbedienne (between 1856 and 1866, Clésinger received nearly 14,000 francs from Barbedienne). As a contemporary report noted,

> The sculptor declared that he owed his bread, and his deliverance from hardship to Mr Barbedienne. One has to admit that the logic of the facts were very much in favour of Mr Barbedienne.[169]

The delegation suggests that sculptors would do well to assert a more discrete and cohesive position for themselves as sculptors. Distinguishing themselves as a professional body might help them avoid being subsumed and dominated in this way by industry.

Significant information is provided regarding the salaries of sculptors, and divisions and numbers within the profession.[170] The report begins, appropriately, with the model,

> which occupies the primary place, firstly by helping in the execution for wood, marble or stone, then because it is reproduced directly in all materials that require recasting. For this part of sculpture, the wage for private work is very variable; modellers who know how to compose ornaments with a mixture of figures and animals, on architecture or any other given form, might earn from 5,000 to 6,000 francs a year; the number of these artists is very small; in the category that follows, the wages fall to 3,500 francs; it is in this category that the superior class is recruited, the first hands in their specialism; below this class, a few, due to their skill at repairing plaster, earn 8 to 10 francs a day, but the average is 5 to 7 francs, and as the work is periodic, earnings are reduced to between 1,000 and 1,500 francs a year.[171]

Being able to model figurative and animalier sculpture therefore meant a potential wage difference of up to 2,500 francs a year on a modeller who could not; and up to 5,000 francs more than a skilled plaster worker; well worth the additional training required if that opportunity was available and one had the potential to develop in that direction. For sculptors working in wood, which occupied the greatest number of sculptors, the 200 most skilled earned 10 francs a day; another 800 of the less skilled between 5 and 7 francs; and the remaining 1,000 between 4 and 5 francs. The average daily wage for these sculptors and modellers was therefore partly above, yet largely below or on a par with, that of male workers in the 'small industries' (*petites industries*) in Paris, which stood at 3.82 francs in 1853, 4.99 francs in 1871 and 5.66 francs in 1881.[172]

In comparison with other trades working in wood, and the wages of apprentice sculptors, a study of a Parisian family reveals that in 1891 a 42 year old *ébéniste* (cabinet maker) working for a high-end furniture maker earned 6.74 francs a day; his eldest son, an 18 year old apprentice sculptor also employed by a high-end furniture maker began on 30 centimes a week (sic), rising to 3 francs a week, and was soon to be earning half the (unspecified) wage for his profession.[173] His 13 year old sister had been an apprentice burnisher (for gold and silver) on 30 centimes a day, but the *atelier*, run by a young woman, had recently closed. The five-person family rented a small

but decent two-room apartment 'de la très petite bourgeoisie', earned a joint annual income of 3,488.98 francs and had 129 francs in savings.[174]

These average earnings, however, do not take into account the periodic nature of employment, periods of unemployment, lost time and differences in employment. For sculpture in stone (*sculpture en pierre*) the average is difficult to establish as it is based on piece work; furthermore, wages were harder to determine as these men were often more nomadic than those working in, say, cabinet making workshops, and so they could not always consult each other on the price of a work or on the nature of the stone. Presumably any dispute came out in favour of the employer. Article 1781 of the Code Civil stipulates that, 'in all matters relating to salaries between worker and employer, the latter is trusted on his word'.[175]

The sculptors' report also details how a daily rate of pay is not an accurate determinant of real income. If a stone sculptor in 1867 works all year at 8 francs a day, he earns 96 francs a fortnight (implying a six-day working week) or 2,496 francs a year (over 312 days); but shortages in scaffolding, delays in the preparation of the work by stonecutters (*tailleurs de pierre*), waiting for the models, changes of location which require the movement of tools, and the vagaries of the seasons, mean that he probably earned closer to 2,112 francs.[176] In reality, a stone sculptor therefore earned just under 6 francs a day, far below the rate of pay of 8 francs. Even if a sculptor-ornamentist's wage in 1881 was a good two francs above the average for his industry, taking into consideration the above calculation of real wages his actual wage would have been much lower than this.[177] The work generated by the international exhibitions appears to have enabled workers to demand higher wages. In 1867, despite the influx of 2,000 to 3,000 workers from the provinces, wages rose to 5.45 francs a day.[178]

In terms of length of working day and opportunities for personal study, the 1867 sculptors' report recommends a maximum of ten hours, comprised of eight hours manual work followed by two hours of schooling (attending drawing or modelling school should be obligatory for all workers).[179] The report favours professional, workshop based education over general education in professional drawing and modelling schools for the decorative arts.[180] According to a recent analysis, eighteen other delegations in the 1867 report expressed this view, while twenty-six preferred general education.[181] For Stéphane Laurent, the position of the minority groups (including our sculptors) is understood as representing personal rather than professional interests. However, if one examines the sculptors' report in more detail, personal and professional interests are not exclusive, but interrelated and mutually beneficial. From their own observations in decorative art schools they conclude that the teachers have never earned their living creating industrial art as they do not know how to design whole objects; they concentrate more on the cracks in the plaster models than on the plaster models themselves.[182]

The sculptors question why it is that teaching programmes are based on the study of fragments – heads, leaves, etc.; 'why are your principal models not decorative subjects which attain the proposed goal: arrangement, taste?'[183] This echoes concerns raised in the 1862 report regarding the subdivision of work and its detrimental effect on the profession and on industry; sculptors solely occupied with the fragment could not conceive of whole objects, and this in turn diminished their status and the quality and creativity of their work.

As well as its benefits to industry, the report suggests the economic benefit to the State of extending the education of ornamental sculptors. Students were increasingly neglecting this type of sculpture in favour of figurative sculpture:

> From this [lacunae in decorative education] comes fine art sculptors [*statuaires*] who greatly burden the state and who vegetate; and our manufacturers or decorators, when they have plenty of work (especially on the eve of Exhibitions), look in vain for capable modellers of ornament [*modeleurs d'ornements*] and capable decorative arrangers [*arrangeurs décoratifs*].[184]

The education of ornamental sculptors was thus promoted as a means of curbing the exodus of sculptors from the decorative to the fine arts, and the consequent burden of this on the State, which largely financed fine art sculpture through the beaux-arts education system, the Salon, state commissions and monumental projects. However, in line with the report's emphasis on creating a distinct profession of ornamental sculptors, it argues against calls for the teaching of industrial art at the Ecole des beaux-arts:

> It would soon wither. Decorative and industrial art must be independent; it must flourish by following a line parallel to great art, without being drawn by it towards a path that would make it deviate ... During the annual exhibitions, we would like to see a section dedicated to art applied to industry.[185]

As in the 1862 report, the delegation seeks to distinguish its profession as a separate, cohesive strand of the arts, in order to elevate the status and situation of its own particular sculptors. Its assimilation within either industry or the fine arts, as was now being increasingly proposed, would be detrimental to this process. A step forwards would be the establishment of a separate category of 'art applied to industry' at the annual Salon, in which ornamental sculptors could exhibit their work.

The 1862 and 1867 reports are thus important documents for the study of sculpture in this period. They provide useful information as regards wages, authorship, associations and sculptors' concerns. They present a different trajectory to the now established artisan-to-sculptor narrative and an alternative to the standard design reform rhetoric on the 'union' of art and industry. They also highlight the problematic position of sculptors working within and between art and industry, and their efforts to improve their legal,

economic and professional status by carving a specific niche for ornamental sculpture that both distinguished them from fine art sculptors and increased their independence from manufacturers. Having established something of the condition, concerns, and expertise of sculptors working in industry, I end this chapter with a study of one of the most renowned ornamental sculptors of the mid to late nineteenth-century: Constant Sévin.

CONSTANT SÉVIN, SCULPTEUR ORNEMANISTE (1821–1888)

The historiography on Sévin is extremely slight. The only known 'biography' is a posthumous article by the art critic Victor Champier, from 1889, based on Champier's meeting with Sévin four or five years earlier.[186] Champier describes Sévin thus:

> [Sévin] spoke of his art with an exuberant and loud passion, but with tenderness, in a restrained tone, in a neat and precise manner, judging with neither malice nor jealousy the men and the works, [he was] never banal in his appreciations, having his own, firm views. As he spoke of the small, and so little or poorly known world of artists of industry, which he had known since his early youth, we asked him if he would consent to give us, on this interesting subject, a few notes that we were vaguely thinking of using for a book that we will perhaps decide to have published one of these days.[187]

This description presents Sévin as a firm, passionate, precise and restrained man, capable of judging the works of others. Although Champier draws attention to the 'small, and so little or poorly known world of artists of industry', his own position is ambivalent, if not slightly dismissive. One only has to look at the works produced in the period to see that sculptors of one type or another were involved in the majority, if not almost all, pieces produced by the luxury goods industry, from mouldings for bronze furniture mounts to models for new ceramic plates. This was not a 'small' world, but Champier's remark suggests that the efforts of ornamental sculptors to galvanise and improve the status of their profession had clearly not succeeded. Champier's overall tone is hesitant and noncommittal; he has 'vaguely' thought about writing a book, which may 'perhaps' be published 'one of these days'. He had interviewed Sévin four or five years previously yet did not write his article until after Sévin's death. Even then, the article is billed as the first in a series on the sculptor but no more articles materialise; its subject was appropriate as a posthumous, newsworthy piece, but did not necessarily merit further application.

As is the case for sculptors who did not exhibit at the Salon, Sévin does not feature in Lami's extensive dictionary of nineteenth-century sculptors. Today, his name surfaces in exhibition or sale catalogues in relation to Barbedienne, for whom he worked for the best part of his career.[188] Born to an itinerant

actor in Versailles in 1821, Sévin was apprenticed at thirteen to the Parisian sculptor Antoine-André Marneuf, who had entered the Ecole des beaux-arts in 1811 and executed various architectural projects in Paris and in the provinces, including work on the Madeleine church.[189] In 1839 Sévin formed a partnership with the sculptor-modellers (*sculpteurs-modeleurs*) Phenix and Joyau, with himself as designer, to produce ornamental metalwork for bronze manufacturers and goldsmiths, including Denière, Froment-Meurice, Morel and Duponchel. This partnership deserves further study, if documentation permits, as an example of a sculpture partnership/enterprise founded and operated by sculptors, and one specifically aimed at producing models for manufacturers. It may also have inspired Barbedienne and Collas's own joint venture in sculpture reproduction.

The duration of the partnership is unknown, and may have disbanded in the political and economic upheavals of 1848. In 1848 Sévin was one of a number of French artists to travel to London in search of work. There, he worked for his earlier client the French jeweller Morel who had set up establishment in New Burlington Street funded by a private investor, Joly de Banneville.[190] At Morel's, Sévin worked alongside a number of French compatriots, many of whom would go on to become the leading lights of French (and English) industrial art. These were the young Henri Fourdinois, who had previously produced models for the bronze founder Paillard and would go on to develop his father's furniture making business into one of the most important artistic and technical enterprises of the late nineteenth century; the extraordinary metal chaser Désiré Attarge, with whom Sévin would later work regularly at Barbedienne's in Paris; Albert Willms, who had previously worked for Diéterle and Klagmann; and 'Buhot', possibly the sculptor Louis-Charles-Hippolyte Buhot, a student of David d'Angers whose Salon entries include medallions, busts, galvanoplasty in imitation of oxidised silver and bronzes.[191] As Olivier Gabet evocatively suggests in his study of Fourdinois in England, 'it is easy to imagine the young man's excitement when Henri found himself surrounded by these artists whose names were common currency in everyday family conversations at home'.[192]

Sévin's experience at Morel's thus placed him within an important network of French sculptors and related professionals in England. These friendships and associations continued after their return to France. In Paris Willms was employed by leading manufacturers, including Christofle and Froment-Meurice, and later relocated to England as head artist at Elkington's in Birmingham.[193] Sévin, alongside many of his compatriots, returned to Paris in 1850. Champier interprets this in terms of nationalist homesickness:

> The fog over the Thames has not got the reputation of being attractive for any length of time to our French eyes, which like a bright light and a cheerful sun, Constant Sévin felt nostalgia for Paris.[194]

Back in Paris, Sévin first found a few months' work at his colleague from Morel's, Henri Fourdinois. He then moved to Limoges to produce new models for the ceramic firm Jouhanneaud and Dubois. In 1855 he returned to Paris, at a time when Barbedienne had just lost his head designer, the young Cahieu, to cholera. A surviving contract (Appendix 1) shows that Sévin was soon in Barbedienne's employ. In August 1855 he took direction of Barbedienne's sculpture studio on an annual salary of 6,000 francs. The ten-year contract stipulates significant salary increases resulting in the 'definitive salary' of 12,000 francs from 1860 to 1865. The contract not only clarifies financial matters between Sévin and Barbedienne and ties Sévin exclusively to Barbedienne; it also acknowledges their shared pursuit of developing industrial art to its highest level:

> Mr Ferdinand Barbedienne, since the foundation of his enterprise, intends to bring his field of industry to its highest level; it is in the hope of reaching this goal that he has sought the cooperation of Mr Constant Sévin. For his part, Mr Constant Sévin being in full agreement with this approach, which is also his own, has accepted from Mr Ferdinand Barbedienne the direction of his Sculpture studio which had been offered to him … On his part Mr Constant Sévin promises to Mr Ferdinand Barbedienne that he will exclusively devote his talent and his care to everything that might contribute to the reputation and the success of his industrial firm.[195]

The terms of the contract and the extant works produced reveal how Barbedienne and Sévin shared a complex understanding of sculpture and its relationship to design. While the scholarship on Barbedienne's enterprise has focused exclusively on his reproduction of fine art sculpture and his contracts with sculptors such as Rodin, I argue that this was a relatively low cost investment compared to the ambitious decorative projects he pursued with Sévin. The current focus on Barbedienne's stand-alone sculpture needs to be refigured to take account of this. The sculpture reproduction side of Barbedienne's business partly operated as a means of funding his real passion for the creation of new and innovative examples of industrial art. Champier's posthumous article on Sévin deals not with the sculpture reproduction side of the business, but uniquely with Barbedienne's in-house, decorative creations. As Champier explains,

> [Sévin's] lucky star took him to the unhoped-for leader [Barbedienne] who, by sacrificing all monetary considerations to his only concern for making masterpieces, did not refuse him anything which would permit him to fulfil his slightest dreams as an artist: he knows it, he understands it and henceforth only dreams of giving free rein to his imagination. Does he need gold, diamonds, precious stones to execute what he wishes to make? He worries less about containing the costly extravagances of the artist than about the improvements they might hold to reach the glimpsed ideal. Does it please him to make some furniture? Has he got the idea of some monumental fireplace where

the splendour of marble will blend with the ardent harmonies of the chased bronzes and of the painted enamel plaques? Is it about a torchère, or about cabinets with magical decors which will rival the marvels of Persia or India? All that Constant Sévin needs to do is speak: it is not Mr Barbedienne who will stop his collaborator on this path of costly endeavours as long as art is the goal, it is a matter of always rising higher in order to reach beauty. Materials? He gets it, no matter what. The workers? He discovers them and goes and gets them among the best, or else he trains them. The workshops? He installs them, directs them, maintains them under a methodical and determined impulse on the path of perfection driven by an inner force.[196]

This passage focuses on what was perhaps Barbedienne's most significant contribution to sculpture: the production of new models, combining diverse materials and techniques, contemporary and historic influences, and European and non-European sources. Champier represents Barbedienne and Sévin as dreamers and idealists, exploiting every available resource and digging deep into their knowledge and imaginations to create the 'glimpsed ideal'. Sévin's facilities were so great, he concludes, that Barbedienne endowed him with unlimited funds, access to the finest materials, unbridled creative freedom, and the choice of staff in his employ. As the passage underscores, this area of Barbedienne's production was an extremely expensive, time consuming, experimental and risky undertaking; and, I would add, this was particularly so compared to the financial and intellectual commitment involved in the production of the serial sculpture for which he is now better known.

The sheer cost of creating such novel and high quality works meant that, while they might receive critical acclaim as prominent 'exhibition' pieces, they would not necessarily find a buyer. For example, it is said that Barbedienne's famous monumental clock designed by Sévin and composed of over a thousand individual sections, cost 300,000 francs 'of research, inventiveness, work and taste', to produce.[197] It was exhibited at the International Exhibition of 1878, yet despite its being widely praised remained unsold at the time of Barbedienne's death in 1889. It was later donated by his descendants to the Hôtel de Ville in Paris, where it can still be seen today. This was not an unusual fate for such experimental and expensive works, as can be seen in the fortune of similar unique exhibition pieces by the likes of Fourdinois.[198] Indeed, Fourdinois criticised the government for refusing to act on its verbal support of the decorative arts by actually purchasing them. Where, demanded Fourdinois, can one find, in museums, palaces, or public buildings,

some of these superb pieces through which the [City of Paris] is anxious to prove the vitality of our artistic and industrial genius? Which are the pieces that form part of the state-owned furniture collection? The answer, unfortunately, does not require a lengthy enquiry; it is negative on every point.[199]

Barbedienne was once asked by La Païva, the celebrated courtesan and patron of contemporary decorative art, sculpture and architecture, how

he dared to produce such important works without waiting for them to be commissioned. He responded, 'Oh, Madam, if I waited for orders, these works, I would never execute them! What one has to do is to anticipate the amateur's wishes'.[200] Manufacturers such as Barbedienne and Fourdinois demonstrate a commitment to the decorative arts which extends far beyond the merely historicist, derivative or 'bourgeois bibelot'. They were, alongside Christofle and other high-end manufacturers, creating highly original works, developing new techniques such as galvanoplasty, rediscovering historic ones such as enamelling, and using and developing the knowledge and skills of a variety of sculptors to design and model new objects. This represents an entirely different commitment to sculpture than Barbedienne's bronze, plaster and marble reproductions.

Significantly, in a period in which sculptors rarely, if ever, saw their Salon plaster models transferred into permanent marble or bronze, Sévin was given carte blanche to not only design but to 'palpably' produce sculptural objects:

> You see, said Constant Sévin to us, I can only be interested in things when they take shape, when they are materialised. Drawing for the sake of drawing, this holds little attraction for me now. To put on paper objects meticulously finished, with pretty effects of pen or pencil, this does not interest me. But what delights me, what really intoxicates me, is to create, to create, can you understand, in a palpable shape the things that come out of my imagination in the form of dreams and that I clothe with what nature gives us as most precious; gold, silver, precious stones, marbles with radiant tones, and enamel, oh, above all enamel, the only material that can be transformed into diamond by the furnace, and which, obediently, according to my whim, is incorporated where I wish it to go on my work, and make it radiate![201]

In this passage, Champier again stresses Sévin's idealism; the phrases are almost late Romantic or Symbolist, referring to dreams, intoxication, imagination and radiation. This is tempered by Sévin's control over materials and techniques; the result is not accidental but premeditated, 'incorporated where I wish it to go on my work'. Unlike the predominance of plaster sculpture at the Salon, Sévin's creations for Barbedienne were exhibited as fully realised, highly finished, often monumental works.

Such support, trust and freedom between employer and employee, manufacturer and sculptor, was extremely rare in and outside the luxury goods industry, and was an important factor in Barbedienne's success within the context of industrial art. The following extract from a letter from Barbedienne to Sévin reveals something of the thought processes involved in their creations:

> I was not absolutely satisfied with a little guéridon [small table] with the figures by J. Goujon. I wanted to talk about this with you. Time not allowing me to, here is my critique: all the details are prettily elegant, but the ensemble is empty and

lacks homogeneity. As you say, the back of the low reliefs is not agreeable. But, in my opinion, it is not only due to their plainness, but to their isolation, that they don't look right. Could you not, with the aid of a new combination, bring these low reliefs to the centre of the guéridon as a triangle, in such a way that between each foot we can only see a single one? If you make a fine ornament for beneath the underside we will achieve, I think, a more original little piece of furniture. The ornament that protrudes from the low relief's frames should be modified so that they become very light, perhaps pierced, and rest on the points of the triangles formed by the low reliefs reduced to their most simple expression.[202]

This rare letter demonstrates a close working relationship between Barbedienne and his head designer, and a thoughtful and considered approach to design which can be seen in their careful positioning of its composite elements, notably its Renaissance panels. This is a form of historicism, as understood as a direct visual, iconographic and material reference to historically located precedents identified by contemporaries as periods of aesthetic difference in the history of design. Thus, the 'Renaissance style' in nineteenth-century furniture prioritises polished wood and particular forms and motifs which reproduce or echo recorded historic examples from the sixteenth century; and the 'Louis XVI' style, popularised from the Second Empire onwards with Empress Eugenie's fascination for Marie-Antoinette, prioritises gilt finishes to wood and bronze, and the neoclassical style favoured by the French court during her reign. Such 'styles' rapidly became shorthand for particular types of models, and types of modelling and finish, as evidenced in the lists of dozens of 'garniture Renaissance', 'garniture grecque' and items in the 'style Louis XVI' in bronze founders' catalogues, irrespective of whether they were direct copies of extant historic examples or new models by nineteenth-century sculptors and designers echoing and imitating renowned historic examples.[203]

What the documentation between Sévin and Barbedienne reveals, however, is that while the objects they produced can be similarly categorised as 'Renaissance', 'Louis XVI' and so forth, this was a *thoughtful* process based on considerable knowledge and high aesthetic aims, rather than an avaricious scavenging of history by manufacturers seeking low-cost models and applying them relatively indiscriminately to a random selection of objects. The table is redesigned so as to display the low reliefs to better advantage, and the legs repositioned so that they can only be seen independently of each other. And while Barbedienne may not have consistently applied this level of attention to all his productions – particularly in terms of direct copies of historic models such as Michelangelo's *Night* and *Day*, which he would have entrusted to his specialist workforce – it is important to recognise that for Barbedienne, and for other manufacturers, the process of incorporating said *Night* and *Day* into an object such as a clock or a bookcase did require deliberation as to the appropriateness of object, scale, materials, colour and finish. In composing a

clock to accommodate *Night* and *Day*, for example, the manufacturer would have designed and selected the additional elements to reflect the then-popular understanding of Renaissance design as relatively dark, heavy and sombre, with a deep red or black marble socle, richly patinated bronzes, and gilt bronze highlights for variety, emphasis and luxury. The proliferation of 'Renaissance', 'Louis XIV' etc. clocks, garnitures and light fittings in exhibition catalogues, reports and reviews therefore represent more than a sacking of history; they demonstrate different degrees of imaginative interaction with the past based on different intentions, knowledge bases, financial reserves and skill sets.

A further significant work designed by Sévin for Barbedienne is a mirror, now at the Bowes Museum.[204] A detailed engraving of the mirror (Fig. 1.9) was published in *The Art Journal*, which noted that it was one of the leading objects of the 1867 International Exhibition in Paris. Barbedienne was seen to have transformed a nonprecious metal into a precious commodity through his application of art and the astute selection and management of artists and artisans: 'he has, indeed, so elevated the art he professes as to give it rank with that of the goldsmith'; 'it is Bronze, but Art has given it the value of gold; it is argenté, partially gilt'.[205] The bronze is so minutely and expertly chased by Attarge that even the garlands of fruit (Fig. 1.10) are brought to life. This degree of realism is the result of the combination of modelling and surface effect, without recourse to polychromy.

The mirror is a composite of many elements, each accurately designed and modelled to accommodate the next. The corner sections comprise a silver gilt figure of a nymph in the round, which reclines on a pierced silver gilt panel of scrolling foliage. This in turn is set within a gilded frame which is anchored to a thick, solid scroll. Each of the five nymphs is individually modelled by Carrier-Belleuse. The figures are hollow; the backs cut away in order for it to sit flush on the pierced panel. Sévin thus sourced some of the modelling for the mirror from an acclaimed sculptor, and adapted the figures from his original models in the round to suit the design and constructional requirements of the mirror.

While the Renaissance style of the mirror might be seen to reflect a rather uncreative reliance on historic styles and precedents, it also demonstrates an extensive knowledge of historic and geographical references. As Barbedienne himself explained in 1867:

> One can say of Mr Constant Sévin, *sculpteur ornemaniste*, that the future history of works of art will mention his compositions. Greek art is at the basis of his beliefs and the first rule of his studies; and, when he gives way to other inspirations, either in the Renaissance style, or in the Louis XVI style, his style remains sober and pure. His knowledge of all Antique and Modern ornamentation is deep. He has been able to carry out with success Chinese, Hindu, Persian, Byzantine, Moorish, Gothic compositions, so much so that connoisseurs are mistaken about their origin; moreover, he is one of the rare artists who concern themselves with the particular and distinctive decorative qualities of each of the materials he works with.[206]

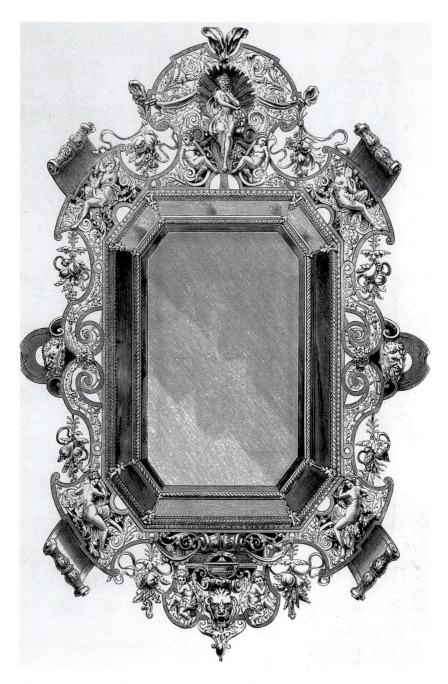

1.9 Ferdinand Barbedienne, Constant Sévin and Albert-Ernest Carrier-Belleuse,
Mirror (1867), reproduced in *The Art Journal: The Illustrated Catalogue of the Universal
Exhibition, Paris, 1867* (London: Virtue, 1867), p. 172.

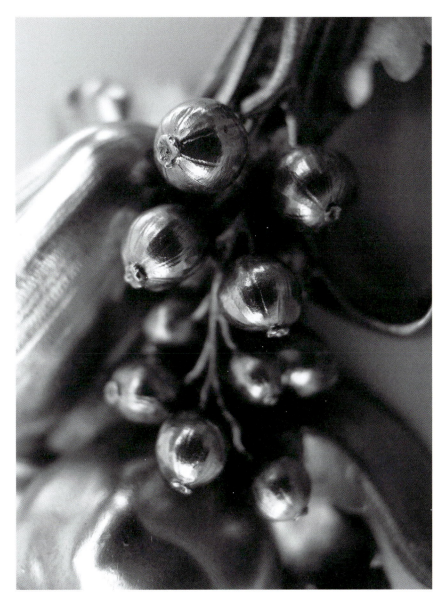

1.10 Ferdinand Barbedienne, Constant Sévin and Albert-Ernest Carrier-Belleuse, *Mirror* (1867), patinated, gilt and silvered bronze, 208 × 133 cm, detail of metal chasing on fruit. The Bowes Museum, Barnard Castle.

Sévin's knowledge of everything from Chinese to Gothic art and design is here seen to be so extensive that connoisseurs have mistaken his work for originals. While this puffing up of his own workshop and staff may be partly exaggerated, Barbedienne's reference to the research undertaken by manufacturers and sculptors working in industry is an important and neglected area in the study of eclecticism and historicism. Nevertheless, Barbedienne still felt the need to affirm that Sévin's art was fundamentally based on Greek principles of art and ideal beauty, a direct reference to the beaux-arts system and perhaps a response to contemporary criticisms regarding the appropriate application of historic and international styles to modern works. Furthermore, his emphasis on the distinctive decorative qualities of individual materials demonstrates a particularity of approach to materiality within the decorative arts – and within sculptural reproduction – that extends beyond what might be perceived as an indiscriminate interchangeability of materials between different objects.

Sévin's success as an ornamental sculptor was extraordinary in terms of the monumental scale of the objects he was encouraged and enabled to create by his employer. When asked by Champier to list his principal works, he responded that it would be impossible as he had executed around two thousand designs for Barbedienne. His unrealised designs must have extended well beyond that number. He names the gilt bronze column bases, capitals and four large pendant lamps for Prince Albert's chapel and tomb at Frogmore, commissioned by Queen Victoria; the doors of Tsar Nicolas's tomb at Odessa; and bronzes for La Païva's hôtel.[207] These are important commissions, and list royalty and courtesans in the same sentence, united by their choice of Barbedienne and Sévin.

The success of a firm like Barbedienne's was, however, finite. It was restricted to a particular moment in time when industrial art was valued as a valid artistic category and in which the qualities inherent to it, such as collaboration, a highly finished surface and expertise in a broad range of art and design sources, were appreciated and celebrated. Unlike Pradier or Carrier-Belleuse, Sévin does not represent institutional porosity between fine and decorative art but a distinct category of sculpture, whose financial and critical successes were found uniquely within industry and which drew on an extensive knowledge of fine and decorative sources to create unique and experimental pieces. A reconsideration of sculpture in the context of industrial art reveals a greater interchange between fine and decorative sculpture, and a more complex site for sculpture within industrial art, than has previously been recognised. These present as-yet largely untapped sources for the study of nineteenth-century sculpture, from the integration of non-Salon sculpture into art historical discourse to the study of Salon sculpture within design history.

The study of ornamental sculptors such as Sévin, and those involved in the 1862 and 1867 reports, challenges assumptions regarding the place and

practice of sculpture in mid-nineteenth-century France. It reveals that there were sculptors who featured outside the Salon who significantly contributed to the history of French (and English) sculpture, if one expands the definition of 'sculpture' to include works other than those traditionally associated with the Salon. It also offers an alternative trajectory to the 'artisan to artist' narrative regularly evoked in relation to sculptors such as Rodin. An 'artisanal' sculptor such as an ornamental sculptor was not necessarily creatively or financially impoverished, nor was his work necessarily a repetitive and derivative branch of sculpture. Originality and innovation were actively sought by some manufacturers to maintain market lead and fulfil the manufacturer's own creative ambitions; in the industrial arts produced by Sévin and Barbedienne this represented a considerable financial, intellectual and artistic commitment, alongside the firm's commitment to the reproduction of Salon and historic sculpture.

Notes

1 *Exposition Universelle de Londres en 1851. Distribution des Récompenses aux Exposants Français par le Président de la République (25 novembre 1851)* (Paris, 1852), p. 9.

2 Roger Price (ed.), *Revolution and Reaction, 1848 and the Second Republic* (London and New York, 1975), p. 23.

3 Louis Blanc's cooperative-run 'social workshops' were rejected. Maurice Agulhon, *The Republican Experiment, 1848–1852* (Cambridge, 1983), p. 36.

4 Agulhon, *The Republican Experiment*, p. 67.

5 Gustave Planche, *Portraits d'artistes peintres et sculpteurs*, vol. 2 (Paris, 1853).

6 See also the 1848 competition for a figure of the Republic; Marie-Claude Chaudonneret, *La Figure de la République. Le concours de 1848* (Paris, 1987).

7 William Fortescue, *France and 1848, the End of Monarchy* (London and New York, 2005), p. 90.

8 Fortescue, *France and 1848*, p. 98.

9 Tamara Préaud, *Sèvres de 1850 à nos jours* (Paris, 1983), p. 7.

10 ' … venir en aide à l'industrie privée en lui fournissant de beaux modèles et en rendant publiques les améliorations obtenues dans les procédés de fabrication', *Notices sur les pièces qui composent l'exposition des manufactures nationales de porcelaine, vitraux et émaux de Sèvres … faite au Palais National le 21 avril 1850*, quoted in Préaud, *Sèvres de 1850*, p. 7.

11 An unreferenced quotation by Flaubert in Agulhon, *The Republican Experiment*, p. 39.

12 AN F.12.7600 includes responses from Chambers of Commerce throughout France.

13 Wagner, *Carpeaux*; Anne Pingeot, *La Sculpture française au XIX siècle* (Paris, 1986).

14 Fortescue, *France and 1848*, p. 49.

15 Arnould Desvernay (ed.), *Rapports des délégations ouvrières, contenant l'origine et l'histoire des diverses professions, l'appréciation des objets exposés, la comparaison des arts et des industries en France et à l'étranger : ouvrage contenant 100 rapports rédigés par 315 délégué ... Exposition universelle de 1867 à Paris* (Paris, 1868), vol. 3, pp. 10–11.

16 Price, *Revolution and Reaction*, p. 245.

17 Desvernay, *Rapports des délégations ouvrières 1867,* vol. 3, pp. 10–11.

18 *Almanach-Bottin* (Paris, 1851).

19 On ecclesiastical decorative sculpture by goldsmiths, see Daniel Alcouffe et al, *Trésors d'argent. Les Froment-Meurice, orfèvres romantiques parisiens* (Paris, 2003).

20 Mainardi, *Art and Politics*, p. 21.

21 Lord Pilgrim, 'Voyage au pays des étrennes. Barbedienne: la galerie d'or', *L'Artiste*, vol. 10, n.s. no. 12 (15 December 1860): p. 281; Charles Cauchois, 'Notes d'un ciseleur', MSS, May 1892 (AN 368. AP.2 Dossier 2).

22 For example, after an apprenticeship in the cameo trade, Rupert Carabin became unemployed in the early 1870s when cameos fell out of fashion, and found work as a wood carver in the furniture district of the Faubourg Saint-Antoine. Yvonne Brunhammer and Colette Merklen, *L'Œuvre de Rupert Carabin (1862–1932)* (Paris, 1974), p. 22.

23 Michael Cole's analysis of the notion of 'vocational identity' is a useful model for understanding how sculptors viewed themselves and their work. Michael W. Cole, *Cellini and the Principles of Sculpture* (Cambridge, 2002).

24 Letter by Carpeaux, Valenciennes, December 1851, in Annie Braunwald and Anne Wagner, 'Jean-Baptiste Carpeaux', in Jeanne L. Wasserman (ed.), *Metamorphoses in Nineteenth-Century Sculpture* (Harvard, 1975), p. 110.

25 Robert J. Bezucha, 'The French Revolution of 1848 and the Social History of Work', *Theory and Society*, vol. 12, no. 4 (July 1983): pp. 469–484.

26 Théodore Child, 'Ferdinand Barbedienne: Artistic Bronze', *Harper's New Monthly Magazine*, vol. 73, no. 436 (September 1886): pp. 489–505.

27 Child, 'Barbedienne', p. 494.

28 Child, 'Barbedienne', p. 493.

29 Meredith Shedd, 'A Mania for Statuettes: Achille Collas and other Pioneers in the Mechanical Reproduction of Sculpture', *Gazette des Beaux-Arts* (July–August 1992): pp. 36–48.

30 Child, 'Barbedienne', p. 495.

31 RFB, Minutes of 34th General Assembly, 25 October 1841, pp. 86–88. AN 106.AS.5.

32 Catherine Chevillot, 'Artistes et Fondeurs au XIXe siècle', *Revue de l'Art*, no. 162 (2008), p. 54.

33 Jacques de Caso, 'Serial Sculpture in the Nineteenth Century', in Wasserman, *Metamorphoses*, p. 11.

34 Article 1, 'French Literary and Artistic Property Act (1793)', translated by Andrew Counter, in Lionel Bently and Martin Kretschmer (eds), Primary Sources on Copyright (1450–1900): www. copyrighthistory.org.

35 Robin v. Romagnesi, Court of Cassation, 17 November 1814; 'Court of Cassation on Sculptures (1814)', in Lionel Bently and Martin Kretschmer (eds), Primary Sources on Copyright (1450–1900): www.copyrighthistory.org.

36 For the details of this ruling, brought by the sculptors Carlo Marochetti and Denis Foyatier against manufacturers in 1839, see Chevillot, 'Artistes et Fondeurs', p. 25.

37 Chevillot, 'Artistes et Fondeurs', p. 53.

38 Summary of Bulla vs. Vaugerme, in *Almanach de Messieurs les fabricants de bronze réunis de la Ville de Paris, 1844* (Paris, 1844), pp. 50–52.

39 The Bowes Museum, CW.19 object file. A lithograph by Jean-Eloi-Ferdinand Malenfaut for a clock design incorporating this scene survives in the Bibliothèque nationale, Paris.

40 RFB, Minutes of General Assembly, 28 April 1845, p. 213. AN 106.AS.5.

41 RFB, Minutes of Meeting, 13 August 1846. AN 106.AS.5.

42 RFB, Minutes of Meeting, 18 March 1847. AN 106.AS.5.

43 *The Art Journal Illustrated Catalogue of the International Exhibition 1862* (London, 1862), 199.

44 *450 modèles en bronze provenant de la maison Levy frères fabricants de bronzes Paris, rue de Turenne 13* (Paris, 1876); 'tous le modèles compris au présent catalogue seront vendus avec droit de

reproduction'. The models include groups, statuettes and figures after Clodion, Bosio, Houdon and Crozatier, suggesting longevity of these eighteenth-century models into the nineteenth century.

45 AN 106.AS.70. All the following models sold with reproduction rights: *450 modèles en bronze* (1876); *Vente G. Servant, Modèles pour bronzes d'art de la maison G. Servant, fabricant de bronzes d'art à Paris, par suite de cessation de fabrication, rue Vieille du Temple 137* (Paris, 1882); sale 3–7 April 1882; *Vente Ch. Pickard, 4–6 July 1882, rue Béranger, 6. Modèles pour bronze d'art de la Maison Ch. Pickard, fabricant de bronzes d'art à Paris, par suite de cessation de fabrication* (Paris, 1882); sale 4–6 July 1882; *Vente de E. Sevenier, 26–28 mai 1884, rue Vieille-du-Temple, 110. Modèles pour bronzes d'art provenant de la Maison E. Sevenier, par suite de cessation de fabrication* (Paris, 1884); sale 26–28 May 1884.

46 *Catalogue de beaux bronzes d'art et d'ameublement, groupes, statuettes, garnitures de cheminée, lustres, suspensions de salles à manger, objets de curiosité, cheminée monumentale, bronzes et modèles par Barye, meubles et étagères en noyer sculpté provenant des ateliers et magasins de M Romain, successeur de M Victor Paillard, et dont la vente aura lieu en vertu d'une ordonnance* (Paris: Hôtel Drouot, 11–17 June 1879). This sale took place at Hôtel Drouot from 11 to 17 June 1879.

47 *Vente aux enchères publiques en vertue d'une ordonnance de modèles de bronzes d'art et d'ameublement, modèles en plâtre (non édités), mobilier industriel et outillage, ateliers Romain, boulevard Beaumarchais 105* (Paris, 1879). This 18-day sale took place at Romain's studios between 24 July and 29 August 1879.

48 The archives of the bronze founders Susse frères (still in operation) and Barbedienne (Archives nationales 368.AP.1–8), and of the Réunion des fabricants de bronze (AN 106.AS.1–70) are particularly useful regarding copyright and contracts with sculptors.

49 'Pour tout esprit pratique la sculpture industrielle ne peut pas non plus supporter le régime du dépôt, tant à cause du volume de certains objets, que de l'innombrable variété des modèles et aussi des différents usages qu'on peut en faire. Ainsi un meuble, un lustre, un vase, un candélabre, se composent souvent d'un grand nombre d'ornements qui, pris séparément, servent à d'autres usages, et le seul fait de savoir à l'aide de modifications et d'arrangements faire un nouveau modèle avec des ornements déjà utilisés, constitue à nos yeux un art véritable qui peut être assimilé, comme principe, à l'art de Piranesi, composant avec des débris de l'antiquité un candélabre devenu célèbre. ... Pour un objet de ronde-bosse, le dessin et la photographie ne peuvent donner que le premier plan de l'une des faces; et d'ailleurs ils ne donnent ni la couleur générale de la sculpture, ni la qualité, ni l'esprit du modèle, ni la hauteur exacte des reliefs, ni les combinaisons des lignes et des ornements qui se trouvent dans l'intérieur d'un lustre, le revers d'une coupe, sur les côtés et le derrière d'une pendule, etc. etc. (Disons que la contrefaçon s'exerce sur tout ou partie d'un objet.) Et, tout défectueux que soit le mode de dépôt par le dessin, il deviendrait encore une cause de dépense et de temps perdu, ruineuse pour le fabricant.' *Annuaire de la Réunion des fabricants de bronzes et des industries qui s'y rattachent. Résumé des travaux de l'année 1888* (Paris, 1888), pp. 85–86.

50 One clear area of differentiation perhaps regards the interiors of models; these hold importance in decorative objects such as vases and inkwells, whereas fine art sculpture in this period is on the whole concerned with exteriors.

51 The guilds were restricted to French male Catholics.

52 Statute of the fondeurs mouleurs en sable et bossetiers, 1752, in Pierre Verlet, *Les Bronzes dorés français du XVIII siècle* (Paris, 1987), p. 153.

53 On the *marchand merciers* and on the guild system more broadly, see Carolyn Sargentson, *Merchants and Luxury Markets: The Marchands Merciers of Eighteenth-Century Paris* (London, 1996).

54 Christopher Gilbert, *The Life and Work of Thomas Chippendale* (London, 1978).

55 While some of these manufacturers have been studied in isolation, notably Susse and Barbedienne, a study of their joint activities would benefit our understanding of the industry as a whole, the breadth of objects produced, and the sculptors who worked for them.

56 On Barbedienne's bronze edition see Louis Clément de Ris, 'Mouvement des arts, bronzes et réductions de MM. Collas et Barbedienne', *L'Artiste*, ser. 5, no. 10 (15 April 1853), pp. 88–90; Théophile Gautier, 'Une visite chez Barbedienne', *L'Artiste*, n.s., vol. 4, no. 1 (9 May 1858): pp. 7–8; Lord Pilgrim, 'Barbedienne'; Charles Blanc, 'Le procès Barbedienne', *Gazette des Beaux-Arts*, no. 4 (1 April 1862): pp. 384–389; Théodore Child, 'Ferdinand Barbedienne: Artistic Bronze', *Harper's New Monthly Magazine*, vol. 73, no. 436 (September 1886): pp. 489–504; Victor Champier, 'Ferdinand Barbedienne (1810–1892)', *Revue des Arts Décoratifs* (April 1892): pp. 289–292; Catherine Chevillot, 'Les Stands industriels d'édition de sculptures à l'exposition universelle de 1889: l'exemple de Barbedienne', *La Revue de l'Art*, no. 95 (1992): pp. 61–67; Florence Rionnet, 'Barbedienne ou la

fortune de la sculpture au XIXe siècle', *Bulletin de la Société de l'Histoire de l'Art français* (2001): pp. 301–323; and Florence Rionnet, *La Maison Barbedienne: Correspondances d'artistes* (Paris, 2008).

57 On aluminium in France between 1854 and 1890, see David Bourgarit and Jean Plateau, 'When Aluminium was Equal to Gold: Can a "Chemical" Aluminium be Distinguished from an "Electrolytic" One?', *Historic Metallurgy*, vol. 41, part 1 (2007): pp. 57–76. By 1860 lower production costs diminished its desirability in the luxury goods industry.

58 On this centrepiece see Catherine Arminjon, 'Le groupe sculpté en aluminium du Musée du Second Empire au Château de Compiègne', *Cahiers d'Histoire de l'Aluminium*, vol. 10 (1992): pp. 19–20.

59 Mainardi, *Art and Politics*; Silverman, *Art Nouveau*; Nancy Troy, *Modernism and the Decorative Arts in France: Art Nouveau to Le Corbusier* (New Haven and London, 1991).

60 Léon de Laborde, *De l'Union des Arts et de l'Industrie* (Paris, 1856). On critics and the media in the Second Empire, see Mainardi, *Art and Politics*, pp. 67–69.

61 Maxime du Camp, *Salon de 1867* (Paris, 1867).

62 On Pradier's life and work, see the recent catalogue raisonné, Claude Lapaire, *James Pradier et la sculpture française de la génération romantique. Catalogue raisonné* (Lausanne, 2010).

63 Letter from Lebreton to the Société des arts de Genève, 15 November 1809, in Douglas Siler, 'Les Années d'apprentissage', in de Caso, *Statues de chair*, p. 62.

64 'J'ai déjà tout disposé pour l'éducation du dernier [Pradier]. M. Lemot, statuaire, lui apprendra à modeler, MM. Jouffroi et Galle lui enseigneront à graver la médaille et les pierres fines, car ce sont deux arts qui peuvent et qui devraient marcher ensemble.' Letter from Lebreton to the Société des arts de Genève, 15 November 1809, in Douglas Siler, 'Les Années d'apprentissage', in de Caso, *Statues de chair*, p. 62.

65 Pingeot, *La Sculpture française*. Anne Wagner's study on Carpeaux is an important exception to this, which examines the 'Petite Ecole' as well as the EBA; Wagner, *Carpeaux*.

66 Siler, 'Les Années d'apprentissage', p. 67.

67 Antoinette Le Normand Romain, 'Les Ecoles', in Pingeot, *La Sculpture française*, pp. 28–31.

68 On the Prix de Rome, see Antoinette Le Normand Romain, 'L'Académie de France à Rome, les envois de Rome', in Pingeot, *La Sculpture française*, pp. 53–57.

69 G. Garnier, 'La carrière d'un artiste officiel à Paris', in de Caso, *Statues de chair*, p. 78.

70 Théophile Gautier, 'Salon de 1848. Deuxième article', *La Presse* (21 April 1848), partially reprinted in de Caso, *Statues de chair*, p. 157.

71 De Caso, *Statues de chair*, p. 158. Only two other bronzes to this scale are known; one at the Dahesh Museum New York and one in a private collection.

72 RFB, Minutes of Meeting, 31 October 1850, p. 384. AN 106.AS.5.

73 Daniel Alcouffe, Anne Dion-Tenenbaum and Pierre Ennès, *Un Age d'Or des Arts décoratifs 1814–1848* (Paris, 1991), p. 491.

74 Bowes Museum, M.234 object file. This is one of three known versions at 89 cm high, of which the one at Osborne may be Pradier's original bronze.

75 Alcouffe et al, *Un Age d'Or*, pp. 489–491.

76 Théophile Gautier, *La Presse* (9 December 1849), partially reproduced in Alcouffe et al, *Un Age d'Or*, p. 490.

77 *L'Illustration*, vol. 18, (19 July 1851): p. 41.

78 Models of *Night* and *Day* for clocks are listed in Boulle's probate inventories of 1732. Peter Hughes, *The Wallace Collection Catalogue of Furniture* (London, 1996), vol. 1, catalogue entry 108.

79 Sotheby's London Olympia, 6 December 2007, includes the original plinth on a marble base with glazed enamel dial. On sculpture plinths, see Catherine Chevillot, 'Le socle' in Pingeot, *La Sculpture française*, pp. 242–251.

80 Lot 139, Sotheby's, 6 November 1992.

81 I am indebted to Catherine de Bourgoing at the Musée de la Vie romantique for allowing me access to the clock and its associated documentation.

82 On Froment-Meurice, see Alcouffe et al, *Trésors d'argent*.

83 'Très conventionnels, reprenant les modèles de l'époque; son talent ne ressort donc pas'. Michèle Heuzé, 'Pradier intime, bijoux et camées', *L'Objet d'Art*, no. 380 (May 2003), p. 75.

84 Georges Bell, *Pradier* (Paris, 1852), p. 15, quoted in Siler, 'Les Années d'apprentissage', p. 71.

85 Antoine Etex, *J. Pradier. Etude sur sa vie et ses ouvrages* (Paris: A. Etex, 1859).

86 *Leda* was the second lot in the Loterie des artistes for 1851, and estimated at 200,000 francs.

87 Andreas Blühm, *The Colour of Sculpture 1840–1910* (Amsterdam and Leeds, 1996), p. 25.

88 De Caso, *Statues de chair*, p. 140.

89 'Comme beaucoup d'artistes de son temps qui, par inclination ou par nécessité, créent pour le commerce, Pradier dut connaître les difficultés qu'entraîne la collaboration des artistes et des industriels et marchands; la sculpture créée, au XIXe siècle, pour la production sérielle, est dirigée, contrôlée, dans ses sujets et dans ses formes, par les industriels soucieux de sa rentabilité. A-t-il pris en compte leurs suggestions? De plus, la statuette, telle un titre au porteur et à terme, et, comme lui, aliénable par l'artiste et par l'industriel, se trouve entièrement soumise au *jus utendi* et *abutendi* qu'exerce l'acquéreur qui la modifie, l'adapte: les aventures de la pendule et du presse-papier romantiques en témoignent. Pradier, comme d'autres, s'est trouvé pris dans la spéculation des industriels, risquant l'action en contrefaçon lorsque, cherchant un profit supplémentaire dans l'exploitation d'une œuvre populaire mais déjà aliénée, il en fait une variante et se trouve accusé de se contrefaire.' De Caso, *Statues de chair*, p. 45.

90 'Ce n'est plus maintenant un art réservé au petit nombre; grâce à Pradier, la foule aime aujourd'hui la sculpture.' Planche, *Portraits d'Artistes*, p. 353, quoted in Garnier, 'La carrière d'un artiste officiel', in de Caso, *Statues de chair*, p. 87.

91 *The Second Empire 1852–1870: Art in France under Napoleon III* (Philadelphia, Detroit and Paris, 1978), pp. 92–93. In 1855 Defossé also exhibited a block print wallpaper, *La Bacchante endormie*, which reproduced Clésinger's sculpture *Woman Bitten by a Serpent;* Clésinger personally supervised the engraving.

92 Chenavard published *Nouveau Recueil de Décorations intérieures* (1833–35), and *Album de l'Ornemaniste* (1835).

93 '... de vases, style de la Renaissance, pour la manufacture royale de porcelaine de Sèvres', *Explication*, 1831, no. 520, quoted in Alcouffe et al., *Un Age d'Or*, p. 265.

94 'timidité', Pierre Ennès, 'Aimé Chenavard, Vase dans le style de la Renaissance', in Alcouffe et al., *Un Age d'Or*, p. 266.

95 J. B. Bullen, 'The Sources and Development of the Idea of the Renaissance in Early Nineteenth-Century French Criticism', *The Modern Language Review*, vol. 76, no. 2 (April 1981), p. 321. On the place and impact of the Renaissance in nineteenth-century France see Yannick Portebois and Nicholas Terpstra (eds), *The Renaissance in the Nineteenth Century* (Toronto, 2003) and Roland Recht, Philippe Sénéchal, Claire Barbillon and François-René Martin (eds), *Histoire de l'Art en France au XIXe siècle* (Paris, 2008).

96 This formed part of Michelet's nineteen-volume *Histoire de France* and predates Jacob Burckhardt's more well-known *The Civilization of the Renaissance in Italy* (1860).

97 Bullen, 'The Sources and Development of the Idea of the Renaissance', p. 274.

98 Alcouffe et al., *Un Age d'Or*, especially catalogue entries 73, 74 and 82.

99 For example, Froment-Meurice's *Toilette for the Duchesse of Parma* (1845–51), the most celebrated and lengthy decorative undertaking of the July Monarchy (1830–48), was offered by Legitimists to the daughter of the Duc de Berry on her wedding to the Duke of Parma in 1845.

100 'Le vase "de la Renaissance" représente, sans nul doute, à l'aube du règne de Louis-Philippe, le manifeste d'un art nouveau. Malgré ses faiblesses, remarqué de ses contemporains, la puissance décorative du style de Chenavard entraina dans des voies nouvelles toute une génération qui cherchait à sortir des voies stériles du néoclassicisme.' Ennès, 'Aimé Chenavard', p. 267.

101 'veut faire de la renaissance, puisque la renaissance est à la mode'. Ennès, 'Aimé Chenavard', p. 271.

102 Jean-Luc Martinez (ed.), *Les Antiques du Louvre. Une histoire du gout d'Henri IV à Napoléon 1ᵉʳ* (Paris, 2004), p. 140.

103 Ravaisson was then General Inspector of Higher Education and supported the replacement of Roman with Greek sculpture in drawing schools; he went on to become Curator of Ancient Sculpture at the Louvre. Meredith Shedd, 'Phidias in Paris: Félix Ravaisson's *Musée Grec* at the Palais de l'Industrie in 1860', *Gazette des Beaux-Arts* (April 1985): pp. 155–170. His Greek Museum included a copy of the *Borghese Vase*, among others.

104 J. Durm, 'De l'anse des vases antiques', *Magasin des arts et de l'industrie*, no. 2 (1868), p. 17.

105 Alcouffe et al., *Un Age d'Or*, pp. 345–346.

106 Elisabeth Lebon, *Dictionnaire des fondeurs de bronzes d'art, France, 1890–1950* (Perth, 2003).

107 Shedd, 'A Mania for Statuettes', 1992.

108 'Exposition des réductions de tous les chefs-d'œuvre de la Statuaire; plâtre d'art, pour musées, académies, écoles, ateliers, etc. Bronze d'art, pour musées, galeries particulières, &c.' Advertisement dated 1845 in an undated catalogue *Moulage, Ecole royale des beaux-arts, Paris*.

109 Lebrun, *Nouveau manuel complet du Mouleur ou l'art de mouler en plâtre, carton, carton-pierre, carton-cuire, cire, plomb, argile, bois, écaille, corne, etc. etc.* (Paris, 1850), p. 61.

110 Letter from L. Gustini to Barbedienne, 7 March 1870, AN 368.AP.2 Dossier 5.

111 The turnover fell from 137,145,246 francs in 1847 to 34,716,696 francs in 1848. Charles Dupin, *Industries comparées de Paris et de Londres, tableau présenté le 4 janvier 1852 par Le Baron Charles Dupin, dans la séance d'ouverture du cours de géométrie appliquée à l'industrie et aux beaux-arts, au Conservatoire national des arts et métiers* (Paris, 1852), p. 30.

112 Dupin, *Industries comparées*, p. 15.

113 *Exhibition of the Works of Industry of all Nations, 1851. Reports of the Juries on the Subjects of the 36 Classes into which the Exhibition was divided* (London, 1852), p. 550. On the Fourdinois sideboard, see Barry Shifman, 'The Fourdinois Sideboard at the 1851 Great Exhibition', *Apollo* (January 2003): pp. 14–21.

114 Dupin, *Industries comparées*, pp. 4 and 2.

115 Nikolaus Pevsner, *High Victorian Design: A Study of the Exhibits of 1851* (London, 1951), pp. 119–21.

116 This is possibly the one purchased by the Vanderbilts and installed in their New York home. Alice Cooney Frelinghuysen, 'Christian Herter's Decoration of the William H. Vanderbilt House in New York City', *Magazine Antiques* (March 1995): pp. 414–415. It may have been hung as a panel or functioned as a door. A plaster copy, now painted to imitate bronze, is at Vassar College. According to the College's records, this was purchased in 1888–89; the name of the manufacturer is not recorded. I would like to thank Joann Potter for this information.

117 On Jackson and Graham, see Clive Edwards, 'The Firm of Jackson and Graham', *Furniture History*, vol. 34 (1998): pp. 238–265.

118 'C'est là, … une belle application, dans une voie toute nouvelle, du bronze travaillé par la puissance mécanique, à l'ameublement, avec lequel il vient se fondre en quelque sorte, au lieu de se borner à le décorer.' Unreferenced document, 'Barbedienne, classe 24', annotated '1855', Musée d'Orsay Documentation, Barbedienne file.

119 *Great Exhibition of the Works of Industry of All Nations. Official Descriptive and Illustrated Catalogue* (London, 1851), p. 1258.

120 De Caso, 'Serial Sculpture', p. 16.

121 'Ce groupe a été réduit par l'infaillible procédé Collas et, fondu en bronze ou en argent, s'allongera sur le socle de marbre onyx d'une pendule monumentale. Et quoi ! Une pendule ? Allez-vous dire: O profanation ! O sacrilège ! O décadence – Pas du tout. Où est le mal d'apprendre le beau en apprenant l'heure ? – passer du Parthénon sur une cheminée ? Parfaitement. Sous prétexte de respecter l'art, ne le chassons pas de chez nous, et remercions M Barbedienne de l'y faire entrer sous toute forme.' Gautier, 'Une visite chez Barbedienne', pp. 7–8.

122 For a list of commissions for casts of items at the Louvre, by founders, casters and manufacturers, see Florence Rionnet, *L'Atelier du moulage du Musée du Louvre 1794–1928* (Paris, 1996), Appendix 8.

123 Jean-René Gaborit, *Michel-Ange, Les Esclaves* (Paris, c.2004), pp. 53–54.

124 See for example, Antoine Etex, *Cours élémentaires de dessin appliqués à l'architecture, à la sculpture, à la peinture, ainsi qu'à tous les arts industriels, comprenant les éléments de la géométrie, de la perspective, du dessin, de la mécanique, de l'architecture, de la sculpture et de la peinture* (Paris, 1850).

125 On these casts, see John Kenworthy-Browne, 'Plaster casts for the Crystal Palace, Sydenham', *Sculpture Journal*, vol. 15, no. 2 (December 2006): pp. 173–198.

126 *Rapports des délégués des ouvriers parisiens à l'exposition de Londres en 1862 publiés par la commission ouvrière* (Paris, 1862–1864), p. 639.

127 *Exposition de 1865 au Palais de l'industrie / Union centrale des beaux-arts appliqués à l'industrie* (Paris, 1866).

128 Robert Lehr, Joan Jones and Marilyn Karmason, 'Les Majoliques de Minton', *L'Estampille, L'Objet d'Art*, no. 270 (June 1993): pp. 71–82.

129 'style vigoureux', 'Pot à tabac de Denière', *Magasin Pittoresque*, no. 23 (1855), p. 339.

130 Since 1824, the Louvre had housed a collection of nearly a hundred works of French sixteenth-century sculpture, but artists were required to gain authorisation to copy them. De Caso, *Statues de chair*, p. 123.

131 'Composition et exécution en plâtre d'une torchère, femme renaissance vendue en toute propriété sans réserves'; receipt of payment from Barbedienne to Falguière, 1 January 1869, AN 368.AP.2 Dossier 5.

132 As illustrated in *Catalogue des Bronzes d'Art F. Barbedienne* (Paris, 1875), p. 48. as 'Deux femmes debout (port-lumière style Renaissance) par Paul Dubois et Falguière'.

133 On Carpeaux, Rome and Michelangelo, see Wagner, *Carpeaux*, Chapter 4.

134 'De même que le nom de Cellini s'est identifié à l'orfèvrerie, le bronze d'art évoque celui de Barbedienne', Cauchois, 'Notes d'un ciseleur', MSS, p. 29.

135 *Statuts de l'Union centrale des beaux-arts appliqués à l'industrie* (Paris, 1864).

136 '… à propager les connaissances les plus essentielles à l'artiste et à l'ouvrier qui veulent unir le beau à l'utile'; 'des expositions de collections particulières présentant à l'étude de belles applications de l'art à l'industrie'. Ibid., p. 4.

137 Stéphane Laurent, *L'Art Utile. Les écoles d'arts appliqués sous le Second Empire et la Troisième République* (Paris, 1998); Stéphane Laurent, *Les arts appliqués en France. Genèse d'un enseignement* (Paris, 1999). These examine design education reform; one details its theoretical, political, economic and historical context; the other, the genesis and teaching programme of state and independent design schools in Paris and the provinces.

138 Klagmann's actions are summarised in extracts published in *Bulletin de l'Union centrale 1875–1876*, p. 108; and *Bulletin de la Société du progrès 1862*, p. 41. On Klagmann and the reform of design education see Laurent, *Les arts appliqués en France*, pp. 179–186.

139 Combarieu, Heingle and Monjon, 'Sculpteurs-ornemanistes', in *Rapports des délégués des ouvriers parisiens à l'exposition de Londres en 1862 publiés par la commission ouvrière* (Paris and Chabaud, 1862–1864), pp. 471–486.

140 Laurent, *Les arts appliqués en France*, p. 180.

141 The state acquired Combrieu's submission for the Prix de Rome in 1864 for 15,000 francs, and he exhibited at the Salon from 1868 although he never received a medal. Ill and discouraged, he committed suicide in 1884. Lami, *Dictionnaire des sculpteurs, A–C*, pp. 411–412.

142 'Nous ne chercherons pas à prouver que Phidias ciselait de petits bijoux pour se délasser des colosses admirables qu'il exécutait, ni que Callimaque a inventé le chapiteau corinthien; peut-être que plusieurs générations ont apporté chacune, non pas leur pierre, mais leur feuille à cet édifice.' Combarieu, Heingle and Monjon, 'Sculpteurs-ornemanistes', p. 471.

143 'En continuant ce malencontreux système, on a vu surgir le sculpteur des cheveux et du nez, et le reste, souvent sacrifié comme étant d'une importante secondaire, devint le lot d'un autre spécialiste, de l'ornemaniste de nos jours, lequel à son tour subdivisa le travail et créa des spécialités dans sa spécialité. Remarquons, en passant, que la spécialité peut faire plus vite, mais jamais mieux, et elle ne sert qu'à briser cette unité des conceptions et d'exécution qui imprimait un cachet si particulier aux œuvres des anciens.' Combarieu, Heingle and Monjon, 'Sculpteurs-ornemanistes', p. 473.

144 'C'est à Klagmann, J. Feuchères, Combettes, Liénard, Auguste Lechesne, etc., dernièrement encore à Constant Sévin et à Pyat, que nous avons dû jusqu'à présent notre supériorité, en fait d'ornementation, sur les autres nations. Dans leurs œuvres, nous trouvons proportions élégamment soutenues, conceptions audacieuses, sentiment, bon goût dans les arrangements, fermeté des silhouettes, dessin pur, recherche incessante d'un genre nouveau: tout nous les désigne comme nos modèles; ils ont prêché l'exemple et ont fait plus pour la décoration artistique que beaucoup d'architectes et d'artistes spéciaux.' Combarieu, Heingle and Monjon, 'Sculpteurs-ornemanistes', p. 473.

145 Lami, *Dictionnaire des sculpteurs, G–M*, pp. 222–225.

146 Lami, *Dictionnaire des sculpteurs, D–F*, p. 364.

147 'Son atelier était rempli d'objets d'art anciens, tableaux, dessins, médailles, meubles, marbres et bronzes, qu'il avait réunis depuis une vingtaine d'années. Amateur passionné, fervent collectionneur, c'est à satisfaire son goût pour les ouvrages des siècles passés qu'il employait tout l'agent que lui rapportaient ses travaux, placement qui, à l'époque, n'avait pas le succès qu'il obtient de nos jours.' Ibid., p. 364.

148 'Quand à la statuaire, nos ornemanistes n'ont aucune idée de ce que, en termes d'atelier, on appelle le *bonhomme* (figure ou figurine), et si, par hasard, ils en introduisent l'ombre d'un dans leurs rinceaux, rien n'y motive son apparition.' Combarieu, Heingle and Monjon, 'Sculpteurs-ornemanistes', p. 474.

149 Ibid., p. 479.

150 Ibid., p. 483.

151 Ibid., p. 483.

152 Ibid., p. 483.

153 'En se bornant à copier servilement les styles connus, on n'est plus *soi*.' Ibid., p. 475.

154 F. Bedigie, C. Legier, E. Solon, Troisvallets père, *Délégations ouvrières à l'exposition universelle de Londres en 1862, rapports sur la céramique des délégués peintres et décorateurs sur porcelaine et des délégués pour les pâtes faïence, porcelaine opaque, gros grès etc.* (Paris, 1863).

155 'Nous regrettons vivement que la manufacture de Sèvres n'ait exposé en porcelaine tendre que des formes anciennes qui ont été copiées depuis longtemps par les fabricants de Saint-Amand-les-Eaux, de Tournay, et même par les fabricants anglais. Nous sommes certains que Sèvres possède des artistes d'un mérite supérieur, qui, nous en sommes convaincus, auraient pu produire des nouveautés. Aussi ne comprenons-nous pas que ses produits n'aient pas pris un autre caractère: ne reproduire que ce qu'on fait nos pères, c'est s'endormir dans la routine; ne pas créer, c'est faire preuve d'inertie.' Bedigie et al, *Délégations ouvrières*, p. 11.

156 'Vœux', Bedigie et al, *Délégations ouvrières*, p. 23.

157 Taylor quoted in John B. Waring, *Masterpieces of Industrial Art and Sculpture at the International Exhibition, 1862* (London, 1863), vol. 3, text accompanying Pl. 276, 'Bronzes by Deniére fils'.

158 'Nous ne croyons pas nous tromper en disant que nous aurions toujours en France les meilleurs sculpteurs s'ils y gagnaient de quoi vivre et étudier; mais si la mesquinerie, l'économie mal entendue des uns, l'avidité des autres, leur refusent le nécessaire, ils iront exécuter ailleurs les objets artistiques et de goût dont la vente rapporte au commerce parisien des millions si facilement gagnés, qu'il perdra alors; et tout le monde regrettera, mais trop tard, de nous voir descendre au second ou au troisième rang, quand, au moyen de quelques francs, il était si facile de rester au premier.' Combarieu, Heingle and Monjon, 'Sculpteurs-ornemanistes', pp. 485–6.

159 Arnould Desvernay (ed.), *Rapports des délégations ouvrières, contenant l'origine et l'histoire des diverses professions, l'appréciation des objets exposés, la comparaison des arts et des industries en France et à l'étranger: ouvrage contenant 100 rapports rédigés par 315 délégué… Exposition universelle de 1867 à Paris* (Paris, 1868), 3 vols..

160 'L'origine et l'histoire des diverses professions, l'appréciation des objets exposés, la comparaison des arts et des industries en France et à l'étranger, l'exposé des vœux et besoins de la classe laborieuse, et l'ensemble des considérations sociales intéressant les ouvriers.' Desvernay, *Rapports des délégations ouvrières 1867*, p. 1.

161 Lami, *Dictionnaire des Sculpteurs, D–F*, p. 134.

162 'Ce n'est guère que de 1835 à 1840 que la sculpture d'ornementation prit plus d'essor, en secouant la routine dans laquelle elle s'était traie jusque-là.' Porlie, Vigoureux, Antony Debon, Demessirejean, Bertheux and Lege fils, 'Rapport des sculpteurs' in Desvernay, *Rapports des délégations ouvrières 1867*, p. 2.

163 'par l'heureux choix du style Renaissance'. Ibid., p. 2.

164 'De la condition matérielle et morale des ouvriers sculpteurs et des différents moyens de l'améliorer.' Ibid., p. 8.

165 'Chez Jules Allard fils et Chopin, de Paris, nous avons remarqué deux grandes torchères composées d'une bacchante et d'une faune soutenant un enfant. L'ensemble s'arrange bien; l'exécution, due à M Combarieux (ainé), d'après les modèles de Party, en est souple et modelée. Le bas-relief de gibier faisant partie d'un dressoir est aussi une bonne sculpture, exécutée par Ligeret d'après le modèle de Arson. Pour ce qui est de la console en tilleul, style Louis XVI, certaines parties ne manquent pas de qualités; telles sont par exemple: les petites cariatides formant pieds sur le premier plan …; mais on n'a pas tenu assez compte des repos si nécessaires en décoration; il semblerait aussi que cette console ait été conçue par détails, vu le peu d'ensemble de la composition.' Ibid., p. 2.

166 Ibid., pp. 10–11.

167 'Prenant de jour en jour une plus grande extension.' Ibid., p. 13.

168 AN 368.AP.2.3.

169 'Le sculpteur y déclarait qu'il devait son pain, et sa délivrance à la misère à M Barbedienne. Il faut admettre que la logique des faits était fort en faveur de M Barbedienne.' 'La route de l'Art', December 1866, MSS, AN 368.AP.2 Dossier 3.

170 The following details are taken from Porlie et al, 'Rapport des sculpteurs', pp. 14–15.

171 '… qui occupe la première place d'abord en venant en aide à l'exécution pour le bois, le marbre ou la pierre, ensuite parce qu'il est reproduit directement par toutes les matières qui nécessitent un surmoulage. Pour cette partie de la sculpture, le salaire du travail personnel est très variable; les modeleurs qui savent composer des ornements mélangés de figures et d'animaux, sur une architecture ou toute autre forme déterminée, peuvent gagner de 5 à 6,000 francs par an; le nombre de ces artistes est très restreint; dans la série qui vient ensuite, le salaire tombe à 3,500 fr, c'est dans cette série que se recrute la classe supérieure, les premières mains dans leur spécialité; au-dessous de cette classe, quelques-uns, par leur habileté à bien réparer le plâtre, gagnent une journée de 8 à 10 fr, mais la moyenne est de 5 à 7fr, et comme le travail est intermittent, le gain se réduit à 1,000 à 1,500 fr par an.' Ibid., pp. 14–15

172 Emile Chevallier, *Les salaires au XIXe siècle* (Paris, 1887), p. 42. These wages were around two francs less in the provinces.

173 Pierre du Maroussem, 'Ebéniste Parisien de Haut Luxe (Seine – France), ouvrier journalier, dans le système des engagements momentanés, d'après les renseignements recueillis sur les lieux, en janvier et février 1891', in la Société d'Economie Sociale, *Les ouvriers des deux mondes*, 2 ser., vol. 4 (Paris, 1892), pp. 64–65. This detailed anthropological study notes that an *armoire sculptée* (wardrobe with sculptural elements) at the father's firm sold for 70,000 francs. Between 1857 and 1892 the Society published 78 studies of working families.

174 Du Maroussem, 'Ebéniste Parisien', p. 62.

175 'L'article 1781 du Code civil, qui dit que, dans toute question de salaire entre l'ouvrier et le patron, ce dernier est cru sur sa parole.' Ibid., p. 13.

176 Porlie et al, 'Rapport des sculpteurs', p. 15.

177 In the provinces *sculpteurs-ornemanistes* earnt 4.95 francs although Chevallier notes that they were already highly paid. Chevallier, *Les salaires*, p. 45.

178 Chevallier, *Les salaires*, p. 47.

179 Porlie et al, 'Rapport des sculpteurs', p. 17.

180 Ibid., p. 19.

181 Laurent, *Les Arts appliqués*, p. 183.

182 Porlie et al, 'Rapport des sculpteurs', p. 19.

183 'Pourquoi vos modèles de principes ne seraient-ils pas des sujets décoratifs atteignant le but qu'on se propose: l'arrangement, le goût?'. Ibid., p. 20.

184 'De là surgissent des statuaires dont l'administration est très-embarrassée et qui végètent; et nos fabricants ou décorateurs, quand les travaux marchent (surtout aux veilles d'expositions), cherchent vainement des modeleurs d'ornements et des *arrangeurs* décoratifs capables.' Ibid., p. 18.

185 'Elle s'y étiolerait bien vite. Il faut que l'art décoratif et industriel soit indépendant, qu'il fleurisse en suivant une ligne parallèle au grand art, sans qu'il soit entraîné par lui dans une route qui le ferait dévier. ... nous voudrions, aux époques des expositions annuelles, voir une section de l'art appliqué à l'industrie.' Ibid., p. 19.

186 Victor Champier, 'Les Artistes de l'industrie. Constant Sévin', *Revue des Arts Décoratifs* (February 1889): pp. 161–176.

187 'Il parlait de son art avec une passion exubérante et bruyante, mais avec tendresse, sur un ton contenu, d'une façon nette et précise, jugeant sans méchanceté ni jalousie les hommes et les œuvres, jamais banal en ses appréciations, ayant des vues à lui et très arrêtées. Comme il nous parlait de ce petit monde si peu ou si mal connu des artistes de l'industrie qu'il avait fréquenté depuis sa première jeunesse, nous lui demandâmes s'il consentirait à nous fournir sur ce sujet si intéressant quelques notes que nous songions vaguement à utiliser pour un livre qu'un jour ou l'autre peut-être nous nous déciderons à publier.' Champier, 'Constant Sévin', p. 166.

188 *The Second Empire*, p. 126.

189 Lami, *Dictionnaire des Sculpteurs, G–M*, p. 393.

190 Champier, 'Constant Sévin', p. 170.

191 Champier, 'Constant Sévin', p. 170. On Buhot, see Lami, *Dictionnaire des Sculpteurs, A–C*, p. 214.

192 Olivier Gabet,. 'French Cabinet Makers and England, the Case of the Maison Fourdinois (1835–85), *Apollo*, vol. 155, no. 479 (January 2002), p. 26.

193 *The Second Empire*, p. 166.

194 'Les brouillards de la Tamise n'ont pas la réputation d'être longtemps séduisants pour nos yeux français qui aiment la claire lumière et le gai soleil. Constant Sévin pris la nostalgie de Paris.' Champier, 'Constant Sévin', p. 171.

195 AN 368.AP.4, Sévin file. For the full text, see Appendix 1.

196 'Sa [Sévin] bonne étoile l'a conduit au chef inespéré qui, sacrifiant toute considération d'argent à l'unique souci de faire des chefs-d'œuvre, ne lui refuse rien de ce qui peut lui permettre de réaliser ses moindres rêves d'artiste: il le sait, le comprend, et ne songe plus désormais qu'à donner pleine carrière à son imagination. Lui faut-il de l'or, des diamants, des pierres précieuses pour exécuter ce qu'il désire, il s'inquiète moins de contenir les fantaisies coûteuses de l'artiste que des perfectionnements qu'elles peuvent comporter pour atteindre l'idéal entrevu. Lui plaît-il de faire un meuble? A-t-il l'idée de quelque cheminée monumentale où la splendeur du marbre se mariera aux harmonies ardentes des bronzes ciselés et des plaques d'émail peint? S'agit-il d'une torchère, ou bien de cabinets dont le décor féerique rivalisera d'éclat et de richesse avec les merveilles de la Perse ou de l'Inde? Constant Sévin n'a qu'à parler: ce n'est pas M. Barbedienne qui arrêtera son collaborateur dans cette voie de tentatives ''coûteuses'' du moment que l'art est le but, et qu'il est question de s'élever toujours plus haut pour atteindre la beauté. La matière? Il se la procure coûte que coûte. Les ouvriers? Il les découvre et va les chercher parmi les meilleurs, ou bien il les forme. Les ateliers? Il les installe, les dirige, les maintient sous une impulsion méthodique et volontaire dans la voie de la perfection où une force intérieure le pousse lui-même.' Champier, 'Constant Sévin', pp. 172–173.

197 'De recherches, d'invention, de travail et de goût', Lucien Falize, 'Les Bronzes', in Louis Gonse (ed.), *Exposition universelle de 1878, les beaux-arts et les arts décoratif, vol. 1: L'Art moderne* (Paris, 1879), p. 362.

198 See, for example, *Catalogue des meubles d'art anciens et modernes en bois sculpté et en marqueterie ... le tout appartenant à M. Fourdinois: Vente à Paris, Hôtel Drouot les 24 et 25 janvier 1887 (Paris, 1887).*

199 '... quelques-unes de ces pièces superbes par lesquelles la corporation a tenu à prouver la vitalité de notre génie artistique et de notre industrie? Quelles sont les pièces d'ébénisterie entrées au Mobilier national? La réponse, hélas! n'exige point une longue enquête; elle est négative sur tous les points.' Henri Fourdinois, *Etude économique et sociale sur l'ameublement* (Paris, 1894), pp. 23–24.

200 'Ah! madame, si j'attendais les commandes, je ne les exécuterais jamais, ces œuvres! Ce qu'il faut,
 c'est devancer les désirs des amateurs.' Champier, 'Constant Sévin', p. 173.

201 'Voyez-vous, nous disait Constant Sévin, je ne puis m'intéresser aux choses que quand elles
 prennent corps, quand elles deviennent matière. Le dessin pour le dessin, cela n'a plus de
 charme pour moi. Mettre sur le papier, avec de jolis effets de plume ou de crayon, des objets
 méticuleusement fignolés, je l'avoue, cela ne m'intéresse. Mais ce qui me ravit, ce qui me procure
 une véritable griserie, c'est de créer, de créer, entendez-vous, en une forme palpable des choses qui
 sortent de mon imagination à l'état de rêve et que je revêts de tout ce que la nature nous offre de
 plus rare et de plus précieux; l'or, l'argent, les pierres fines, les marbres aux tons radieux, et l'émail,
 oh! l'émail surtout, ce seul terreux changé en diamant par la fournaise, et qui vient docilement, à
 mon caprice, s'incorporer à l'endroit que je souhaite de mon œuvre, et la faire resplendir!'. Ibid.,
 p. 173.

202 'Je n'ai pas été absolument satisfait du petit guéridon où se trouvent les figures de J Goujon.
 Je voulais vous en parler. Le temps ne m'a permis de le faire, voici ma critique: tous les détails
 sont jolis élégants, mais l'ensemble est vide et sans homogénéité. Comme vous le dites, l'envers
 des bas-reliefs n'est pas agréable. Mais à mon avis, ce n'est pas seulement pour la nudité mais
 pour l'isolement qu'ils ne font pas bien. Ne pourriez-vous, à l'aide d'une nouvelle combinaison
 de lignes rapporter ces bas-reliefs au centre du guéridon en les adornant triangulairement de
 façon à ce que entre chaque pied on ne puisse en voir qu'un seul. Vous feriez un ornement fin
 pour le dessous et nous arriverons, selon moi, à un petit meuble plus original. L'ornement qui
 sert d'encadrement aux bas-reliefs devrait être modifié en cela qu'il devra être très léger, ajouré
 peut- être, et posé sur les pointes du triangle formé par les bas-reliefs réduits à leur plus simple
 expression.' Undated letter from Ferdinand Barbedienne to Constant Sévin, AN 368.AP.1 Dossier
 10.

203 See for example no. 381 'Pendule Louis XV à deux enfants (Klagmann) and no. 390 'Pendule Louis
 XIV (modèle ancien) in *450 modèles en bronze* (1876).

204 On the mirror, see Alfred Darcel, 'Exposition universelle: bronze et fonte modernes', *Gazette des
 Beaux-Arts*, no. 23 (November 1867), p. 425; *The Art Journal of the Paris International Exhibition 1867*
 (London, 1867), p. 172; Clive Wainwright, 'A Barbedienne Mirror. Reflections on Nineteenth-
 Century Cross-Channel Taste', *National Art Collections Fund Annual Review* (1992), pp. 86–90.

205 *The Art Journal of the Paris International Exhibition 1867*, p. 172.

206 'On peut dire de M. Constant Sévin, sculpteur ornemaniste, que l'histoire future du travail
 mentionnera ses compositions. L'art grec est la base de ses croyances et la règle première de ses
 études; et, lorsqu'il se laisse aller à d'autres inspirations, soit dans le genre Renaissance, soit dans
 le genre Louis XVI, son style reste sobre et pur. Là sa connaissance de toutes les ornementations
 antiques et modernes est profonde. Il a pu mener à bonne fin des compositions chinoises,
 hindoues, persanes, byzantines, mauresques, gothiques, au point que des connaisseurs se
 méprennent sur leur origine; c'est, de plus, l'un des rares artistes qui se préoccupent des qualités
 décoratives propres et particulières à chacune des matières qu'il met en œuvre.' Ferdinand
 Barbedienne, 'Classe 22, bronzes d'art, fontes d'art diverses, objets en métaux repoussés',
 Exposition Universelle de 1867, Rapport du jury international (Paris, 1867), pp. 309–310.

207 Champier, 'Constant Sévin', p. 174; *The Second Empire*, p. 126.

Decorative Sculpture and the Third Republic, 1870–1889

Sculptors and the State in the 1870s

In 1870 the Second Empire collapsed following an unsuccessful war against Prussia, and was replaced by a provisional government that became known as the Third Republic. Paris was particularly affected by the war, firstly while it was under siege from the Prussians (September 1870 to January 1871), then during the short-lived Paris Commune (March to May 1871) when its citizens refused to acknowledge the capitulation to the Prussians and operated independently from the provisional government established at Versailles. Parisians suffered again in the violent repression of the Commune, as the government, aided by the Prussians, gained control of Paris. This claimed perhaps a quarter of Paris's working class population. Prominent Communards such as the painter Gustave Courbet and the sculptor Aimé-Jules Dalou fled into exile, and did not return until after the amnesty of 1879.[1] Others avoided the conflict by working abroad, as in the case of Carrier-Belleuse who relocated to Belgium in 1870, where his assistant, Rodin, joined him in 1871.[2]

These political conflicts had a predictably detrimental effect on the Parisian luxury goods industries. The market was depleted, and workshops and retail outlets destroyed.[3] The workforce was reduced through loss of life, imprisonment, conscription, and temporary or permanent movement abroad. As a result, France was poorly represented at the International Exhibition in London in 1871, which opened on 1 May.[4] This was three weeks before the Paris Commune was suppressed, and only three months after the siege of Paris had ended. Given the political, logistical and economic barriers to transporting goods from Paris to London, *The Art Journal* suggested that French residents in England should be permitted to 'show any articles in their possession illustrative of their national industry'.[5] Manufacturers who had London representatives were least affected as they already had products in

London. Barbedienne, who sold through Jackson and Graham, was noted as 'a large contributor' to the exhibition.[6]

Despite having to function within a volatile political period, a French art market of sorts continued to operate. At the outbreak of the Franco-Prussian war in 1870 the dealer Paul Durand-Ruel relocated to London, where he introduced painters such as Claude Monet and Camille Pissarro to an English audience.[7] After the fall of the Commune on 28 May, some entrepreneurs and sculptors quickly took advantage of the reopened transport networks. They sent sculpture directly to London for sale in a bid to attract potential buyers attending the International Exhibition. In June, a C. de Marnihac rented the lower gallery at the Royal Institute of British Architects for a selling exhibition of 'French marbles, bronzes, terra-cottas, and other works of Art', including several by Barbedienne and Clésinger.[8] In November, Carrier-Belleuse offered over a hundred of his works at Christie's.[9] This made £219, 7s before commission; the primary lots, fourteen original terracotta and plaster models for sale with copyright, were unsold.[10]

Back in France, changes to the institutional organisation of art were instigated, firstly by the Commune and then by the Third Republic. During the Commune, the short-lived Federation of Artists, led by its President, Courbet, sought to democratise systems of purchase, competition and education within the arts.[11] Its exhibitions policy specifically addressed the concerns of artists regarding their relationship with manufacturers. It stipulated that exhibitions should only admit works signed by its author, and rejected 'absolutely, all mercantile exhibitions which substitute the name of an editor or a manufacturer for that of the genuine creator'.[12] This reflected concerns by sculptors regarding copyright and authorship within industrial art.

The Commune was, however, short lived, and the new Third Republic centralised its control over the arts through the creation of the Department of Fine Arts in 1870.[13] This comprised five departments: fine art, historic monuments, national manufactories, theatre and public finance. This chapter in part considers the Department of Art's role in the national manufactories, specifically in terms of the revival of sculpture at Sèvres, which was a significant factor in Rodin's burgeoning fine art career during the 1880s.[14] I suggest that institutional sculpture was not as stagnant as has been supposed in the 1870s, as Sèvres presented an important site for sculptural creativity. Unlike the Salon, where sculptors exhibited their self-financed works in the hope of receiving a state commission, at Sèvres sculptors received an hourly wage for their work, which for externally sourced sculptors such as Rodin and Desbois was predominantly research-led. Innovation was pivotal to maintaining market lead, and Sèvres was financially dependent on commercial sales and state subsidies for its survival.

Despite increasing state intervention in the arts, the legal position of sculptors saw little improvement under the Third Republic. In 1878 two

international congresses on copyright addressed the separate interests of artists and industry.[15] The International Congress on Artistic Copyright supported the exclusive right of artists to the reproduction, execution and representation of their work, 'whatever the nature or the importance of the work and whatever its mode of reproduction, execution or representation'.[16] It established that the greatest threat to an artist's rights came from industry through the reproduction or imitation of a work of art by a different artist and the false use of an artist's name.[17] The International Congress on Industrial Property neither affirmed nor denied the rights of artists; it simply placed the responsibility of asserting authorship on the artist. An artist could only benefit from legal protection if he registered his drawings and models.[18] Copyright and authorship therefore remained problematic issues for sculptors involved in industry during the first decades of the Third Republic. This in part could account for their increasing association with the State during this period, and their formation of independent societies such as L'Art dans Tout in the 1890s.

Carrier-Belleuse and the Revival of Sculpture in Ceramics, 1875–1887

Sèvres was established under royal patronage in 1738 at Vincennes, and under Louis XV was transferred to a new site at Sèvres, operational from 1756. It has survived subsequent changes in French political rule, being renamed the imperial, royal and national manufactory, accordingly. In 1871, less than a month after the fall of the Paris Commune and shortly after the demise of the Second Empire, a government-printed pamphlet posed the question, 'Should the State maintain or disband the national manufactories?'.[19] The main arguments against were cost and unfair competition to private industry.[20] Between 1848 and 1870 Sèvres received an annual budget of 588,000 francs and raised around 100,000 francs annually from sales; and it was not exempt from receiving awards at national and international exhibitions despite its advantages over private manufacturers. Its defenders emphasised the creative importance of Sèvres to the French ceramic industry as a whole. It had the resources to develop new designs, techniques and materials, which in principle were available to private industry for consultation or purchase.[21]

The new Third Republic supported the state manufactories as creatively significant to France's international economic success. In 1870 they were incorporated within the new Department of Fine Arts, and in 1872 the Director of Fine Arts established a commission 'to supervise the artistic works at Sèvres and to give it a direction progressive and worthy of its past'.[22] Five members were elected to meet quarterly to 'examine and appreciate from the point of view of art, the ceramic works executed by Sèvres'.[23] Its membership did not initially include a sculptor, although this was soon remedied with the appointment of Eugène Guillaume, Director of the Ecole des beaux-arts (1864–

1878).[24] The Commission examined works then in production at Sèvres, and on 19 March 1874 reported on areas which it thought should be suppressed or encouraged. It identified sculpture as a particular area for concern:

> [T]he Commission recognised that sculpture is in a state of notorious inadequacy. It is almost absent and seems to have been abandoned. As proof of this art, which can play a large role in ceramics, we can only cite a few handles, heads and other indispensable appendages. Two models for biscuit, the only two presented to the Commission, were so weak, that it felt it embarrassing to critique them. Today there is a complete absence of those compositions where the marriage of sculpture and coloration offer charming decorative combinations. The only ones which exist are those which date from twenty years ago and to which we owe the talent of Klagmann, under the direction of Dieterle. Today they are relegated to the antechambers like witnesses of an abandoned art. It seems that we have renounced the fight against the varied products of Minton … Assuredly we do not lack the artistic elements to engage in this battle. We possess a great number of talented sculptors. The English know it well, and it is with us that they recruit distinguished artists who furnish them with the means by which they owe their superiority. One of the colleagues of the Commission can furnish the proof … It is time to come to the aid of sculpture; there is much to be done to raise it up and put it in a state ready to contribute to the revival of ceramics.[25]

These are strong words, in which the decorative arts are appropriated into the State's nationalist and militarist rhetoric against foreign, specifically British, competition. The failure of Sèvres to appreciate and exploit the contribution of French artists to the ceramic industry in the 'last twenty years' is a reference to the 1848 Revolution, which had lost sculptors including Carrier-Belleuse and Pierre-Emile Jeannest to Minton's in England, and a critique of the perceived broader shortcomings of the defunct Second Empire. The reference to a 'colleague' of the Commission who can 'furnish proof of this' suggests an early contribution by Carrier-Belleuse to the development of artistic policy at Sèvres. Carrier-Belleuse was appointed as a member of the Commission in 1874 when its membership was extended to thirteen.[26] This occurred under the new Director of Fine Arts, Charles-Philippe de Chennevières, who placed great importance on the economic benefits of art to industry:

> In the present direction of the fine arts, the government, in common interest with the Ecole des beaux-arts, considers itself the intermediary between the arts of painting, sculpture, architecture, and the industrial arts. It is our responsibility in this important affair to see to it that art has a productive influence on national industry.[27]

In 1875 the Commission created a new Department of Works of Art at Sèvres and appointed Carrier-Belleuse its Director on a salary of 4,000 francs a year.[28] No documentation survives as to the reasons for Carrier-Belleuse's appointment.[29] However, given his achievements in the fine and industrial

arts at home and abroad, his management experience within his own highly successful sculptural enterprise, and his familiarity with modelling for ceramics, notably at Minton's where he had also directed a design school, he would seem the obvious choice.[30] As one critic noted in 1865, '[h]e is almost a sculpture machine … but how much spirit, imagination and verve this machine has! At times one might almost say he is a genius'.[31] He was also, like Rodin, not implicated in the Paris Commune, as he was working in Belgium during the tumultuous events of 1870 and 1871.[32]

Carrier-Belleuse was presumably also chosen because he was so adept at working within a broad range of materials, forms, applications and styles, taking 'inspiration from the great decorative schools, the Italian school, the Rouen school, the Japanese school, the Moorish and Persian schools'.[33] This knowledge base and experience was essential to Sèvres as it produced a wide catalogue of works, from table services created from relatively simple moulds to elaborate clock cases incorporating extensive figurative modelling. Carrier-Belleuse's particular interest in eighteenth-century sculptural precedents may also have especially appealed to Sèvres, as the firm's reputation was partly built on the result of its collaborations with sculptors such as Falconet and Clodion. Carrier-Belleuse had developed an aesthetic sensibility closely related to Clodion's own work. He similarly worked extensively in terracotta; explored themes of love through representations of women, babies and children; inclined towards the Rococo style; and extended his sculpture practice to incorporate ceramics. While the Goncourt brothers regarded the connection between Carrier-Belleuse and Clodion with derision, describing Carrier-Belleuse in 1867 as a 'banal sculptor', a 'cheap junk maker of the nineteenth century, this copier of Clodion', for Sèvres this association was seen as a positive attribute, and deeply resonant to the firm's history.[34] Carrier-Belleuse's Clodionesque style and his status and outlook as a sculptor, represented a continuation of eighteenth-century approaches to sculpture and the decorative at Sèvres. He was well placed to renew the historic connection between sculpture and ceramics at Sèvres, creating new forms that would revitalise the manufactory, both in terms of models that could be serially reproduced, and elaborate, complex and distinctive 'exhibition' pieces.

Carrier-Belleuse took up his post on 1 January 1876.[35] His remit was to oversee all works of art executed at the manufactory and to direct its schools. However, while it has perhaps been assumed that the position was full time, Carrier-Belleuse evidently maintained his private sculpture practice concurrently with his employment at Sèvres. The financial and creative incentives offered him by the Commission suggest that he was not as committed to the manufactory as they would have hoped. The 1875 decree did not specify hours but in 1881 he was asked to dedicate a full day on Monday in addition to his usual Wednesday and Friday mornings.

This additional half day 'will allow you to follow more closely the works in progress and to let nothing escape your critique'.[36] As an incentive, his wage was to be increased to 6,000 francs if he dedicated more of his time to his work at Sèvres, and a new studio was created for him, where he 'would have all the facilities for studying and perfecting the new models' required of him by the manufactory.[37] While this might seem to align with wages for highly skilled modellers (up to 6,000 francs a year for those who could execute ornamental, animalier and figurative sculpture) Carrier-Belleuse was, however, working on a part-time basis.[38] In 1883 the administrator requested that he extend the two days he spent in the workshops to a third day directing the school.[39] This was to include frequent lectures in its museum as well as critiques of the students' work with reasons for corrections.

The Commission appointed a sculptor, as opposed to a painter, as its Director of Works of Art, because it believed that sculpture was the most potentially valuable of all the arts to Sèvres's revival. It condemned what it saw as 'troubling' elements in painted decoration, notably the use of perspective (which should be reserved for genre painting) and the transposition of a design intended for a plane to a curved surface.[40] During the early to mid-nineteenth century painted decoration dominated production, notably as propaganda for successive heads of state and as copies of historic and contemporary paintings. Now, artists were no longer to be bound by artificially imposed frames or to imitate paintings on canvas; 'in one word, the artist seems to ignore that a vase, like a monument, has a decorative architecture'.[41] The Commission considered sculpture to be particularly suited to the development of a new aesthetic at Sèvres:

> As regards large decorative pieces, there is a large field open to a diverse range of compositions: it is an order of creation where artists can let their imaginations run wild. It is here that all the decorators' qualities should shine; everything is permitted, liberty, originality, even audacity, and if they are nourished on the memories of the great periods of art, if, penetrating their beauty, they have the force to extract their own originality, they can create a quantity of very interesting decorative pieces. It is at that moment that they should look largely to sculpture for assistance … .[42]

That the Commission, and therefore the State, encouraged artistic freedom and experimentation at Sèvres runs counter to the art historical understanding of sculpture during this period, in which creativity is seen to have been stifled by government intervention and harnessed as a political medium.[43] For example, in 1872 new rules at the Ecole des beaux-arts 'rigorously proscribed modern subjects and those who wanted to depict contemporary life had to do so allegorically'.[44] By 1879, the poet and art critic Joris-Karl Huysmans was criticising fine art sculpture for its lack of progress, as evidenced in the recent Salon:

[E]ither sculpture can acclimatise itself to modern life or it cannot. If it can, it needs to address present-day subjects ... [if it cannot] then sculptors will have to content themselves with being 'ornemanistes' and they should not encumber the art Salon with their products![45]

While the art historian Albert Boime has rightly identified the decorative arts as 'one trend in the period that promoted sculptural experimentation', he suggests that this operated outside the parameters of state art policy, exclusively within the commercial art world.[46] Sèvres presents a specific, and positive, area of state intervention in support of sculpture, in both a commercial and artistic context.

Although appointed as Director of Works of Art in 1876, it was not until 1878 that Carrier-Belleuse's first model for a vase, *Cylindroïde Vase*, was approved for production by the Commission.[47] Change took time, as the following letter from the manufactory to the Director of Fine Arts had noted in 1872, '*unfortunately, in ceramics, patience is a virtue of the first order*'.[48] It took five or six months to create a plaster model for a new form of vase. At least a year was required to produce a sufficient number of works to suggest 'a new aesthetic path'.[49] Carrier-Belleuse modelled two types of vases for Sèvres: those that presented 'vast opportunities for decoration according to the inspiration of the decorators' and more sculptural pieces which, 'by the addition of modelled figures, sculpted handles and motifs in relief [would] totally modify the appearance of Sèvres products'.[50] As Carrier-Belleuse's biographer, Saint-Juirs, notes, both types of vases had to withstand scrutiny as independent forms, irrespective of their later applied decoration:

> The piece of porcelain must be of artistic interest, by itself, by its form, without mentioning its colour, which only comes after. I am convinced that Mr Carrier-Belleuse shares these ideas. He wants the plaster model of a piece of the manufacture of Sèvres to already be a masterpiece ... With him, we can expect surprises and marvels.[51]

Carrier-Belleuse's vase form *Saigon Vase* was approved for production in 1879. It followed the Commission's recommendation that above all, 'decoration should always respect the form of the decorated piece' by creating a large smooth area for the subsequent artist to work on.[52] The Commission favoured colour and relief, in imitation of Chinese celadon vases, rather than painted scenes.[53] The simplicity of the *Saigon Vase* with its large, barely curved body, short neck and almost imperceptible base, is clearly based on Chinese models and was a departure from the more architectural vases of the Second Empire. These were on the whole more bulbous, with a more defined division between neck, foot and body, the base often turned, on a square foot, decorated with a strong, uniform colour, with framed, painted panels to the front and rear, and mounted with gilt bronze handles or bases.

The design of the *Saigon Vase* presented a more easily reproducible form than its Second Empire counterpart, necessitating a simple two-part plaster mould rather than separate moulds for body, neck and base. This also removed the necessity for gilt bronze mounts, which were an important feature of eighteenth and early nineteenth-century ceramic production at Sèvres.[54] Ceramic vases, particularly monumental versions, are often created in sections, which are then attached together with slip before firing or by gilt bronze bands after firing, producing the illusion that the vase is moulded as a single piece. The Commission was aware that gilt bronze mounts were often applied to hide structural faults and that this was damaging Sèvres's reputation as a purveyor of high quality products.[55] In 1871, Sèvres's metal chasing and mounting workshops were closed.[56] Carrier-Belleuse's new models largely removed handles from vases, focusing on the ceramic body itself. When he did incorporate them, they were made of ceramic, not gilt bronze, thus highlighting Sèvres's specific remit and skills.

The *Saigon Vase* was produced in a number of versions, with or without a lid, and ornamented with or without the following: lion's heads, snail, rosette, water lily, frog or tortoise. These smaller elements could be produced in separate moulds and applied directly to the vase, rather than necessitating entirely new moulds for each version. Its small scale (at either 25 or 35 cm high) also required less time to complete than a larger model, and was more suitable for the domestic interior than its monumental counterpart. The vase has no perceptible front or back and thus supports the application of decoration over its entire surface.

In 1879, the same year as the *Saigon Vase* was approved for production, Carrier-Belleuse employed Rodin and Desbois to develop new forms of decoration at Sèvres.[57] This followed requests by the manufactory's new Administrator, Charles Lauth, for an update on the appointment of fresh talent:

> [You said that you would send me] the dossiers related to your young artists; I am very desirous to see new blood at our manufactory, it only depends on you that this should be soon.[58]

Unusually for Sèvres, which generally employed permanent staff, Rodin and Desbois were classified as 'external' staff. This meant that they were commissioned to work on specific projects and paid on an hourly basis, and were thus free to pursue work independently of the factory. The fact that their appointment took place three years into Carrier-Belleuse's tenure might suggest some hesitancy on the latter's part to source new artists. However, he was faced with two problems. Firstly, the difficulty of recruiting and maintaining staff, who were 'finding more attractive opportunities elsewhere'.[59] In 1879 *sculpteurs*, *décorateurs* and *modeleurs* at

Sèvres earnt between 1,000 and 1,400 francs annually; by 1887 this rose to between 3,400 and 5,800 francs.[60] Secondly, as we have seen, it took time to create new forms for these artists to decorate. Lauth's impatience might also have been the result of pressure from the new Under Secretary of Fine Arts, Edmond Turquet.[61] Turquet had a personal interest in sculpture, and under his direction the State's sculpture budget was increased from 210,800 francs in 1878 to 534,070 francs, reaching an average annual level of over 500,000 francs in the 1880s.[62] The broad remit of the Department of Fine Arts would also facilitate Rodin's fine art sculpture career, as he made Turquet's acquaintance through colleagues at Sèvres. Turquet was to commission *The Gates of Hell* in 1880.

To decorate the *Saigon Vase*, Rodin and Desbois favoured the method of direct engraving. This technique was a new departure for Sèvres, which had previously favoured painted decoration. While it has been suggested that this was the result of the sculptors' own experimentations and inventions, the form of decoration and its subject matter were in fact the result of detailed recommendations made by the manufactory's Commission.[63] In 1875 the Commission noted that 'directly engraving ornaments into the clay' would not only give the artist freedom to create an original work but would also reduce costs as the technique did not require a design.[64] The method integrates both composition and execution and, while this can keep costs down, it also requires an artist skilled in both areas. It is more suited to a sculptor or an engraver than a painter as it involves creating an inverted relief sculpture freehand, by incising wet clay. The effect is based on a subtle interplay of light and shade. An example by Rodin (Fig. 2.1) depicts a naked mermaid, viewed from the back. The outer contours of her body are delineated with an incised line, as is the division between her buttocks; her skin and musculature are suggested by shallow gradations in the surface of the clay. Her tail is hardly visible; rather, the mythological subject matter is a vehicle for the depiction of the naked female form. The figure is viewed from the back, reminiscent of Jean-Auguste-Dominique Ingres's *Grande Odalisque* of 1814. She stretches upwards, as if uncoiling, her hair pinned up in a chignon, recalling contemporary representations of women at their toilette.

In 1880 Rodin designed and executed decoration for a further new model by Carrier-Belleuse, the Pompeii vase. In *La Nuit* (c.1880) (Fig. 2.2), Rodin depicts a more traditional female figure in the manner of Sandro Botticelli's *Birth of Venus* (1478), standing upright in contrapposto and viewed from the front. She holds an infant in her arms, reflecting the Third Republic's representation of women as mothers. For this vase Rodin employed a second technique for relief decoration, known as pâte-sur-pâte.[65] Pâte-sur-pâte is a highly specialized, time consuming and expensive form of ceramic decoration. Because of this, it is generally reserved for the high status form of the vase.

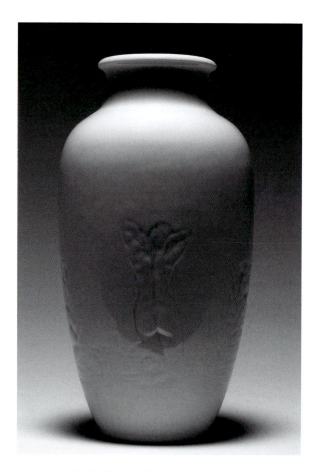

2.1 Manufacture nationale de Sèvres, Albert-Ernest Carrier-Belleuse and Auguste
Rodin, *Saigon Vase, Les Limbes et les Syrènes* (c. 1888), porcelain, 24.7 × 13.3 × 13.3 cm.
Musée Rodin, Paris.

Tamara Préaud has identified the earliest pâte-sur-pâte at Sèvres to
1849, and suggests that there was some delay in its adoption due to initial
hesitations as to how relief decoration should be produced, and whether it
was a form of decoration more suited to sculptors or to painters. The painter
Maximilien-Ferdinand Mérigot applied layers of thin slip with a brush;
while the *mouleur* Edouard Breton applied thin clay sections with slip, akin
to the cameo-style decoration developed in France and England during
the 1770s.[66] The definitive technique adopted by the firm in 1852 is created
directly onto the object.[67] This involves painting as many as forty layers of
diluted slip onto the ceramic body, allowing each coat to dry before applying
the next; then scraping, incising and polishing the individual layers to create
a low relief design. The effect is simultaneously transparent and opaque.

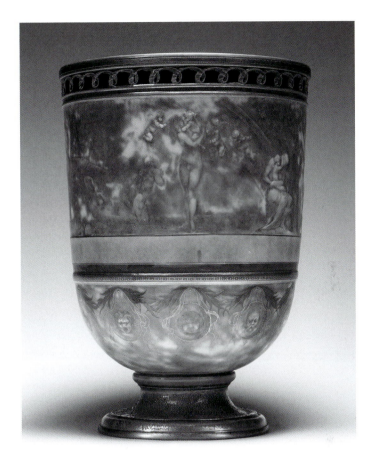

2.2 Manufacture nationale de Sèvres, Albert-Ernest Carrier-Belleuse and Auguste Rodin, *La Nuit, urne pompéienne* (1881–82), porcelain, enamel, gilding, 31.8 × 22.7 × 22.7 cm. Musée Rodin, Paris.

The artist is both designer and executor and needs to be skilled in drawing, painting and sculpture, as well having knowledge of ceramic materials and techniques. A sculptor was therefore more suited to developing and employing pâte-sur-pâte than a painter, particularly when creating designs in the round.

One of the most famous exponents of pâte-sur-pâte is Marc Louis Solon, who developed the technique at Sèvres from 1857 until 1870, when he moved to England following the onset of the Franco-Prussian war.[68] There, he developed the technique to great effect for Minton. He described the technique for *The Art Journal* as follows:

The piece intended to decorate must be in the clay state, that is to say, just as it leaves the hand of the potter, and before it has been submitted to any firing. Upon the still powdery and porous surface, the artist sketches freely the main lines of his subject. Then with a painting brush dipped in 'slip' – a term used in the trade for clay diluted with water to the consistency of a batter – he proceeds to lay on the foundations of his relief work. Coat after coat the slip is carefully applied; no fresh coat is to be added before the preceding one is perfectly dry ... With this preliminary brushwork a rough sketch is produced, in which care has to be taken to give to each part comparatively its right degree of relief; but the surface is rough and rugged, and no attempt has been made to introduce any detail. The work has now to be treated in the same way as a sculptor would treat a bas-relief of plaster of Paris or of fine grained stone. By means of sharp iron tools the substance is scraped, smoothed, incised, forms are softly modelled, details neatly defined, outlines made rigorously precise. As long as the artist is not satisfied, he may take the brush again and use it alternatively with the tool, raising one part, effacing another, as he may think it expedient. The last finishing touches, which shall preserve to the details a sharpness that glazing and firing would otherwise obliterate, are painted on with the thicker slip in a style quite peculiar to the treatment of pâte-sur-pâte. Although the clever management and happy graduations of the transparencies are only developed by vitrification, the operator has no other guide in that respect but his experience and judgment.[69]

While Solon's description cannot be applied universally or uncritically to the study of pâte-sur-pâte, with other renowned practitioners such as Taxile Doat writing accounts of their working methods, it does underscore the close interrelation of painting and sculpture techniques required in the execution of pâte-sur-pâte, the extremely high level of skills necessary in its production, and the lengths of time required.[70] In 1877 the Commission noted its surprise at the underuse of pâte-sur-pâte at Sèvres. Although not directly referred to in the report, this was presumably a reaction to its success at Minton's:

The Commission is surprised at how little has been derived from the application of the process of pâte-sur-pâte. It would seem that its introduction in decoration, used with sobriety, could produce a great number of varied and unexpected results, either as cameos, 'cartels' [wall clocks?], frames ornamented with subjects in fine bas-relief, friezes of children, of horses or fantastical figures.[71]

This recommendation was taken up by Rodin, whose decoration of two examples of Carrier-Belleuse's Pompeii vase; the aforementioned *Night* (1880) and also *Day* (1880), includes friezes of children and fantastical figures. Parallels have been drawn between these vases and Rodin's preparatory sketches for *The Gates of Hell*.[72] However, while it is tempting, as part of a reconsideration of the State's role in the arts or from an avant-gardist perspective, to suggest that Sèvres presented Rodin with a unique opportunity of unbridled creative experimentation within a state controlled context, the reality is more complex. Rodin was not, as has been suggested, an entirely free agent.

Rodin's pâte-sur-pâte decoration for these two Pompeii vases responded very directly to the 1887 directive, consisting as they do of friezes of children, horses and fantastical creatures, and cameo portraits of heads. The children, as in all Rodin's children, are reminiscent of eighteenth-century precedents by the likes of Clodion and Falconet, as illustrated in Emile Reiber's 1877 drawing manual *Bibliothèque pratique des arts du dessin* (Fig. 2.3).[73] This illustration is based on a sketch by the Rococo painter Fragonard, and clearly shows not only the form of the bodies but the careful positioning of the group as a mass. The heads are distinctively bald, large and ovoid and the bodies are soft, with folds of fat. Babies similar to these can be found extensively in the work of Rodin and his contemporaries, notably Gustave Doré, Carrier-Belleuse and Joseph Chéret. See for example Rodin's early figures while working for Carrier-Belleuse, his drawings and designs for Sèvres (Fig. 2.4) and the later infants that people *The Gates of Hell*. The gender distinction is also reminiscent of Rodin's later work: the women on these vases have soft, rounded bodies, while the men have a more defined musculature.

Although Rodin's employment at Sèvres provided the opportunity for him to develop his sculptural knowledge and to experiment with different subject matters and techniques, the Commission ultimately deemed his pâte-sur-pâte technique to be inadequate: 'it has not given the results expected of the artist. It would be good to attempt a new work before pronouncing on

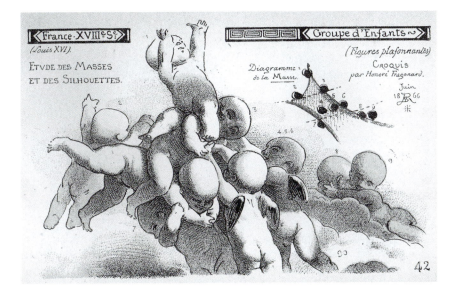

2.3 *Study of a Group of Children after Fragonard* (1866), in Emile Reiber, *Bibliothèque portative des arts du dessin* (Paris: Ateliers du Musée-Reiber, 1877), Plate 42. Les Arts décoratifs – Bibliothèque des Arts décoratifs, Paris.

the value of this process'.[74] *Night* and *Day* were never put into production. In 1907 they were exhibited at a ceramic exhibition at the Musée Galliera, where an anonymous critic also noted their deficiencies: 'we regret that the master [Rodin] had equally poor collaborators as the national kilns; why, on these vases, [is there] this brown tint that renders the Clodionesque contours of the figures illegible?'.[75] Ironically, these vases are now the most highly regarded of Rodin's ceramic *oeuvre* precisely because of their mottled, clouded effect. They appear more 'modern' than the more professionally produced pâte-sur-pâte and pre-empt the 'unworked' finish of his sculpture in the 1880s.

By contrast, the *Vase commémoratif de la nouvelle manufacture* (1867–1877) (Fig. 2.5) is indicative of the clarity achievable with pâte-sur-pâte; the distinction between it and its ground; and the subtle gradations of opacity and

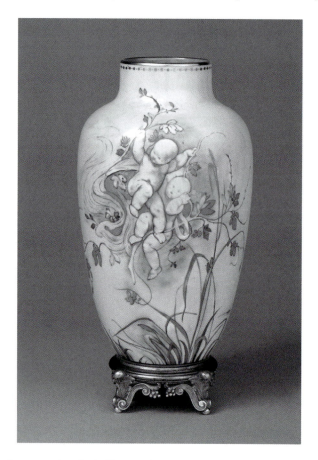

2.4 Manufacture nationale de Sèvres, Albert-Ernest Carrier-Belleuse and Auguste Rodin, *Saigon Vase, Les Eléments* (1879–1880), porcelain, H 19 cm. Sèvres, Cité de la céramique.

transparency in the pâte-sur-pâte itself, which allow for the representation of specific materials and textures, particularly in the different types of drapery. This vase commemorates Sèvres itself as a narrative in the round. The section illustrated here represents its modelling workshops. Centre stage are examples of sculpture from antiquity: the *Belvedere Torso*, a head of Athena, an ideal male nude; a Renaissance urn; and two (possibly nineteenth-century) vase forms. The shelves adjacent are filled with examples of the firm's products, awaiting decoration. To the foreground, in Clodionesque style, young children represent the workers; a pair discusses the merits of a figure in the round, another the painted decoration of a large vase; while a further child applies possibly gilding to the lip of a cup. Although sculpture and painting coexist in this space, sculpture takes precedence. It is the modeller, steeped in the sculptural tradition, and adept in all areas of modelling, who creates the forms on which the painter might be called on to decorate.

Carrier-Belleuse's new models for vases were an essential component of his role at Sèvres. Apart from the relatively simple vase forms such as the

2.5 Manufacture nationale de Sèvres and Larue Jean-Denis, *Vase commémoratif de la nouvelle manufacture* (1867–77), porcelain with pâte-sur-pâte decoration, H 97 cm. Sèvres, Cité de la céramique.

Saigon Vase and the *Pompeii Vase* which were designed to 'take' decoration in the round, Carrier-Belleuse was also responsible for modelling a second type of vase for Sèvres. This followed the Commission's recommendation that 'high relief sculpture would also find a happy application on these vases'.[76] These vases incorporate three dimensional figurative sculpture in their designs, such as the *Vase carré aux Cariatides* (1880), with its four female busts representing the four seasons; *Vase carré aux Chimères* (1880), with its two Renaissance-style winged female busts integrated into the vase with a scroll and drapery; and the *Vase de Corinthe* (1880), which is supported by two kneeling winged children. In each of these, the figurative elements are fully integrated within the design of the vase, either as support or decoration.

An exception is the *Vase Delafosse* (1880), which is 'supported' by two female figures at its base (Fig. 2.6). This was designed to be produced with or without the figures, and was therefore a cost-effective design as in both cases the same mould was used to produce the main body of the vase. That is not to say that these figurative models were necessarily more complicated or difficult for Carrier-Belleuse to conceive of and model than examples such as the *Saigon Vase*, but their reproduction in ceramic was more complex as it required the production and use of a greater number of moulds. A further example of the figurative vase type is Carrier-Belleuse's model for the Renaissance-style *Buire de Bloi* (Fig. 2.7). In 1879, Rodin spent 26 hours modelling figures of children for its handle, perhaps more than would be expected of him for such apparently 'simple', 'historicist' and 'derivative' work.[77]

Carrier-Belleuse's fullest expression of figurative sculpture at Sèvres was reserved for freestanding sculpture, in his revival of biscuit porcelain. This fired porcelain is deliberately left unglazed and is therefore unsuitable for tableware or painted decoration.[78] It has a sugary, marble-like surface texture.[79] Sèvres had successfully produced biscuit ware from the 1750s onwards, when it employed prestigious sculptors as directors of its modelling studios, including Falconet from 1757 to 1766 and Louis-Simon Boizot from 1773 to 1800.[80] Falconet was particularly instrumental in the success of Sèvres statuettes and groups in biscuit porcelain. In the 1840s the Copeland factory in England developed a similar ceramic known as Parian ware, for which Carrier-Belleuse produced numerous models.[81] By 1878 Sèvres had almost ceased the production of biscuit porcelain, and with it, small scale sculpture.[82]

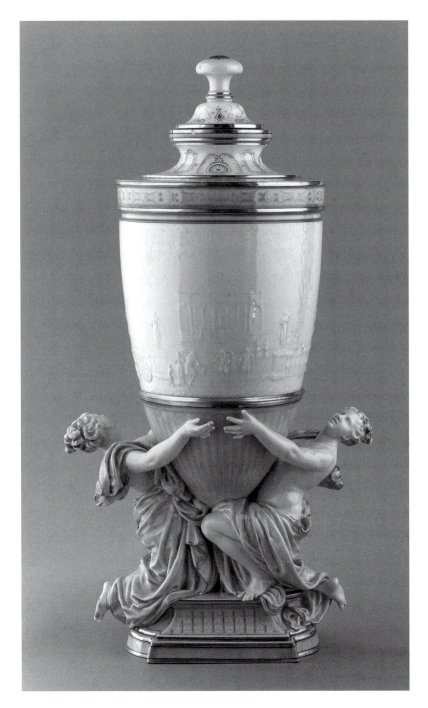

2.6 Manufacture nationale de Sèvres and Albert-Ernest Carrier-Belleuse, *Vase Delafosse* (1880), porcelain. Musée d'Orsay, Paris.

2.7 Manufacture nationale de Sèvres, Albert-Ernest Carrier-Belleuse, Auguste Rodin
and Suzanne Estelle Apoil, *Buire de Blois* (1883–84), hard-paste porcelain with enamel
and gilt decoration, 42 × 27 cm. Les Arts décoratifs – Musée des Arts décoratifs, Paris.

Carrier-Belleuse's new models for biscuit were exhibited in public for the first time, alongside his vases, at the 1884 exhibition of the Union centrale des arts décoratifs. In a typed speech, presumably given as a eulogy at Carrier-Belleuse's funeral in 1887, these were described as follows:

> In 1884, without speaking of the important place of sculpture in the decoration of vases, appeared the first modern models, the great table centre *Les Chasses*, the *Bust of the Republic,* and the exquisite *Minerva*. Here, and there especially, he knew how to renovate the tradition of grace – of elegance, of fantasy, that had assured the success of [Sèvres] in the eighteenth century, and which it had neglected in the nineteenth century to the point of compromising the very existence of the manufactory.[83]

Les Chasses (which does not survive) was part modelled by Rodin.[84] It comprised a central piece, *Le Triomphe de la Chasse*, and two side elements, *Le Départ de la Chasse* and *Le Retour de la Chasse*, as well as socles for each. The plaster models were completed in 1883 at a cost of 22,475 francs.[85] The Commission approved its production, but decided not to put Carrier-Belleuse's life size biscuit busts *Buffon* and *Daubenton* into production.[86] These were difficult and costly to execute, and were in direct competition from busts produced by the marble and bronze industries.

During his part-time employment at Sèvres, Carrier-Belleuse pursued his interest in figurative sculpture primarily outside the manufactory, producing works for the Salon and for a range of manufacturers. For example, in 1878 he modelled the 'Renaissance' table centre for Christofle with the types of figures he had earlier produced for Barbedienne's mirror in 1867.[87] From around 1879, he reproduced his Salon and decorative sculpture in polychrome tin-glazed earthenware through the artistic ceramic firm of Choisy-le-Roi.[88] Examples include the *Titan Vase* (Fig. I.1), discussed earlier in Chapter 1. This drew on, and developed, an earlier interest by ceramic manufacturers in Renaissance majolica by the likes of Bernard de Palissy and della Robbia, as seen in Minton's majolica range which was first exhibited to great acclaim at the International Exhibition of 1851. And despite his position at Sèvres, Carrier-Belleuse continued to supply models for Minton, one of its main competitors. In 1881 he signed a contract with the firm, giving them sole rights to his designs in England.[89] Carrier-Belleuse also continued to supply models for other types of manufacturers. In around 1880, he modelled 'perhaps the finest' sword hilt of the period, for the goldsmith Lucien Falize.[90] In 1880 he created a coffee pot for Christofle that won the gold medal at UCAD's 1880 Exhibition on the Arts of Metal, and led to the service *L'Union fait le succès*. The jury's report noted that 'it is of a new invention in goldsmithing. The figures which detach themselves in full relief on the vase and protrude from the front give an uncommon aspect not lacking in elegance'.[91] Christofle consequently created a full service related to the piece.

From 1885, concerns were raised regarding Carrier-Belleuse's failing health, and that his work for the 1889 International Exhibition would be interrupted or uncompleted.[92] His son–in–law and collaborator, the sculptor Joseph Chéret, was appointed to assist him under the condition that this would incur no cost to Sèvres.[93] Carrier-Belleuse died on 3 June 1887 and the workshops closed for a day of mourning.[94] He was officially recognised as having regenerated Sèvres, to the point that 'the preservation of the firm now appears as necessary as its destruction seemed indispensable a few years previously'.[95]

The question of Carrier-Belleuse's succession 'could tempt a certain number of artists', and the Academic sculptor Louis-Ernest Barrias, who had succeeded Pierre-Jules Cavelier as Professor of sculpture at the Ecole des beaux-arts in 1884, was proposed.[96] In the end, Sèvres appointed the Sèvres painter Alfred-Thompson Gobert as Director of Works of Art, as well as a new Administrator, the ceramicist Théodore Deck. According to Ernest Auscher, former Head of Manufacture at Sèvres (1879–89), this change in management stopped works in progress, provoked a period of indecision in artists, and halted production for several months. Auscher calculated that the cost of suspended models, unused new moulds, and works that were interrupted because they did not please or were not 'new' enough, represented a minimum value of 50,000 francs to the firm.[97] Some artists displayed their work independently at the 1889 International Exhibition, one of whom had cost the factory 25,000 francs.[98]

It has been estimated that Carrier-Belleuse produced around 150 new models for Sèvres; others suggest that it is closer to 500.[99] The vases listed in the firm's records under his name amount to two dozen. A large part of his models are therefore currently unrecorded, unidentified, destroyed or misplaced. According to Préaud, the Sèvres archive holds no drawings by sculptors.[100] Some preliminary models by Carrier-Belleuse survive at Sèvres, photographed by his biographer June Hargrove. One, identified as a perfume burner could be a preliminary model for *Vase Cassolette des Quatre Saisons* (1884).

The question of how we address the unknown work of artists poses a major problem for the study of the decorative arts, which are largely produced by an artist for a commercial enterprise and often as a fragment of a piece, rather than as a whole. The secondary value placed on the decorative arts as opposed to the fine arts has also meant that the decorative work of artists has been less consistently recorded. For example, apart from his Salon sculpture and work for Sèvres, only a few works, including two figures for a bed, fragments for a wardrobe, and figures for a marble dresser are documented in Rodin's decorative works for manufacturers, despite consistent references to his 'early work' for manufacturers prior to his commission for *The Gates of Hell*.

The decorative arts present an extensive, untapped resource for further research into nineteenth-century French sculpture. Analysing the work of sculptors at Sèvres in direct relation to directives issued by the manufactory reveals how the State's interest in sculpture during the first two decades of the Third Republic extended beyond the monumental, to include smaller scale objects. The personal creativity of sculptors such as Carrier-Belleuse and Rodin was supported and directed by this institutional context, and the division between private, state, commercial, fine and decorative, are less clearly defined than one could surmise from the existing historiography on French sculpture for this period.

As an endnote to this section, while Carrier-Belleuse's work at Sèvres has not, until now, been the subject of serious study, his legacy was considerable. During the late 1880s and 1890s Sèvres employed the skills of contemporary sculptors including Henry Cros and Jules Dalou to create monumental vases, as in Dalou's earthenware *L'Age d'or* (1888) (Petit Palais). Between 1891 and 1901, the Department of Fine Arts awarded Cros an annual grant to pursue his research into *pâte de verre* (paste glass) at Sèvres.[101] This process involves fusing crushed glass, and Cros produced a number of works using this technique, incorporating polychromy and low relief, as in the monumental low relief fountain *History of Water* (1893) (Musée d'Orsay). In preparation for the 1900 International Exhibition, Sèvres commissioned 'diverse artists to model decorative pieces'.[102] This included a project for an extensive table service: a biscuit centrepiece comprising four main groups, three end groups and six tritons and mermaids, at a cost of 55,000 francs for the models alone.[103] The successful Salon sculptor Emmanuel Frémiet was commissioned to model the four main groups, at a cost of 40,000 francs.

This renewed interest in sculpture and ceramics was the result of Carrier-Belleuse's efforts at Sèvres. As it attracted prominent Salon sculptors to work at Sèvres, it also encouraged other artists to reconsider ceramics as a medium for artistic exploration. Paul Gauguin began producing sculptures in ceramic from 1886.[104] In 1908, Camille Alaphilippe produced the life size figure *Woman with a Monkey* (Petit Palais) (Fig. 2.8). This comprises a gilt bronze head and hands on a polychrome dress composed of glazed ceramic plaques mounted on a wood and iron frame held together with crushed brick mortar; the joins hidden with coloured plaster. This ceramic statue represents one of the most fully realised expressions of the union of ceramics and sculpture, as reinvigorated by Carrier-Belleuse three decades earlier at Sèvres.

A Reconsideration of Rodin's Involvement in Design Reform

1880 is seen to mark a turning point in Rodin's professional career as a sculptor. He exhibited the *Age of Bronze* at the Salon, where it was awarded a

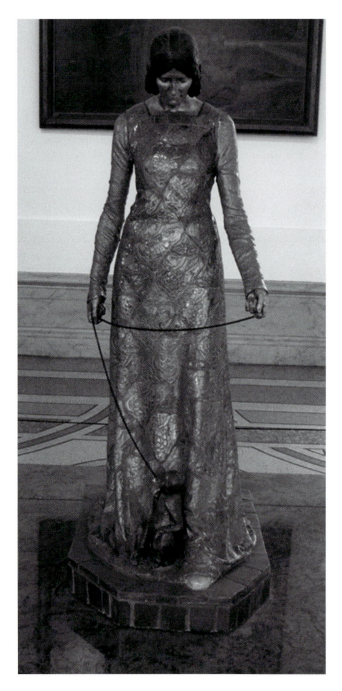

2.8 Camille Alaphilippe, *Woman with a Monkey* (1908), polychrome and glazed earthenware, gilt and patinated bronze, 184 × 78 × 96 cm. Petit Palais, Musée des Beaux-Arts de la Ville de Paris.

third class medal and was purchased by the State for 2,000 francs. This was his first acquisition by the State and signals Rodin's acceptance, of sorts, within the establishment, although the Academy would never invite him to become a member. In 1880 Rodin also received a State commission to make a model of a door for a planned decorative arts museum, a work that would occupy him for the rest of his life and result in some of his most renowned and recognised figurative sculpture. *The Gates of Hell*, as it has become known, and the State's purchase of the *Age of Bronze*, were both made possible through the network of contacts Rodin had developed while working at Sèvres.

In the pages that follow, I bring new documentary evidence to bear on Rodin's career during the 1880s and 1890s and reassess his supposed trajectory from artisan to artist by demonstrating how he simultaneously developed his profile within the fine *and* decorative arts. I map the cumulative effect of his involvement in state and private 'decorative' organisations and exhibitions, by plotting the networks of sculptors, artists and other influential people Rodin came into contact with and their close interrelation with his parallel success in the fine arts.

As we have already seen, in 1879 the new Under Secretary of Fine Arts, Edmond Turquet, increased the State's sculpture budget from 210,800 to 534,070 francs, reaching an average yearly level of over 500,000 francs in the 1880s.[105] Turquet's interest in sculpture formed part of a broader political and economic programme in which the arts were an essential component. One of these projects was the continued reconstruction of the Hôtel de Ville, following its destruction during the Commune.[106] Once the building work was complete the decoration of the building began in 1879, and Rodin was one of numerous sculptors who requested a commission. He wrote to the President of the Municipal Commission of Fine Arts for the Works to the Hôtel de Ville, as follows:

> Being employed at the National Manufactory of Sèvres, and having obtained an Honourable mention at this year's Salon [for *Saint John the Baptist*], I have the honour of soliciting your enlightened kindness for a figure for the works of the Hôtel de Ville. I would be grateful if, failing the figure, you entrusted me with a low relief, decorative masks etc. or other statuary part accessory to an ornamental motif.[107]

In this letter, Rodin first outlines his existing support from the State, prioritising his employment at Sèvres over his honourable mention at the Salon. This is perhaps due to the decorative nature of the Hôtel de Ville scheme, which involved the internal and external ornamentation of a building. It was also an astute recognition of the Department of Fine Art's broad remit; as it administered both the Salon and Sèvres, validation by both was a significant milestone in his career, which he hoped to build on. In this letter, Rodin's

stated preference is for the more prestigious statuary commission although he clearly demonstrates a willingness to accept any type of work.

Rodin's application for the Hôtel de Ville (supported by a letter from Carrier-Belleuse) was successful, and he was commissioned to produce a figure of the eighteenth-century mathematician and philosopher Jean le Rond d'Alembert, co-editor, alongside Denis Diderot, of the *Encyclopédie*. Rodin's figure forms part of the principal façade. It has received little attention from scholars, perhaps because of the architectural destination of the work, its context within a large state commission involving numerous other sculptors, and the figure itself, which, unusually for Rodin, is in historic costume. *Jean le Rond d'Alembert* was one of 116 stone figures of celebrated men and women created for the exterior of the building. At a cost of 4,000 francs each, these comprised a third of the total cost of sculpture to the rebuilding and ornamentation of the Hôtel de Ville, which created a much needed source of income for a variety of sculptors.[108]

In February 1880, Carrier-Belleuse was again to lend Rodin support, over the controversy regarding the *Age of Bronze*. Rodin had first exhibited this work under the title *Le Vaincu* in Brussels in 1877, and renamed it *L'Age d'airain* for the French Salon later that same year. As is now well known, Rodin was accused of having cast the figure from life, and Turquet set up a commission of administrators and critics to clear the matter up; they decided that it was cast from life.[109] A second report was submitted in Rodin's defence, signed by the sculptors Carrier-Belleuse, Dubois, Falguière, Jules-Clément Chaplain, Gabriel-Jules Thomas and Eugène Delaplanche. According to Ruth Butler, 'a more distinguished group of sculptors could hardly be found. It was the first significant sign of professional acceptance in Rodin's life'.[110] These sculptors had all attended the Ecole des beaux-arts and exhibited regularly at the Salon; Delaplanche, Dubois and Thomas were members of the Institut; Dubois was Curator of the Musée du Luxembourg; and Carrier-Belleuse, Chaplain, Delaplanche and Falguière had all received the Legion of Honour. Rodin's previous associations with these sculptors reveal that he first met them on decorative and architectural projects.

By the time of the 1880 report over the *Age of Bronze* controversy, Rodin was already part of a broad network of academic sculptors, primarily instigated by his contact with Carrier-Belleuse, and had been involved in the same projects as Falguière, Chaplain, Thomas and Delaplanche. He had worked intermittently with Carrier-Belleuse from 1864. One such project was the Hôtel de Païva, begun in 1865, for which the sculptor Eugène Legrain was in charge of the interior decoration. Delaplanche and Thomas were also involved in this work, as was Dalou. In 1878 Legrain hired Rodin to model masks for the Trocadéro fountain, a centrepiece of the International Exhibition, of which two of the masks survive at the Musée des Arts décoratifs.[111] Falguière was also involved in the fountain project. It has been suggested that Rodin's

masks were inspired by his visit to Florence in 1875 but a strikingly similar source exists closer to home: the stone heads of the Pont Neuf in Paris, produced by Rodin's former teacher Barye in 1851.[112] In 1879 Carrier-Belleuse, Chaplain, Thomas and Delaplanche were among the sculptors who received commissions for the Hôtel de Ville.

Following the report by these friends and colleagues in defence of the *Age of Bronze,* Turquet favoured their opinion over that of his administrators and the State purchased the work in 1880, when it was awarded a third class medal at the Salon. In August that same year Turquet commissioned Rodin to 'model a decorative door, with low reliefs representing Dante's *Divine Comedy*', for a proposed Museum of Decorative Arts.[113] The commission may have been, in part, recompense for the potential damage the *Age of Bronze* scandal had caused to Rodin's career. Rodin viewed the *Gates* as an opportunity to prove himself, noting: 'I shall make a lot of little figures; then, perhaps, they will not accuse me of making casts from life'.[114] Nevertheless, his designs show that he was clearly not conforming to the details of the commission, which requested a work in low relief. And while *The Gates of Hell* is now regarded as one of the most seminal objects in the history of sculpture, it must be remembered that the original commission was for a model, and the intended museum was as yet only a pipe dream. And the price, at 8,000 francs, was low, further suggesting that it was a relatively discrete gesture on Turquet's part to support Rodin. As we have seen in the previous chapter, sculptors could command much higher prices for decorative work, as in the 7,500 francs each given to Dubois and Falguière by Barbedienne in 1867 for life size plaster figures for torchères, and Frémiet's models for a table service for Sèvres.

Rodin's employment at Sèvres was critical to his commission for *The Gates of Hell.* As Butler has observed, its 'role in helping him obtain the commission for the door of the Musée des Arts décoratifs cannot be overemphasised'.[115] It was at Sèvres that Rodin broadened and consolidated his network of support and patronage through his acquaintance with the Haquette family. Haquette senior was Sèvres's accountant, assisted by his son Maurice, and was in regular contact with the Department of Fine Arts. His second son George taught painting at Sèvres's school, and was related by marriage to the Under Secretary of Fine Arts, Turquet. Butler has suggested that *The Gates of Hell* was a 'low-key' and 'daring' commission, because it was known initially only to Rodin's intimate circle.[116] Alternatively, it could be interpreted as a minor, inexpensive commission that Turquet did not necessarily expect to be fully realised, but which enabled him to support a sculptor he admired by providing him with some funds, official approval, and studio space at the state-funded Dépôt des marbres.

The commission was for a model of a door, not an actual door; it was not until 1885 that the State authorised funds for its realisation in bronze, dependent on Rodin's production of a final model. This was unusual. The

state generally commissioned works with a view to realisation, and the price paid to the sculptor normally included the cost of the model and its execution in a permanent material. The model itself, at least for a monumental work, was rarely, if ever, to full scale, as on approval it could be enlarged during the process of manufacture. Rodin's continued failure to present a completed model led to the State's withdrawal, in 1904, of the 35,000 francs it had laid out in 1885 for its casting.[117] As suggested earlier in Chapter 1, Rodin's non-completion of *The Gates of Hell* could also be explained by the copyright status of State funded works, which were in the public domain. While it remained a work in progress, Rodin successfully sold bronze and marble reproductions of its individual figurative elements, which he produced within his own studio and through contracts with manufacturers including Barbedienne.

In 1884 the Sèvres painter Fernand Paillet produced the first known illustration of what would become known as *The Gates of Hell* (colour plate 3). It forms part of an album of portraits of Sèvres's employees, 'Album de portraits-charges de personages de la Manufacture'.[118] Surprisingly, given that Rodin's work at Sèvres involved ceramics, the watercolour depicts Rodin carrying *The Gates of Hell* on his back. It was produced at a time when the commission was still relatively little known; it predates, by a year, its first full description in an article published by Octave Mirbeau in 1885.[119] This suggests that Rodin's colleagues at Sèvres had knowledge of the commission. Mirbeau's article set the tone for much of the subsequent writing on *The Gates of Hell*. It focuses on the individual figurative elements of the doors, rather than the whole, naming specific groups, describing their positions, and their relation to each other. Its language is evocative of pain and suffering – the figures struggle, turn, twist, fall, hurl, intertwine, Ugolino bays like a 'famished wild animal'.[120]

Paillet's watercolour is illustrated in Albert Elsen's 1985 monograph on *The Gates of Hell*, and more recently in the catalogue accompanying the 2009 exhibition 'Rodin et les Arts décoratifs', where Blanchetière notes its dual association with *The Gates of Hell* and with Sèvres.[121] Yet this 'caricature' is a complex and arresting image which suggests alternative readings to the tragic and erotic subject matter normally associated with *The Gates of Hell*. The brownish colour of the doors is suggestive of clay, an obvious reference to Sèvres and to sculpture. 'ARTS DÉCORATIFS' is prominently inscribed across its upper panel. This indicates the destination of the doors, the importance of the decorative arts to France's international supremacy in luxury goods, Sèvres's prominent position within this, and of Rodin's involvement in both. In 1906, Frederick Lawton provides possibly a unique reference to the influence of Rodin's modelling at Sèvres (rather than subject matter) on *The Gates of Hell*:

> [T]he general aspect of the Door is, of course one of terror and desolation. In the themes, the whole gamut of emotion and passion is expressed plastically ...

On the sides of the Door, the figures are in lower relief and more ethereal, but with a fine perfection of detail that recalls the decoration of the Sèvres vases.[122]

The door is signed to the lower right 'Rodin, sculpt', reflecting the concerns of ceramic workers and sculptors working within industry for their authorship to be recognised and for their names to be marked upon their productions.[123]

Rodin is depicted as a worker, a sculptor and a gentleman. He wears a pince-nez and holds a walking stick, his clothes are clean, his skin is smooth, and his shoes are polished. This could be seen to reflect Rodin's emergence as a fine art sculptor from his 'humble' origins in the decorative arts, but considering the context of this image within Sèvres, it is more likely that it asserts the decorative arts as a valid and rewarded field of artistic activity. Rodin bears *The Gates of Hell* on his back, and its scale and position exert an evident strain on him, though he does not frown or buckle under its weight. His body is partly in contrapposto, suggestive of his *Walking Man* (1879). One hand grasps a cord extended over the top of the door, preventing it from tilting backwards. It tips precariously to the right, its uncertain fate intrinsically linked to Rodin's ability to support and propel it. Rodin's gaze is set on a forward point out of frame, suggestive of a purposeful, forward march (towards new horizons in sculpture, including the decorative arts?). He is also depicted outside rather that in the studio or workshop; walking on grass, with his coat removed and his braces showing, reminiscent of contemporary caricatures of Impressionist painters heading off to work *en plein air* and thus suggestive of a rejection of Academic training in favour of a more 'authentic' truth to nature.

Behind Rodin's right shoulder is a figure of a bearded naked man, holding a sword which spears two figures, one of which at least is identifiable as a woman. The bearded man could be Rodin, but the shortness of his beard compared to Rodin's flowing example, and his apparent baldness, suggest that this is someone else. The sword itself could represent the sword of the Academy of Fine Arts. In 1906, the author Gustave Kahn recalled Rodin's one-man show at the Place de l'Alma during the 1900 International Exhibition as follows:

> Rodin was barred from the doors of Paradise of this International Exhibition, by angels dressed in the clothes of attendants of the Institute, carrying without a flaming torch, the small academic sword, and our greatest Sculptor exhibited on his own account, alone, outside the State.[124]

In 1687 members of the Academy were invited to deposit their personal arms at the entrance to its building as a token of their obedience to the banning of duels in 1626.[125] Since then, newly elected members are presented with a sword, whose ornamentation symbolises the ideals, career and philosophy of that particular individual. Rodin was never elected to the Academy and his antipathy to this institution is well known.[126] In Paillet's illustration the sword

appropriately lances sculpture. This is suggestive of Rodin's path outside of Academic art, and positions decorative art as a fruitful, alternative creative avenue from the Academy. The spindly, almost gargoyle-like nature of some of the figures, with their pointed noses, elongated bodies and contorted positions, are reminiscent of the illustrations in *Le Diable à Paris, Paris et les Parisiens* (1845), which tells the tale of the devil's visit to Paris.[127] This is appropriate given the reference to Dante's poem in the commission for *The Gates of Hell*, and perhaps identifies Rodin himself as a disrupting element in the fine and decorative art world(s).

Paillet's illustration therefore appears to encapsulate a number of contemporary interests at Sèvres – authorship, professional status, the importance of the decorative arts, the interrelation of the fine and the decorative, and the position of sculptors within this. At the time it was painted, in 1884, Rodin was still working for Sèvres, although intermittently and from his own studio rather than at Sèvres itself. In 1885 Sèvres's Administrator, Charles Lauth, attempted to strike Rodin from the list of external employees because of his continued lack of completion of the works he had been entrusted with, but Turquet stepped in to prevent this.[128] Lauth was replaced by Deck in 1887, and Rodin continued to work for the manufactory until 1902.[129]

If Rodin's work at Sèvres contributed to his commission for the (initially) decorative (and hypothetical) work *The Gates of Hell*, new documentation on his involvement in other aspects of design reform during this period further demonstrate the importance of the decorative to his career and sculpture practice.

RODIN AND THE UNION CENTRALE DES ARTS DÉCORATIFS

The Union centrale des arts décoratifs (hereafter UCAD) was founded in 1882 as a merger between the Union centrale des beaux-arts appliqués à l'industrie and the Société du Musée des Arts décoratifs.[130] The former had been founded in 1864 by a broad base of manufacturers, artists, patrons and government officials, and the latter in 1877 under the presidency of the Director of Fine Arts, Chennevières, with the aim of establishing a decorative art museum.[131] UCAD held a number of exhibitions focusing on historic and contemporary decorative arts.

Although his name is not mentioned, it is highly likely that work by Rodin was shown at UCAD's 1882 exhibition of wood, textile and paper. The cabinet maker Mathias Ginsbach exhibited a mahogany bed and wardrobes, for which he was awarded a silver medal for 'good execution'.[132] I assume these to be the bed for which Rodin had modelled figures of two children for Ginsbach in 1882, and possibly a Renaissance-style wardrobe for which Rodin had modelled two caryatids and a female mask for the same maker in 1878 (Fig. 2.9). The reason we know of Rodin's involvement in the bed is

that he authenticated a photograph of it in around 1912, presumably at the behest of Ginsbach who hoped to benefit from his association with a now famous sculptor (Fig. I.2).[133] In 1920 the bed was included in an article on Rodin's furniture, written by the writer and critic Mathias Morhardt.[134] It was rediscovered in the early 1970s and came up for auction in 2006.[135] Yet despite the bed being a rare example of Rodin's work for wood, and a unique piece untainted by any problems of reproduction that surround much of Rodin's sculpture, the bed remained unsold.[136] It would seem that the reintegration of

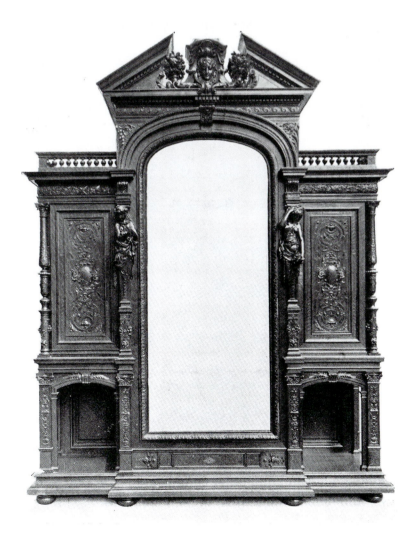

2.9 Mathias Ginsbach and Auguste Rodin, *Wardrobe* (1878), in Mathias Morhardt, 'Rodin ébéniste', *L'Art et les Artistes*, vol. 1, n.s. (no. 1–9) (1920), p. 348. Les Arts décoratifs – Bibliothèque des Arts décoratifs, Paris.

a work within Rodin's *oeuvre*, most visibly through its acquisition or display by a museum, requires more than the identification of authorship.[137] It needs to exhibit Rodin's *stylistic* signature as a 'modern' sculptor.

At first glance, the bed appears to be an unexceptional example of mid to late nineteenth-century furniture, encapsulating negative associations with decorative arts of the period, notably historicism and the application of ubiquitous cherubs. On closer inspection each 'cherub' is prominently signed 'A. Rodin, Sculpteur'. It is unclear when these signatures were carved into the figures, but presumably this occurred after Rodin authenticated them on Ginsbach's photograph. Rodin modelled the figures in 1882, two years after he is seen by most biographers and art historians to have abandoned decorative and architectural work following his success at the Salon in 1880, when the State purchased the *Age of Bronze* and commissioned *The Gates of Hell*. However, as Denys Sutton reminds us in his biography of Rodin, Rodin was not yet financially independent and continued to rely on manufacturers for employment:

> Despite the excitement aroused by *The Age of Bronze* Rodin was still compelled to earn his living as a commercial artist; for instance, he designed a walnut chest with a grotesque mask, two caryatids and a bed with cupids in high relief for a cabinet-maker named Ginsbach, who worked in the Faubourg Saint-Antoine. … Rodin was now making a name for himself, if still compelled to pot-boil.[138]

While Sutton dismisses Rodin's work for Ginsbach as financially motivated 'pot-boiling', on closer analysis Rodin's 'cupids' *could* be integrated within the dominant narrative of Rodin as the father of modern sculpture. The subject, form and modelling are unexpected in the traditional motif of two flanking cherubs. While they symbolise the traditional composition and product of the heterosexual marital state, they are not generic cherubs but contemporary children, a boy and a girl, with introspective expressions, modelled with an awareness of the muscles beneath the skin, and modern hairstyles executed in a subtle low relief more commonly associated with marble sculpture than with furniture carving. These figures are perhaps not characteristically 'Rodin' but are decidedly a novel departure in furniture and in Rodin's own *oeuvre* at this time. They are distinct to the children that people his vases for Sèvres and *The Gates of Hell*, which follow eighteenth-century precedents. Furthermore, unlike Rodin's more 'traditional' female mask and caryatids for Ginsbach's wardrobe in 1878, the modelling of the figures on the bed represent an innovative departure in furniture design towards the depiction of contemporary rather than idealised or mythological children, and a treatment of wood which is more akin to carving in marble.

This bed therefore holds potential as a location of a modern aesthetic, and of an eroticism understood to be at the heart of Rodin's later work. Yet the location of these figures on a decorative object, notably one that is historicist and with

an all-too-domestic function and scale has prevented closer examination of the bed and its full integration within the current understanding of Rodin's *oeuvre*. Its surface treatment is also problematic since it is highly finished and polished, in contrast to the 'non fini' of much of Rodin's more recognised and admired work. As Charles Rosen and Henri Zerner have observed in their study of the 'licked surface' in French painting between 1848 and 1880, the art historical division between 'official' and 'avant-garde' art has established a preference for the 'unfinished' surface.[139] This has had important implications for the status of those painters working within the 'official' realm of the 'finished' surface. This distinction between 'finished' and 'unfinished' surface treatments is partly an illusion, as both surfaces are in reality highly worked, only differently. The fact that Rodin's 'rough' finish is *thought* to bring us closer to the sculptor's vision has significant implications for the study of decorative objects. Whether definable as avant-garde or bourgeois, the decorative arts tend to have a highly 'finished' surface throughout the period 1848–1895, largely due to entrenched associations between luxury and perfection of execution.

In 1882 and 1883 the newly formed UCAD held two Decorative Art Salons (Salon des Arts décoratifs, also called the Salon des artistes de l'industrie). At the 1883 event, Rodin exhibited a painted plaster group of children in Class 2 (Decorative Sculpture).[140] This work is unrecorded in Rodin's *oeuvre*, and no illustration appears to survive; neither does this Salon feature in Alain Beausire's extensive anthology of Rodin's exhibitions.[141] The painted plaster group could be the *Enfants s'embrassant*, painted in imitation of red marble, that Beausire first identifies in February 1883 at the exhibition 'l'Art' on the Avenue de l'Opéra.[142] If this is the same work, by the time of UCAD's exhibition it is listed in the catalogue as being in the collection of a Mr Ionides of London.[143] To mention this fact was important to Rodin, as it demonstrated that he had an international private clientele; it was equally relevant to UCAD, whose membership was mainly comprised of amateurs, collectors, art historians, archivists and administrators.[144]

UCAD's aims with its two, short-lived Decorative Art Salons, was to challenge distinctions between fine and decorative art:

> … which law of subtle distinctions was previously obeyed to arrive at the conclusion of refusing vases by Klagmann or Fannière access to the Salon, while accepting a bust by the same artists, – and what was the system followed by which enamel plaques were revered because they were presented in a frame in the form of a painting, while these same enamelled plaques were dismissed when they were presented in the mouldings of a casket for the decoration of which they had been conceived and executed; [UCAD's Consultative Commission] has decided that today, now that artist painters and sculptors, as a body, no longer limit themselves so narrowly to the rules which were once obeyed, it is the role of UCAD to remedy this, and to open its doors freely not only to drawings and maquettes, but to executed works, under the sole

condition that they would be presented with the name of their author, of the artist that composed them, or of those that collaborated on its execution.[145]

Rodin's participation in this Salon could suggest that he was aware of, and supported, the intentions of its organisers to lessen distinctions between the fine and decorative arts and gain greater recognition for those artists working within industry. Alternatively, he may have taken the Salon's title to imply works that were distinct to those generally shown at the Salon. He chose to exhibit a painted plaster group of children, a work which in subject matter and surface finish could be seen to be 'decorative' and suited to the domestic interior.

During the 1880s Rodin's association with UCAD strengthened, and through it his network of sculptors and colleagues involved in both the fine and decorative arts. In 1887 UCAD staged its ninth exhibition of Fine Arts Applied to Industry, which included historic and modern works representative of France's successes in this field.[146] Rodin is named as a jury member in a number of categories.[147] I list these here, and the names of his fellow jurors, to reveal the sculptors, industrialists, academics, amateurs and administrators that such a position brought Rodin into contact with. For the competition for 'a decorative piece destined to be executed in metal', Rodin sat on the jury alongside Barbedienne, the goldsmith Falize and Henri Bouilhet, Vice President of UCAD and nephew and son-in-law of Charles Christofle, founder of the silversmith firm Christofle. Also on this jury were the following sculptors (*statuaires*): Dalou, Falguière, Guillaume, Antonin Mercié, Mathurin Moreau; and the sculptors and medallists Jules-Clément Chaplain and Louis-Oscar Roty. Rodin was the only sculptor on the jury for the schools' competition. Other members of this jury included the journalist and former Minister of Arts, Antonin Proust, of whom Rodin had created a bust in 1884, Bouilhet, Falize and the painter Pierre-Cécile Puvis de Chavannes, whose work Rodin greatly admired. Rodin was also a member of the jury elected to examine the exhibits 'from the point of view of the merit of their form, of invention and of décor', alongside the sculptors Falguière, Robert and Paul Moreau-Vauthier, Puvis de Chavannes, the art critic Paul Mantz and the fine and decorative art historian Henry Havard, among others.[148] Rodin was also a member of the jury for metal and textile products, which included Barbedienne, Mantz and Froment-Meurice.

Given this new information regarding Rodin's association with UCAD, the commission for *The Gates of Hell* in 1880 clearly did not signify a break with the decorative arts for Rodin. The list of names above reveals that Rodin (and his fellow artists and sculptors) simultaneously increased his profile within the decorative arts as his stature improved within the fine arts. Rodin's acceptance within UCAD expanded his contact base and offered an alternative, though not oppositional, system of patronage and support to the Salon. The decorative

art networks afforded by UCAD were instrumental in his forming similar networks in state-funded arts projects. UCAD's 1887 Exhibition predates the reconstitution of the Commission des travaux d'art, the Department of Fine Arts' advisory group on public art projects. As Butler's research reveals, this Commission included Dalou, Chapu, Puvis de Chavannes and Guillaume.[149] In 1889 a subcommittee for the sculptural decoration of the Pantheon was initiated, which included Dalou, Chapu, Chaplain and Guillaume.[150] It selected a number of sculptors for the commission, including Rodin, Mercié, Dubois and Delaplanche. Nearly all of these sculptors, at committee level and as recipients of a commission, had been jury members at UCAD's 1887 Industrial Art Exhibition.

RODIN AND THE INTERNATIONAL EXHIBITION OF 1889

Rodin's continued involvement in the decorative arts during the 1880s is also evident in his involvement in the 1889 International Exhibition in Paris. In 1887 he received notice that he was to be a member of the subcommittee for this exhibition.[151] Research suggests that Rodin also produced a sculpture, *l'Architecture*, for this exhibition, alongside *La Peinture* by Franck and *La Sculpture* by Thomas.[152] A watercolour and photograph of these works have recently been identified.[153] My research has uncovered documentary evidence for this commission, in a dossier of *sculpteurs-statuaires* employed by the State to ornament buildings for the International Exhibition.[154] The list of 31 successful sculptors, from a provisional list of 72, assigns each sculptor a specific sculpture for a particular building in the exhibition's grounds. For example, Cordier was commissioned for a frieze of two figures for the Palais des Arts libéraux, at 1,500 francs each; Desbois for motifs for the corners of the crown to the Palais des Expositions diverses, at 3,000 francs; Gautherin and Gauthier each received 8,000 francs for the groups *Le Commerce* and *L'Industrie*; and Chapu's large figure representing *Electricity* and Barrias's group *Steam*, both for the Palais des Machines, cost 25,000 francs each. Rodin was commissioned for 'one figure, *L'Architecture*', for the central porch of the Palais des beaux-arts, at a cost of 4,000 francs. This was flanked by *La Peinture* by Crauck (not Franck) and *La Sculpture* by Thomas, also at 4,000 francs each.

The documentation on this commission reveals that the committee noted sculptors' addresses, previous work or diplomas, references and observations. Rodin's application was recommended by the recent Minister of Fine Arts, Eugène Spuller (1887–1889) and is one of two singled out as a 'very special dossier' ('dossier très spécial'), alongside Léon Grandier. Osbach, with whom Rodin initially shared a studio at the Dépôt des marbres, was recommended by the former Minister of Fine Arts, Turquet. The addresses of those commissioned show that most of the work went to sculptors working in the 'fine art' area near the Ecole des beaux-arts and the Dépôt des marbres,

and less to those to the north and east of Paris near the bronze and furniture making districts.[155] For example, François Roger and Jean Pezieux gave the same address as Rodin, at 182 rue de l'Université, near the Dépôt des marbres, with Osbach at no. 176 on the same street. To the north, Voyer worked at 16 rue de la Tour d'Auvergne, opposite Carrier-Belleuse at no. 13 (deceased in 1887) and Chéret at no. 15. While this information is useful in terms of mapping the locations of sculptors and potential associations between them, it should not be read as necessarily demarcating a rigid division between geographical areas and specialisms in sculpture. This is best exemplified by Carrier-Belleuse's own successful career in the fine and decorative arts, and Rodin's continued involvement in decorative commissions and associated projects.

Alongside his involvement in the 1889 International Exhibition, Rodin continued to supply models for manufacturers who were intending to exhibit there. Beausire has identified a letter in the Musée Rodin archives which states that Rodin helped Cuvillier realise a marble dresser in 1889.[156] I have sourced a contemporary photograph of this work (Fig. 2.10).[157] Its caption identifies it within the marble section of the 1889 International Exhibition and reads as follows: 'Large dresser for a dining room in Sarrancolin marble, with ornaments and decoration in various marbles; design by Cuvillier, architect; figures by Aug. Rodin; execution by Parfonry & Huvé frères'.[158] The figures themselves are hard to discern from the photograph, but it is hoped that the dresser may now be located and examined in more detail. The outside figures are a man and a woman with naked, armless torsos, in contrapposto, facing each other; their lower bodies take the form of an architectural column, with a drapery between both sections. In the centre of the dresser are two apparently identical busts of women facing forwards, their arms truncated below the shoulder. The figures appear to be carved in white marble, as does the frieze and two large cornucopias above. This contrasts with the red coloured veins and creamy white ground of the Sarrancolin marble which makes up the majority of the dresser. Sarrancolin marble is quarried in the French town of the same name in the High Pyrenees, and was popular under the reign of Louis XV to the extent that these were considered 'royal' quarries. It is found in the most prestigious staterooms at Versailles. Parfonry's dresser thus combines the white marble of Salon sculpture for the figurative elements, with the red and cream flamed marble associated with royal patronage and high-end luxury goods production.

These sculptures do not look particularly remarkable, but given the benefits of a close reading of the Ginsbach bed, it is impossible to draw any conclusions without seeing the piece. However, it is significant as a new documented work by Rodin, and in terms of authorship. Rodin's name is included in the caption and he was commissioned to create figures, rather than the masks and ornaments he was prepared to model for the decoration of the Hôtel de Ville

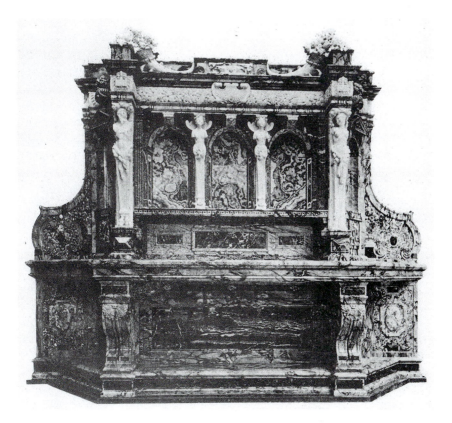

2.10 Auguste Rodin, Cuvillier and Parfonry & Huvé Frères, *Grand Dresser for a Dining Room* (1889), various marbles. Reproduced in Victor Champier, *Les Industries d'Art à l'exposition universelle de 1900* (Paris: Bureau de la Revue des Arts Décoratifs, 1903), vol. 3, Plate 30. Les Arts décoratifs – Bibliothèque des Arts décoratifs, Paris.

in 1879. Furthermore, Parfonry was a prestigious firm. It had been awarded a gold medal at the 1867 International Exhibition in Paris for a chimneypiece.[159] The sculptors' reports from this exhibition comment on a further work by Parfonry, which it described as 'a serious work'; this was a large red marble chimneypiece designed for a dining room, with a medallion of birds in white marble by the animalier sculptor Auguste Cain.[160] By 1878 Parfonry's was one of the largest marble companies in Paris, employing 150 workers on site and around 350 on projects outside the workshops.[161] Its stock was valued at around 400,000 francs. Rodin's involvement with Parfonry could therefore be considered as a prestigious decorative art commission.

Rodin was clearly continuing to produce decorative works for private manufacturers into the late 1880s, when he is considered to have relinquished such work in favour of fine art sculpture. His one-man show at the Place de l'Alma in 1900 is regarded as the definitive demonstration of his artistic

and financial independence. Yet what has not been previously recognised is that Rodin was simultaneously involved in the International Exhibition of 1900. He was a member of the Jury for Group 2, Sculpture and Engraving on Medals and Fine Stones.[162] He was also a member of the titular French jury (*jurés titulaires français*), presided by Guillaume, alongside the sculptors Frédéric Auguste Bartholdi, Dalou, Dubois, Mercié, Thomas and the critic Roger Marx, who collected Rodin's ceramics and was the first to research this area of his production.[163] The nature of the international exhibitions meant that the juries were composed of members of the host and other nations, putting sculptors directly into contact with their counterparts in other countries. The deputy French jury (*jurés suppléant français*) included Edward Onslow Ford, representing England.

Rodin's involvement in national and international exhibitions of industrial and decorative art, private organisations such as UCAD, and his continued work in decorative projects for the relatively meagre sum of 4,000 francs alongside his increasing stature as a fine art sculptor, reveals that he found support and recognition outside the parameters of the Salon, amateur commissions and fine-art criticism. Reasserting the place of decorative sculpture in Rodin's *oeuvre* introduces new documentary sources to the scholarship on Rodin and allows for the integration of previously neglected works, techniques, subject matter and levels of authorship within his *oeuvre*, thus contributing to a more precise understanding of Rodin's life and works during the 1880s and 1890s. This challenges the standard narrative trajectory of 'artisan to artist', and the image of Rodin as a rather isolated individual working outside of contemporary sculpture and associated networks. The reality is more nuanced, and is indicative of a complex interplay between public and private industry, fine and decorative art, and independence and community that characterises nineteenth-century French sculpture more broadly.

Notes

1 Dalou established a successful teaching career in England, where he was influential among young sculptors, contributing to the emergence of the so-called 'New Sculpture'.

2 On Rodin in Brussels see Butler, *Rodin. The Shape of Genius*.

3 For example the retail outlet of the furnishing and furniture manufacturer Monbro was destroyed by the Prussians. Alfred Darcel, 'Les Musées, les arts et les artistes pendant la Commune', *Gazette des Beaux-Arts*, no. 5, 1 November 1871, p. 422.

4 *Réimpression du Journal officiel de la République française sous la Commune*, 9 April 1871, p. 204.

5 'International Exhibition of 1871', *The Art Journal*, 1 March 1871, p. 90.

6 *The Art Journal Catalogue of the International Exhibition* (London, 1871), p. 83. This also noted Fannière Frères' association with a Mr Philippi, p. 78.

7	Durand-Ruel established himself as 'The Society of French Artists'; Harrison C. White and Cynthia A. White, *Canvases and Careers: Institutional Change in the French Painting World* (New York, London and Sydney, 1965), pp. 125–126. Monet and Pissarro lived in London for the duration of the Franco-Prussian war.

8	'The Royal Institute of British Architects', *The Art Journal*, 1 August 1871, p. 205. The exhibition ran from June to October 1871.

9	'The Works of Carrier-Belleuse', *The Art Journal*, 1 September 1871, p. 229.

10	*Catalogue of the Beautiful Works in Terra-cotta by Carrier-Belleuse*, Christie, Manson & Woods, King Street, London, 1 November 1871. The copy in Christie's Archive includes some annotated sale prices, names of purchasers, final bids on unsold items and reserve prices.

11	Gonzalo J. Sánchez, 'The Development of Art and the Universal Republic: the Paris Commune's Fédération des Artistes and French Republicanism, 1871–1889' (Ph.D. dissertation, Columbia University, 1994).

12	'Assemblée des artistes', *Journal officiel de la République française sous la Commune*, 15 April 1871, p. 273. This extended to national and international exhibitions, see 'Exposition', *Journal officiel de la République française sous la Commune*, 15 April 1871 (suite), p. 274. Its constitution mirrors the RFB in its self-regulation and mutual support.

13	The Department of Fine Arts was attached to the Ministry of Public Education. It had a budget of around seven and a half million francs, and 45 staff. Jane Mayo Roos, 'Aristocracy in the Arts: Philippe de Chennevières and the Salons of the Mid 1870s', *Art Journal*, vol. 48, no. 1 (Spring 1989): pp. 53–62.

14	On other aspects of institutional art in nineteenth-century France, see Mainardi, *Art and Politics*; White and White, *Canvases and Careers*; Albert Boime, *The Academy and French Painting in the Nineteenth Century* (London, 1971); and Jane Mayo Roos, *Early Impressionism and the French State (1866–1874)* (Cambridge, 1996).

15	These were the International Congress of Industrial Property and the International Congress on Artistic Property, part of a series of congresses and lectures held at the Trocadéro Palace by the Ministry of Agriculture and Commerce during the 1878 International Exhibition in Paris.

16	'... quelles que soient la nature et l'importance de l'œuvre et quel que soit le mode de reproduction, d'exécution ou de représentation.' *Congrès international de la propriété artistique, 18 au 21 Septembre* (Paris, 1879), p. 209, Appendix 10, Art. 1.

17	*Congrès international de la propriété artistique,* p. 210, Appendix 10, Art. 5.

18	*Congrès international de la propriété industrielle, 5 au 17 septembre* (Paris, 1879), p. 740.

19	'L'État doit-il conserver ou supprimer les manufactures nationales?', *Des Manufactures nationales* (Paris, 1871), p. 1. While its title suggests otherwise, this pamphlet only concerns Sèvres.

20	For a detailed critique of Sèvres during this period, see Ernest-Simon Auscher, *Une Manufacture nationale en 1888, étude critique sur la manufacture de porcelaine de Sèvres* (Paris, 1894). Auscher was Head of Manufacturing at Sèvres (1879–1889).

21	*Des Manufactures nationales*, p. 1. Sèvres also sold its 'seconds' to decorators and porcelain dealers, allowing them access to the highest quality porcelain.

22	'Considérant qu'il est du plus grand intérêt de surveiller les travaux artistiques de la Manufacture de Sèvres et de leur imprimer une marche progressive et digne de son passé', Order of the Director of Fine Arts, 24 July 1872, AN F.21.493.1.

23	'Examiner et apprécier au point de vue de l'art, les travaux céramiques qui s'exécutent à la Manufacture de Sèvres', Article 1, Order of the Director of Fine Arts, 24 July 1872, AN F.21.493.1. The Commission members were Charles Blanc, Member of the Institut, Director of Fine Arts, President; Joseph-Louis Duc, Member of the Institut, architect; Baudry, Member of the Institut, artist painter; Mazerolle, artist painter; and Adrien Dubouché, former mayor of Limoges.

24	The Order of the Director of Fine Arts of 26 July 1872 includes Guillaume and omits Baudry. Joseph-Louis Duc, *Rapport adressé à Monsieur le Ministre, au nom de la commission de perfectionnement de la manufacture de Sèvres* (Paris, 1875), p. 4.

25	'Dans sa séance du 19 mars la commission a reconnu que la sculpture est dans un état d'insuffisance notoire. Elle est presque nulle et semble abandonnée. Comme preuves de cet art, qui peut jouer un grand rôle dans la céramique, nous ne pouvons citer que quelques anses, des

têtes d'ajustement ou autres appendices indispensables. Deux modèles pour biscuit, les deux seules compositions présentées à la Commission, étaient tellement faibles, qu'elle s'est trouvée embarrassée de les critiquer. Il y a aujourd'hui absence complète de ces compositions où la sculpture et la coloration offraient par leur mariage de charmantes combinaisons décoratives. Les seules qui existent sont celles qui datent d'une vingtaine d'années et qu'on doit au talent de Klagmann, sous la direction de M Dieterle. Aujourd'hui elles sont reléguées dans les antichambres comme les témoins d'un art abandonné. Il semble qu'on ait renoncé à lutter avec les produits si variés de Minton Assurément les éléments artistiques ne nous manquent pas pour engager cette lutte. Nous possédons en grand nombre des sculpteurs de talent. Les Anglais le savent bien, et c'est chez nous qu'ils se recrutent d'artistes distingués qui leur fournissent les armes auxquelles ils doivent leur supériorité. Un de nos collègues de la Commission pourrait en fournir la preuve. ... Il est donc grand temps de venir au secours de la sculpture; il y a beaucoup à faire pour la relever et la mettre en état de prêter un digne concours à la céramique.' Ibid., p. 16.

26 Ibid., p. 6.

27 De Chennevières, 'Distribution des prix le 9 août 1874', cited in Marie Jeannine Aquilino, 'Painted Promises: The Politics of Public Art in Late Nineteenth-Century France', *The Art Bulletin*, vol. 75, no. 4 (December 1993), p. 702.

28 Ministerial decree, Department of Fine Arts, 27 November 1875.

29 From a conversation with the former Archivist at Sèvres, Tamara Préaud, 3 July 2008.

30 On Carrier-Belleuse and Minton, see Philip Ward-Jackson, 'French Modellers in the Potteries', in Paul Atterbury (ed.), *The Parian Phenomenon. A Survey of Victorian Parian Porcelain Statuary and Busts* (Shepton Beauchamp, 1989), pp. 48–56; Lehr, Jones and Karmason, 'Les Majoliques de Minton'.

31 'C'est presque une machine à sculpter ce M. Carrier-Belleuse ... mais que cette machine à d'esprit, d'imagination, de verve! Parfois on lui croirait du génie'. Edouard Lockroy, 'Le Monde des Arts', *L'Artiste*, 15 January 1865, p. 40.

32 Jules Dalou, in contrast, was exiled for his role in the Paris Commune and did not return to France from England until the amnesty of 1879.

33 'Il s'inspira des grandes écoles décoratives, de l'école italienne, de l'école rouennaise, de l'école japonaise, de l'école mauresque et persane, qui ont si bien su approprier le décor à la forme des objets ...'. Saint-Juirs, 'Carrier-Belleuse', *Galerie Contemporaine*.

34 'banal sculpteur', 'ce pacotilleur du xix siècle, ce copieur de Clodion'; Edmond and Jules Goncourt, *Journal des Goncourts*, vol. 3 (Paris, 1888), p. 135.

35 Letter from the Director of Fine Arts to the Administrator at Sèvres, 27 December 1875. Sèvres – Cité de la céramique Archive, Carrier-Belleuse file (hereafter SA/CB).

36 'Cette demi-journée supplémentaire vous permettra de suivre, de plus près, les travaux en train et de ne rien laisser échapper à votre critique', draft letter to Carrier-Belleuse, 18 October 1881, SA/CB.

37 '... vous aurez toutes facilités pour étudier et perfectionner les modèles nouveaux que je vous demanderai pour la manufacture', draft letter to Carrier-Belleuse, 18 October 1881, SA/CB.

38 Porlie et al, 'Rapport des sculpteurs', p. 14.

39 Draft letter from the Administrator Charles Lauth to Carrier-Belleuse, 8 November 1883, SA/CB. If agreed to, his wage would increase from 6,000 to 8,000 francs.

40 'Séances de la première Commission' (9 November 1872 to 29 April 1873). Duc, *Rapport* (1875), p. 7.

41 Ibid., p. 14.

42 'Quant aux grandes pièces décoratives, il y a là un large champ ouvert aux compositions les plus diverses: c'est un ordre de créations où les artistes peuvent donner carrière à toute leur imagination. C'est ici que doivent briller toutes les qualités des décorateurs; tout leur est permis, la liberté, l'originalité, même l'audace, et s'ils sont nourris des souvenirs des belles époques de l'art, si, pénétrés de leur beauté, ils ont assez de force pour en dégager leur propre originalité, ils peuvent créer une quantité de pièces décoratives des plus intéressantes. C'est à ce moment qu'ils doivent appeler largement les concours de la sculpture' Ibid., p. 19.

43 On the political appropriation of sculpture in this period, see Albert Boime, *Hollow Icons: The Politics of Sculpture in Nineteenth Century France* (Kent, Ohio, 1987).

44 '... proscrivait rigoureusement les sujets modernes et imposait donc aux pensionnaires désireux d'évoquer le monde contemporain d'utiliser le biais de l'allégorie...'. Le Normand-Romain, 'L'Académie de France à Rome', p. 56.

45 '... ou la sculpture peut s'acclimater avec la vie moderne ou elle ne le peut pas. Si elle le peut, qu'elle s'essaye alors aux sujets actuels, et nous saurons au moins à quoi nous en tenir. ... que les sculpteurs se bornent à être des ornemanistes et qu'on n'encombre point le Salon des arts de leurs produits!', Joris-Karl Huysmans, *L'Art moderne* (Paris, 1883), p. 79.

46 Boime, *Hollow Icons*, p. 4. On the development of non-institutional art in this period, see White and White, *Canvases and Careers* and Timothy J. Clark, *The Painting of Modern Life: Paris in the Art of Manet and his Followers* (London, 1985).

47 Article 11 of the Staff Rules of 27 May 1879, states that 'the models for sculpture, pâte-sur-pâte decoration, painting, gilding and ornamentation, cannot be executed (the necessary studies completed) until they have been approved by the Director of Art and the Administrator'. 'Les modèles de sculpture, les travaux de décoration en pâte-sur-pâte, de peinture, de dorure et d'ornementation ne pourront être exécutés (les études suffisantes préablement faites) qu'après avoir été approuvés par le directeur des travaux d'art et l'administrateur'. Charles Lauth, *La Manufacture nationale de Sèvres, 1879–1887, son administration, notices scientifiques et documents administratifs* (Paris, 1889), p. 47.

48 '... malheureusement patience, est en céramique vertu de 1ᵉʳ ordre', unsigned letter from Sèvres to the Director of Fine Arts, 22 April 1872, p. 2. AN F.21.493.1.

49 'une nouvelle impulsion', unsigned letter from Sèvres to the Director of Fine Arts, 22 April 1872, Ibid., p. 2.

50 '... présentant de vastes champs à orner selon l'inspiration des décorateurs. ... par l'adjonction de figures modelées, d'anses sculptées, de motifs en relief, à modifier totalement l'aspect des produits de Sèvres'. Typed speech, c. 1887, p. 2. SA/CB.

51 'La pièce de porcelaine doit, par elle-même, par sa forme, sans parler de la couleur, qui ne vient qu'après, offrir un intérêt artistique. Je suis convaincu que M. Carrier-Belleuse partage ces idées. Il voudra que le modèle en plâtre d'une pièce de la manufacture de Sèvres soit déjà un chef d'œuvre. ... Avec lui, nous pouvons nous attendre à des surprises et à des merveilles.' Saint-Juirs, 'Carrier-Belleuse'.

52 '... le décor doit toujours respecter la forme de la chose décorée'. Duc, *Rapport* (1875), p. 30.

53 This imitation of Celadon ware was suggested by the ceramicist Théodore Deck, Commission member and Director of Sèvres from 1887. Duc, *Rapport* (1875), p. 23.

54 On bronze mounts in eighteenth-century French ceramics, see Verlet, *Les Bronzes dorés*.

55 Duc, *Rapport* (1875), p. 39.

56 This was presumably also a cost cutting measure, as bronzes could be easily outsourced in Paris.

57 On Rodin at Sèvres see Roger Marx, 'Rodin céramiste', *Art et Décoration*, vol. 18 (1905): pp. 117–128; Roger Marx, *Auguste Rodin céramiste* (Paris, 1907); Anne Lajoix, 'Auguste Rodin et les arts du feu', *Revue de l'Art*, no. 116 (1997–2): pp. 76–88 and Blanchetière and Saadé, *Rodin. Les Arts décoratifs*.

58 'Les dossiers relatifs à vos jeunes artistes; je suis très désireux de voir circuler un peu de sang nouveau dans notre Manufacture; il ne dépend que de vous que cela soit bientôt.' Draft letter from Lauth to Carrier-Belleuse, 15 May 1879, SA/CB.

59 Letter to the Director of Fine Arts, 4 July 1872, AN F.21.493.1. In 1876 a 5,000-franc bonus was shared amongst staff, Carrier-Belleuse receiving the second largest sum of 600 francs. Decree of 28 December 1876, AN F.21.687.

60 Lauth, *La Manufacture nationale de Sèvres, 1879–1887*, p. 60.

61 Turquet held this position under five successive changes of government, 1879–1886.

62 *Ministère de l'instruction publique et des beaux-arts, état comparatif des commandes et achats faits par les administrations des beaux-arts depuis 1870, no. 3088* (Paris, 1884), p. 380.

63 See for example Blanchetière and Saadé, *Rodin. Les Arts décoratifs*, pp. 112–114, whose emphasis on the 'independence' of Rodin's work at Sèvres follows an approach to French art of this period which pivots around particular artists and key events which are seen to represent significant ruptures with existing stylistic and institutional models, such as the first Impressionist exhibition

in 1874. See for example Clark, *The Painting of Modern Life* and Martha Ward, 'Impressionist Installations and Private Exhibitions', *The Art Bulletin*, vol. 73, no. 4 (December 1991): pp. 599–622. In the decorative arts historians have largely identified manufacturers as an obstacle to change and emphasised the contribution of state and private patronage via individual commissions to the emergence of Art Nouveau. See for example Silverman, *Art Nouveau*; Rossella Froissart-Pezone, *L'Art dans tout. Les arts décoratifs en France et l'utopie d'un Art nouveau* (Paris, 2004).

64 'Graver directement dans la pâte'. Duc, *Rapport* (1875), p. 23.

65 On Rodin's use of pâte-sur-pâte, see Bernard Bumpus, 'Auguste Rodin and the Technique of *pâte-sur-pâte*', *Apollo* (January 1998): pp. 13–18. On its origins at Sèvres, see Tamara Préaud, 'Sèvres, la pâte sur pâte, un procédé original', *L'Estampille, L'Objet d'Art*, no. 263 (November 1992): pp. 46–57.

66 Préaud, 'Sèvres', p. 52.

67 Ibid., p. 52.

68 On pâte-sur-pâte and Solon in England, see Geoffrey A. Godden, *Victorian Porcelain* (London, 1961).

69 Marc Louis Solon, 'Pâte-sur-pâte', *The Art Journal*, no. 63 (1901), pp. 73–79, quoted in Godden, *Victorian Porcelain*, pp. 171–172.

70 For a more comprehensive discussion of the technique, see Bernard Bumpus, *Pâte-sur-Pâte, the Art of Ceramic Relief Decoration, 1849–1992* (London, 1992).

71 'La Commission est surprise du peu de ressources qu'on a tiré de l'application du procédé des pâtes sur pâtes. Il semble que son introduction dans la décoration, mais employé avec sobriété, pourrait produire un grand nombre d'effets variés et inattendus, soit pour des camées, des cartels, des encadrements ornés de sujets en fins bas-reliefs, de frises d'enfants, de chevaux ou de figures fantastiques.' Duc, *Rapport* (1877), p. 5.

72 Lampert, *Rodin* juxtaposes images of the *Pompeii Vase* with Rodin's drawings.

73 Emile Reiber, *Bibliothèque pratique des arts du dessin* (Paris, 1877), Pl. 42. The design is dated 1866.

74 '...n'a point donné le résultat qu'en attendait l'artiste. Il serait bon de tenter une nouvelle expérience avant de se prononcer sur la valeur du procédé', Octave du Sartel, *Manufactures nationales. Exposition de 1884. Rapport adressé à Monsieur le Ministre au nom de la Commission de perfectionnement de la manufacture nationale de Sèvres* (Paris, 1884), p. 15.

75 '...et l'on regrette que le maitre ait eu d'aussi mauvais collaborateurs que les fours nationaux; pourquoi, sur ces vases, cette teinte brune qui rend illisibles les contours des figurines clodionesques?' 'Exposition de la Porcelaine, sa dorure, sa monture', *L'Art et les Artistes*, vol. 5 (April to September 1907), p. 206.

76 'La sculpture en haut relief trouverait aussi dans ce genre de vases une heureuse application'. Duc, *Rapport* (1875), p. 23.

77 Between 1880 and 1881 Rodin worked 536 hours on the Pompeii vases. Marx, *Rodin céramiste*, pp. 43–44.

78 On the process of making biscuit figures at Sèvres see Véronique Milande, 'Du modèle en terre au biscuit de porcelaine. Les terres cuites du Musée national de céramique – réalisation d'un biscuit de porcelaine', in Marie-Noëlle Pinot de Villechenon (ed.), *Falconet à Sèvres ou l'art de plaire 1757–1766* (Sèvres: Musée national de céramique, 2001), pp. 77–86.

79 On sugar sculpture, see Ivan Day, *Royal Sugar Sculpture: 600 Years of Splendour* (Barnard Castle, The Bowes Museum, 2002).

80 Pinot de Villechenon, *Falconet à Sèvres*.

81 Atterbury, *The Parian Phenomenon*.

82 Typed speech, c. 1887, p. 2. SA/CB.

83 'En 1884, sans parler de toute la part que la sculpture avait dans le décor des vases, nous voyons apparaitre les premiers modèles modernes, le grand surtouts "des Chasses", la figure et le buste de la République, l'exquise Minerve. Ici et là, surtout, il avait su renouer la tradition de grâce – d'élégance, de fantaisie qui avait assuré le succès de la Manufacture au 18ème siècle et que le 19ème siècle avait négligée au point de compromettre l'existence même de l'établissement.' Typed speech, c. 1887, p. 2. SA/CB.

84 In 1870 Rodin worked 84 hours on elements of this centrepiece. Marx, *Rodin céramiste*, pp. 13–14.

85 Sèvres – Cité de la céramique Archive, object file 'Surtouts de tables'.

86 Du Sartel, *Manufactures nationales*, p. 13.

87 Christofle Archive, vol. 11/478/2.4.75.

88 On Choisy-le-Roi and Carrier-Belleuse, see Carmen Espinosa Martín, 'La faïencerie de Choisy-le-Roi a través de los modelos de Albert Ernest y Louis Robert Carrier de Belleuse en el Museo Lázaro Galdiano' *Goya*, no. 274 (January–Febraury 2000): pp. 35–43; and the firm's undated illustrated catalogue *Faïence d'Art, Œuvres de A. & L. Carrier-Belleuse*.

89 Ward-Jackson, 'French Modellers', p. 55.

90 Stuart W. Pyhrr, 'Recent Acquisitions: A Selection 1989–1990', *The Metropolitan Museum of Art Bulletin*, n.s. vol. 48, no. 2 (Autumn 1990), p. 22.

91 '...est d'une invention nouvelle en orfèvrerie. Les personnages qui se détachent en plein relief sur le vase et viennent saillir en avant lui donnent un aspect inusité qui ne manque pas d'élégance'. 'Rapports sur les concours spéciaux du métal', *Revue des Arts Décoratifs* (1880), p. 316.

92 Letter to the Director of Fine Arts dated 25 February 1887. SA/CB.

93 Chéret's appointment was agreed by ministerial decree, 5 March 1887.

94 Memorandum by Lauth regarding the closure of workshops on 6 June, dated 4 June 1887. SA/CB.

95 'La conservation de la maison apparaissait aussi nécessaire que sa destruction avait été jugée indispensable quelques années auparavant'. Typed speech, c. 1887, p. 3. SA/CB.

96 Letter from Ernest Brelay, 10 June 1887. SA/CB.

97 Auscher, *Une Manufacture nationale en 1888*, p. 16.

98 Ibid., p. 17.

99 Achille Ségard, *Albert Carrier-Belleuse 1824–1887* (Paris, 1928), p. 42.

100 Conversation with Tamara Préaud, 3 July 2008.

101 AN F.21.2164A.

102 'divers artistes des modèles de pièces décoratives'. Undated draft letter to the Minister of Fine Arts from Sèvres, AN F.21.2171.

103 Decree of 18 April 1898, AN F.21.2171.

104 Haruko Hirota, 'La Sculpture en céramique de Gauguin: sources et signification', *Histoire de l'Art*, no. 15 (September 1991): pp. 43–60.

105 Turquet retained this position under five successive governments (1879–1881, and 1885–1886). On Turquet, the Haquette family and *The Gates of Hell*, see Butler, *Rodin: The Shape of Genius*, Chapter 12.

106 Jean-Jacques Lévêque, *L'Hôtel de Ville de Paris, une histoire, un musée* (Paris, 1983).

107 'Employé à la Manufacture nationale de Sèvres et ayant obtenu une Mention honorable au Salon de cette année, j'ai l'honneur de solliciter de votre bienveillance éclairée une figure pour les travaux de l'Hôtel de Ville je serai reconnaissant du reste si à défaut de figure l'on me confiait un bas-relief des têtes décoratives mascarons etc ou autre partie statuaire, accessoire quelquefois à des motifs d'ornements.' Letter from Rodin to the Président de la Commission municipale des beaux-arts pour les travaux de l'Hôtel de Ville, Paris, around 20 June 1879, in Alain Beausire and Héléne Pinet (eds), *Correspondance de Rodin, vol. 1, 1860–1899* (Paris, 1985), p. 47.

108 The cost of sculpture, which included the above-mentioned stone statues, stone medallions and allegories in low and high relief, bronze figures, and sculpture to the interior of the building, amounted to 1,620,250 francs; the total project cost was 30,547,161 francs. For a full list and costings for the sculpture (which unfortunately does not include the names of the sculptors), see Louis d'Haucour, *L'Hôtel de Ville de Paris à travers les siècles* (Paris, 1900), pp. 736–741.

109 On the controversy surrounding the *Age of Bronze*, see Butler, *Rodin: The Shape of Genius*, Chapter 10.

110 Ibid., p. 120.

111 According to Mercier, Rodin modelled two masks for the Trocadéro fountain, and Desbois a third; Jocelyn Mercier, *Jules Desbois, illustre statuaire angevin* (Longué, 1978), p. 12. This information was presumably not known to Alhadeff, who suggests that all eleven heads were modelled by Rodin; Albert Alhadeff, 'An Infinity of Grotesque Heads: Rodin, Legrain, and a Problem in Attribution', in Albert E. Elsen (ed.), *Rodin Rediscovered* (Washington, 1981), pp. 51–60.

112 Rodin took classes with Barye at the Museum of Natural History in 1864, where he worked alongside one of Barye's sons; Cladel, *Rodin*, pp. 19–20. On Barye's masks for the Pont Neuf see Glenn F. Benge, *Antoine-Louis Barye, Sculptor of Romantic Realism* (University Park, 1984), pp. 49–51.

113 'Modèle d'une porte décorative, bas reliefs représentant la Divine Comédie de Dante'. For details of the commission, see AN F.2109.

114 Rodin, quoted from a discussion with the Minister, in Cladel, *Rodin*, p. xvi.

115 Butler, *Rodin: The Shape of Genius*, p. 145.

116 Ibid., p. 140.

117 'Auguste Rodin, bas reliefs représentant la Divine Comédie de Dante, 1880', order of 24 February 1904, AN F.2109.

118 'Album de portraits-charges de personnages de la Manufacture', Sèvres – Cité de la céramique Archive.

119 Octave Mirbeau, 'Auguste Rodin', *La France*, 18 February 1885.

120 Octave Mirbeau, 'Auguste Rodin', translated in Ruth Butler, *Rodin in Perspective* (Englewood Cliffs and London, 1980), p. 47.

121 Albert E. Elsen, *The Gates of Hell by Auguste Rodin* (Stanford, 1985), p. 124; Blanchetière, 'Un franc-tireur inspiré', p. 126.

122 Lawton, *The Life and Work of Auguste Rodin*, p. 112.

123 Bedigie et al, *Délégations ouvrières 1862, céramique*.

124 'Rodin fut consigné à la porte de ce Paradis de l'Exposition Universelle par des anges vêtus en appariteurs d'Institut, portant sans flambeau, la petite épée académique, et que notre plus grand Statuaire exposa pour son compte, seul, en dehors de l'Etat.' Gustave Kahn, 'Auguste Rodin', *L'Art et le Beau*, no. 12 (December 1906), p. 102.

125 On the Academy's swords, see *Les épées de l'Académie des beaux-arts* (Paris, 1997).

126 Rodin was, however, awarded the second-highest rank in the Legion of Honour, the Grand Officer.

127 George Sand et al, *Le diable à Paris, Paris et les Parisiens* (Paris, 1845).

128 Blanchetière, 'Un franc-tireur inspiré', p. 126.

129 Ibid., p. 127.

130 It has been suggested that these were rival organisations; Rossella Froissart, 'Les Collections du Musée des Arts décoratifs, modèles de savoir ou objets d'art?', in Chantal Georgel (ed.) *La Jeunesse des musées: les musées de France au XIXe siècle* (Paris, 1994), p. 88. However, many were members of both, even at committee level.

131 The museum finally opened in 1905 under UCAD, in the Louvre's Pavillon de Marsan.

132 'Médailles d'argent, Ginsbach, lit acajou, armoires, bonne exécution', *7e Exposition de 1882 organisée au Palais de l'industrie: deuxième exposition technologique des industries d'art, le bois, les tissus, le papier: documents officiels de l'exposition. Union centrale des arts décoratifs* (Paris, 1883), p. 74.

133 In around 1912 Rodin signed a photograph of the bed, 'figures d'enfants que j'ai faites pour Monsieur Ginsbach en 1882, Aug. Rodin'; 'figures of children that I did for Mr Ginsbach in 1882, Aug. Rodin'. Presumably Rodin's signature was carved on the bed at this time. The bed was designed by Ollinger, and Hiolle executed Rodin's plaster models in wood.

134 Mathias Morhardt, 'Rodin ébéniste', *L'Art et les Artistes,* vol. 1, n.s. (no. 1–9) (1920): pp. 348–349. Morhardt was also editor of *Le Temps*, and promoted the work of Rodin and Zola in his writings.

135 Lot 150, *19th-Century Furniture, Sculpture, Works of Art, Ceramics and Carpets*, 23 February 2006, Christie's, 8 King Street, London. On the rediscovery of Ginsbach's bed, see 'Un chef d'œuvre retrouvé: deux sculptures d'enfants par Rodin', *Plaisir de France* (May 1971).

136 The issue of reproduction has been a significant area of study for Rodin scholars from the 1960s onwards. Some have entered the debate to legitimise modern reproductions, as in Elsen, *The Gates of Hell*; others have explored versions of works to show the differences (and therefore uniqueness) of the reproductions, as in Patricia Sanders, 'Auguste Rodin', in Wasserman, *Metamorphoses*, pp. 145–180.

137 The Musée Rodin has neither acquired nor displayed the bed, and it was not included in its 2009 exhibition 'Rodin et les Arts décoratifs'.

138 Denys Sutton, *Triumphant Satyr: The World of Auguste Rodin* (London, 1966), p. 42.

139 Charles Rosen and Henri Zerner, *Romanticism and Realism: The Mythology of Nineteenth-Century Art* (New York, 1984), pp. 203–232.

140 No. 26, 'Enfants, groupe plâtre peint', *Catalogue illustré officiel du Salon des arts décoratifs, 1883 (2e année). Union centrale des arts décoratifs* (Paris, 1883), p. 24. The exhibition ran from 15 April to 1 June 1883 at the Palais des Champs-Elysées.

141 Alain Beausire, *Quand Rodin exposait* (Paris, 1988).

142 Ibid., p. 81.

143 *Catalogue illustré officiel du Salon des arts décoratifs, 1883*, p. 24, no. 26. This refers presumably to Alexander Constantine Ionides, father to Constantine Alexander Ionides, who bequeathed his art collection to the V&A.

144 On UCAD, see Silverman, *Art Nouveau* and Froissart-Pezone, *L'Art dans tout*.

145 '...à quelle loi de distinctions subtiles on avait obéi autrefois pour arriver à refuser l'accès du Salon à des vases de Klagmann ou de Fannière, alors qu'on acceptait un buste des mêmes artistes, – et quel était le système qu'on prétendait suivre en rêvant des plaques émaillées parce qu'elles étaient présentées dans un cadre en forme de tableau, alors qu'on écartait ces mêmes plaques émaillées lorsqu'elles étaient apportées ajustées dans les moulures d'un coffret pour la décoration duquel elles étaient conçues et exécutées; elle avait décidé qu'aujourd'hui que les artistes peintres et sculpteurs, constitués en corporation, limitent plus étroitement encore les règles auxquelles on avait obéi, il était du devoir de l'Union centrale de porter un remède à cet état de choses, et qu'il fallait ouvrir gratuitement nos portes non seulement aux dessins et aux maquettes, mais encore aux œuvres exécutées, avec la seule condition qu'elles seraient présentées sous le nom de leur auteur, de l'artiste qui les aurait composées ou de ceux qui auraient concouru à leur exécution.' *7e Exposition de 1882*, p. 32.

146 Palais de l'industrie, 1 August to 25 November 1887. These exhibitions were first organised by UCAD's forerunner, the UCBAAI, from 1863 and UCAD continued to administer them. Silverman has focused on the historic exhibitions staged by UCAD and its aristocratic associations, whereas its composition and its exhibition programme was more diverse. Silverman, *Art Nouveau*.

147 *Liste des récompenses. Union centrale des arts décoratifs, 9e exposition de 1887* (Paris, 1887).

148 'Au point de vue de mérite de la forme, de l'invention ou du décor', Ibid.

149 Butler, *Rodin: The Shape of Genius*, p. 240.

150 Ibid., p. 240.

151 Beausire and Pinet (eds), *Correspondance de Rodin, vol. 1*, p. 92.

152 Beausire, *Quand Rodin exposait*, p. 101.

153 Aurélie de Decker, 'Rodin et la décoration monumentale', in Blanchetière and Saadé, *Rodin: Les Arts décoratifs*, p. 79.

154 'Liste des sculpteurs statuaires chargés de la décoration des divers palais de l'exposition universelle', AN F.12.3926.

155 The dossier demonstrates, for example, a concentration of sculptors on the rue de Vaugirard: Rubin at 131, Delorme at 120, Charles Gauthier at 108, Lormier at 108, Louiseau at 117, A. Rubin at 131, Truphene at 152, Louis Noel at no. 108, Labatus at 131, Guilbers at 59. Ibid.

156 Letter from Cuvillier, 14 June 1889. Beausire, *Quand Rodin exposait*, p. 101.

157 Victor Champier, *Les Industries d'art à l'exposition universelle de 1900. Ouvrage en deux parties, deuxième partie, tome troisième, les industries d'art depuis cent ans* (Paris, 1903), vol. 3, Pl. 30.

158 'Grand dressoir de salle a manger en marbre Sarancolin, avec ornements et décoration de marbres divers, composition de M. Cuvillier, architecte, figures de M. Aug. Rodin; exécution de MM Parfonry & Huvé frères', caption to Pl. 30, Ibid.

159 AN F.12.3040. Illustrated in Mesnard, *Les Merveilles de l'exposition universelle de 1867* (Paris, 1867), p. 101.

160 'une œuvre sérieuse', Desvernay, *Rapports des délégations ouvrières, 1867*, p. 5. Illustrated in Mesnard, *Les Merveilles de l'exposition*, p. 103.

161 Detailed advertisement for Parfonry in *Catalogue général descriptif de l'exposition: section française / Exposition universelle de Paris 1878* (Paris, 1878), Group 3, Class 18, p. 8.

162 *Jury international. Exposition universelle internationale de 1900, Direction générale de l'exploitation* (Paris, 1900).

163 Marx, 'Rodin Céramiste' (1905) and *Auguste Rodin céramiste* (1907).

Decorative Sculpture and the Fine Arts, 1890–1895

The *Objets d'Art* Section at the Annual Salon of the Société nationale des beaux-arts, 1892

In 1890 the Société nationale des beaux-arts (hereafter SNBA) was formed by a group of artists dominated by painters, including its President Ernest Meissonier and the sculptors Rodin and Dalou.[1] It was founded as a splinter group to the official Société des artistes français (hereafter SAF). The SNBA did away with medals, established a rotating jury system, permitted unlimited submissions, welcomed foreign artists, and allowed artists to display their work as a group. It also implemented an elitist selection process which preferenced its founder members. *Fondateurs* or founder members (including Rodin and Dalou) were exempt from jury scrutiny; *sociétaires* or members were approved by existing members and had the right to exhibit; and *membres associés* were associate members who were not yet permitted to exhibit. It held an annual Salon at the Palais des beaux-arts at the Champ-de-Mars, known as the Salon du Champ-de-Mars. This was important in terms of ending the hegemony of the official SAF Salon, but was neither necessarily avant-garde nor fully independent of the State. Many of its members were distinguished artists who had regularly exhibited at the SAF, and the Society received state support in the form of exhibition space and the state acquisition of works exhibited at its annual Salon.

In 1892 the SNBA introduced a new artistic category – '*objets d'art*' – at its annual Salon. The existing categories were paintings; watercolours and pastels; engravings; and sculpture. The introduction of a decorative arts category has been described as 'its most striking departure from the practice of the exclusively 'fine art' SAF Salon'.[2] However, as has been demonstrated throughout this book, the decorative arts *were* historically integrated into the 'traditional' SAF Salon. To suggest that this was a novel departure by the SNBA is therefore incorrect; it was more that the SNBA chose to display

these types of works as a unified, distinct group, rather than within existing categories such as sculpture, as the SAF had done previously.

Previous to 1892, manufacturers had attempted unsuccessfully to have decorative art more overtly recognised at the Salon. In 1887 the Réunion des fabricants de bronze (hereafter RFB), the body representing bronze manufacturers, voiced concerns about the tendency for youngsters to abandon industry in favour of a career in the fine arts.[3] In an attempt to counter this, it did not ask sculptors to rally behind industry but called for the bastion of fine art, the Salon, to open its doors to 'artist decorators'. Its annual report for 1890 stated that,

> The annual Salon is a powerful stimulant to our painters and sculptors. Why not open its doors to our artist decorators? Are they less artists, less interesting? But these conventions, these distinctions in the different emanations of art did not exist in the days when industrial art was flourishing and creative: why not let our industrial artists enjoy the same prerogatives as other artists. I think on the contrary that their entrance at the annual Salon would constitute a novel attraction. I dream of a special gallery ornamented with decorative panels, tapestries after new models. The length of the wall panelling would be arranged with furniture, credenzas, sideboards, on which would be placed works in bronze, ceramic, gold, glass ... But a similar Salon exists, the Apollo gallery [at the Louvre] ... But would these beautiful objects of industrial art disfigure the Louvre? Who, then, would want to chase them out? Well, what we can see and admire every day at the Louvre we want to see every year in the Salon of living artists. It would be for our industries, for our artists who would exhibit under *their own name*, a strong stimulant: new, original works, perhaps daring ones, could be produced as a result, and we can hope that amateurs will allow themselves to be tempted to buy these new works, weary at last of eternal repetition.[4]

This passage frames the admission of 'artist decorators' to the Salon within the historical precedent of royal patronage and the Louvre. The Louvre (compared to, say, the National Gallery, London), encompasses both the decorative and fine arts in its collections. This is the direct result of its origins in royal patronage, when furniture was prized as highly as paintings (if not more so) and displayed prominently within the palaces. The RFB positions the industrial arts firmly within this French tradition of unity in the arts. It also signals a contemporary crisis in the industrial arts as no longer 'flourishing and creative'. To counter this, the bronze manufacturers suggest aligning themselves more closely with the fine arts by giving (their) industrial artists greater prominence within the fine art system of the Salon.

The SNBA's initial reasons for introducing an *objets d'art* section were remarkably similar to those outlined by the RFB, as the following extract from *La Chronique des Arts et de la Curiosité* (1891) makes clear;

For its annual Exhibition the Société nationale des beaux-arts du Champ-de-Mars intends to take the opportunity to carry out some views regarding the unity of art which Messrs. Castagnary, Antonin Proust, Aynard, member for Lyon, Roger Marx, etc. have often advocated in their speeches and in their writings. The idea is to open the doors of its salon to the many workers of industrial art. The Société nationale considers that ceramicists, glass workers, enamellers, goldsmiths, cabinet makers, craftsmen in wrought iron, to mention only those, when they show talent, are the equals of painters and sculptors and must share the same privileges and the same rewards. The Société also thinks that a joint exhibition will be an incentive for decorators to produce works of imagination and will serve the interests of industrial art, which has confined itself exclusively to a slavish imitation of the past. In a commendable spirit of competition, the first awards given for achieved efforts and for merit [in this field] will develop this branch of art and restore the strength it has noticeably lost. The Comité du Champ-de-Mars has decided to neglect nothing to convince the newcomers that they are welcome. Only original works, signed by the artist who has created them, will be accepted, without the name of the firm to which they are attached, in order to remove all suspicions of publicity. The three [existing] panels of judges will meet to judge them. A Committee made up of Messrs. Dalou, Dubois, Cazin and Roll, will be in charge of forming the rules that are to be applied to industrial art and to prepare its merging with fine art.[5]

This anonymous article, possibly a press release from the SNBA, is addressed to 'the many workers of industrial art' who, 'when they show talent, are the equals of painters and sculptors and must share the same privileges and the same rewards'. Their identification as 'workers' rather than 'artisans' effectively glosses these goldsmiths, enamellers and others within a quasi-democratic framework predicated on the expression of their specific 'talents' in relation to the fine arts. The 'workers' are to be united (and divided) 'in a commendable spirit of competition', outside the capitalist framework of industrial art and the hegemony of its manufacturers. Removing their work to a context outside the control of manufacturers will allow for the artistic contribution of individual workers to be recognised.

This approach unhelpfully requires the setting up of a false dichotomy between individual creativity and industrial production, but its aim is clear: to redress the problem of authorship in the industrial arts. The article states that the SNBA will only accept original pieces signed by the artist concerned, and that it must not feature the name of its manufacturer. While this recognises and physically records the contribution of the artist on a given object, such a requirement also negates the financial, professional and creative opportunities offered by manufacturers. However, although manufacturers did occasionally include the sculptor's signature alongside the manufacturer's stamp, this was a relatively rare occurrence and was generally reserved for established fine art sculptors. The artist's signature can vary from piece to piece as it is generally executed by the artist directly into the clay model, unlike the manufacturer's

stamp which is standardised. Within a framework that places the artist and manufacturer in opposition to each other, these two marks can mean very different things; the manufacturer's mark certifies a particular quality of production, while the artist's signature is seen to guarantee an authentic artistic product and even suggest that the artist has approved its reproduction.

The SNBA's proposal to 'open the doors of its salon to the many workers of industrial art' was unachievable for most workers (including sculptors). Given the specialisation of the education system, and the division of labour in the processes of production, it would have been unusual for a worker to have been capable of creating a whole work singlehandedly, particularly in an environment which placed great emphasis on perfection of execution and the high level of skills that that implies. Furthermore, it is unclear whether manufacturers would have permitted their workers to exhibit works produced in their employ if the work could not publicise the firm. The question of authorship is further complicated by differences between the SNBA and SAF Salons. In a later, 1913, lawsuit brought by the sculptor Albert Bartholomé against the goldsmith Falize, Bartholomé accused Falize of not including his name on the disputed work.[6] In his defence, Falize claimed that doing so would have contravened the rules governing the Salons, which stipulated that a member of the SNBA (as the sculptor was) could not exhibit at the SAF Salon, where the work was displayed. This poses difficulties for historians regarding the documentation of authorship, and demonstrates the ways in which manufacturers continued to assert their dominance over sculptors.

The opportunity for workers to display their work at the SNBA Salon is also questionable, given the stringent selection process required to exhibit there. This favoured sculptors and artists already operating to some degree within the fine arts. Despite its earlier rhetoric in favour of industrial workers, the SNBA's new category of *objets d'art*, introduced at its 1892 Salon, ultimately favoured independent sculptors rather than industrial workers and sculptors. The title *objets d'art* is noteworthy; it suggests a shift away from direct association with industrial art and its workers, towards original, non-reproduced works in the fine arts. The rules for the *objets d'art* section were as follows:

> As the Société nationale considers that there are good reasons to attach the production of artists, creators of original and non-reproduced objects to the fine arts proper, it has permanently set up a section called the *Objets d'Art Section.* The Society *addresses itself to isolated workers,* those whose work cannot easily be displayed in commercial and cluttered exhibitions called 'Decorative Art', and will do all it can to put these works in the public eye and thus ensure the success and the ownership of these fully personal creations.

> FIRST ARTICLE. Only original works that have not been exhibited at previous public exhibitions are accepted. This category includes not only executed works, but also sketches, drawings and models.

ART. 2. In the case of collaboration, the consent and the signature of the collaborators is required.

ART. 3. Precious objects must be housed in lockable cases or boxes.

ART. 4. In the case of special installations (display cabinets, cases, etc.) the cost falls on the exhibitor.

The cleaning of objects exhibited in this section will take place in the mornings before opening.[7]

The SNBA's ambition of integrating the decorative arts within the fine arts was therefore limited to original and signed works. This served to assert the artists' independence from industry, as it disassociated them and their works from the reproduced and unsigned objects perceived to be prevalent in industrial art. The efforts of Klagmann and the delegation of sculptors at the International Exhibitions of 1862 and 1867 to create a separate category for industrial artists were therefore only partially realised. The new *objets d'art* section was predicated on the superiority of the fine arts rather than on the establishment of a truly independent category of decorative or ornamental art.

Articles 2 and 3 in the regulations refer to the introduction of display cases to the Salon. One of the SNBA's original objectives was to allow artists to display their work as a group, rather than, as was the practice in the SAF Salon, to have their work hung in various areas of the exhibition according to an order and arrangement imposed by the organising committee. Although unfamiliar to those attending fine art salons, where sculpture was located on individual plinths without protection, display cases were commonly in use in museums, international exhibitions and decorative art exhibitions. These affirm the 'precious' nature of the objects contained within, suggestive of high economic value, fragility, and uniqueness; and protect the objects from dust, damage and theft. The cased displays at the SNBA are indicative of the ways in which artists wished to be represented. Thus, Eugène Coupri exhibited five components from the same table service – a large tray in the form of a leaf propped vertically behind four smaller objects. This combination of unity and particularity was reflected in other display cabinets, serving to highlight the artist's unique stylistic or/and material skills, while demonstrating their adaptability and creativity within this specialism.

The materials in the *objets d'art* section were diverse – terracotta, bronze, gold, silver, plaster, glass, pewter, salt-glazed earthenware, enamels, wrought iron, wood, marquetry, watercolours, and a variety of ceramic glazes. Although not all related to works produced by sculptors, the combination as a whole created an ambience distinct to the paintings and sculpture sections. This setting reinforced the domestic nature and scale of many of the sculptural objects exhibited, and their appeal to private buyers.

In terms of quality of execution, those who exhibited within the new *objets d'art* section were not necessarily trained in the diversity of skills required of high quality equivalent examples found in industrial art. For example, sculptors who had worked for manufacturers may have come into regular contact with a broad variety of materials, techniques, surface finishes and practitioners, but their role was to design, carve or model sculptural elements in relation to the particular needs of that industry. In order to do so, they may have had to understand, but have had no need to acquire, skills such as cabinet making or metal chasing.

This in turn influenced the type of *objets d'art* produced for the Salon. As will be examined further in the case study on Desbois, some sculptors developed a 'rustic' aesthetic partly as a result of their limited skills at producing decorative objects. Desbois and Rupert Carabin created works in a single material (respectively pewter and wood), in contrast to the industrial arts where a variety of materials were often employed in a single work. This specialisation by sculptors in a single material enabled them to develop a degree of skill within a specific field. Furthermore, by selecting materials distinct to those operating widely in the fine and industrial arts, such as pewter and wood rather than bronze, marble or porcelain, their work was less likely to be judged unfavourably in comparison to existing examples. This single material approach was therefore, in part, a strategic acknowledgment of their limited expertise in modelling *and* making, rather than in modelling, objects. It also created a new taxonomic category in a competitive art market, which would appeal to critics, private collectors and State institutions alike.

A quantitative analysis of the sculptors and works at the SNBA's Salon between 1890 and 1892 demonstrates the creative and commercial importance of its *objets d'art* section to sculptors. The SNBA's first Salon in 1890 had 39 sculptors and its catalogue lists 83 numbered works; these all refer to single works, apart from four, each of which includes up to ten medallions under the one rubric. The sculptors include Jean Baffier, Alexandre Charpentier, Dalou, Desbois and Rodin. The works are representative of the fine arts – busts, low reliefs, medallions, statues and groups, mainly produced in plaster, bronze and marble; and some in terracotta. Exceptions in terms of materials are Charlotte Besnard's earthenware *Statue of a Girl*; stoneware groups and busts by Alphonse-Amédée Cordonnier and Desbois; and Rodin's silver *Bust of Mrs R****.

In 1891 38 sculptors exhibited 101 entries, broadly following the same types of objects and materials as in 1890. An exception is a new reference to the lost wax technique, which is mentioned in relation to six bronzes. This is indicative of attempts by sculptors to disassociate and differentiate themselves from industrial art by adopting a different method for casting bronze than the sand casting commonly found in large scale enterprises such as Barbedienne's. This preference for unique, rather than multiple, sculpture

is further expressed in the catalogue entry for Jean Dampt's marble *Head of a Child*. This notes that it is a study after nature made without recourse to the pointing process ('étude d'après nature sans mise au point'). This suggests that the head was directly carved rather than made using the more standard method of creating a clay model and transposing it into marble (which often relied on the skills of marble craftsmen rather than the sculptor). Although the term 'direct carving' ('taille directe') was not yet common currency, Dampt is clearly distinguishing his work from other marbles through this process. The only 'decorative' work in the sculpture section is Victor Prouvé's *A Tomb*, a 'decorative panel in coloured clay'.

At the SNBA's 1892 Salon 52 sculptors exhibited in the sculpture section, with 153 numbered entries. These are again typical of fine art sculpture – medallions, busts and groups in marble, bronze and plaster. The number of bronzes produced using the lost wax process is much higher, at 22. These include Jean-François Raffaelli's *Head of a Little Bourgeois*, whose description identifies the merits of the lost wax process – '*unique* example cast using the lost wax process by Gruet [my italics]' – and also advertises the name of the founder responsible. One work was in silver, Alfred Lanson's *Abduction*. Founder members of the SNBA were also represented through busts: Camille Claudel's *Bust of the Sculptor Rodin*, and Rodin's marble bust of Puvis de Chavannes.

In the new *objets d'art* section, there were 50 exhibitors in total, with around twenty being identifiable as sculptors. Baffier, Charpentier, Dampt, Jean Carriès, the Swedish sculptor Christian Eriksson, Constantin Meunier and Ernest Michel-Malherbe all exhibited in both the sculpture and the *objets d'art* sections. They moved freely between more traditionally conceived sculpture such as busts, statues and reliefs in plaster, marble and bronze, and ostensibly functional objects such as vases (Eriksson), a wine jug (Charpentier), a handle for a fan (Jules Brateau), a plaster model for an electric light (Michel-Malherbe) and a wrought iron lamp base (Eriksson). The *objets d'art* section thus enabled sculptors to present a broader variety of works than those traditionally found within the sculpture section of the SNBA Salon, consequently attracting a potentially different client base without ostracising their existing patrons.

While it has been suggested, in relation to two silver boxes by Eriksson, produced for the American collector Isabella Stewart Gardner, that 'perhaps specific meaning should not be sought in such a fanciful work', I would argue that while narrative and symbolic meaning may appear to be less pronounced in decorative objects than in paintings (and has perhaps been overemphasised in relation to paintings), it is not altogether absent (recall Pradier's *Standing Sappho* on a clock, for instance, or the 'narrative' of art history in Barbedienne's Renaissance-style bookcases).[8] Furthermore, meaning also lies in less overtly identifiable areas, such as the significance ascribed to materials, scale and function, as will be explored further in relation to Desbois's pewter ware.

There are 98 numbered entries in the *objets d'art* section, although the actual number is much greater. For example, Emile Gallé exhibited seventeen works under entry 47; Carriès's display case included an unidentified quantity of 'busts, animals and pottery, in enamelled stoneware with fragments of bricks destined for a door for Mrs Vinnaretta Singer, currently in progress'.[9] This use of stoneware reflects its earlier presence in the sculpture section of the 1891 SNBA Salon, and the revived interest in ceramics generated by Carrier-Belleuse's work at Sèvres during the 1870s and 1880s. The *objets d'art* section included a number of vases and other ceramics, some of which displayed artistic experiments by painters, including Eugène Carrière's *Flight of Ducks*, painted on ceramic tiles, a distinctly non-Symbolist work from a painter generally associated with Symbolism. The majority of objects appear to be domestic in terms of scale and destination, from Carabin's *Coffer for Bibelots*, to Coupri's table service. Pewter also made its first appearance at the SNBA Salon in 1892, in the form of plates, table centres and other domestic items by Baffier, Brateau and Desbois.

Desbois's Pewter Ware

Jules Desbois is a relatively unknown artist, and died too late to be included in Lami's invaluable 1914–1921 dictionary of French nineteenth-century sculptors. He was born in 1851 to Jules and Marie Jouve Desbois, innkeepers in the small town of Parçay-les-Pins. He showed an early aptitude for drawing and from 1865 was apprenticed to sculptors in Tours and Angers. In around 1867 he entered the Ecole des beaux-arts in Angers, and in 1873 the Ecole des beaux-arts in Paris. In Paris, he joined the studio of the Academic sculptor Pierre-Jules Cavelier, himself the son of a designer of bronzes, silverware and furniture.[10] Cavelier also taught Barrias, Charpentier and the English sculptor Alfred Gilbert, all of whom, like Desbois, experimented in decorative materials, techniques and objects.[11]

Desbois achieved early success at the Salon, first exhibiting in 1875 with a head, *Orphée* (destroyed), for which he was awarded a third class medal, although a contemporary review noted that it was 'rather worthless'.[12] In 1877 he received his first State purchase, for *Othryades* (destroyed).[13] After his three-year training, Desbois found employment in various undocumented studios and projects, including the Trocadéro fountain (where he met Rodin).[14] In 1879 he travelled to New York, having heard that America offered good prospects for sculptors.[15] He may also have moved there in order to avoid military service.[16]

On his return to France, in around 1881, he gave up sculpture, establishing a business producing heliogravure copies of master paintings, but went bankrupt in the process. He subsequently returned to sculpture and

successfully re-established himself within the Paris art world, partly due to Rodin's interventions. He exhibited again at the Salon from 1884 onwards. At this time, he was living at rue de la Tour d'Auvergne, on the same street as Carrier-Belleuse, and began working for Sèvres decorating vases, and for Rodin at his state-funded studio at 182 rue de l'Université.[17] The following year, in 1885, and on Rodin's recommendation, Desbois received a commission from Baron Alphonse de Rothschild for *Acis changé en source*, now known as *La Source*, which was awarded a first class medal at the 1886 Salon. By 1889 Desbois was living closer to Rodin's studio, at 89 rue Denfert-Rochereau, in the artistic area of Montparnasse.[18] Also on Rodin's recommendation, Desbois was made Chevalier of the Legion of Honour in 1889.[19]

Due to the aesthetic similarities in their work, Desbois today is most generally referenced in relation to Rodin rather than studied as a sculptor in his own right. This is largely because of Rodin's superior professional position – he was Desbois's employer – and, given Rodin's reputation, the assumption that any stylistic parallels must predominantly originate with Rodin. In contrast, another of Rodin's associates, Antoine Bourdelle, has been more widely researched, because he is seen to represent a new direction in sculpture through direct carving. Yet in 1900 Rodin founded the Rodin Institute in association with both Desbois and Bourdelle, suggesting that he considered them to be equally talented sculptors.[20]

The Desbois–Rodin relationship has been most extensively addressed by Véronique Wiesinger.[21] Wiesinger accords Desbois privileged status as the sole artist, apart from Camille Claudel, who can be regarded as Rodin's collaborator rather than as his studio assistant.[22] The most recent monograph on Desbois, published to coincide with the opening of the Musée Jules Desbois in his home town of Parçay-les-Pins in 2001, similarly acknowledges the Desbois–Rodin relationship, and convincingly suggests that in some cases Desbois presents a more complex and subtle understanding of the human condition than does Rodin.[23] While this research provides valuable insight into the complexity of authorship, the focus on the Rodin–Desbois relationship presents a somewhat limited understanding of Desbois's influence(s) and sculptural concerns. Although Rodin's employment and support were important to Desbois as he reintegrated himself into the fine (and decorative – note Sèvres) art worlds, he aligned himself more overtly with the decorative arts than did Rodin. Both sculptors were involved with the SNBA from its inception in 1890. Rodin was a member of the sculpture jury, while Desbois sat on its *Objets d'Art* Committee alongside Dalou, Cazin and Rolle.[24]

In 1892 Desbois first exhibited his pewter ware in the new *objets d'art* section of the SNBA Salon. Rodin never exhibited works in this section, and only ever a few works in its sculpture section despite being a founder member. The new category of *objets d'art* was thus a potentially significant forum for sculptors to exhibit outside of Rodin's 'shadow', as well as potentially attracting new

patrons and sources of income. Desbois's preference for pewter helped him establish a personal and individually recognisable style. As the art critic Gustave Coquiot noted by 1911, anyone could 'instantly' recognise a work by Desbois in the *objets d'art* section:

> With a practised eye, out of all the works of art, you will recognise, instantly, a 'woman' by Desbois; even if, barely in relief, she is modelled at the bottom of a pewter or silver plate.[25]

As this quotation makes clear, the stylistic identification of a sculptor with his work was not restricted to the fine arts. While we may lament the near absence of a sculptor's name on the thousands of objects created under the rubric of industrial art from the 1850s onwards, at least some contemporaries claimed that they could distinguish between them. As the goldsmith Falize (whose pieces sometimes carried both his name and that of the artist) noted in 1879,

> [b]ronze bears the manufacturer's mark, but there is no need to look for the artist's signature to recognise Piat, Carrier-Belleuse, Robert or Moreau ... Carrier created more cupids and nymphs than there are inhabitants in a large county town; and if Piat signed his works, he would equal or, even better, he would outdo in number the works of the most prolific artists of the last century. And Robert, in spite of his invaluable research, and the intelligence that permeates his delicate works, has created more vases, statuettes and furniture pieces than can be kept in a museum, and Mathieu Moreau, if he looks back, must see a long succession of white figures marking his life's stages.[26]

An artist's written signature was thus not the only means of identifying authorship. Also important was a perceptibly personal style of modelling. For those who could distinguish the work of one sculptor from another, the written name, whether on the object, in an exhibition catalogue or on an exhibition label, was simply a means of confirming this. In the case of Desbois, he further identified himself with his works by developing a special affinity with a particular material – pewter.

Desbois exhibited five pewter plates in 1892. The Musée du Luxembourg, which collected the work of contemporary artists, purchased *Women and Centaurs* (Fig. 3.1).[27] A critic observed that the figures on these plates were 'composed in the tormented and curious style of Rodin or of [Félicien] Rops'.[28] While this positions Desbois' pewter ware in the vanguard of contemporary sculpture through a stylistic and thematic association with the works of Rodin and Rops, it is rather a limited interpretation that relies on applying fine art precedents to *objets d'art*. It suggests that critics who attended the Salon had more experience of assessing fine art as opposed to decorative art, and were positioning these works for a readership also more familiar with the fine arts. What is absent from such critiques is an understanding of the additional meanings inherent within decorative art objects – the significance

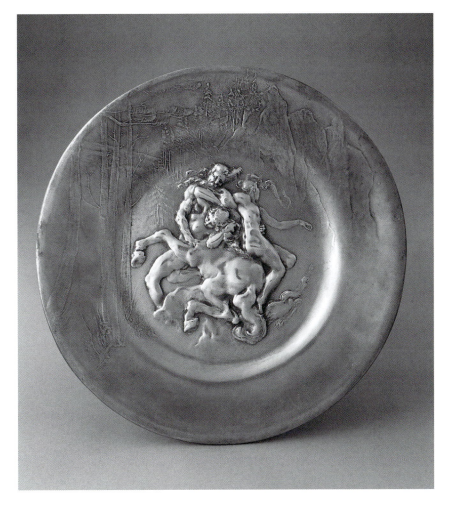

3.1 Adrien-Aurélien Hébrard and Jules Desbois, *Femmes et centaures* (1892), pewter, D 33.7 cm. Musée d'Orsay, Paris.

of materials, form, implied function and style, and their intrinsic relationship to historic precedents within a long tradition of luxury objects in France. There is a kind of narrative object history implicit within Desbois' pewter ware; they are distinct from but inextricably related to and evocative of fifteenth to eighteenth-century precedents through material (pewter), form (round plates reminiscent of chargers, with a slightly concave or flat rim incorporating a decorative border and a shallow dip or raised shallow dome to the centre), implied function (plates, jugs and ewers) and style (relief monochrome decoration without the addition of colour or secondary materials).

In 1894 Desbois exhibited an unrecorded group of pewter under the title *Mes étains* (My Pewter). A few of these have been identified: *Cider Pitcher*, acquired by the Musée du Luxembourg and now in the Musée d'Orsay, and *Pewter Pot* which featured on the front cover of the periodical *Les Arts du Métal* in 1893 (Fig. 3.2). The *Pewter Pot* takes the form of a gourd, and its handle the form of a naked woman. The waisted form of the pot, with its bulbous

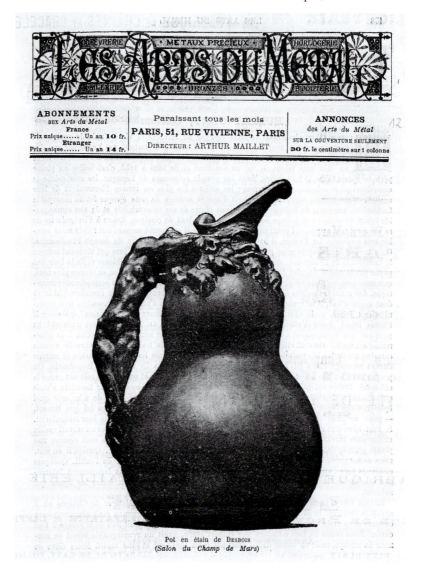

Pot en étain de DESBOIS
(Salon du Champ de Mars)

3.2 Jules Desbois, *Pot en étain* (1892), in *Les Arts du Métal* (September 1893), p. 1. Les Arts décoratifs – Bibliothèque des Arts décoratifs, Paris.

upper and lower sections, recall seventeenth and eighteenth-century pewter tankards, while the sinuous lines of the figure echo their serpentine handles. Her body arches away from the gourd but her extremities lean in/remain attached, creating an opening between herself and the body of the jug and juxtaposing their concave and convex contours. If she relaxed her pose and slid her body slightly to the right, she would meld with the jug. The woman's feet are attached to the lower section of the gourd, and her arms stretch to encircle the neck of the jug, which is decorated with vine foliage and fruit. Her body is not supple and yielding, as was more commonly found in depictions of the female figure at this time, but shows signs of musculature and strain. The jug's lip is angular, erect, in sharp contrast to the curved contours of the body and the handle, and creates a certain tension in the figure and its relationship to the body of the vase. While the scale of the gourd is life size, the woman is clearly reduced to a statuette. She was exhibited by Desbois as an independent figurative sculpture under the title *La Treille* (*Climbing Vine*) (Fig. 3.3), reflecting the hierarchy of figurative over plant-based, ornamental or decorative work.[29]

At the SNBA Salon of 1896, Desbois was accorded his own gallery, in which he brought together thirty-three examples of his work.[30] These include his decorative and other sculpture, produced in a variety of materials that were simultaneously exceptional and characteristic of both: pewter, wood, plaster, marble, bronze and silver.[31] The catalogue entries accompanying all these works are more detailed than before and identify his decorative work in the same way as fine art sculpture, with title, object type and material. Scale, as was usual, was not included. Thus, the catalogue entries for his pewter pieces at the 1896 SNBA Salon are as follows,

44. *Autour d'une Courge (Around a Squash)*, tobacco jar (pewter)

45. *Le Cep (Vine Stock)*, pitcher (pewter)

46. *Le Lierre (Ivy)*, pitcher (pewter)

47. *La Danse (Dance)*, jug (pewter)

48. *Halte (A pause)*, hunting gourd (pewter)

49. *Le Coucher (Bedtime)*, candlestick (pewter)

50. *Faunesses (Fauns)*, small pot (pewter)

51. *La Tentación (Temptation)*, cider jug (pewter)

52. *Huitre à la Perle (Oyster with Pearl)*, ring holder (pewter)

3.3 Adrien-Aurélien Hébrard and Jules Desbois, *La Treille* (after 1890), terracotta, 19.5 × 6.9 cm. Musée d'Orsay, Paris.

Plate 1 Victor Paillard and James Pradier, *Clock Garniture of the Standing Sappho by Pradier* (1848), silvered and gilt bronze on a black marble base, 71.5 × 44.5 cm. Paris, Musée de la Vie Romantique.

Plate 2 Lapeyre & Cie, designed by Wagner, *Décor 'Style de la Renaissance'* or *Chasse et Pêche*, wallpaper, hand painted and printed, 286 × 323 cm. Les Arts décoratifs – Musée des Arts décoratifs, Paris.

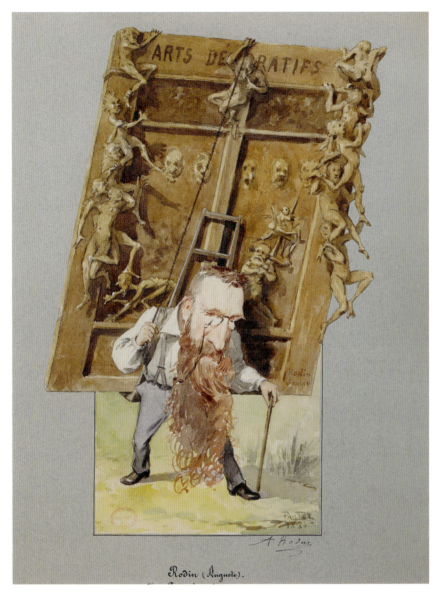

Plate 3 Ferdinand Paillet, *Rodin* (1884), watercolour in 'Album de portraits-charges de personnages de la Manufacture'. Sèvres, Cité de la céramique.

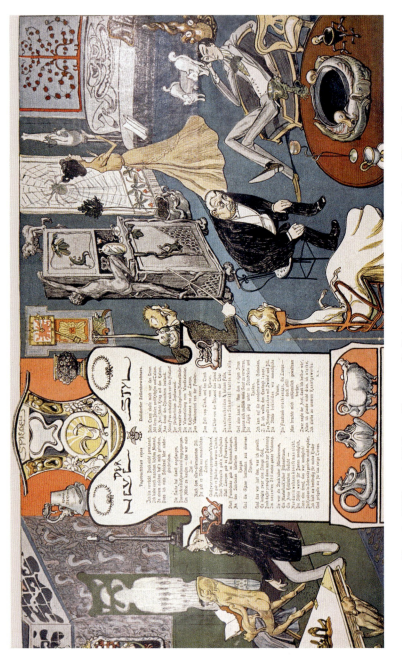

Plate 4 William A. Wellner, 'Der neue Styl', in *Lustige Blätter* (1899), vol. 14, no. 17, pp. 8–9.

53. *Phoebé (Phoebe)*, vide-poche (pewter)

54. *Fillette (Young Girl)*, study for a bust (pewter)

55. *L'Eau courante (Running Water)*, oval plate (pewter)

56. *Charybde (Charybdis)*, plate (pewter)

57. *Léda (Leda)*, plate (pewter)

58. *Eve (Eve)*, plate (pewter)

59. *La Proie (The Prey)*, plate (pewter)

60. *La Houle (The Swell)*, plate (pewter)

61. *La Houle (The Swell)*, plate (pewter) [sic]

62. *Sirène aux Roches (Mermaid on Rocks)*, plate (pewter)

The SNBA's catalogue lists these within the sculpture, rather than the *objets d'art* section, suggestive of a further porosity between the arts. It reflects a continued hierarchy, in which a solo exhibition defines the 'arrival' of a sculptor and thus merits inclusion in the sculpture section, while the inclusion of decorative objects within this gallery denotes a more extensive acceptance of the decorative within the fine arts than the SNBA's separate category of *objets d'art*. Furthermore, the titles of some of these works reflect those found more generally in painting and sculpture, notably biblical and mythological figures such as Eve, Leda, and Phoebe; and moments of action or decision, such as retiring to bed or being confronted by temptation. An aquatic theme is also present, from a mermaid on the rocks to an oyster with a pearl, both of which are evocative of Venus. More particular to Desbois' work are the titles that recall local vegetation, as in *Around a Squash*, *Vine Stock* and *Ivy*. This reflects a contemporary interest in national and regional plants, as perhaps most popularly expressed in the work of Gallé and what would become known as the 'Nancy School' of decorative arts. The objects themselves imply functionality, although it is improbable that Desbois' plates were ever eaten from, considering the relief sculpture at their centre.

Desbois's choice of pewter as a material distinguished his work from both contemporary industrial and fine art, and simultaneously placed him firmly within a long tradition of luxury pewter ware in France. It took place around a decade after academic interest in the material began in the early 1880s. In 1880 the goldsmith and art historian Germain Bapst, a member of UCAD's commission, was invited to display and classify the pewter section at its 'History of the Metal Industries' exhibition. This led Bapst to research and

publish the first French studies on pewter between 1882 and 1884.[32] Bapst's interest lay in historic objects and historical records; he consulted with archivists and curators, not with manufacturers or artists.[33] He identified the Renaissance as the highpoint of pewter production in France, as exemplified in the work of the medallist and pewterer François Briot, who was particularly renowned for his pewter chargers. Although worked with relief decoration, these large plates with their circular interrelated designs to the centre and border partly give the effect of sculpture in the round, while their decoration and scale denote their function as objects of status and ceremony rather than as items of functional tableware.

Although taken up by a few sculptors in the 1890s pewter is less researched as a sculptural medium than the more traditional sculpture materials of marble, bronze and plaster.[34] The French word 'étain' denotes both tin and pewter, which can lead to some confusion. Pewter is an alloy of tin and other metals, notably lead. Pewter can be cast, spun, pressed, rolled and hand formed. Its surface can be polished or darkened, engraved, etched, hammered, gilded, painted and enamelled. France was not a major producer, and imported from various countries, including England and Germany. However, its use must have become extensive enough for the publisher Roret to produce an instruction manual on its manufacture in 1909.[35] The production process was similar to casting bronze, apart from sealing the mould with flaming charcoal after pouring the hot metal in order to maintain the temperature and prevent oxidisation. This is important, given that pewter, unlike bronze, is generally not patinated or gilded. The chasing methods are the same as those used in the bronze industry, apart from the polishing process which is particular to pewter's distinctive malleable qualities. Pewter can be highly polished without the overt brilliance of silver; it 'dissipates the light across the surface and produces soft shadows', producing a 'remarkable suppleness' that is 'soft to touch'.[36]

The first contemporary work in pewter to be reviewed by critics was the *Zodiac Plate* (1878–1880), stylistically inspired by the Renaissance and the work of Briot. Created by the sculptor, goldsmith, jeweller and pewterer Jules Brateau, this was first exhibited at the 1882 Exhibition of Decorative Arts. When it was later exhibited at the International Exhibition of 1889 the jury asked to view the moulds and to observe the casting process, presumably because it was such a novel material in the arts.[37]

At the SNBA Salon of 1892, pewter was represented in the *objets d'art* section by both Desbois and Baffier. As Neil McWilliam observes in his study of Baffier's decorative art, Baffier adopted naturalism as a regionalist reference to the peasant wares of his native central France and as a nationalist reference to the Middle Ages; his work 'was seen to possess a moral power in which form and material signified the unspoilt integrity of "la France profonde"'.[38] Other sculptors who experimented in pewter in the 1890s include Ledru,

Charpentier, Moreau-Vauthier, Max Blondat and André, whose pieces were edited by the bronze manufacturers Siot-Decauville, Susse and Collin. These were purchased by museums including the Musée du Luxembourg and the Musée Galliera.

The use of pewter by contemporary artists was, as I suggested previously, partly a strategic acknowledgment of their limited expertise in making, rather than in modelling, objects. Pewter's surface does not require the extensive chasing of a bronze and its supple, semi-reflective surface lends itself to 'impressionist' rather than precise decoration. However, the very fact that sculptors were modelling *and* producing their own domestic objects, and exhibiting them independently of a manufacturer, was a cause of some concern; if an artist could do so successfully, the artisan and manufacturer would, in effect, be made redundant in the production of 'artistic' objects. Victor Potier addressed this issue in 1902, in an article on pewter in the industrial arts. He suggests that artists were not equipped to make pewter objects:

> Most of the time artist-sculptors who deal in industrial art are not artisans enough; they do not always know the craft for which they create models and are insufficiently aware of the needs of the industrial art for which they work; they only create objects which, as soon as they are created, can only become collection or museum bibelots.[39]

Potier's unease regarding the use of pewter in the fine arts is revealing in terms of the distinctions between art and industry and the professional divisions between artists, artisans and manufacturers. While it must be remembered that Desbois did not necessarily cast his own pewter, the fact that he exhibited it independently of the manufacturer is a decisive modification to earlier practice. Furthermore, Potier belittles attempts by sculptors to create artistic objects out of 'industrial' materials, dismissing them as 'museum bibelots'. Coquiot echoes this in his critique of pewter at the Salons, describing it as a 'mania' with little intrinsic value; 'even [Desbois] didn't escape the mania for specialisation, which renders such a service, it must be said, to lazy brains and short memories'.[40]

Desbois's involvement in the decorative arts was partly a means of asserting his independence from manufacturers, dealers and existing institutions such as the SAF, but he did so by joining with other artists in alternate self-governed groups, the SNBA and L'Art dans Tout.[41] This reveals the importance of artist networks to a sculptor's career, and their cooperation in creating self-directed forums to promote their personal careers and the status of sculptors more broadly. The *objets d'art* section at the SNBA is a good example of this, as it united a range of artists, primarily sculptors, within a newly defined yet relatively flexible category. This enabled them to extend the types of works they exhibited, and thereby widen their appeal to a diverse range of museums, collectors and even manufacturers.

Desbois's involvement in the SNBA's *objets d'art* section between 1892 and 1896 was also partly an astute response to the State's purchasing system, of which he would have been well aware given that the State purchased his works at the Salon from 1875 onwards. The State actively encouraged the decorative arts through its support of the national manufactories. A remit of the Musée du Luxembourg, which displayed the work of living French artists, was to acquire pieces produced by Sèvres, Gobelins and Beauvais. It could also purchase works by independent artists providing they had been admitted to the Salon. The SNBA's *objets d'art* section, whether consciously or not, thus provided a potentially important opportunity for sculptors to have their work purchased by the State. As has been noted, the Musée du Luxembourg acquired Desbois's pewter plate, *Women and Centaurs*, and a pewter pitcher, in 1893. By 1894 the Museum had a collection of forty-two *objets d'art*.[42] This system also made it easier for curators of contemporary art to purchase works which showed progress in the decorative arts, as its inclusion in the Salon implied a degree of peer selection; furthermore, the numbers of objects represented were manageable, compared to the extensive and dense displays found at the international exhibitions.

Despite Desbois's involvement in the SNBA, he is described by contemporary critics as an isolated individual. This is seen to express independence of spirit and an artistic authenticity untainted by external influences:

> Solitary, not very talkative, unconcerned by society and too independent to show himself as so many do in ministerial antechambers, he always believed that his studio, from early morning, was the only retreat he needed to be happy, and he worked without respite, with a tenacious and thoughtful mind.[43]

This description of Desbois as a man of few, yet significant, words, is echoed in similar portraits of Rodin. This was a motif adopted by critics to integrate essentially 'uneducated' working class sculptors into the cerebral and literary world of the *fin de siècle*. Silence is interpreted as profound, rather than as ignorance; physical and vocal isolation represent a serene and sincere dedication to art. The complexities of social class, artistic independence and institutional acceptance have been sensitively and extensively studied by Anne Wagner in relation to Carpeaux.[44]

In 1896 Desbois's studio was located on the rue des Plantes in Petit-Montrouge. The studio was vast, half brick, half wood, its garden merging with the nearby railway embankment. Contemporary critics interpreted the garden as an extension of his studio. It was here that Desbois gathered pumpkins, squashes and gourds that served as models for his works in pewter:

> The studio had no expensive wall hangings, rare furniture, exotic plants, nor a piano, or a guitar; only a few shelves in white wood, a rusty stove, a

watering can, a bucket, clay and roughing out and measuring tools, callipers, etc. … These shelves bend under the weight of animate and inanimate objects: pewter moulds, bronzes, scratched statuettes, salamanders, squashes, morel mushrooms, thistles, seaweeds, trunks of miniature willow trees, shrivelled leaves, etc. … plunged in bottles filled with water, beautiful long-stemmed thyrsus, where the eye can follow, day by day, hour by hour, the miracle of flowering. And it's from this disorder that the master's chefs-d'oeuvre emerge.[45]

This description suggests that in around 1896 artistic success was measured by the absence, rather than by the trappings, of wealth. Desbois's apparent poverty is understood as a noble choice, as dedication to his art rather than the pursuit of financial rewards, and of an art aligned with nature. It reflects, though differently, Huysman's novel *A Rebours* (1884) in which the protagonist, tired of his decadent life in Paris and sickened with human society, retreats to an isolated life in the country, although the house itself is meticulously designed by its owner. Desbois's studio is distinct to those one might more commonly associate with the 1890s. It is the sparse, functional studio of an artist worker rather than the contrived interior of a Parisian artist with its 'expensive wall hangings, rare furniture, [or] exotic plants'. Desbois produces masterpieces, but does not feel the need to assert this through the creation of a 'successful' studio environment. Rather, he lives as close as he can to his creative inspiration, nature, which is found both within, and in the direct vicinity of, his studio. This in turn is seen to embody a greater authenticity than the elaborately furnished studios of his aspirational colleagues. As in the reference to his silence, the description of Desbois's studio makes a virtue of Desbois's poverty, reconciling necessity with moral and artistic superiority.

Desbois lived at a time when a sculptor's livelihood was extremely precarious, despite the extensive application of sculpture in industry and commissions by the State. To suggest, as I do, that Desbois was both a talented, independent sculptor, and an opportunist, should not be read as incompatible, or denigrating his artistic credentials. His association with the SNBA may have been a strategic affiliation to further his own profile within the art world, but it was also a meeting place for friends and colleagues, and his involvement in the creation of its *objets d'art* section was a serious contribution to the redefinition of Salon sculpture during the 1890s. His creation of pewter ware could be regarded as a creative gambit to attract an additional source of income to his fine art 'proper', in an art world thirsty for novelty. This economic imperative should not affect its reception as an art historical field of study; through it, he pursued his own creative direction, notably through naturalism, his experimentation with materials, and his extension of the parameters of sculpture to incorporate quasi-functional objects.

Desbois's involvement in the SNBA situates him in a variety of overlapping areas: the avant-garde and the institutional, the 'bibelot' and fine art, the creative and the economic, and the personal and the collective. This

reveals perhaps more accurately the very real concerns and motivations of nineteenth-century sculptors than a focus on, say, style: artistic creativity and recognition, and perhaps more fundamentally, artistic autonomy, market control and financial independence, as well as the ongoing crossover between these domains. Desbois's pewter work demonstrates a successful attempt by a sculptor to develop his sculpture practice within changing capitalist, political and institutional frameworks.

In the final section of this chapter, I examine the partial integration of decorative sculpture within the fine art establishment, through a study of the posthumous exhibition of the mainly decorative sculptor Joseph Chéret at the Ecole nationale des beaux-arts in 1894.

Chéret's Posthumous Exhibition at the Ecole des beaux-arts, 1894

On the morning of 13 December 1894 Georges Leygues, Minister of Education and Fine Arts (1894–1895), inaugurated the posthumous exhibition of the works of Joseph Chéret at the Ecole des beaux-arts.[46] He was received by the exhibition's organising committee, which represented the great and the good of the fine art establishment: Henry Roujon, Director of Fine Arts and the committee's Honorary President; its Presidents, the sculptors Frémiet and Jean-Léon Gérôme; and committee members including the poster artist Jules Chéret (Joseph Chéret's brother), the painter Pierre Carrier-Belleuse (son of Albert-Ernest), the sculptor Paul Dubois (Director of the Ecole des beaux-arts) and Henri Bouilhet, a founder member of the Union centrale des arts décoratifs.[47] Dubois, Frémiet and Gérôme were members of the Academy of Fine Arts, and Bouilhet, Gérôme, Frémiet, Dubois and Chéret were recipients of the Legion of Honour.

It could therefore be assumed, given the exhibition's location and the status of its organisers and supporters within the fine arts, that Joseph Chéret was an established and respected Academic sculptor. Yet Chéret was a relative outsider in terms of official awards, commissions, and his sculpture practice. Although he did exhibit at the Salon, he was primarily a decorative sculptor, whose services were principally called upon by industry. Why, then, was he honoured posthumously by the fine art establishment? And why has he since languished in obscurity?[48] Specific decorative qualities in Chéret's work have problematised his integration within the art and design scholarship on the 1890s, namely an overt reliance on eighteenth-century models, his representation of women and infants, and the gaiety and humour inherent to his work. These sit uncomfortably within the study of sculpture and the decorative arts of this period, which is dominated by works which can be categorised as perceptibly 'modern' and their supposedly related qualities of intellectual and aesthetic progress.

In order to understand why Chéret's posthumous exhibition took place at the Ecole des beaux-arts, it is useful to consider an event that took place there earlier that year. This was a two-week congress on the decorative arts, hosted at the school, organised by UCAD and presided over by Eugène Spuller, Minister of Education and Fine Arts (1893–1894). The published transcript of the conference and related discussions in contemporary journals provide valuable insights into the concerns of sculptors regarding their position within the decorative arts during this period.[49] It also sheds light on the Ecole des beaux-arts' decision to host an exhibition of Chéret's work.

THE 1894 CONGRESS ON DECORATIVE ART AT THE ECOLE DES BEAUX-ARTS

On 18–30 May the 1894 Congress on Decorative Art took place at the Ecole des beaux-arts, attended by some 390 delegates.[50] It was organised by UCAD, suggesting a degree of cooperation between the Department of Fine Arts and this independent decorative art organisation.[51] The Ministry's decision to offer the Ecole des beaux-arts as a venue may have been prompted by the critical success of the SNBA's introduction of an *objets d'art* section at its Salon two years earlier. The congress's programme was organised around a number of set questions pre-agreed by UCAD, including the role of imitation in industrial art, the influence of women in the decorative arts, the exemption of industrial art workers from military service, and the role of decorative art museums.[52] The published transcripts reveal specific concerns raised by sculptors, particularly regarding the status of *sculpteurs-modeleurs* and *sculpteurs-ornemanistes*, authorship, and artistic and industrial copyright. It is on these that I focus here.

On the morning of 22 May the *sculpteur-modeleur* Eugène Coupri gave a paper on behalf of the Artistic Union of Sculptor-Modellers (*Union artistique des sculpteurs-modeleurs*), which was printed in the journal *Les Arts du Métal*.[53] It echoed concerns by the sculptor-delegates at the 1862 and 1867 International Exhibitions regarding professional identity and status:

> Today, the greatest confusion reigns in all that touches the industrial arts. The artists who create, those who invent, who compose the models for all artists are daily confused with artisans and art workers. The *sculpteurs-modeleurs* are unknown and unrecognised.[54]

Coupri concluded that the profession's isolation was mostly self-inflicted due to a lack of organisation, group identity, identified objectives and self-promotion.[55] The delegates also identified their exclusion from, or at least minimal representation in, important networking sites such as UCAD and the Réunion des fabricants de bronze. *Sculpteurs-modeleurs* are notably absent at UCAD's committee level throughout its thirty-year history.[56]

Sculptors also expressed their concern regarding UCAD's and manufacturers' extensive use of extant and historic models, which limited the demand for new designs and models. UCAD sold plaster casts of its own and other historic collections to industry, and manufacturers acquired models at auctions of businesses that had closed.[57] *Sculpteurs-modeleurs* were the most affected by this practice, of whom 'the happiest make ends meet while the rest live in terrible poverty'.[58] An interrelated problem raised by the sculptors was education and training. UCAD was accused of excluding the poorest paid sculptors from its library, as they could not afford the joining fee of thirty francs.[59] This limited their efforts at self-improvement and the creation of new models for industry. In around 1894 the art critic, journalist, historian, novelist and early champion of the Impressionists Gustave Geffroy proposed a 'Museum of the Night', an (unrealised) related initiative supporting artist workers.[60] Geffroy envisaged a situation where artisans could exhibit the works they produced independently of industry, namely in their private time, at night.

Sculptors also questioned the proposed reform of the education system by UCAD, which Coupri condemned as hierarchical and unrelated to the needs of artists and industry.[61] Coupri identifies two distinct types of sculpture, each with their own ideal beauty, and specific educational needs:

> The *sculptor-statuaries* find this summit in the anatomical study of the human body which bears no correlation to the knowledge of the sculptor of applied art who finds his summit in the study of styles. Thus if each of these branches of art has its own expression it is impossible that one runs into the other.[62]

This distinction between the arts is an unexpected alternative to the contemporary impulse to unite the arts, particularly as it comes from a sculptor-ornamentist who could be expected to have aspired to the trajectory of progress facilitated by initiatives such as the SNBA's *objets d'art* section. In its place, Coupri suggests two distinct, parallel artistic categories, each with its own value system, echoing the initiative of Klagmann in 1855 and of sculptors in 1862 and 1867 to create a distinct category for industrial or ornamental sculpture. This challenges the supremacy of the fine arts more fundamentally than the SNBA, because it suggests that the methods for appraising fine and decorative sculpture are not interchangeable, but specific. Coupri's model was not taken up at the time, but his vision can be seen to have partly borne fruit in the division between art and design that characterises the early twentieth century onwards.

Despite its critics, the 1894 Congress successfully consolidated the dominant position of manufacturers in the decorative arts. This is particularly borne out in the congress's resolutions on copyright. It instigated a system of registration of artistic models by sculptors and ornamentists, through a new archive of artistic and industrial copyright to be housed at and controlled by

UCAD.[63] Three models were to be deposited by the sculptor: one to be kept in the Society's register, another in its collections where it would be catalogued, and a third to be stamped by the society and returned to the depositor.[64] The congress also adopted a printed form to facilitate this transfer of property rights:

Sketch or photograph	Transfer of property rights
	No. … Paris [date]
	The undersigned (1) [name] certifies to having executed the model (2) [description] no. (3).
	I certify to having sold for the sum of [sum] this model to Mr [name] **all rights**, that is to say with all rights of reproduction, in all dimensions, in all materials, by all processes and with the freedom to transform the work without changing its character (with or without the right to include my signature). This transfer of property is made for France and Abroad, without any reservation, whatever future changes may be made to existing laws by new laws and international conventions. This serves as a bill and a receipt for all sums relative to this model.
	(4) [Signature]
	Address
	Affix a ten cent stamp

(1) Surname, name, profession. (2) As full a description as possible and a sketch in the margin of this receipt, or attach a photograph made after its execution, certified and signed by the artist. (3) Number of the model in the register. NOTE – The editor is required to return a copy of this to the author, certified by him and confirming the above receipt. (4) If the receipt is printed or is not fully written in the hand of the artist, he should write on this line the following words: READ and APPROVED after having effaced those words above which do not absolutely conform to the agreement between both parties. [The reverse of the form states as follows: We advise those purchasing models to post this, so that the administrative stamp can, if necessary, serve to establish the precise date of receipt].

This form unequivocally benefits manufacturers rather than sculptors. Unlike earlier contracts by the likes of Barbedienne and Susse, which were individually written for each transfer of property rights, this form presents the full transfer of all property rights as standard. There is literally no room for sculptors to reserve their property rights in specific dimensions, materials or processes, for example in marble. Furthermore, the editor could 'transform' the work, and maintain the right to include (or exclude) the sculptor's

signature irrespective of whether the sculptor approved of the changes. This would presumably apply to its application on various types of objects, and as constituent parts.

More fundamentally in the context of this chapter, the register and its associated form reveal industry's anxiety over sculptors who were attempting to control their affairs through the creation of independent works for alternative exhibitions, including the SNBA. The responsibility and expense for establishing copyright is placed on the sculptor, who had to pay for the stamps, copy the form in triplicate, and commission a photograph if necessary. Enquiries at UCAD's archive and museum (now the Musée des Arts décoratifs) have been negative as to the survival of this register. However, at least three examples of the completed forms survive in the Barbedienne Archive at the Archives nationales.[65] These include a sculpted wooden cartel clock by Edmond Becker sold with full rights in 1898 for 1,800 francs. The organisation of Chéret's posthumous exhibition at the Ecole des beaux-arts by Academic sculptors could therefore demonstrate a degree of professional solidarity in the face of industry's increasing control over artistic and industrial copyright.

CHÉRET'S POSTHUMOUS EXHIBITION AT THE ECOLE DES BEAUX-ARTS, 1894

Although little is known of Chéret, the fact that a group of prestigious figures within the fine arts organised his posthumous exhibition suggests that he was personally liked and respected by them. They may also have wished to support his widow, Carrier-Belleuse's daughter, Marie, who would undoubtedly have encountered her father's and husband's network of sculptors, clients and colleagues, either at home or in the studio; they lived and worked a few doors from each other at the rue de la Tour d'Auvergne.[66] The exhibition may also have served the particular agenda of its organisers in asserting the profile, rights and status of sculptors within a legal and economic framework increasingly dominated by industry. It also suggests an alignment with the SNBA over the SAF, as the SNBA had introduced an *objets d'art* section in 1892. The SAF would do so in the year immediately following Chéret's exhibition at the Ecole des beaux-arts.

The exhibition comprised a staggering 1,128 works. These were first exhibited at the Ecole des beaux-arts from 14 to 21 December 1894, and then transferred to three rooms at the Hotel Drouot auction rooms, where they were sold over a four-day sale from 26 to 29 December 1894.[67] The accompanying catalogue served the sale and the exhibition, a fact that is not always made clear in abbreviated library entries which suggest it is a sale catalogue.[68] The catalogue's final section refers to twenty-eight loans from private and corporate collections. These provide the clearest indication of Chéret's involvement with industry, including works by Sèvres, Baccarat, Christofle and Godillot.[69]

The exhibition's catalogue proper (excluding the loans) is organised by material (numbers are given in brackets) – plaster (8), terracotta (46), bronze and pewter (30), earthenware (8), original drawings (927), photographs (5) and watercolours (2). The catalogue is unfortunately not illustrated, but it does list individual as well as groups of works, including titles, materials, some dimensions, and references to completed projects. A broad range of objects are represented in each category, from a model of a fountain executed for the department store Magasin de la Place de Clichy, to designs for clocks, pianos and table centres. Some feature in more than one material or adaptation, for example the vase *Children with Frogs* is listed alongside a similar pair cast in silvered bronze and mounted as lamps by Gagneau. The most common objects are vases, chimneypieces and light fittings, including a section devoted to electric lights. None of the works are dated, but as one commentator observed, the retrospective nature of the exhibition enabled a chronological assessment of Chéret's work, from his Louis XVI 'imitations' to his more 'modern' conceptions.[70] The catalogue was available for sale in Paris, London, Frankfurt, Rome, Amsterdam and Berlin, suggesting a Europe-wide appeal for Chéret's models and designs from collectors, manufacturers and museums.[71]

Before turning to a more detailed study of the exhibition, it is worth examining Chéret's biography, and the reasons why he aligned himself with the fine arts towards the end of his career through the SNBA's *objets d'art* section. Gustave-Joseph Chéret, known as Joseph Chéret, was born in Paris in 1838, to Nicolas-Marie Chéret and Justine Ormeaud, whose occupations are unrecorded.[72] His elder brother by two years was Jules Chéret. Jules was apprenticed to a lithographer and Joseph to the ornamentist Gallois. They lived together in a small room, and spent their evenings drawing and reading, and their Sundays in museums.[73] Following his apprenticeship, Chéret worked for a variety of bronze founders, cabinet makers and goldsmiths.[74] In 1863 he exhibited his first piece at the Salon, a plaster *Flowers*, followed in 1865 with a plaster medallion, *Portrait of the Empress*.[75] A little-known fact is that Chéret and Carrier-Belleuse both entered the sculpture competition in an 1863 exhibition of fine arts applied to industry.[76] Chéret was awarded the first prize, for a low relief of a vase of flowers, while Carrier-Belleuse received the second prize for a 'charming' terracotta clock design.[77] This also gives the earliest known address for Chéret, near the Champ-de-Mars, while Carrier-Belleuse was located to the north, near the bronze district.[78] At a similar exhibition in 1865 the jury criticised Chéret's decoration (which should be accessory to the object) and its combination of sculpture in the round with low relief.[79]

In 1866 Chéret joined Carrier-Belleuse's studio, and appears to have worked closely with him until Carrier-Belleuse's death in 1887, when Chéret temporarily assumed his position as Director of Works of Art at Sèvres. As has been noted, their relationship was strengthened through Chéret's

marriage to Carrier-Belleuse's daughter, Marie (date unknown). It is probable that Carrier-Belleuse employed Chéret in 1866 in order to fulfil obligations to manufacturers for creating works specifically intended for the International Exhibition in Paris in 1867. Unfortunately, no documentary evidence related to either Carrier-Belleuse or Chéret's sculpture practice survives to establish the details of their individual practices, working relationship, commissions, clients and so forth. However, surviving works shed some light on Chéret's responsibilities within Carrier-Belleuse's studio. They collaborated on at least three pieces for the 1867 Exhibition: a silver dressing table and mirror by Christofle (the table survives at the Musée des Arts décoratifs), which was directly inspired by the work of Adam Weisweiller, Marie-Antoinette's royal cabinet maker; an elaborate lock by the celebrated locksmith Huby; and a circular display cabinet by Alessandri and sons, recently restored by the Petit Palais.[80] The manufacturer supplied the design, and in all three works, Carrier-Belleuse modelled the figures and Chéret the ornamental sections. This suggests a division of specialisation within Carrier-Belleuse's studio between figurative and ornamental sculpture. Chéret also worked independently of Carrier-Belleuse for the 1867 International Exhibition, designing and modelling a Louis XVI-style piece of furniture and caryatids for the cabinet maker Grohé.[81]

In 1873, at the age of 35, Chéret enrolled in drawing classes in the studio of the painter Léon Bonnat, whose students included John Singer Sargent, Henri de Toulouse-Lautrec and Edvard Munch (not necessarily at the same time).[82] This suggests that Chéret was actively seeking to develop his drawing and sculpture skills through practical application in Carrier-Belleuse's studio as well as external, specialised tuition. After five years with Bonnat, 'he revealed himself to be an equally knowledgeable and original figurative modeller-designer'.[83]

Following Carrier-Belleuse's precedent, by around 1878 Chéret had therefore developed the skills required for a successful career within the industrial arts – drawing and modelling ornamental and figurative sculpture. He also developed a similar interest in the Rococo, adopting and extending a Clodionesque subject matter and sensibility in his own work, and in his use of terracotta. Chéret continued to be inspired by Carrier-Belleuse after the latter's death, as can be seen in a vase on which he collaborated with Gallé in 1889 (Fig. 3.4). This bears a strong resemblance to Carrier-Belleuse's published design for a vase (Fig. 3.5). This suggests either that the manufacturers were aware of the design and approached Chéret as Carrier-Belleuse's 'successor', or that Chéret was integrating Carrier-Belleuse's designs within his own repertoire. Carrier-Belleuse's designs were not, to my knowledge, copyrighted.

Unfortunately, Chéret's culmination as a proficient sculptor-ornamentist occurred at a time in which sculptors increasingly found fame and fortune not

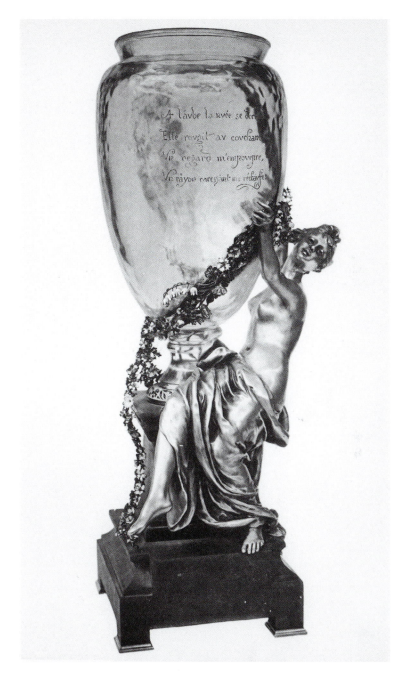

3.4 Maison Bréant & Coulbeaux, Joseph Chéret and Emile Gallé, *Vase Mounted in Silver with a Garland of Fine Gold and Enamel* (1889), in 'Les Industries d'Art à l'exposition universelle de 1889', supplement to *Revue des Arts Décoratifs* (September 1890), p. 105. Les Arts décoratifs – Bibliothèque des Arts décoratifs, Paris.

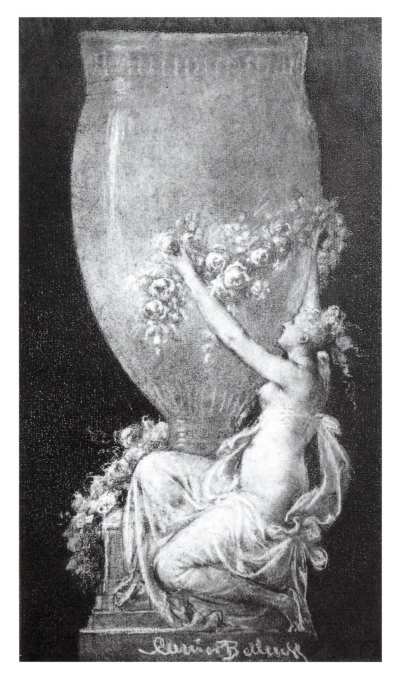

3.5 Albert-Ernest Carrier-Belleuse, *Le Printemps (vase et support)* (before 1884),
in Albert-Ernest Carrier-Belleuse, *Application de la figure humaine à la décoration
et à l'ornementation industrielle* (Paris: Goupil, 1884), Plate 2. Les Arts décoratifs –
Bibliothèque des Arts décoratifs, Paris.

only in industry, but in the state-funded projects of the Third Republic. While Chéret found some success within this changing framework, notably twice winning the State's new ceramic competition, the Prix de Sèvres, in 1879 and 1882, he did not, as far as I am aware, receive state patronage in monumental or commemorative sculpture. This may be because he chose to concentrate on decorative sculpture, as can be seen in his submissions to the Salon from 1875 onwards. These include a plaster model of a vase, *Spring* (1875); a plaster cup, *Autumn* (1876); a plaster fountain and a terracotta vase (1877); and a plaster model of a chimney belonging to a Mr Dervillé (1886). These types of work – vases, chimneypieces and fountains – are relatively common within the Salon, possibly because of their connection to architecture (the Salon had an architecture section, and therefore placed high value on this type of work). In 1892 Chéret followed contemporary sculptors such as Desbois and Charpentier in transferring from the SAF to the new SNBA Salon, although he exhibited exclusively in its *objets d'art* section. The SNBA's introduction of an *objets d'art* section in 1892 was in part a strategic re-emphasis of the historic inclusion of 'decorative' works at the Salon; it similarly includes monumental objects such as chimneypieces and large scale vases. However, the works in the SNBA are notable for their domestic scale, quasi-functional status and portability. Collectors could easily handle, examine and admire them. Furthermore, their small scale facilitated their integration within an existing interior scheme, where they could be placed on chimneypieces, housed in display cases, and so on. They do not 'disrupt' an interior, like the introduction of sculpture in the round which requires considerable space and, in the case of marbles, adequately strong floors. Rather, *objets d'art* are at once present and non-present; they can be positioned within existing furniture and hung on walls and from ceilings, creating a focus if required or blending in with other objects and furnishings to enhance the overall harmonious 'mood' of a given interior. They are also perhaps more familiar, and therefore less invasive or demanding, than sculpture 'proper'.

The interrelation of novelty, portability, art, domesticity, collectability and familiarity outlined above, is evident in the choice of materials, objects and naturalism exhibited by Chéret at the SNBA Salon. These include a pot plant holder, silver candlesticks, pewter trays, bronze vases, a pewter tobacco jar and a wrought iron tripod electric light. Chéret's use of pewter, and his experimentation in leaf-like trays inspired by local rather than Classical vegetation, is characteristic of works shown at the SNBA's *objets d'art* section. This perhaps demonstrates Chéret's awareness of changing markets and value systems in the decorative arts, rather than his alliance with the objectives of groups such as L'Art dans Tout. I do not suggest that Chéret was necessarily disinterested in contemporary artistic and design debates, but I hesitate from including him within such groups simply because he made similar objects and exhibited at similar venues. Furthermore, the very notion of a cohesive group

is not held out in the different objectives of L'Art dans Tout's democratic motivations and Baffier's extreme nationalism, and I have yet to find evidence that Chéret was associated with either.

Generational differences may also have been at play. Chéret was born in 1838, while Desbois, Charpentier and Baffier were all born in the 1850s. Again, I do not suggest that there was no intergenerational exchange and friendship, or that older men were not involved in developing new directions in the French decorative arts during the 1890s (take, for example, Gallé, born in 1848). But the fact that Chéret developed as a sculptor at a time when industrial art dominated the commercial market and design discourse, while Desbois and others emerged during the increasing state involvement of the Third Republic, could have generated different attitudes towards decorative arts and sculpture. Carrier-Belleuse's death in 1887 could also have prompted Chéret to seek support within these new 'groups' of sculptors.

As in Desbois's work, each of Chéret's catalogue entries is accompanied by a title, reflecting common practice in the fine arts. However, unlike Desbois's, Chéret's are playful and allegorical rather than representative of the 'serious' and Symbolist titles associated with the 'modern' sculpture of his colleagues including Rodin. In contrast to Desbois's *The Dream* (inkstand) *The Wave* (bottle), *Temptation* (cider pitcher) and *Eve* (plate), Chéret entitled his works as follows:

1892

24. Vase, *Women Chased by Butterflies*

25. Vase, *Vase with Masks*

26. Vase with Garlands

27. Vase, *The Preview, Composition of Children and Flowers*

1893

285. Bronze, Light Fitting

286. Electric light, Tripod in wrought iron

287. Wax vase, *The Surprises of Love*

288. Bronze vase, *The Preview* (1892, plaster)

289. Bronze vase, *Butterflies* (1892, plaster)

1894

339. Bronze vase, *The Surprises of Love*

340. Pewter tray, *Geranium Leaf*

341. Pewter tray, *The Snail*

342. Pewter tray, shell form, *Dawn Serenade to the Moon*

343. Pewter tray, *Chestnut Leaf*

344. Pewter tray, *Butterflies*

345. Pewter tray, *Dragonflies*

346. Pewter tobacco jar

These titles recall new life in the form of dawn and children, and the freedom and beauty of butterflies and dragonflies (the dragonfly would later become a recurring image in Art Nouveau jewellery in particular). They are also flirtatiously erotic, suggestive of the excitement and anticipation of love and sex.

In his introductory essay to Chéret's posthumous exhibition catalogue, the art critic Arsène Alexandre notes that it is specifically the frivolity, gaiety and *lack* of seriousness, which qualify Chéret's work as art:

> It is precisely because it is not serious that it is art, and excellent art, not an easy art: the art of not being serious. Being serious is open to everyone, with application. Not to be serious, is to show oneself elegant, cheerful, lively, to throw flowers and light on everything one touches, to create women who are not stereotypes, to spread the kind of gaiety which is not in books, and here application begins to open its eyes, to put out its tongue and to make neither head nor tail of it.[84]

This statement is perhaps surprising, given that Alexandre was a strong supporter of modern developments in art, including the Impressionists, and of Rodin. In 1900, he would organise and contribute an essay to the catalogue accompanying Rodin's one-man show at the Place de l'Alma, in which he describes Rodin as the sculptor who has most profoundly troubled the spirit, impassioned public opinion, and inspired poets.[85] Chéret's work does not fit easily into this context of an avant-garde. However, in his 1898 defence of Rodin's *Balzac*, Alexandre identified with its sense of movement as being distinct to the 'repertory of artificial movements' then prevalent at the Salon; and it is perhaps partly this that he earlier identified in the work of Chéret.[86]

For Alexandre, Chéret's choice of the Parisienne as subject matter significantly contributes to the apparent lack of seriousness in his work:

> Those are the Parisiennes, the true Parisiennes from a moment ago, who walked beside you, warmly wrapped up, or again, taking in a furtive ray of sunshine,

thumping the cobbles with their dainty heels, worldly women putting on an air of respectability, or trotting along 'delivering pieces of work', here perfect equals when undressing. Don't you recognize them with their dimples, their capricious noses, their cheeky eyes, their giggles, their unruly hair, their titillating suppleness like that of electrical eels ...? Still, as the exhibition is taking place here, do not respect them too much; – you would be disrespectful towards them.[87]

Alexandre's description of a free-spirited Parisienne who relishes life's pleasures is partly heart-warming; yet women presumably developed this type of persona precisely because they were so dependent on men for financial support and income. He warns visitors to the exhibition at the Ecole des beaux-arts to refrain from treating Chéret's women with undue reverence simply because they are on display in a fine art establishment. Doing so would misconstrue the Parisienne's role and purpose as a plaything. Unusually, Alexandre takes frivolity and playfulness seriously while simultaneously denying Chéret's work (or at least its subjects) any serious meaning. Similarly, Alexandre objectifies these women while, also unusually for an art critic, paying a great deal of attention to the anonymous women that people Chéret's work by imagining their personal thoughts and feelings. In contrast, this level of 'empathy' is notably largely absent in responses to Rodin's representation of women in *The Gates of Hell*, which focuses on Rodin and on the Dante-related themes of the work.

Chéret's representations of women and children also take a different trajectory to those developed by his contemporaries such as Dalou and Charpentier, whose representations of maternity, fecundity and virility express the contemporary concerns of the Third Republic following the failure of French troops in the Franco-Prussian war. Chéret's women are sexual and sexualised beings, devoid of moral and maternal obligation. They are surrounded by babies and children but there is no suggestion of a familial bond between them. The babies are teasing, playful cherubs who encourage the women to act out their whims and desires rather than to temper their personal feelings with maternal ones. This simultaneously represents the women as autonomous beings and as playthings. Equally troubling are the ways in which Chéret's babies and children chart a kind of evolution towards the Parisienne. As in eighteenth-century precedents by the likes of Clodion and Falconet, Chéret's babies are often depicted in scenes suggestive of romance or sexual desire, as allegorical adjuncts to the narrative. Yet with Chéret there is also a more explicit exploration of the sexual 'awakening' of a girl into womanhood, in which the erotic serves as a general approach to all women, irrespective of age. The young girl holding a pair of flower vases in *The Quiver* (Fig. 3.6) has heavily lidded eyes, a partially open mouth and a pudenda barely hidden by a ribbon, all of which seem to imply that she is aware of her own latent or potential sexuality. In *Sleep* (Fig. 3.7) the girl is

3.6 Joseph Chéret, *The Quiver* (before 1885), in *La terre cuite française. Reproductions héliographiques de l'œuvre de Joseph Chéret, sculpteur à Paris* (Paris; Liège: C. Claesen, 1885), Plate 7.

3.7 Joseph Chéret, *Sleep* (before 1885), in *La terre cuite française. Reproductions héliographiques de l'œuvre de Joseph Chéret, sculpteur à Paris* (Paris; Liège: C. Claesen, 1885), Plate 23.

older; her body is more developed, with leaner limbs, elegant hands and the faintest suggestion of breasts. She sits on an upholstered wooden chair made more comfortable by a large tasselled cushion and a textile that protects her legs from the angular contours of the chair frame. Her hair is in a fashionable adult style, partly pulled back and up, with a curly fringe. On the chair back a cat plays with her plait, its senses on high alert to external disturbance. These elements suggest the girl's imminent transition to womanhood, in which she might (perhaps rather depressingly) become a Parisienne.

Chéret's representations of the fully-fledged Parisiennes are animated by Alexandre, who imagines them jostling and provoking the male visitors, climbing on their knees and teasing their beards, dancing in the school's corridors and studios, and encountering their ancient cousins in plaster casts and Greek figurines, with whom they are seen to identify the same purpose, 'making pleasure from the world with art'.[88] This use of animated, 'conscious' sculpture as a narrative device enables Alexandre to position Chéret's work in relation to ideal Classical beauty, and thus to the context of the Ecole des beaux-arts which was aesthetically so different to Chéret's work. Alexandre then goes on to identify Chéret's work as a welcome respite from the seriousness of academic art:

> Joseph Chéret had grace in his fragile person, this virile grace, tender and open … and his works were so filled with it that the rather … serious atmosphere of the Ecole des beaux-arts will for a few days find itself enlivened and tantalised.[89]

This differs from Alexandre's later 1898 reference to Rodin's *Balzac*, in which Rodin's work is seen to introduce a significant departure from the 'repertory of artificial movements' at the Salon. Yet it is similarly positioned as an alternative to the academic tradition, although one in which tenderness and transience are seen to be less significant in changing the course of modern sculpture than Rodin's exploration of the tortured human condition. It is a transience which might be associated with the popular entertainment forms of comic opera, the café-concert, the dance hall, shopping, picnics and day trips; but which in Chéret's case represents the everyday reality, rather than incidental moments, in his subjects' lives.

Chéret's playful sense of movement is also firmly present in the poster art of his brother, Jules Chéret, who is renowned for having encapsulated the fashionable, pleasure-loving Parisienne of the last quarter of the century. In these posters, as in *Students' Gala Ball* (1895) (Fig. 3.8) the subject is dislocated from its ground, creating an ethereal, fugitive image, which is heightened by the billowing clothes, the position of the body parts, the freedom of expression and the waving hair. She seems to be able to embrace modern developments in Paris, seeking out and benefiting from the novel and pleasurable experiences that electricity, the department store, the comic opera, fashion and colour

might offer her. This finds echoes in Chéret's pewter work in this period, as in *Vase with Masks* (1892) (Fig. 3.9), which in part transposes his brother's aesthetic into three-dimensional form. An unashamedly naked woman plays with a group of cherubs while Comedy laughs down benignly. Large areas of unornamented ground accentuate the impression of freedom and lightness in the figures; while the different depths of relief add texture, shadow and movement. These women represent a different approach to modernity than

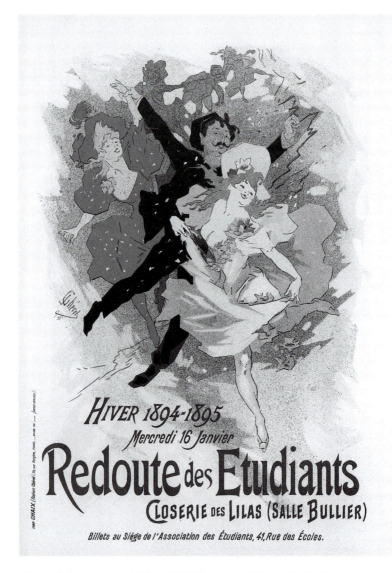

3.8 Jules Chéret, *Students' Gala Ball* (1895), colour lithograph, H 124 cm. Minneapolis College of Art and Design, Minneapolis.

SCULPTURE

SALON DU CHAMP-DE-MARS (1892).

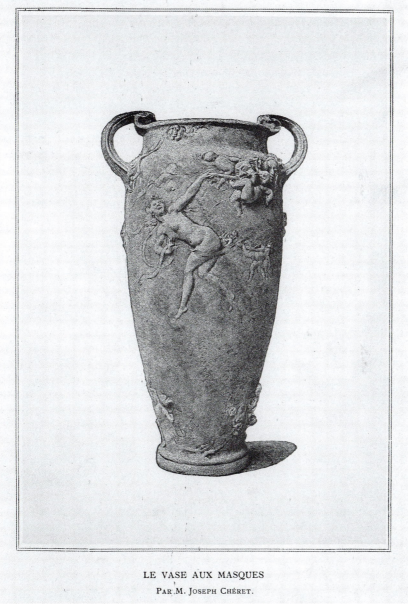

LE VASE AUX MASQUES
Par M. Joseph Chéret.

3.9 Joseph Chéret, *Le Vase aux Masques* (1892), in *Revue des Arts Décoratifs* (July 1892), p. 8. Les Arts décoratifs – Bibliothèque des Arts décoratifs, Paris.

Rodin's earnest, tormented selves. Their responses are equally physical and emotional but differently so; they seem to float and expand, rather than to contract; and sex, while inferred, is not their only purpose or means of pleasure. They represent both male and female fantasies of female behaviour – the Parisienne as a desirable source (and route to) pleasure – while also recognising that this is a (not unproblematic) fantasy. After all, the woman on Chéret's vase is naked; and while his brother's might be more appropriately clothed for the purpose of a public poster, she is similarly located out of time and place rather than against an identifiable Parisian streetscape.

Chéret's depictions of vivacious Parisiennes could be easily dismissed because they represent a negative male ideal of the secondary position of women in French society. Yet I hesitate. Are Rodin's depictions of 'erotic' or 'tortured' women any more representative of the breadth and complexity of women than a laughing, playful one? To reject Chéret's women would, then, partly defeat the object of this book, which is to address seriously the decorative in the variety of its permutations, irrespective of their style or content. It would deny specific human qualities that are found extensively in the decorative (and fine) arts, such as fantasy, laughter, sentimentality and playfulness. Furthermore, Alexandre suggests a more subversive role in Chéret's women. They do not require the intervention of a third party for them to be understood by the public:

> All of this is flesh, and it is charming, and I am very careful not to spoil your enjoyment or to guide your pleasure with lists and descriptions. It is too easy, do it yourself.[90]

If Chéret's art represents the 'Parisienne', then visitors to the exhibition, presumably mainly Parisians themselves, would recognise one of their own in the galleries. We might imagine this as a democratic address to those who have had no formal classical or artistic education. This in turn disrupts the role of the art critic as mediator between the artwork and the public, although Alexandre maintains this role by, in a sense, becoming this audience's voice.

Alexandre's introduction to the catalogue of Chéret's posthumous exhibition therefore reflects the newly serious concerns of the decorative in this period, by partially integrating them within the context of the fine arts and according them separate value outside this, notably in terms of its atypical 'frivolous' content and its related 'uneducated' audience. It is both innocuous and potentially subversive; and disrupts the conventions of academic art, if only fleetingly. It is significant in terms of the longstanding concerns of the 'playful' (for whom?) in French decorative sculpture and the decorative more broadly, from Falconet's biscuit groups of shepherds and shepherdesses in rural idylls, to metamorphic tables and automata. Historically, the decorative arts are, among other factors such as monarchical authority and craftsmanship,

about novelty and delight, produced in the tension between form, texture, colour and function, concealment and exterior finish.

Chéret's sculpture and his posthumous exhibition are thus representative of the complexity of sculpture practice in this period. Chéret's work and career can be included in any number of object, stylistic and professional categories, including Academic sculpture, industrial art, *objets d'art*, Art Nouveau, Rococo revival, sculptor and ornamentist. He experimented in a number of materials, including pewter and marble, and created decorative sculpture for that most modern of inventions, the electric light. These suggest new avenues for understanding the decorative and for reintegrating previously neglected subjects such as children and humour into art historical discourse, as well as works that do not fit neatly into a modernist trajectory of progress. Approaching Chéret's work as an entity, outside the parameters of modern sculpture or Art Nouveau, allows for a more inclusive approach to sculpture which acknowledges rather than obscures the overlaps between a number of intersecting practices and networks.

The *objets d'art* section at the SNBA is a complex synthesis of, and reaction to, sculptural developments in industrial art, fine art and state-funded industry, and the interests and aspirations of a select group of sculptors working in these interrelated fields. Its organisation, by sculptors, at the newly formed SNBA demonstrates a desire on the part of sculptors to distinguish themselves from industry and the fine art establishment, while simultaneously pursuing the creative and potentially economic benefits of working with a variety of objects that were more common to industrial art and partly included in the fine arts. This is indicative of the success of industrial art in extending the scope and breadth of sculpture over the previous decades. Sculptors benefited from the critical and public acceptance of high quality and artistic 'everyday' objects as a specialised artistic and marketable commodity, brought about by industrial art. They produced similar but distinct works for the SNBA, exhibiting small scale domestic objects as well as the more monumental vases and chimneypieces found historically at the (pre-SNBA) Salon.

The SNBA presented an alternative to industrial and fine art, within the context of fine art. Sculptors attempted to create this specific niche for themselves in a number of ways. In terms of materials, their preference for pewter and stoneware distinguished their work from the precious metals (or the appearance of precious metals, as in gilt bronze and electroplated silver) associated with the highest quality examples of industrial art. Furthermore, the approach to materials changed; they were prized and enhanced rather than 'obscured' behind patination or gilding. The limited skills of sculptors in making (rather than in modelling) objects, in comparison to the professionalisation and division of labour within industrial art, lent a rather naïve character to some of the works produced. Pewter was a particularly

forgiving material in this respect as it cannot be worked to the same degree of high definition as bronze.

This new approach to materials was interpreted as representing a new authenticity in sculpture. This was further emphasised by the sculptors' stress on processes such as direct carving, lost wax casting, and on the unique and signed work, wholly conceived and created by the artist without the (apparent) intervention of a manufacturer. In tandem to this, a new type of manufacturer emerges at the SNBA, an apparently 'authentic' and 'artistic' alternative to 'commercially motivated' manufacturers. For example Gallé, who managed a successful business producing glassware, is a frequent exhibitor, as is the American glass firm Tiffany; and the sculptors' catalogue entries refer to specific bronze founders who specialised in the lost wax process. While the prospect of expanding their client base must have been a primary motivation for sculptors exhibiting works at the SNBA, sculptors and manufacturers underplay this in favour of their artistic credentials. The fine art environment of the Salon further demarcates their apparent separation from industry (and the concomitant negative associations of economic interests with artistic constraints).

The remit of the SNBA also reveals concerns by sculptors regarding authorship, copyright, anonymity and autonomy. They attempt to redress the imbalance in industrial art in favour of manufacturers by adopting the fine art practice of signed, unique or serialised objects and by giving their works titles. The SNBA, unlike the SAF Salon, also allowed sculptors to display an indefinite number of works and to place them as a group. This in turn facilitated their profile within an increasingly varied and extensive group of competing *objets d'art*. However, although it significantly challenged the type of sculpture that was acceptable within a fine art context, despite its initial remit, it mainly excluded industrial and ornamental sculptors.

The introduction of an *objets d'art* section at the SNBA is therefore perhaps not as radical a departure from the fine arts as has previously been supposed. Rather, it was a strategic attempt to modify and integrate the industrial and fine arts to the advantage of sculptors. It was partly successful. It became an additional source of revenue and patronage for sculptors, as the Department of Fine Art acquired works for the Musée du Luxembourg, and other museums and private clients acquired works for their own collections. The *objets d'art* section could also be defined as the catalyst behind the Department's decision to host a congress on decorative art at the Ecole des beaux-arts in 1894; the first solo exhibition of a 'decorative' sculptor, Chéret, at the same venue shortly afterwards; and the introduction of an *objets d'art* section at the SAF Salon in 1895. However, such a tidy conclusion would negate the complex pre-existing interrelation between the fine and the decorative arts within a fine art context, and the contribution of the State in supporting new materials, techniques and objects in sculpture.

Notes

1 The other founder members were Puvis de Chavannes, Carolus-Duran, Bracquemond, Pierre Victor Galland, Alfred Philippe Roll, Ernest Ange Duez, Henri Gervex, Jean Charles Cazin, Paul Albert Besnard, Pascal-Adolphe-Jean Dagnan-Bouveret, Charles Waltner, Jean André Rixens, Jean Béraud, René Billotte and Frédéric Montenard. The catalogues accompanying each of the SNBA's salons helpfully include the society's statutes, full membership lists, jury members, and the rules and regulations for each Salon. On the founding of the SNBA, see Constance C. Hungerford, 'Meissonier and the Founding of the Société Nationale des Beaux-Arts', *Art Journal*, vol. 48, no. 1 (Spring 1989): pp. 71–77.

2 Ibid., p. 71. Dominique Lobstein has similarly underscored the novelty of the new *objets d'art* section. Dominique Lobstein, *Les Salons au XIXe siècle. Paris, capitale des arts* (Paris, 2006), p. 267.

3 *Annuaire de la Réunion des fabricants de bronze et des industries qui s'y rattachent, résumé des travaux de l'année 1887* (Paris, 1887), p. 42.

4 'Le Salon annuel est un puissant stimulant pour les peintres et les sculpteurs. Pourquoi ne pas en ouvrir les portes à nos artistes décorateurs? Sont-ils moins artistes, moins intéressants? Mais ces conventions, ces distinctions dans les différentes émanations de l'art n'existaient pas dans le temps où l'art industriel était florissant et créateur: pourquoi ne pas laisser nos artistes industriels jouir des prérogatives des autres artistes. Je crois tout au contraire que leur entrée au Salon annuel constituerait une attraction nouvelle. Je rêve d'une salle spéciale ornée de panneaux décoratifs, de tapisseries d'après des modèles nouveaux. Le long des lambris seraient disposés des meubles, crédences, bahuts sur lesquels seraient placées des œuvres de bronze, de céramique, d'orfèvrerie, de verre. ... Mais un Salon semblable c'est la galerie d'Apollon Mais est-ce que ces beaux objets d'art … industriel déparent le Louvre? Qui donc voudrait les en chasser? Eh bien, ce que nous pouvons voir et admirer tous les jours au Louvre nous voudrions le voir tous les ans au Salon des artistes vivants. Ce serait pour nos industries, pour nos artistes qui exposeraient sous leur *nom seul*, un puissant stimulant: des œuvres originales, nouvelles, hardies peut-être, pourraient s'y produire et on peut espérer que des amateurs se laisseraient tenter à acheter des œuvres nouvelles, lasses enfin des éternelles redites.' *Annuaire de la Réunion des fabricants de bronze et des industries qui s'y rattachent. Résumé des travaux de l'année 1890* (Paris, 1890), p. 44.

5 'La Société nationale des beaux-arts du Champ-de-Mars se propose de réaliser à l'occasion de son exposition annuelle, certaines idées sur l'unité de l'art qu'ont préconisées bien souvent, dans leurs discours et dans leurs écrits MM. Castagnary, Antonin Proust, Aynard, député de Lyon, Roger Marx, etc. Il s'agissait d'ouvrir les portes de son Salon aux nombreux ouvriers de l'art industriel. La Société nationale estime que les céramistes, les verriers, les émailleurs, les orfèvres, les ébénistes, les ferronniers, pour ne citer que ceux-ci, quand ils font preuve de talent, sont les égaux des peintres et des sculpteurs, et doivent participer aux mêmes privilèges, partager les mêmes récompenses. La Société pense encore qu'une exposition commune incitera les décorateurs à faire des œuvres d'imagination et servira les intérêts de l'art industriel qui s'en tenait exclusivement à la servile imitation du passé. Une louable émulation, les récompenses originelles accordées aux efforts réalisés et au mérite, développeront cette branche de l'art et lui rendront la vigueur qu'il a sensiblement perdue. Le Comité du Champ-de-Mars est décidé à ne négliger rien pour persuader aux nouveaux venus qu'ils sont chez eux. Les seules pièces originales, signées de l'artiste qui les aura faites, seront reçues, sans nom de la maison à laquelle elles appartiennent afin d'éloigner tout soupçon de réclame. Les trois sections du jury se réuniront pour les juger. Une Commission composée des MM. Dalou, Dubois, Cazin et Roll, est chargée d'étudier le règlement qui doit s'appliquer à l'art industriel et de préparer sa fusion avec les beaux-arts.' 'L'Art industriel au Salon du Champ-de-Mars', *La Chronique des Arts et de la Curiosité*, no. 89, 28 February 1891, p. 67.

6 Katherine Purcell, *Falize: A Dynasty of Jewellers* (London, 1999), p. 187.

7 'Règlement de la section des objets d'art. La Société nationale, considérant qu'il y a lieu de rattacher aux beaux-arts proprement dits la production des artistes, créateurs d'objets originaux et non reproduits, a définitivement constitué une section ayant pour titre: *Section des objets d'art*. La Société *s'adressant aux travailleurs isolés*, à ceux dont les œuvres trouvent difficilement place dans les expositions mercantiles et encombrées dites 'd'Art décoratif' fera tous ses efforts pour mettre ces travaux en vue et assurer ainsi le succès et la propriété des inventions toutes personnelles. ARTICLE PREMIER – Ne sont acceptées que les œuvres originales qui n'ont pas figuré aux expositions publiques précédentes. Dans cette catégorie sont compris non seulement les ouvrages exécutés, mais encore les maquettes, dessins et modèles. ART. 2. – En cas de collaboration, le consentement et la signature des collaborateurs seront exigés. ART. 3. – Les objets précieux devront être remis dans les écrins ou boîtes fermant à clef. ART. 4. – Dans le cas d'installation spéciale (vitrine, écrins, etc.), les frais de l'exposition sont à la charge de l'exposant. Le nettoyage des objets exposés dans cette section se fera le matin avant l'ouverture.' *Catalogue des ouvrages de*

peinture, sculpture, dessins, gravure, architecture et objets d'art, exposés au Champ-de-Mars (Paris, 1896), p. 311.

8 Alan Chong, 'Mrs Gardner's Two Silver Boxes by Christian Eriksson and Anders Zorn', *Cleveland Studies in the History of Art*, vol. 8 (2003), p. 225.

9 'Vitrine contenant des bustes, animaux et poterie, de grès émaillé avec fragments de briques destinées à une porte en exécution pour Mme Vinnaretta Singer', no. 20, SNBA Salon, 1892. Carriès had completed the life size plaster model for his monumental door, but died before he could complete its transposition into stoneware. The plaster door was displayed at the Petit Palais between 1904 and 1935, when it was destroyed to make way for an exhibition.

10 'Pierre Jules Cavelier', *New York Times*, 11 February 1894; and Lami, *Dictionnarie des sculpteurs, A–C*, p. 305.

11 As well as freestanding busts and statues, Cavelier undertook architectural work and was involved in the famous table centre for the duc d'Orléans. Ibid., pp. 305–11.

12 'L'Orphée de M. Desbois est bien nul', 'Salon of 1875', in Jules-Antoine Castagnary, *Salons (1857–1870)* (Paris, 1892), p. 189.

13 Possibly also *Acis changé en fleuve* (marble) and *Satyre et Nymphe* (marble group).

14 Rodin modelled two masks for the Trocadéro fountain, and Desbois a third; Mercier, *Desbois*, p. 12.

15 In New York, he worked for John Quincy Ward on the statue of George Washington (1883) and on low reliefs for the Post Office. He also painted fans, lampshades and modelled figures in wax. Ibid., p. 14.

16 On his return to France, Desbois was conscripted, and his captain apparently offered to release him on condition that he execute his bust. Mercier, *Desbois*, p. 25. Military service was a real concern for manufacturers. According to Article 23 of the Law of 15 July 1889, young workers in art industries were exempt from military service if authorised by a regional jury composed of workers and patrons. V. Thiebaut, 'Application de la loi militaire aux ouvriers d'art', *Annuaire de la Réunion des fabricants de bronze et des industries qui s'y rattachent. Résumé des travaux de l'année 1893* (Paris, 1893), pp. 71–78.

17 Desbois collaborated on several major works with Rodin, including the *Burghers of Calais*.

18 '1889 Exposition universelle, liste des sculpteurs statuaires' file, AN F.12.3926. Also noted at this address are the Academic sculptors Charles Maniglier and Barthélemy Caniez, while Jean Coulon lived at no. 85 and Alphonse Cordonnier lived at no. 77.

19 AN LH.742.70, Desbois file. This includes a summary of his awards to date, 'Resumé des récompenses obtenues par M Jules Desbois sculpteur'.

20 Contract, Inv. Ma 199, Musée Rodin, Jules Desbois folder.

21 Véronique Wiesinger, 'Desbois et Rodin' (M.A. dissertation, Univ. Paris-Sorbonne IV, 2 vols, 1983); and 'Jules Desbois (1851–1935), sculpteur de talent ou imitateur de Rodin?', *Bulletin de la Société de l'Histoire de l'Art Français* (1985): pp. 315–330.

22 Wiesinger explores this in specific relation to the *Monument to Claude Lorrain* (1889–1892), which Desbois supervised for Rodin. Véronique Wiesinger, 'Les Collaborations: A propos du monument à Claude Gellée dit Le Lorrain d'Auguste Rodin', in Pingeot, *La Sculpture française*, pp. 110–114.

23 Huard and Maillot convincingly suggest that Desbois conceived of the apparently opposing sculptures *Léda* (1896) and *La Misère* (1894) as complimentary works embodying life and death, youth and age, ecstasy and agony. Raymond Huard and Pierre Maillot, *Jules Desbois sculpteur (1851–1935): une célébration tragique de la vie* (Paris, 2000).

24 'L'Art industriel admis à l'Exposition, *L'Art pour Tous* (February 1891), p. 3.

25 'Ayez l'œil exercé, et, entre toutes les œuvres d'art, vous reconnaitrez, du premier coup, une "femme" de Desbois; même si, à peine en relief, elle se modèle au fond d'un plat d'étain ou d'argent.' Gustave Coquiot, 'Jules Desbois', *L'Art et les Artistes*, vol. 13, no. 76 (July 1911): pp. 166–167.

26 'Les bronzes portent la marque du fabricant, mais il n'est pas besoin de chercher la signature de l'artiste pour reconnaître Piat, Carrier-Belleuse, les Robert ou les Moreau … Carrier a engendré plus d'amours et de nymphes que n'a d'habitants un gros chef-lieu de canton; et si Piat gravait son œuvre, il égalerait ou mieux il surpasserait en nombre l'œuvre du plus fécond artiste du dernier

siècle. Et Robert, malgré sa précieuse recherche et l'esprit qu'il distille en ses délicats ouvrages, a construit plus de vases, de statuettes et de pièces d'ameublement, que n'en conserve un musée, et Mathieu Moreau s'il regarde en arrière, doit voir une longue suite de blanches figures marquant les étapes de sa vie.' Falize, 'Les Bronzes', p. 369.

27 *L'Art pour Tous* (March 1893), p. 2; it also acquired a pewter pitcher, see *L'Art pour Tous* (September 1893), p. 2.

28 '...composés dans le style tourmenté et curieux d'un Rodin ou d'un Rops.' 'L'Art Pour Tous au Salon', *L'Art pour Tous* (July 1892), p. 2.

29 In 1907, Desbois exhibited a plaster version at the SNBA (now at the Petit Palais) with a view to its being cast by Hébrard in silver or gilt bronze using the lost wax technique. Wiesinger, 'Desbois et Rodin', pp. 70, 150.

30 Froissart-Pezone, *L'Art dans tout*, p. 116.

31 Some of his plasters were similar to his pewter objects, and were presumably destined for production in metal. 34, *Fleurs des eaux (Water Flowers):* water pot (plaster); 35, *Sirènes (Mermaids):* vide-poche (plaster); 36, *Le Songe (Dream):* inkwell (plaster); 37, *La Coquille (Shell):* ashtray (plaster); 38, *La Vague (Wave):* bottle (plaster); 39, *Le Centaure (Centaur):* plate (plaster); 40, *Les Nénuphars (Water lilies):* plate (plaster).

32 Germain Bapst, 'Orfèvrerie d'étain dans l'Antiquité', *Revue Archéologique* (January 1882): pp. 9–23; Germain Bapst, 'Briot François, orfèvre en étain au XVIe siècle', *Revue des Arts Décoratifs*, vol. 4 (1883): pp. 164–173 and pp. 190–198; Germain Bapst, *Etudes sur l'étain dans l'Antiquité et au Moyen âge, orfèvrerie et industries diverses* (Paris, 1884). UCAD's Archive holds a file on exhibitions of Bapst's pewter collection from around 1890–1896, B2/27.

33 Bapst, *Etudes sur l'étain*, p. ii.

34 For example, pewter does not feature in Marjorie Trusted (ed.), *The Making of Sculpture: The Materials and Techniques of European Sculpture* (London, 2007).

35 G. Laurent, *Nouveau manuel complet du potier d'étain et de la fabrication des poids et mesures* (Paris, 1909), p. 2.

36 '...il étale en quelque sorte la lumière sur sa surface et n'offre a l'œil que des ombres douces'; 'souplesse remarquable', Laurent, 1909, pp. 139, 140. 'doux au toucher', Victor Potier, 'Notes sur l'art industriel de l'étain', *Revue de la Bijouterie, Joaillerie, Orfèvrerie*, no. 31 (November 1902), p. 241.

37 Ibid., p. 230.

38 Neil McWilliam, *Monumental Intolerance: Jean Baffier, a Nationalist Sculptor in Fin-de-Siècle France* (University Park, Pa., 2000); Neil McWilliam, 'Craft, Commerce and the Contradictions of Anti-Capitalism: Reproducing the Applied Art of Jean Baffier', in Anthony Hughes and Erich Ranfft (eds), *Sculpture and its Reproductions* (London, 1997), p. 105.

39 'La plupart du temps, les artistes sculpteurs qui s'occupent d'art industriel ne sont pas assez artisans; ils ne connaissent pas toujours le métier pour lequel ils créent des modèles et sont insuffisamment instruits des besoins de l'art industriel pour lequel ils travaillent; ils ne produisent que des objets qui, dès leur naissance, ne peuvent devenir que des bibelots de collection et de musée.' Potier, 'Notes sur l'art industriel de l'étain', pp. 252–253.

40 'C'est qu'il n'échappait point alors lui aussi à cette manie de la spécialisation, qui rend tant de service – il faut l'avouer! – aux cerveaux paresseux et aux mémoires courtes.' Coquiot, 'Jules Desbois', p. 167.

41 L'Art dans Tout (1896–1901) organised exhibitions of decorative art aimed at uniting the arts, industry and daily life. Desbois exhibited his pewter ware twice, but was not an active member of the group. Froissart-Pezone, *L'Art dans tout*.

42 Léonce Bénédite, *Le Musée du Luxembourg* (Paris, 1894).

43 'Solitaire, peu causeur, ignorant le monde et trop indépendant pour se faire voir comme tant d'autres dans les antichambres ministérielles. Il a toujours cru que son atelier était dès l'aube, l'unique retraite pour son bonheur, et il a travaillé sans relâche, avec une conscience réfléchie, tenace.' Unreferenced quotation in Mercier, *Desbois*, p. 24.

44 Wagner, *Carpeaux*; the conclusion in particular.

45 'L'atelier ne possède ni tenture de prix, meubles rares, plantes exotiques, ni piano, ni guitare, seulement quelques étagères en bois blanc, un poêle tout rouillé, un arrosoir, un sceau, de la terre glaise et des ébauchoirs, mirettes, compas, etc…. Ces étagères plient sous le poids d'objets inanimés et vivants: moulages d'étain, bronzes, maquettes écorchées, salamandres, courges, morilles, chardons, algues marines, troncs de saules nains, feuilles racornies, etc…; plongeant dans des bouteilles remplies d'eau, de beaux thyrses à longues tiges où l'œil a pu suivre jour par jour, heure par heure, le miracle de la floraison. Et c'est dans ce capharnaüm que sortiront les chefs-d'œuvre du maître.' Unreferenced quotation in Mercier, *Desbois*, p. 15.

46 'Beaux-arts', *La Presse*, no. 929, 13 December 1894, p. 1.

47 G. Pelca (pseudonym of Georges Capelle), 'Ecole des beaux-arts', *Le Gaulois*, no. 5375, 13 December 1894, p. 2.

48 The bibliography on Joseph Chéret is as follows: Lami, *Dictionnaire des sculpteurs A–C*, pp. 371–361; June Hargrove, 'Gustave-Joseph Chéret's "Day"', *Cleveland Studies in the History of Art*, vol. 8 (2003): pp. 214–221. For contemporary articles see Frantz Jourdain, 'Les Artistes Décorateurs, no. 5, Joseph Chéret', *Revue des Arts Décoratifs*, no. 2 (August 1893): pp. 39–43; Arsène Alexandre, 'Joseph Chéret', in *Catalogue des œuvres originales, projets de monuments, de cheminées et de meubles, groupes, statuettes, bas-reliefs, pièces décoratives, terres cuites, bronzes, faïences, étains, dessins et croquis, composant l'œuvre de Joseph Chéret, sculpteur décorateur, exposées du 14 au 21 décembre 1894 à l'Ecole nationale des beaux-arts, quai Malaquais, et dont la vente aura lieu par suite de décès, Hôtel Drouot, 26–29 décembre 1894* (Paris, 1894), pp. 3–10; Victor Champier, 'L'Œuvre de Joseph Chéret à l'Ecole des beaux-arts', *Revue des Arts Décoratifs* (January 1895): pp. 193–196 (entitled 'first article' although no subsequent article appears); Jules Salmson and Eugène Coupri, 'Les Artiste de l'industrie: Joseph Chéret', *L'Art Décoratif Moderne* (February 1895): pp. 81–88; all are illustrated apart from Alexandre.

49 *Le Congrès des arts décoratifs de 1894 tenu à l'Ecole Nationale des beaux-arts du 18 au 30 mai sur l'initiative et par les soins de l'Union centrale des arts décoratifs. Comptes-rendus sténographiques* (Paris, 1894).

50 Ibid., p. 620.

51 In contrast a similar initiative, the 1878 International Congress on Artistic and Industrial Copyright, was organised by the Ministry of Agriculture and Commerce and held at the Palais du Trocadéro during the 1878 International Exhibition.

52 The rules and programme were published in *Congrès des arts décoratifs organisé à Paris sur l'initiative et par les soins de l'Union centrale, Mai 1894; règlement et programme* (Paris, 1894).

53 Eugène Coupri, 'Union artistique des sculpteurs-modeleurs', *Les Arts du Métal* (October 1894): pp. 263–268.

54 'A l'heure actuelle, la confusion la plus grande règne dans tout ce qui touche aux arts industriels. Les artistes qui créent, ceux qui inventent, qui composent les modèles pour tous les artistes sont journellement confondus avec les artisans et les ouvriers d'art. Les sculpteurs modeleurs sont inconnus et méconnus.' Ibid., p. 315.

55 Ibid., p. 263.

56 Comment by Griffath in *Le Congrès des arts décoratifs tenu à l'Ecole nationale des beaux-arts du 18 au 30 mai 1894. Compte rendu sténographique* (Paris, 1894), p. 127.

57 For example the sale of Charles Pickard's foundry in 1882 included the following models: no. 62, Clock Louis XVI, *Flora*, by Chéret and Carrier-Belleuse, sculpteurs; no. 63, Candelabra Louis XVI, *Flora*, by Chéret and Carrier-Belleuse, sculpteurs. *Vente Ch. Pickard, 4–6 July 1882* (Paris, 1882).

58 'Les plus heureux joignent les deux bouts, les autres sont dans une misère affreuse'. Arthur Maillet, 'L'UCAD, lettre ouvert à M. Berger, député, Président de l'Union', *Les Arts du Métal* (October 1894), p. 195.

59 Ibid., p. 217.

60 Gustave Geffroy, *Musée du soir aux quartiers ouvriers. Le Temple, le Marais, le Faubourg Saint-Antoine* (Paris, c. 1894).

61 Coupri, 'Union artistique', p. 267. Proust suggested a three-tier system: higher education fine art schools, secondary art and craft schools, and drawing and modelling schools.

62 'Les sculpteurs-statuaires trouvent ce sommet dans l'étude anatomique de la nature humaine qui n'a aucune corrélation avec le savoir du sculpteur de l'art appliqué, lequel trouve son sommet dans

l'étude des styles. Si donc chacune des branches de l'art a une manifestation bien personnelle, il est impossible que l'une découle de l'autre.' Ibid., p. 267.

63 *Le Congrès des arts décoratifs tenu à l'Ecole nationale des beaux-arts du 18 au 30 mai 1894. Compte rendu sténographique* (Paris, 1894), pp. 662–665.

64 *Le Congrès des arts décoratifs organisé à Paris sur l'initiative et par les soins de l'Union centrale, mai 1894; règlement et programme* (Paris, 1894), p. 25.

65 AN 368A.P4.

66 René Lalique's published correspondence demonstrates that his wife, Alice, actively pursued commissions on his behalf, and it is not inconceivable that Chéret's wife was similarly involved in the artistic and commercial community. Philippe Thiébault, *René Lalique. Correspondance d'un bijoutier art nouveau 1890–1908* (Paris, 2007). Marie referred to herself as Madame Joseph Chéret Carrier-Belleuse, thus maintaining her association with both her husband and her father.

67 For some of the auction results see Arhtur Bloche, 'Le Cabinet de l'amateur, vente Chéret, deuxième vacation', *Le Gaulois*, 28 December 1894, p. 3.

68 *Catalogue des œuvres originales, projets de monuments, de cheminées et de meubles, groupes, statuettes, bas-reliefs, pièces décoratives, terres cuites, bronzes, faïences, étains, dessins et croquis, composant l'œuvre de Joseph Chéret, sculpteur décorateur, exposées du 14 au 21 décembre 1894 à l'Ecole nationale des beaux-arts, quai Malaquais, et dont la vente aura lieu par suite de décès, Hôtel Drouot, 26–29 Décembre 1894* (Paris, 1894).

69 These feature iconic works of industrial art, including a Mirror and Table lent by Christofle, which originally featured at the 1867 International Exhibition to critical acclaim.

70 Jules Maciet, 'Rapport au nom de la commission du Musée des Arts décoratifs', *Revue des Arts Décoratifs* (May 1895), p. 337.

71 The Musée des Arts décoratifs purchased two plaster maquettes, models for the decoration of a chimneypiece, and a series of drawings for industrial art, decorative sculpture, goldsmithing, bronze lighting, ceramics 'etc.'; see 'Liste des acquisitions faites du Musée des Arts décoratifs en février 1895', *Revue des Arts Décoratifs* (March 1895), p. 288.

72 Lami, *Dictionnaire des sculpteurs, A–C*, p. 372.

73 Champier, 'L'Œuvre de Joseph Chéret', p. 195.

74 Ibid., pp. 195–196.

75 Lami, *Dictionnaire des sculpteurs A–C*, p. 372.

76 *Exposition des beaux-arts appliqués à l'industrie, 1863* (Paris, 1863).

77 *Rapports du jury de l'exposition des beaux-arts appliqués à l'industrie au Palais des Champs-Elysées en 1863* (Paris, 1865), p. 94.

78 Chéret (Joseph), sculpteur, Avenue de Ségur, 39. *Exposition des beaux-arts appliqués à l'industrie* (Paris, 1863).

79 *Exposition de 1865, règlements et programmes, distribution des récompenses, rapports du jury* (Paris, 1866), p. 119.

80 On the dressing table set, see *The Second Empire 1852–1870*, p. 10; on the lock, Mesnard, *Les Merveilles*, pp. 135–6; and on the Petit Palais cabinet see Dominique Morel, 'The Cabinet of Alessandri and Son at the Paris Universal Exhibition of 1867', www.Nineteenth-Century Art Worldwide.org, vol. 6, no. 2 (Autumn 2007) and Desvernay, *Rapports des délégations ouvrières*, vol. 2, p. 5.

81 'Rapport des ébénistes', in Desvernay, *Rapports des délégations ouvrières*, vol. 2, pp. 30, 51.

82 Salmson and Coupri, 'Joseph Chéret', p. 84.

83 'Il se révéla figuriste modeleur-dessinateur aussi savant qu'original.' Ibid., p. 85.

84 'C'est justement parce que ce n'est pas sérieux que c'est de l'art, et de l'excellent, et du pas commode: l'art de n'être pas sérieux. Être sérieux, c'est à la portée de tout le monde, en s'appliquant. N'être pas sérieux, c'est se montrer élégant, riant, entrainant, jeter des fleurs et de la lumière sur tout ce qu'on touche, faire des femmes qui ne soient pas des formules, répandre de la

gaieté qui ne soit pas dans les manuels, et ici l'application commence à ouvrir les yeux, à tirer la langue et à perdre son latin.' Alexandre, 'Joseph Chéret', p. 4.

85 Arsène Alexandre, *L'œuvre de Rodin. Exposition de 1900* (Paris, 1900), p. x.

86 Arsène Alexandre, 'Rodin's Balzac' (1898), in Butler, *Rodin in Perspective*, p. 95.

87 'Ce sont des Parisiennes, des vraies Parisiennes de tout à l'heure, qui passaient à côté de vous frileusement emmitouflées, ou bien humant un fugitif rayon de soleil, tapant le pavé de leurs petits talons, femmes du monde prenant de très grands airs convenables, ou trottinettes allant 'livrer de l'ouvrage', ici parfaitement égales devant le déshabillage. Si vous ne les reconnaissez pas à leurs fossettes, à leurs nez capricieux, à leurs yeux effrontés, à leur fou rire, à leurs cheveux follets, à leur souplesse affriolante d'anguilles électriques…! Enfin, parce que l'exposition a lieu ici, ne les respectez pas trop, – vous leur manqueriez de respect.' Alexandre, 'Joseph Chéret', p. 4.

88 'Amuser la vie avec art', Ibid., p. 5.

89 'La grâce, Joseph Chéret la possédait dans sa personne périssable, cette grâce virile, tendre et franche … et il en imprégnait son œuvre à ce point que l'atmosphère plutôt un peu … sérieuse de l'Ecole des beaux-arts va s'en trouver pour quelques jours tout égayée et tout émoustillée', Ibid., p. 3.

90 'Tout cela, c'est de la chair, et c'est charmant, et je me garderais bien de troubler votre amusement ou de guider votre plaisir par des énumérations et des descriptions. C'est trop facile, faites-le vous-mêmes', Ibid., p. 6.

Conclusion
The Limits of Decorative Sculpture

This book argues that the modern art historical separation of fine and decorative sculpture has obscured the close interrelation of so-called 'fine' and 'decorative' sculpture in France in the period 1848–1895. In reality, a broad range of sculptors were involved in the designing, modelling, making and conceptualisation of objects in a number of ways, in a variety of environments and with specific but interrelated aims. Salon sculptors simultaneously developed networks in the fine and decorative arts throughout their careers. Their association with industry could afford them a degree of creative freedom unavailable within fine art Salon sculpture and open them up to different materials, practitioners and working methods. The patronage of sculpture by the Third Republic extended beyond the monument and the Salon, to encompass the revival of sculpture at the national manufactory Sèvres.

In addition, this book has sought to recover non-Salon sculptors and the neglected field of ornamental sculpture. It challenges the privileging of fine art sculptors over other forms of sculptors, artists over manufacturers, the unique maker over collaborative works, and assumptions regarding 'authentic' personal experimentation over 'inauthentic' bibelots produced by industry. Such binary terms of reference unhelpfully obscure the palpably more complex, changing and contested interrelationship between these fields. I conclude this book with an analysis of two seemingly unrelated works, produced almost thirty years apart, which foreground these issues and specifically address the question of the 'acceptable' limits of sculpture in the decorative arts.

The objects in question are a display cabinet by the sculptor François-Rupert (known as Rupert) Carabin (1862–1932), commissioned by the City of Paris and exhibited at the SNBA's *objets d'art* section in 1895 (Fig. 4.1), and an earlier cabinet produced by Henri Fourdinois (1830–1907), of the cabinet making firm Fourdinois, for the 1867 International Exhibition in Paris (Fig. 4.2). Critics applauded Fourdinois's work for its controlled use of sculpture, while

Carabin's was criticised for the apparent autonomy of its sculptural parts. I argue that, in the case of Fourdinois, this reflected the importance of rational, learned design within industrial art and the 'appropriate' subordination of sculpture to architecture. Carabin, in contrast, was seen to have overstepped the limits of sculpture and of the sculptor within the decorative arts.

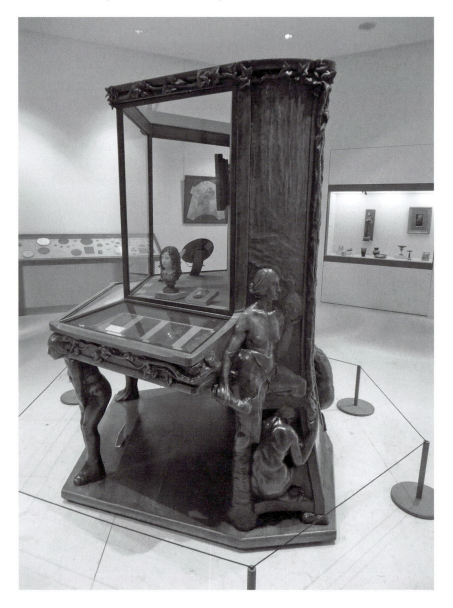

4.1 Rupert Carabin, *Display Cabinet for Objets d'Art* (1895), walnut, 238 × 243 × 184 cm. Petit Palais, Musée des Beaux-Arts de la Ville de Paris.

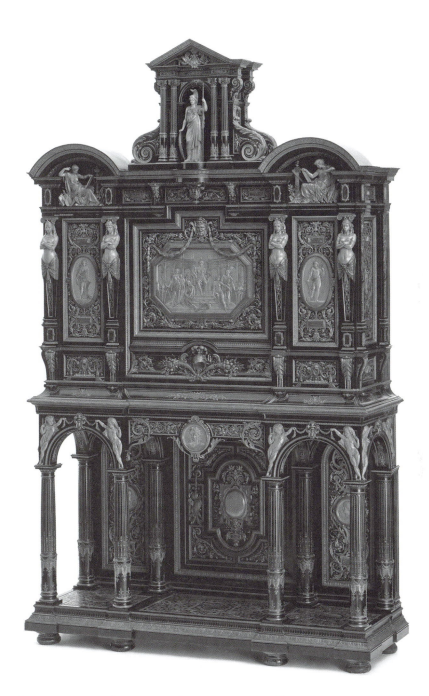

4.2 Henri-Auguste Fourdinois, Hilaire, Pasti and Néviller, Cabinet on Stand (1867),
ebony, partly veneered on oak, with inlay and carved decoration in box, lime, holly,
pear, walnut, mahogany and hardstones, marble plaques and figures in box, 249 × 155
× 52 cm. Victoria and Albert Museum, London.

Fourdinois's cabinet is currently exhibited in the Victoria and Albert Museum's (V&A) nineteenth-century gallery, set within a rich tableaux of Renaissance-style objects, dimly lit, and framed against a rich red colour scheme. Carabin's cabinet is displayed at the Musée d'Orsay in the centre of a well-lit white-walled gallery, which facilitates the visitor's movement around the entire piece and enables close scrutiny of its individual elements. On first inspection, it would seem that these works represent two divergent but interrelated examples of French cabinet making. One, a technically accomplished 'exhibition' piece inspired by the Renaissance and produced in the context of industrial art; the other, a more intellectual and Symbolist development of this tradition, first exhibited within the context of a fine art exhibition and without apparent reference to earlier stylistic tendencies.

Close analysis reveals that contemporaries valued and critiqued works by Fourdinois and Carabin in ways that were not so very different; and exposes some of the continuities as well as the changes regarding the place of sculpture in the decorative arts that have been raised throughout this book. I examine, in turn, brief biographical overviews of their makers, their use of wood and direct carving, allegory and symbolism, and architecture and form.

Both Carabin and Fourdinois were educated within the decorative arts rather than by the fine art establishment. Fourdinois was trained at a time that valued collaboration and specialised labour, cooperation and discourse between artists and artisans. He worked for various architects, bronze makers and goldsmiths, and thus developed a broad understanding of various aspects of the design, modelling and execution of the decorative arts.[1] He was one of a number of French artists and artisans to travel to London in search of work in 1848, where he found work with the French jeweller Morel.[2] On his return to France in 1851 he joined his father's cabinet making firm and applied his skills to the production of high quality furniture. Among his creations is the 1867 cabinet which was awarded the Grand Prize at the Paris International Exhibition that year, and was subsequently purchased by the newly founded South Kensington Museum (V&A) for the vast sum of £2,750 as an example of exceptional craftsmanship.

Rupert Carabin was brought up in Alsace. Following the Franco-Prussian war, his family moved to Paris in 1871 where he was apprenticed first as a cameo engraver and, following the fall in popularity of cameos, as a wood sculptor in the furniture making district of the faubourg Saint-Antoine. Carabin, as was perhaps more typical of his generation than of Fourdinois's, pursued an individualist rather than a collaborative path, and developed a career in the fine arts rather than in industrial art. He first exhibited his sculpture at the Salon des Indépendants in 1884. In 1889 he was commissioned by a private patron to produce a bookcase, which he completed single-handedly (apart from the wrought iron fixtures) in his studio in 1890 (Fig. 4.3). It was first exhibited in his studio, then at the SNBA's *objets d'art* section in 1892. The

art and decorative art critic Roger Marx welcomed it as a new departure in furniture, away from what he saw as the prevalence of historicism.[3] As well as on stylistic grounds, Marx also hoped that Carabin's bookcase would encourage greater autonomy on the part of artists and artisans, with artists pursuing work formerly executed by artisans, and artisans pursuing work

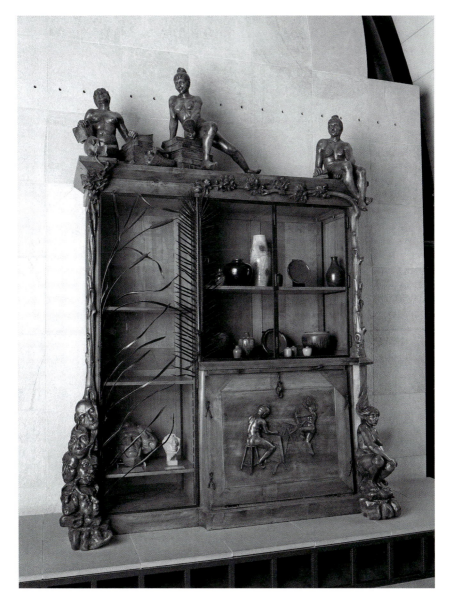

4.3 Rupert Carabin and Albert Servat, *Bookcase* (1890), walnut and forged metal, 290 × 215 × 83 cm. Musée d'Orsay, Paris.

formerly executed by artists. Following the critical success of the bookcase, Carabin produced a number of pieces of furniture until 1908.

Both Carabin and Fourdinois worked almost exclusively in wood for their furniture pieces, and employed direct carving. Their cabinets foreground the natural qualities of wood, eschewing gilded or dyed surface effects. Contemporary critics identified Carabin as a key figure in the renaissance of sculpture in wood in the 1890s.[4] He carved directly from a solid block and produced a deep rich patina by soaking the wood in linseed oil and rubbing it manually on a daily basis. His association with wood relates to his early years in Alsace, where his father was a forester, and, in line with his nationalism and regionalism, he preferred indigenous over exotic varieties.[5] His insistence that a work should bring out the qualities of colour and grain in the material reflects Pedro Rioux de Maillou's insistence on truth to materials in his 1895 essay 'The Decorative Arts and the Machine', which advocated that 'a piece of wooden furniture must look like wood' even if created by mechanical means.[6] Carabin deplored the 'Belgian Modern Style' (Art Nouveau) for having 'tortured' materials to such an extent that they gave the appearance of metal or stone: 'they give *material to a form* and not form to a material.[7] Carabin's approach to wood thus locates him as a precursor to modernism *and* within a certain strain of Gothic revivalism.

In his 1867 cabinet, Fourdinois displays an earlier and similar preoccupation with the natural qualities of woods, although he incorporates both indigenous and exotic varieties – ebony inlaid with box, lime, holly, pear and walnut. This reflects France's imperial expansion and the historical importance of this to the development of the nation's furniture industry. The cabinet also incorporates Fourdinois's newly patented inlay technique, 'solid' marquetry (*marqueterie en pleine*), which allowed him to develop highly sculptural polychrome furniture through direct carving. This technique combines a variety of closely juxtaposed woods, rather like a stick of confectionary rock, which are then inserted into the solid carcase to a depth of nearly 1 cm. This can then be worked like solid wood, carved directly in situ, facilitating a more fluid and complex design than the previous application of separate sections to the surface of the carcase with glue and/or fixings. The V&A acquired a panel demonstrating this technique, presumably at the same time as it purchased the cabinet. The cabinet's surface effect was aptly described in 1874 as 'leather colours', suggesting the flexibility of leather as well as the subtle modulations between the restrained polychromy of the undyed, natural woods.[8]

In terms of thematic content, Fourdinois and Carabin both employ the traditional form of female figures to embody specific subject matter. Fourdinois includes a three-dimensional figure of Minerva above a central panel depicting Peace and the Four Continents. While the allusions to Classical mythology might seem unexceptional, even banal, in a piece inspired by the Renaissance, these have a contemporary resonance in the context of the international

exhibitions. Minerva, the goddess of craft and commerce, directs and facilitates peaceful competition and cooperation between nations and represents the key aims of the exhibitions: freedom of commerce and international trade. The figure of Minerva also underlines Fourdinois' own commitment to the union of art and industry, craft and commerce. Carabin's figurative sculptures represent materials – Wood, Metal, Ceramic, Stone, Softwood and Hardwood. These relate to the cabinet's function as a display case for *objets d'art*. In his 1890 bookcase the female figures relate to the act of reading. Readers flank Truth; a figure of Ignorance and various masks represent the Vices defeated by Knowledge: Vanity, Avarice, Intemperance, Anger, Stupidity and Hypocrisy.

While both cabinets employ allegorical figures these differ in a number of ways. Fourdinois's mythological figures are identifiable through their Classical references and their accompanying attributes; they wear draperies, and Minerva stands upright holding a shield and a spear. Carabin's figures are similarly accompanied by their attributes. For example, Stone holds a hammer and a chisel. However, Carabin's figures are naked rather than clothed and, as the critic Alexandre noted (recalling his praise of Chéret's Parisiennes), these are of 'a frankly modern character, a type of our streets, observed with precision and rendered without flattery'.[9] Carabin's women are also positioned awkwardly. Stone (Fig. 4.4) kneels, uncomfortably pincered between the display cases, her head lowered and hidden, her exposed neck, back and the soles of her feet leaving her vulnerable and exposed, her outstretched arms, clutching a hammer and chisel, pinning her to the furniture. Her body appears bruised, damaged, crucified; the marks and cuts to her surface seemingly not possible through normal wear and tear to furniture, and enveloped in a deep rich patina. Carabin's figures are also integrated into the cabinet in a different way to Fourdinois's. They are equally embedded but are less clearly delineated, their bodies emerging from or receding into the material. This is particularly evident in the treatment of the hair in the figures representing Ceramic and Clay, which recall the use of hair in Symbolism and Art Nouveau.

A further point of difference between the two cabinets is the apparent subordination of sculpture to architecture in Fourdinois's piece, compared to the 'unbounded' sculptural 'freedom' of Carabin's large scale figures. However, as *The Art Journal* observed in 1868, sculpture permeates Fourdinois's work, from three-dimensional figures in the round to its abundant ornamental detailing:

> It is impossible, either by pen or pencil, to do justice to the cabinet of M Fourdinois, the 'Chef d'oeuvre' of the Exhibition, and certainly the best work of its class that has been produced, in modern times, by any manufacturer. But it is not a production of manufacture, not even of Art-manufacture; it is a collection of sculpted works, brought together and made to constitute parts of a cabinet – these 'parts' all exquisitely sculptured; 'carving' is not a word sufficient to express their delicacy and beauty. We engrave it; yet no engraving, however large, could convey an idea of the perfection of this perfect work.[10]

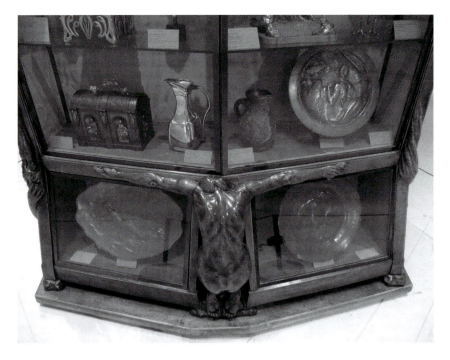

4.4 Rupert Carabin, *Display Cabinet for Objets d'Art* (1895), walnut, 238 × 243 × 184 cm. Detail of Stone. Petit Palais, Musée des Beaux-Arts de la Ville de Paris.

Nevertheless, this 'collection of sculpted works' is grounded in the familiar form of a Renaissance cabinet, the strong symmetrical lines anchoring the sculpture and conveying a strong element of control and forethought. This is not 'accidental' sculpture but a carefully designed and crafted piece. A contemporary essay on Fourdinois emphasised the unity of direction in the firm and the harmony of its work, compared to the incoherent, hybrid mixture of some other (unnamed) manufacturers.[11]

Unlike Fourdinois's cabinet, the sculpture in Carabin's is unframed; there are no niches, no safe surround. The scale and nature of the sculpture appears to extend from its ground and have an independent 'life' of its own. This would seem to contradict Carabin's belief that furniture ought to be adapted to our needs and that ornamentation should be directly related to its function. In 1915, in notes on nineteenth-century design written at the request of the architect Le Corbusier, Carabin explained how he based his furniture on the concept of the cube combined with asymmetry, connecting the lines with figures and ornaments taken from life.[12] As the critic Gustave Geffroy noted in 1890, 'he wanted all the lines to be absorbed by the lines of the decorative models of his sculpture ... by ingenuity to confuse the construction with ornamentation'.[13] This is not so dissimilar to Fourdinois's cabinet, wherein the sculptural elements both accentuate and distort the symmetry and 'cubic'

form of the piece. Furthermore, both employ the traditional form of the caryatid, although in Carabin's piece the figures of Softwood and Hardwood also function as structural supports. Their feet, as in the lower bodies of Fourdinois's caryatids, are replaced by non-figurative carving. In Carabin's bookcase the upper woman's legs are quite brutally truncated, rather than resolved, as would be traditional in the decorative arts, with a motif such as an acanthus leaf (as adopted by Rodin in his figures for a bed).

The overall effect of Carabin's cabinet is evidently different to Fourdinois's, yet the ingredients are surprisingly similar: a concern with 'truth to materials', direct carving, a combination of high and low relief and figures in the round, allegorical figures, and a close relationship between form and sculptural decoration. However, despite these similarities, contemporary critics perceived the comparative autonomy of sculpture in Carabin's furniture as a cause for concern, expressing unease regarding the prominence of sculpture in his work. Geffroy, for example, accused Carabin of having created 'wooden statues presented as furniture', rather than furniture decorated with sculpture.[14]

Criticism such as this articulated earlier concerns regarding the potential porosity or slippage between sculpture and architecture in the decorative arts. Fourdinois had been applauded precisely because of the 'harmony' and 'control' of his sculptural furniture. In contrast, Carabin was seen to have excessively and inappropriately extended the field of sculpture in the decorative arts. The art critic Arthur Maillet noted that Carabin's display cabinet was possibly the work of a madman or a fraud, in which 'a piece of furniture is a pretext for a long poem' and the 'furniture is primarily a pretext for modelling figures'.[15] Carabin's application of sculpture was seen to be disproportionate: 'in my opinion, he abuses it'.[16] These references to excess, abuse, insanity and poetry in relation to Carabin's work suggest the degenerative potential of unbounded sculpture. This is most vividly expressed in a poem by Kory Towska (Kory Elisabeth Rosenbaum), 'The New Style: Diary Entry of a Dalldorfer Inmate' (1899).

In this poem the fictional protagonist adorns his home with examples of Carabin's furniture and *objets d'art*. Its disorientating effect on his psyche results in his being forcibly committed to a lunatic asylum, as expressed in the following two stanzas:

> In no instance could I tell the mirror from the music stand,
> The water pipe from the wall calendar,
> The coffee-pot from the lamp,
> The linen cupboard from the window seat,
> The bed from the table, the table from the piano,
> The door from the clock, or the wardrobe from the door.
> They all had the same florid ornament.

And so it happened. From the constant confusion
My mind finally began to be bewildered.
Logic drowned in the scrolls and tendrils,
And the most extraordinary thoughts came to me.
That is, I wanted to read the dining table,
Cook the music stand with onion and dill,
Dress the chairs like human beings,
Shoot the footstool, the lamp –
But enough!
In the end they had to bring me here by force.
Although the doctor said that I could be cured
Yet I do not believe it, I am dying
I am dying from our decorative arts.[17]

Here, an unbounded, uncontrolled sculptural imagination is understood as a danger to the individual, and by association, to society. It can literally render you insane. And precipitate an untimely death. The 'florid ornament' masks the form of objects to such an extent that their function is no longer identifiable. This has caused such confusion in the mind and spirit of the consumer that he is unable to distinguish between inanimate objects and animate beings; he dresses the chairs and shoots the footstool, thinking that they are people.

The poem was originally published within an illustration by William A. Wellner (colour plate 4). Here, four men and three women in wealthy and fashionable dress interact with the furniture and furnishings of an avant-garde domestic interior. While the furniture designs might appear exaggerated, caricatured, particularly given the context of the poem, these are in fact relatively faithful and accurate representations of Carabin's furniture. To the left is a study, in which the corner of a desk is just visible. This is Carabin's *Les Quatres Eléments*, commissioned by Paul Gallimard, a collector of rare books and impressionist paintings whose son Gaston would found the publishing house Gallimard in 1911. The desk is conceived in the form of a book supported by four women. It was first exhibited at the 1891 SNBA Salon. Above this is a chair, also created by Carabin for Gallimard and exhibited at the 1893 SNBA Salon. Wellner represents the figurative element of the chair more overtly than the actual chair, in which a woman's naked body is fused within the rectangular chair back, her arms and legs bound to it, her head hidden within the crook of her arm. Seated in this chair is a woman in the act of reading. The chair merges with her own body, representing her naked, bound, sexually available self. Behind both stands a man, his bent knees and concentrated expression indicating that he is in the process of working out how he might penetrate a woman in this position, and that he may even pleasure himself by physically interacting with the immobile, unresisting form of the chair. He is unobserved by the seated woman and by the two cat armrests reminiscent of Chéret's *Sleep*, who in the original chair face behind the sitter. The furniture,

as stimulation to sexual fantasies, acts as an adjunct to the more traditional pornographic collections of works on paper and photographs, as represented by *Les Quatres Eléments*.

To the right of the poem is a living room. Against the far wall is Carabin's *Coffrets à Secrets* (1894 SNBA Salon), and near it a low stool or table flanked by two cats, reminiscent of the *Grand Siège* Carabin created for Montandon (1893 SNBA Salon). In the foreground an emaciated woman sits rigidly upright in a chair resembling a back brace, while a portly man in evening dress attempts, with some trepidation, to sit on a delicate chair. The only person sitting comfortably is a man seated in a more traditional upholstered armchair (the critic, the owner?) observing the unfolding scene with detachment, even boredom. Behind him, a standing woman is in the process of (self?) discovery as she examines a vase, and is about to be prevented from doing so by an approaching man pointing a cane.

Separating and uniting both rooms is the poem itself, presented as a display cabinet, a mirror or fireplace with integrated shelves which include three animalier decorative objects (a jug, pot and cream jug?), each perhaps suggestive of a penis, vagina and anus respectively. These are not works by Carabin, although they are reminiscent of his glazed ceramic inkwell in which a woman tears open the head of an octopus, spilling ink over its tentacles. These objects underscore the apparent absence, or the saturation, of sexuality within the ordered, bourgeois, public domestic sphere. It is unclear who is the guest or the owner, and who is aware of the erotic (for whom?) nature of the space and its objects.

Yet critics at the time did not comment on the inherent sexuality of Carabin's work, or on his representation of, and attitude towards, women. Rather, they focused on the 'modernity' of his style and the place of his sculpture in relation to the function, form and materials of his furniture. More recent scholars have similarly sidestepped the issue of sex and women in Carabin's work. Neither Towska's poem nor Wellner's accompanying illustration appear in the historiography on Carabin, possibly because they are disregarded as parodies. The catalogue to the 1974 exhibition on Carabin dismisses his daughter's statement that he was a misogynist, preferring to interpret his carved women as representing 'ideal' feminine virtues: 'from 1889, Carabin carved little sculptures in wood, objects: mirrors, vide-poches, in which the woman's body lent her softness, her symbolic suppleness'.[18] A significant exception is Nadine Lehni's 1993 essay, which examines Carabin's carved women in terms of their realism, their depiction of working class women, female submission to male domination, and fears regarding women's emancipation and independence.[19]

Paradoxically, while Carabin's representation of women in gendered furniture may be regarded as a reactionary response to the increasing freedom of women in French society, it simultaneously stimulated concerns regarding

the regulation and containment of the creative, specifically sculptural, imagination. Carabin's furniture distorted perceived hierarchies between high and low art, artist and worker, rationality and creativity, and function and form. It situated sex centre stage, within the Salon, the museum and the home.

From this combination of challenges to established norms, Carabin's critics focused on form and function and the dangers of an overzealous imagination. Sex was avoided, for obvious reasons; and, given the Third Republic's initiatives in design reform, the blurring of divisions between fine and decorative art and the artist and worker were meant to be supported. Critical discourse therefore centred on Carabin's perceived transgression of the traditionally subordinate position of sculpture to architecture, and on its harmful effect on the individual psyche and on society more broadly. Sculpture was the expendable casualty.

In conclusion, I have attempted to disrupt any overriding sense of linear progress in the decorative arts between 1848 and 1895 by drawing connections between two apparently unrelated cabinets, from opposite chronological and stylistic spectrums. This demonstrates how sculptors and manufacturers, at different periods in time and within distinct environments – one, an international exhibition preoccupied with industrial art and collaborative making, the other a fine art Salon concerned with the artist as maker – experimented in similar ways in unique 'exhibition' objects, wood, direct carving, allegory and sculptural 'decoration'. Furthermore, they were equally operating within a system of art and design criticism which placed value on innovation yet demarcated the acceptable limits of sculpture in which sculpture's role was simultaneously valued and restricted.

Carabin's sculptural furniture transgressed too many boundaries, and because of this he was inadvertently instrumental in the demise of figurative sculpture's dominance within the decorative arts. This can be understood within the context of Debora Silverman's analysis of the medical study of nervous pathologies in relation to Art Nouveau. Silverman concludes that concerns over collective degeneration 'promulgated a modern interior style based on vitalizing organic forms' in which a 'retreat to a healthy chamber of naturist physicality was posed against the nervous erosion wrought by the overloaded metropolis'.[20]

Analysis of Carabin's sculptural furniture extends Silverman's study by suggesting that figurative sculpture was specifically targeted as an expression of this degeneracy. In turn, this opened the way for the assertion of ornamental, plant-based sculpture over figurative sculpture. Carabin's furniture represents the culmination of the ascendancy of figurative sculpture as the dominant artistic art form in the decorative arts from 1848 onwards, and its ultimate failure and rejection. By the late 1890s, this was exacerbated by the assertion of the architect in all areas of public and domestic design, and

the abandonment of the stand-out and stand-alone 'exhibition' piece (as in Fourdinois and Carabin's cabinets) in favour of works that could be subsumed within a harmonious and unified interior. By the 1920s this is exemplified in the Art Deco movement wherein colour and linearity dominate, and sculpture is increasingly embedded within architecture, interiors and objects as low relief, subordinate ornamentation.

Notes

1 On Fourdinois, see Olivier Gabet, 'Sources et modèles d'un ébéniste au XIXe siècle: l'exemple d'Henri Fourdinois (1830–1907)', *Bulletin de la Société de l'Histoire de l'Art français* (2002): pp. 261–279.

2 On Fourdinois and England, see Olivier Gabet, 'French Cabinet Makers and England, the Case of the Maison Fourdinois (1835–85)', *Apollo*, vol. 155, no. 479 (January 2002): pp. 22–31.

3 Roger Marx, 'Preface', in Alexandre, *Histoire de l'art décoratif* (Paris, 1891), pp. 19–20.

4 Gustave Geffroy, *La Vie Artistique* (Paris, 1903), p. 449. On Carabin and wood, see Anne Pingeot, 'Carabin Sculpteur', in Nadine Lehni and Etienne Martin (eds), *F. R. Carabin 1862–1932* (Strasbourg and Paris, 1993), pp. 22–29; Etienne Martin, 'Le Mobilier Symboliste de F. R. Carabin, passéiste, moderniste ou visionnaire' in Lehni and Martin, *F. R. Carabin*, pp. 55–60.

5 Rupert Carabin, 'Le Bois', *Art et Industrie* (March 1910), n.p.

6 Pedro Rioux de Maillou, 'The Decorative Arts and the Machine' (1894), reprinted in Isabelle Frank (ed.), *The Theory of Decorative Art: An Anthology of European and American Writings, 1750–1940* (New Haven and London, 2000), p. 188.

7 'Ils donnent *de la matière à une forme* et non une forme à la matière', Carabin, 'Le Bois', n.p.

8 Paul Marbeau, *Union centrale des beaux-arts appliqués à l'industrie, 4ème exposition, 1874, IIIème section, l'art appliqué au mobilier* (Paris, 1874), p. 63.

9 'Figures symboliques d'un caractère franchement moderne, types de nos rues, observés avec précision et rendus sans flatterie', Roger Marx, 'Preface', in Alexandre, *Histoire de l'art décoratif*, p. 19.

10 *The Art Journal Illustrated Catalogue of the Universal Exhibition 1867*, p. 141.

11 Alphonse Cerfberr de Medelsheim, *Meubles et tapisserie, M. Henri Fourdinois, Grand Prix 1867* (Paris, 1868), p. 11.

12 Rupert Carabin, 'Notes', accompanying a letter to Le Corbusier, 17 December 1915. Fondation Le Corbusier.

13 'Il a voulu que toutes les lignes fussent absorbées pas les lignes et les modèles décoratifs de sa sculpture ... par l'ingéniosité à confondre la construction et l'ornementation.' Gustave Geffroy, 'A propos d'une bibliothèque du sculpteur Carabin', *Revue des Arts Décoratifs*, vol. 11 (July–August 1890), p. 43.

14 'Fortes statues de bois présentées comme des meubles', Gustave Geffroy, *La Vie Artistique* (1895), p. 306.

15 'Pour lui un meuble est prétexte à tout un long poème'; 'ses meubles sont-ils surtout prétexte à modeler des figures', Arthur Maillet, 'Les Salons', *Petit Chronique du Mois* (June 1895): pp. 170, 172.

16 'À mon sens, il en abuse', Maillet, 'Les Salons', p. 172.

17 Kory Towska (Kory Elisabeth Rosenbaum), 'The New Style; Diary Entry of a Dalldorfer Inmate', ('Der neue Styl, Tagebuchblatt eines Dalldorfer Zellenbewohners'), *Lustige Blaetter*, vol. 14, no. 17 (1899): pp. 8–9, translated by Jeffery Howe.

18 'Dès 1889, Carabin taille dans le bois des petites sculptures, des objets: miroirs, vide-poche, auxquels le corps de la femme prête sa douceur, sa souplesse symbolique', Yvonne Brunhammer, 'Introduction', *L'œuvre de Rupert Carabin* (Paris, 1974), p. 10.

19 Lehni, *Carabin*.

20 Silverman, *Art Nouveau*, p. 83.

Appendix 1
Contract between Constant Sévin and Ferdinand Barbedienne, 1855[1]

Between the undersigned Mr Ferdinand Barbedienne, Bronze maker, of 30 boulevard Poissonnière, Paris; on the one part:

and Mr Constant Sévin, *Artiste sculpteur, ornemaniste*, of 20 route de Versailles, Auteuil, on the other part:

The following was said and agreed upon:

Mr Ferdinand Barbedienne, since the foundation of his enterprise intends to bring his field of industry to its highest level; it is in the hope of reaching this goal that he has sought the cooperation of Mr Constant Sévin.

For his part Mr Constant Sévin being in full agreement with this approach, which is also his own, has accepted from Mr Ferdinand Barbedienne the direction of his Sculpture studio which was offered to him ; he took this post in August eighteen hundred and fifty five (1855), with a salary of six thousand francs a year.

Since then the efforts and studies of Mr Constant Sévin have induced Mr Ferdinand Barbedienne to increase his salary from the first of May eighteen hundred and fifty six to the amount of seven thousand and two hundred francs for the present year, to eight thousand and four hundred francs for the following one, to nine thousand and six hundred francs for the third year, to ten thousand and eight hundred francs for the fourth year, and finally to twelve thousand for the fifth, sixth, seventh, eighth, ninth and tenth years which will mark the end of the present agreement.

Consequently the definitive salary of twelve thousand francs will begin on the first of May eighteen hundred and sixty.

On his part Mr Constant Sévin promises to Mr Ferdinand Barbedienne that he will exclusively devote his talent and his care to everything that might contribute to the reputation and the success of his industrial firm.

Signed and approved Constant Sévin
Signed and approved Ferdinand Barbedienne
Entre les soussignés Monsieur Ferdinand Barbedienne, Fabriquant de bronzes, demeurant 30 boulevard Poissonnière à Paris; d'une part:
Et Monsieur Constant Sévin, Artiste sculpteur, ornemaniste, demeurant 20 route de Versailles à Auteuil; d'autre part:
Il a été dit et convenu ce qui suit:

Monsieur Ferdinand Barbedienne, depuis la fondation de sa maison, s'est proposé de porter, dans sa profession, l'état industriel à ses plus hautes limites; et c'est dans l'espoir d'atteindre ce but, qu'il a recherché le concours de Monsieur Constant Sévin.

De son côté Monsieur Constant Sévin s'associant sans réserve à cette pensée qui est également la sienne a accepté de Monsieur Ferdinand Barbedienne la direction de son atelier de Sculpture, qui lui était offerte; et il est entré en fonction en Août Mil-huit cent cinquante-cinq, aux appointements de Six mille francs par an.

Depuis cette époque les efforts et les études de Monsieur Constant Sévin ont déterminé Monsieur Ferdinand Barbedienne à élever son traitement à partir du premier Mai Mil-huit cent cinquante six à la somme de Sept mille deux cents francs pour l'année courante, à Huit mille quatre cents francs pour celle qui suivra, à Neuf mille six cents francs pour la troisième année, à Dix mille huit cents francs pour la quatrième, et enfin Douze mille francs pour les cinquième, sixième, septième, huitième, neuvième et dixième années qui seront le terme du présent traité.

En conséquence le traitement définitif de Douze mille francs commence à courir le premier Mai Mil-huit cent soixante.

De son côté Monsieur Constant Sévin promet à Monsieur Ferdinand Barbedienne de lui consacrer exclusivement son talent et ses soins, pour tout ce qui pourra aider à la réputation et au succès de sa maison industrielle.

Approuvé l'écriture ci-dessus Constant Sévin
Approuvé l'écriture ci-dessus Ferdinand Barbedienne

Notes

1 'Sévin file'. AN 368.AP.4

Bibliography

Manuscript Sources

Archives nationales, Paris (abbreviated to AN), F.12.2334, F.12.3040, F.12.3164, F.12.3371, F.12.3926, F.12.4290, F.12.7600, F.21.1553, F.21.2164.A, F.21.2171, F.21.493.1, F.21.687, F.2109, 368.AP.1, 368.AP.2, 368.AP.3, 368.AP.4, 106.AS.48, 106. AS.62, 106.AS.63, 106.AS.69, 106.AS.70.

Butler Mirolli, Ruth, 'The Early Work of Rodin and its Background' (Ph.D. dissertation, New York Univ. 1966).

Cauchois, Charles, 'Notes d'un ciseleur', May 1892 (AN 368.AP.2 Dossier 2).

Fondation Le Corbusier, Paris, Rupert Carabin, 'Notes' accompanying a letter to Le Corbusier (17 December 1915).

Les Arts décoratifs, Paris. D5.34, D4.59, D4.58, A1.40, A1.12, A1.9, A1.10, A1.51, A4.309, B2.19, B2.27, B2.37, B2.75, C4.1, C4.2, C4.14, C4.15.

Lubliner-Mattatia, Sabine, 'Les Fabricants de bronze d'ameublement 1848–1914' (Ph.D. dissertation, Univ. Paris-Sorbonne IV, 2003).

Sèvres – Cité de la céramique Archive. Author files for Carrier-Belleuse, Joseph Chéret, Emmanuel Frémiet, Auguste Rodin and Jules Desbois. Model files for Carrier-Belleuse's recorded designs.

Metman, Bernard, 'La Petite sculpture d'édition au xix siècle de 1818 à 1867' (Paris, Ecole du Louvre, 1944).

Musée Bouilhet Christofle Archive, Paris. Sculptor files for Carrier-Belleuse, Chéret, Klagmann, Levillain, Mercié and Hiolle.

Musée Rodin Archive, Paris. Correspondence files for Joseph Chéret, Jules Chéret, Barbedienne, Alice Lalique, Matias Errazuriz, Auguste Fannière, Jules Desbois and Manufacture nationale de Sèvres.

Rionnet, Florence, 'Le Rôle de la Maison Barbedienne (1834–1954) dans la diffusion de la sculpture aux xix et xx siècles. Considérations sur les bronzes d'édition et l'histoire du goût' (Ph.D. dissertation, Univ. Paris-Sorbonne IV, 2008).

Sánchez, Gonzalo J., 'The Development of Art and the Universal Republic: the Paris Commune's Fédération des Artistes and French Republicanism, 1871–1889' (Ph.D. dissertation, Columbia Univ., 1994).

Wiesinger, Véronique, 'Desbois et Rodin', (MA dissertation, Univ. Paris-Sorbonne IV, 1983).

Printed Primary Sources

'Assemblée des artistes', *Journal officiel de la République française sous la Commune* (15 April 1871): 273.

'Beaux-Arts', *La Presse*, no. 929 (13 December 1894): 1.

'Exposition', *Journal officiel de la République française sous la Commune* (15 April 1871): 274.

'Exposition de la Porcelaine, sa dorure, sa monture', *L'Art et les Artistes*, vol. 5 (April to September 1907): 206.

'International Exhibition of 1871', *The Art Journal* (1 March 1871): 90.

'L'Art industriel admis à l'exposition, *L'Art pour Tous* (February 1891): 3.

'L'Art industriel au Salon du Champ-de-Mars', *La Chronique des Arts et de la Curiosité*, no. 89, (28 February 1891), p. 67.

'L'Art moderne à l'exposition de 1878', *Gazette des Beaux-Arts* (1879): 371–378.

'L'Art Pour Tous au Salon', *L'Art pour Tous* (July 1892): 1–3.

'La Société nationale des beaux-arts', *L'Art pour Tous* (March 1893): 3.

'Liste des acquisitions faites au Musée des Arts décoratifs en février 1895', *Revue des Arts Décoratifs* (March 1895): 288.

'Nécrologie', *Revue des Arts Décoratifs* (July 1887): 30.

'Pierre Jules Cavelier', *New York Times* (11 February 1894).

'Pot à Tabac de Denière', *Magasin Pittoresque*, no. 23 (1855): 339–341.

'Rapport des ébénistes', in Arnould Desvernay, *Rapports des délégations ouvrières, contenant l'origine et l'histoire des diverses professions, l'appréciation des objets exposés, la comparaison des arts et des industries en France et à l'étranger...: ouvrage contenant 100 rapports rédigés par 315 délégués... Exposition universelle de 1867 à Paris*, vol. 2 (Paris: A. Morel, 1868): 13–43.

'Rapports sur les concours spéciaux du métal', *Revue des Arts Décoratifs* (1880): 316.

'Récompenses sur les concours spéciaux du métal', *Revue des Arts Décoratifs* (December 1880): 370–375.

'The Royal Institute of British Architects', *The Art Journal* (1 August 1871): 205.

'The Works of Carrier-Belleuse', *The Art Journal* (1 September 1871): 229.

450 modèles en bronze provenant de la maison Levy frères fabricants de bronzes Paris, rue de Turenne 13 (Paris: 1876).

7e Exposition de 1882 organisée au Palais de l'industrie: deuxième exposition technologique des industries d'art, le bois, les tissus, le papier: documents officiels de l'exposition. Union centrale des arts décoratifs (Paris: A. Quantin, 1883).

Alexandre, Arsène, *Histoire de l'Art décoratif, du XVI siècle à nos jours* (Paris, 1891).

Alexandre, Arsène, 'Joseph Chéret', in *Catalogue des œuvres originales, projets de monuments, de cheminées et de meubles, groupes, statuettes, bas-reliefs, pièces décoratives, terres cuites, bronzes, faïences, étains, dessins et croquis, composant l'œuvre de Joseph Chéret, sculpteur décorateur, exposées du 14 au 21 décembre 1894 à l'Ecole nationale des beaux-arts, quai Malaquais, et dont la vente aura lieu par suite de décès, Hôtel Drouot, 26–29 décembre 1894* (Paris: Impr. Chaix, 1894): 3–10.

Alexandre, Arsène, *L'Œuvre de Rodin. Exposition de 1900* (Paris: Société d'édition artistique, 1900).

Almanach de Messieurs les fabricants de bronze réunis de la Ville de Paris, 1844 (Paris: rue Aumale, 1844).

Almanach-Bottin (Paris: Bureau de l'Almanach du commerce, 1851).

Annales de la propriété industrielle, artistique et littéraire, vol. 16 (Paris, 1870).

Annuaire de la Réunion des fabricants de bronze et des industries qui s'y rattachent. Résumé des travaux de l'année 1887 (Paris, 1887).

Annuaire de la Réunion des fabricants de bronzes et des industries qui s'y rattachent. Résumé des travaux de l'année 1888 (Paris, 1888).

Annuaire de la Réunion des fabricants de bronze et des industries qui s'y rattachent. Résumé des travaux de l'année 1890 (Paris, 1890).

Annuaire de la Réunion des fabricants de bronze et des industries qui s'y rattachent. Résumé des travaux de l'année 1891 (Paris, 1891).

Auscher, Ernest–Simon, *Une Manufacture nationale en 1888, étude critique sur la manufacture de porcelaine de Sèvres* (Paris: J. Michelet, 1894).

Bacquès, Henri, *Des Arts industriels et des expositions en France. Recherches et études historiques suivies de documents utiles sur l'exposition de 1855* (Paris, 1855).

Bapst, Germain, 'Briot François, orfèvre en étain au XVIe siècle', *Revue des Arts Décoratifs*, vol. 4 (1883): 164–173 and 190–198.

Bapst, Germain, *Etudes sur l'étain dans l'Antiquité et au Moyen Age, orfèvrerie et industries diverses* (Paris: G. Masson, 1884).

Bapst, Germain, 'Orfèvrerie d'étain dans l'Antiquité', *Revue Archéologique* (January 1882): 9–23.

Bapst, Germain, 'Orfèvrerie d'étain dans l'Antiquité', *Revue Archéologique* (April 1892): 226–237.

Barbedienne, Ferdinand, 'Classe 22, bronzes d'art, fontes d'art diverses, objets en métaux repoussés', *Exposition Universelle de 1867, Rapport du jury international* (Paris, 1867): 283–313.

Bedigie, F., C. Legier, E. Solon, and Troisvallets père, *Délégations ouvrières à l'exposition universelle de Londres en 1862. Rapports sur la céramique des délégués peintres et décorateurs sur porcelaine et des délégués pour les pâtes faïence, porcelaine opaque, gros grès etc.* (Paris: M. Chabaud, 1863).

Bénédite, Léonce, *Le Musée du Luxembourg* (Paris: L. Bachet, 1894).

Blanc, Charles, 'Le procès Barbedienne', *Gazette des Beaux-Arts*, no. 4 (1 April 1862): 384–389.

Blanc, Charles, 'L'Union centrale des beaux-arts appliqués à l'industrie', *Gazette des Beaux-Arts* (1 September 1865): 193–217.

Bloche, Arthur, 'Le Cabinet de l'amateur, vente Chéret, deuxième vacation', *Le Gaulois* (28 December 1894): 3.

Brun, C., 'L'Exposition des arts appliqués à l'industrie', *Le Courrier Artistique* (1863): 62.

Bulletin de la Société du progrès (Paris, 1862).

Bulletin de l'Union centrale (Paris, 1875–76).

Burty, Philippe, 'Le Mobilier moderne', *Gazette des Beaux-Arts* (1 January 1868): 26–45.

Burty, Philippe, *Rapport présenté par le jury de la VIe section: art appliqué à la céramique et verrerie / Union centrale des beaux-arts appliqués à l'industrie, Exposition de 1874* (Paris: Impr. typogr. de A. Pougin, 1875).

Carabin, Rupert, 'Le Bois', *Art et Industrie* (March 1910).

Carrier-Belleuse, Albert-Ernest, *Application de la figure humaine à la décoration et à l'ornementation industrielle* (Paris: Goupil, 1884).

Carrier-Belleuse, Albert-Ernest, *La Terre Cuite française, decorative Statuetten, allegorische und mythologische Figuren, Amorteen, Büsten, etc. Originalaufnahmen der Terrakotten des Carrier-Belleuse* (Berlin, 1891).

Castagnary, Jules-Antoine, *Salons (1857–1870)* (Paris: G. Charpentier et E. Fasquelle, 1892).

Catalogue de beaux bronzes d'art et d'ameublement, groupes, statuettes, garnitures de cheminée, lustres, suspensions de salles à manger, objets de curiosité, cheminée monumentale, bronzes et modèles par Barye, meubles et étagères en noyer sculpté

provenant des ateliers et magasins de M Romain, successeur de M Victor Paillard, et dont la vente aura lieu en vertu d'une ordonnance (Paris: Hôtel Drouot, 11–17 June 1879).

Catalogue de la collection des moulages en plâtre dont les épreuves se trouvent en vente au Musée des Arts décoratifs. Union centrale des arts décoratifs (Paris: A. Quantin, 1883).

Catalogue de sculptures, bronzes, marbres... de M. Carrier Belleuse... (Paris: Hôtel Drouot, 26 December 1868).

Catalogue des Bronzes d'Art F. Barbedienne (Paris: Barbedienne, 1875).

Catalogue des meubles d'art anciens et modernes en bois sculpté et en marqueterie ... le tout appartenant à M. Fourdinois: Vente à Paris, Hôtel Drouot les 24 et 25 janvier 1887 (Paris: Imp. de l'art, 1887).

Catalogue des œuvres originales, projets de monuments, de cheminées et de meubles, groupes, statuettes, bas-reliefs, pièces décoratives, terres cuites, bronzes, faïences, étains, dessins et croquis, composant l'œuvre de Joseph Chéret, sculpteur décorateur, exposées du 14 au 21 Décembre 1894 à l'Ecole nationale des beaux-arts, quai Malaquais, et dont la vente aura lieu par suite de décès (Paris: Hôtel Drouot, 26–29 December 1894).

Catalogue des ouvrages de peinture, sculpture, dessins, gravure, architecture et objets d'art, exposés au Champ-de-Mars (Evreux: C. Herissey, 1896).

Catalogue des ouvrages de peinture, sculpture, dessins, gravure, architecture et objets d'art, exposés au Champ-de-Mars (Evreux: C. Herissey, 1897).

Catalogue des ouvrages de peinture, sculpture, dessins, gravure, architecture et objets d'art, exposés au Champ-de-Mars (Evreux: C. Herissey, 1898).

Catalogue des ouvrages de peinture, sculpture, dessins, gravure, architecture et objets d'art, exposés au Champ-de-Mars (Evreux: C. Herissey, 1899).

Catalogue du Musée des arts décoratifs. Classe I. Le bois. Union centrale des arts décoratifs (Paris: Librairie des imprimeries réunies, 1889).

Catalogue général descriptif de l'exposition: section française / Exposition universelle de Paris 1878 (Paris: Administration, 1878).

Catalogue illustré officiel du Salon des arts décoratifs, 1883 (2e année). Union centrale des arts décoratifs (Paris: A. Quantin, 1883).

Catalogue of the beautiful works in terra-cotta by Carrier-Belleuse (London: Christie, Manson & Woods, King Street, 1 November 1871).

Cerfberr de Medelsheim, Alphonse, *Meubles et tapisserie, M. Henri Fourdinois, Grand Prix 1867. Extrait des études industrielles à propos de l'exposition universelle de 1867* (Paris: Société des livres utile, 1868).

Champier, Victor, 'Ferdinand Barbedienne (1810–1892)', *Revue des Arts Décoratifs* (April 1892): 289–292.

Champier, Victor, 'L'Œuvre de Joseph Chéret à l'Ecole des beaux-arts', *Revue des Arts Décoratifs* (January 1895):193–196.

Champier, Victor, 'Le Prix de Sèvres, 1882', *Revue des Arts Décoratifs* (1882–1883): 288.

Champier, Victor, 'Les Artistes de l'industrie. Constant Sévin', *Revue des Arts Décoratifs* (February 1889): 161–176.

Champier, Victor, *Les Industries d'art à l'exposition universelle de 1900. Ouvrage en deux parties, deuxième partie, tome troisième, les industries d'art depuis cent ans*, vol. 3 (Paris: Bureau de la Revue des Arts Décoratifs, 1903).

Chapu, Henri, *Exposition universelle internationale de 1878 à Paris. Rapports du jury international groupe 1, classe 3, rapport sur la sculpture* (Paris: Impr. nationale, 1884).

Chevalier, Michel (ed.), *Exposition universelle de 1867 à Paris. Rapports du jury international* (Paris: P. Dupont, 1868).

Chevallier, Emile, *Les salaires au XIXe siècle* (Paris: A. Rousseau, 1887).

Child, Théodore, 'Ferdinand Barbedienne: Artistic Bronze', *Harper's New Monthly Magazine*, vol. 73, no. 436 (September 1886): 489–504.

Combarieu, Heingle and Monjon, 'Sculpteurs-ornemanistes', in *Rapports des délégués des ouvriers parisiens à l'exposition de Londres en 1862 publiés par la commission ouvrière* (Paris and Chabaud: Wanschooteb, Grandpierre et Dargent, 1862–1864): 471–486.

Congrès des arts décoratifs organisé à Paris sur l'initiative et par les soins de l'Union centrale, Mai 1894; règlement et programme (Paris: Impr. nationale, 1894).

Congrès international de la propriété artistique, 18 au 21 Septembre (Paris: Impr. nationale, 1879).

Congrès international de la propriété industrielle, 5 au 17 septembre (Paris: Impr. nationale, 1879).

Coquiot, Gustave, 'Biographies alsaciennes. François Rupert-Carabin, sculpteur', *Revue Alsacienne Illustrée* (1901): 141–149.

Coquiot, Gustave, 'Jules Desbois', *L'Art et les Artistes*, vol. 13, no. 76 (July 1911): 161–168.

Coupri, Eugène, 'Rapport au Congrès au nom de la Chambre syndicale des sculpteurs-modeleurs', *Les Arts du Métal* (October 1894): 315–317.

Coupri, Eugène, 'Union artistique des sculpteurs-modeleurs', *Les Arts du Métal* (October 1894): 263–268.

D'Haucour, Louis, *L'Hôtel de Ville de Paris à travers les siècles* (Paris: V. Giard & E. Brière, 1900).

Darcel, Alfred, 'Exposition universelle: bronze et fonte modernes', *Gazette des Beaux-Arts*, no. 23 (1 November 1867): 419–441.

Darcel, Alfred, 'Les Musées, les arts et les artistes pendant la Commune', *Gazette des Beaux-Arts*, no. 5 (1 November 1871): 414–429.

De Champeaux, Alfred, *Dictionnaire des fondeurs, ciseleurs, modeleurs en bronze et doreurs, depuis le Moyen âge jusqu'à l'époque actuelle* (Paris: J. Rovan; London: J. Wood, 1886).

De Laborde, Léon, *De l'Union des Arts et de l'Industrie* (Paris: Impr. impériale, 1856).

De Ris, Louis Clément, 'Mouvement des arts, bronzes et réductions de MM. Collas et Barbedienne', *L'Artiste*, ser. 5, no. 10 (15 April 1853): 88–90.

Des Manufactures nationales (Paris: Impr. Nationale, 19 June 1871).

Desvernay, Arnould (ed.), *Rapports des délégations ouvrières, contenant l'origine et l'histoire des diverses professions, l'appréciation des objets exposés, la comparaison des arts et des industries en France et à l'étranger...: ouvrage contenant 100 rapports rédigés par 315 délégués... Exposition universelle de 1867 à Paris*, 3 vols (Paris: A. Morel, 1868).

Dognée, Eugène, *Les Arts Industriels à l'exposition universelle de 1867* (Paris: J. Renouar, 1869).

Du Camp, Maxime, *Salon de 1867* (Paris, 1867).

Du Maroussem, Pierre, 'Ebéniste Parisien de Haut Luxe (Seine – France), ouvrier journalier, dans le système des engagements momentanés, d'après les renseignements recueillis sur les lieux, en janvier et février 1891', in la Société d'Economie Sociale, *Les ouvriers des deux mondes*, 2 ser., vol. 4 (Paris: Librairie de Firmin-Didot et Cie, 1892), 53–100.

Du Sartel, Octave., *Manufactures nationales. Exposition de 1884. Rapport adressé à Monsieur le Ministre au nom de la Commission de perfectionnement de la Manufacture nationale de Sèvres* (Paris, 1884).

Duc, Joseph-Louis, *Mémoire de la séance du 14 novembre 1872, commission de perfectionnement près de la manufacture de Sèvres* (Paris: Impr. nationale, 1872).

Duc, Joseph-Louis, *Rapport adressé à Monsieur le Ministre, au nom de la commission de perfectionnement de la manufacture de Sèvres* (Paris: Impr. nationale, 1875).

Duc, Joseph-Louis, *Rapport adressé à Monsieur le Ministre de l'Instruction publique et des beaux-arts, au nom de la commission de perfectionnement de la manufacture de Sèvres* (Paris: Impr. nationale, 1877).

Dupin, Charles, *Industries comparées de Paris et de Londres, tableau présenté le 4 janvier 1852 par le Baron Charles Dupin, dans la séance d'ouverture du cours de géométrie appliquée à l'industrie et aux beaux-arts, au Conservatoire national des arts et métiers* (Paris: Firmin-Didot frères, 1852).

Durm, J., 'De l'anse des vases antiques', *Magasin des arts et de l'industrie*, no. 2 (1868), p. 17.

Etex, Antoine, *Cours élémentaires de dessin appliqués à l'architecture, à la sculpture, à la peinture, ainsi qu'à tous les arts industriels, comprenant les éléments de la géométrie, de la perspective, du dessin, de la mécanique, de l'architecture, de la sculpture et de la peinture* (Paris: A. Etex, 1850).

Etex, Antoine, *J. Pradier. Etude sur sa vie et ses ouvrages* (Paris: A. Etex, 1859).

Exhibition of the Works of Industry of all Nations, 1851. Reports of the Juries on the Subjects of the 36 Classes into which the Exhibition was divided (London: Spicer Brothers, 1852).

Exposition Universelle de Londres en 1851. Distribution des Récompenses aux Exposants Français par le Président de la République (25 novembre 1851) (Paris: Typographie Panckoucke, 1852).

Exposition de 1865 au Palais de l'industrie / Union centrale des beaux-arts appliqués à l'industrie (Paris: Union centrale, 1866).

Exposition de 1865, règlements et programmes, distribution des récompenses, rapports du jury (Paris, 1866).

Exposition de la porcelaine, son décor, sa monture (Paris: Musée Galliera, 1907).

Exposition des beaux-arts appliqués à l'industrie, 1863 (Paris: Seringe frères & Poitevin, 1863).

Exposition universelle de 1867 à Paris, Rapports du jury international (Paris: P. Dupont, 1867).

Faïence d'Art, Oeuvres de A. & L. Carrier-Belleuse (n.l., n.d.).

Falize, Lucien, 'Exposition universelle. Les industries d'art au Champ-de-Mars, II. Les bronzes', *Gazette des Beaux-Arts*, vol. 2 (1 October 1878): 604–633.

Falize, Lucien, 'Les Bronzes', in Louis Gonse (ed.), *Exposition universelle de 1878, les beaux-arts et les arts décoratif, vol. 1: L'Art moderne* (Paris: Gazettes de Beaux-Arts, 1879): 347–372.

Feuchère, Lucien, *L'Art industriel. Recueil de disposition et de décorations intérieures comprenant des modèles pour toutes les industries d'ameublement et de luxe...* (Paris: Goupil, 1851).

Fourdinois, Henri, *De l'Etat actuel de l'industrie du mobilier* (Paris: A. Quantin, 1885).

Fourdinois, Henri, *Etude économique et sociale sur l'ameublement* (Paris: Librairies-imprimeries réunies, 1894).

Garnier, Jean, *Nouveau manuel complet du ciseleur contenant la description des procédés et l'art de ciseler et repousser tous les métaux ductiles, bijouterie, orfèvrerie, armures, ciselure du fondu, bronzes, etc. etc.* (Paris: Roret, 1859).

Gautier, Théophile, 'Une visite chez Barbedienne', *L'Artiste*, n.s., vol. 4, no. 1 (9 May 1858): 6–8.

Geffroy, Gustave, 'A propos d'une bibliothèque du sculpteur Carabin, *Revue des Arts décoratifs*, vol. 11 (July–August 1890): 42–49.

Geffroy, Gustave, *Musée du soir aux quartiers ouvriers. Le Temple, le Marais, le Faubourg Saint-Antoine* (Paris: A. Marty, c. 1894).

Geffroy, Gustave, *La Vie Artistique* (Paris, 1895).

Geffroy, Gustave, *La Vie Artistique* (Paris, 1903).

Gersaint, 'Union centrale des beaux-arts appliqués à l'industrie, exposition des œuvres contemporaines', *Gazette des Beaux-Arts* (1 October 1865): 369–379.

Goncourt, Edmond and Jules Goncourt, *Journal des Goncourts*, vol. 3 (Paris: G. Charpentier et Cie, 1888).

Gonse, Louis (ed.), *Exposition universelle de 1878, les beaux-arts et les arts décoratifs*, vol. 1 (Paris: Gazette des Beaux-Arts, 1879).

Great Exhibition of the Works of Industry of all Nations, 1851. Official Descriptive and Illustrated Catalogue (London: Spicer Brothers, 1851).

Guillaume, Eugène, *Inauguration du monument de Ferdinand Barbedienne au cimetière du Père-Lachaise, le 29 novembre 1894, discours* (Paris, 1894).

Guillaume, Eugène, *La Sculpture en bronze, conférence faite à l'Union centrale des beaux-arts appliqués à l'industrie le 29 avril 1868* (Paris: A. Morel, 1868).

Hugo, Victor, 'A. M. Froment-Meurice', *Les Contemplations*, no. 17 (22 October 1841).

Huysmans, Joris-Karl, *A Rebours* (Paris: G. Charpentier, 1884).

Huysmans, Joris-Karl, *L'Art moderne* (Paris: G. Charpentier, 1883).

Jouin, Henry, 'Un hommage à Carrier-Belleuse', *Journal des Beaux-Arts* (1887): 110.

Jourdain, Frantz, 'Les Artistes Décorateurs, no. 5, Joseph Chéret', *Revue des Arts Décoratifs*, no. 2 (August 1893): 39–43.

Jury international. Exposition universelle internationale de 1900, Direction générale de l'exploitation (Paris: Impr. nationale, 1900).

Kahn, Gustave, 'Auguste Rodin', *L'Art et le Beau*, no. 12 (December 1906): 101–135.

Karageorgevitch, Bojidar, 'L'emploi du métal dans l'ameublement', *L'Art Décoratif* (November 1905): 181–188.

La terre cuite française. 1e série, Reproductions héliographiques de l'oeuvre de Joseph Chéret, sculpteur à Paris (Paris; Liège: C. Claesen, 1885).

Labourieu, Théodore, *Exposition des arts appliqués à l'industrie, aux Champs-Elysées* (Paris: Impr. Tinterlin, 1863).

Lameire, C., *Rapport adressé à M. le Ministre de l'Instruction publique et des beaux-arts par M. Lameire au nom de la commission de perfectionnement de la manufacture nationale de Sèvres sur les porcelaines modernes qui ont figuré à l'exposition universelle de 1878* (Paris, 1879).

Lami, Stanislas, *Dictionnaire des sculpteurs de l'Ecole française au dix-neuvième siècle, A–C* (Paris: H. Champion, 1914).

Lami, Stanislas, *Dictionnaire des sculpteurs de l'Ecole française au dix-neuvième siècle, D–F* (Paris: H. Champion, 1916).

Lami, Stanislas, *Dictionnaire des sculpteurs de l'Ecole française au dix-neuvième siècle, G–M* (Paris: H. Champion, 1919).

Lami, Stanislas, *Dictionnaire des sculpteurs de l'Ecole française au dix-neuvième siècle, N–Z* (Paris: H. Champion, 1921).

Laurent, G., *Nouveau manuel complet du potier d'étain et de la fabrication des poids et mesure* (Paris: L. Mulo, 1909).

Lauth, Charles, *La manufacture nationale de Sèvres et la porcelaine nouvelle: conférence faite le 28 octobre 1884 au Palais de l'industrie. Union centrale des arts décoratifs, 8e Exposition des industries d'art, la pierre, le bois de construction, la terre et le verre* (Paris: A. Quantin, 1884).

Lauth, Charles, *La Manufacture nationale de Sèvres, 1879–1887, son administration, notices scientifiques et documents administratifs* (Paris: J. B. Baillière et fils, 1889).

Le congrès des Arts décoratifs de 1894 tenu à l'Ecole Nationale des beaux-arts du 18 au 30 mai sur l'initiative et par les soins de l'Union centrale des arts décoratifs. Comptes-rendus sténographiques (Paris: Palais de l'Industrie, 1894).

Lebrun, *Nouveau manuel complet du mouleur ou l'art de mouler en plâtre, carton, carton-pierre, carton-cuire, cire, plomb, argile, bois, écaille, corne, etc. etc.* (Paris: Roret, 1850).

Legrain, Eugène, *Manifeste prononcé à l'Assemblé générale de l'Union centrale des arts décoratifs le 16 mai 1894* (Paris: Nony, 1894).

L'Illustration, vol. 18 (19 July 1851).

Liste des récompenses. Union centrale des arts décoratifs, 9e exposition de 1887 (Paris: J. Bell, 1887).

Lockroy, Edouard, 'Le Monde des Arts', *L'Artiste* (15 January 1865): 40.

Lord Pilgrim, 'Voyage au pays des étrennes. Barbedienne: la galerie d'or', *L'Artiste*, vol. 10, n.s. no. 12 (15 December 1860): 281–283.

Louvrier de Lajolais, A., *Direction des beaux-arts, enquête sur les ouvriers et industries d'art. Extrait de la séance du lundi 13 février 1882* (Paris: A. Quantin, 1882).

Luc-Leo, *L'Industrie au XIXe siècle. Ameublement, H. Fourdinois* (Paris: E. Dentu, 1878).

Maciet, Jules, 'Rapport au nom de la commission du Musée des Arts décoratifs', *Revue des Arts Décoratifs* (May 1895): 337.

Maillet, Arthur, 'L'UCAD, lettre ouvert à M. Berger, député, Président de l'Union', *Les Arts du Métal* (October 1894): 194–200.

Maillet, Arthur, 'Les Salons', *Petit Chronique du Mois* (June 1895): 170–176.

Mambrun, F. and F. Chapuy, *Rapport des délégués du bronze de la ville de Lyon à l'exposition universelle de Paris en 1889* (Lyon: Association typographique, 1890).

Marbeau, Paul, *Union centrale des beaux-arts appliqués à l'industrie, 4ème exposition, 1874, IIIème section, l'art appliqué au mobilier* (Paris, 1874).

Marcheix, Lucien, 'Un oublié, Morel-Laudeuil sculpteur-ciseleur, 1820–1888', *Revue de l'Art Ancien et Moderne*, vol. 16 (1904): 73–80.

Marx, Roger, 'Preface', in Arsène Alexandre, *Histoire de l'art décoratif, du XVI siècle à nos jours* (Paris: Librairie Renouard, 1891): 18–20.

Marx, Roger, 'Rodin céramiste', *Art et Décoration*, vol. 18 (1905): 117–128.

Marx, Roger, *Auguste Rodin céramiste* (Paris: Société de propagation des livres d'art, 1907).

Mauclair, Camille, 'La crise des arts décoratifs', *Revue Bleue*, vol. 5 (June 1906): 755–759.

Mauclair, Camille, 'The Decorative Sculpture of Auguste Rodin', *International Monthly, Burlington* (February 1901): 166–181.

Mesnard, Jules, *Les Merveilles de l'exposition universelle de 1867* (Paris: Ch. Labure, 1867).

Ministère de l'Instruction publique et des beaux-arts, direction des beaux-arts, bureau de l'enseignement, Commission d'enquête sur la situation des ouvriers et des industries d'art, instituée par décret en date du 24 Décembre 1881 (Paris: A. Quantin, 1884).

Ministère de l'instruction publique et des beaux-arts, état comparatif des commandes et achats faits par les administrations des beaux-arts depuis 1870, no. 3088 (Paris, 1884).

Mirbeau, Octave, 'Auguste Rodin', *La France* (18 February 1885).

Monod, Emile, *L'Exposition universelle de 1889, grand ouvrage illustré, historique, encyclopédique, descriptif* (Paris: E. Dentu, 1890).

Morhardt, Mathias, 'Rodin ébéniste', *L'Art et les Artistes*, vol. 1, n.s. (no. 1–9) (1920): 348–349.

Nocq, Henry, *Tendances nouvelles. Enquête sur l'évolution des industries d'art* (Paris: Floury, 1896).

Noel, Arthur, *La Forêt, œuvre d'art, conférence faite au Palais de l'industrie à l'occasion de la 9ème exposition de L'Union centrale des arts décoratifs le 25 octobre 1887* (Paris: Librairie des bibliophiles, 1887).

Pelca, G., 'Ecole des beaux-arts', *Le Gaulois*, no. 5375 (13 December 1894): 2.

Penelle, M., *Rapport du délégué de la chambre syndicale des ouvriers sculpteurs de la ville de Lyon à l'exposition universelle de Paris en 1889* (Lyon: Association typographique, 1890).

Planche, Gustave, *Portraits d'artistes peintres et sculpteurs*, vol. 2 (Paris: Michel Lévy, 1853).

Porlie, Vigoureux, Antony Debon, Demessirejean, Bertheux and Lege fils, 'Rapport des sculpteurs', in Arnould Desvernay, *Rapports des délégations ouvrières, contenant l'origine et l'histoire des diverses professions, l'appréciation des objets exposés, la*

comparaison des arts et des industries en France et à l'étranger...: ouvrage contenant 100 rapports rédigés par 315 délégués... / Exposition universelle de 1867 à Paris, vol. 3 (Paris: A. Morel, 1868): 1–20.

Potier, Victor, 'Notes sur l'art industriel de l'étain', *Revue de la Bijouterie, Joaillerie, Orfèvrerie*, no. 31 (November 1902): 221–253.

Proust, Antonin, *Rapport donné au nom du conseil d'administration de l'UCAD par Antonin Proust, président de la société, à l'assemblée générale le 30 octobre 1890* (Paris: Impr. des arts et des manufactures, 1890).

Rapport de l'administration de la Commission impériale sur la section française de l'exposition universelle de Londres de 1862 suivi de documents statistiques et officiels et de la liste des exposants récompensés (Paris: Impr. de J. Claye, 1864).

Rapports des délégués des ouvriers parisiens à l'exposition de Londres en 1862 publiés par la commission ouvrière (Paris and Chabaud: Wanschooteb, Grandpierre et Dargent, 1862–1864).

Rapports du jury de l'exposition des beaux-arts appliqués à l'industrie au Palais des Champs-Elysées en 1863 (Paris: Impr. de Morris, 1865).

Reiber, Emile, *Bibliothèque portative des arts du dessin* (Paris: Ateliers du Musée-Reiber, 1877).

Réimpression du Journal officiel de la République française sous la Commune (Paris: V. Bunuel, 9 April 1871).

Rioux de Maillou, Pedro, 'The Decorative Arts and the Machine' (1894), reprinted in Isabelle Frank (ed.), *The Theory of Decorative Art: An Anthology of European and American Writings, 1750–1940* (New Haven and London: Yale University Press, 2000): 184–193.

Saint-Juirs (René Delorme), 'Carrier-Belleuse', *Galerie Contemporaine*, vol. 2 (Paris, c. 1876).

Salmson, Jules and Eugène Coupri, 'Les Artistes de l'industrie: Joseph Chéret', *L'Art Décoratif Moderne* (February 1895): 81–88.

Sand, George, et al, *Le diable à Paris, Paris et les Parisiens* (Paris: J. Hetzel, 1845).

Servant, G., *Exposition universelle internationale de 1878 à Paris, groupe III, classe 25. Rapport sur les bronzes d'art, fontes d'art diverses, métaux repoussés* (Paris: Impr. nationale, 1880).

Simon, Jules, *L'ouvrier de huit ans*, 2nd ed. (Paris: Librairie internationale, 1867).

Statuts de l'Union centrale des arts décoratifs, reconnue d'utilité publique par décret du 15 mai 1882 (Paris: Impr. de A. Warmont, 1891).

Statuts de l'Union centrale des beaux-arts appliqués à l'industrie (Paris: E. Panckoucke, 1864).

Statuts de l'Union centrale des beaux-arts appliqués à l'industrie (Paris, 1874).

Statuts Société anonyme à capital variable de l'Union centrale des beaux-arts appliqués à l'industrie (Paris: Impr. de A. Quantin, 1880).

The Art Journal Illustrated Catalogue of the International Exhibition 1862 (London: Virtue & Co, 1862).

The Art Journal Illustrated Catalogue of the International Exhibition 1871 (London: Virtue & Co., 1871).

The Art Journal Illustrated Catalogue of the Universal Exhibition 1867 (London: Virtue & Co., 1867).

Thiebaut, V., 'Application de la loi militaire aux ouvriers d'art', *Annuaire de la Réunion des fabricants de bronze et des industries qui s'y rattachent. Résumé des travaux de l'année 1893* (Paris, 1893): 71–78.

Thirion, Ch. (ed.), *Congrès international de la propriété artistique. 18 au 21 Septembre, Ministère de l'agriculture et du commerce, Exposition universelle internationale de 1878 à Paris. Comptes rendus sténographiques* (Paris: Impr. nationale, 1879).

Thirion, Ch. (ed.), *Congrès international de la propriété industrielle tenu à Paris du 5 au*

17 septembre 1878. Ministère de l'agriculture et du commerce, Exposition universelle internationale de 1878 à Paris. Comptes rendus sténographiques (Paris: Impr. nationale, 1879).

Towska, Kory (Kory Elisabeth Rosenbaum), 'Der neue Styl, Tagebuchblatt eines Dalldorfer Zellenbewohners' ('The New Style, Diary Entry of a Dalldorfer Inmate'), *Lustige Blaetter*, vol. 14, no. 17 (1899), pp. 8–9.

Union centrale des arts décoratifs, 9ème exposition, 1887, catalogue officiel (Paris, 1887).

Vente aux enchères publiques en vertu d'une ordonnance de modèles de bronzes d'art et d'ameublement, modèles en plâtre (non édités), mobilier industriel et outillage, ateliers Romain, boulevard Beaumarchais 105 (Paris, 1879).

Vente Ch. Pickard, 4–6 Juillet 1882, rue Béranger, 6. Modèles pour bronze d'art de la Maison Ch. Pickard, fabricant de bronzes d'art à Paris, par suite de cessation de fabrication (Paris, 1882).

Vente Charles Requier, 18 octobre 1898, 6 rue Debelleyme. Modèles pour bronzes d'ameublement avec droit de reproduction, provenant de la Maison Charles Requier, fabricant de bronzes, horloger à Paris, par suite de cessation de fabrication (Paris, 1898).

Vente de E. Sevenier, 26–28 mai 1884, rue Vieille-du-Temple, 110. Modèles pour bronzes d'art provenant de la Maison E. Sevenier, par suite de cessation de fabrication (Paris, 1884).

Vente G. Servant, Modèles pour bronzes d'art de la maison G. Servant, fabricant de bronzes d'art a Paris, par suite de cessation de fabrication. 3–7 Avril 1882, rue Vieille du Temple 137 (Paris, 1882).

Vever, Henri, *La Bijouterie française au XIX siècle*, 3 vols (Paris: H. Floury, 1906–08).

Waring, John B., *Masterpieces of Industrial Art and Sculpture at the International Exhibition, 1862*, 4 vols (London: Day and Son, 1863).

Wyatt Digby, Matthew, *Industrial Arts of the XIX Century at the Great Exhibition of 1851* (London: Day and Son, 1851–1853).

Secondary Sources

'Un chef d'œuvre retrouvé: deux sculptures d'enfants par Rodin', *Plaisir de France* (May 1971).

Agulhon, Maurice, *The Republican Experiment, 1848–1852* (Cambridge: Cambridge University Press, 1983).

Alcouffe, Daniel, 'Les émailleurs français à l'exposition universelle 1867', *Antologia di Bella Arti*, no. 13–14 (1980): 102–121.

Alcouffe, Daniel, Anne Dion-Tenenbaum and Pierre Ennès, *Un Age d'Or des Arts décoratifs 1814–1848* (Paris: Grand Palais, 1991).

Alcouffe, Daniel, Marc Bascou, Bernard Berthod, Anne Dion-Tenenbaum, Nicole Garnier, Fernando A. Martin, Marie-Madeleine Massé and Emmanuelle Toulet (eds), *Trésors d'argent. Les Froment-Meurice, orfèvres romantiques parisiens* (Paris: Musée de la Vie romantique, 2003).

Alhadeff, Albert, 'An Infinity of Grotesque Heads: Rodin, Legrain, and a Problem in Attribution', in Albert E. Elsen (ed.), *Rodin Rediscovered* (Washington: National Gallery of Art, 1981): 51–60.

Ames, Kenneth, 'The Battle of the Sideboards', *Winterthur Portfolio*, vol. 9 (1974): 1–27.

Aquilino, Marie Jeannine, 'Painted Promises: The Politics of Public Art in Late Nineteenth-Century France', *The Art Bulletin*, vol. 75, no. 4 (December 1993): 697–712.

Arminjon, Catherine (ed.), *L'Orfèvrerie au XIXe siècle: actes du colloque international, Galeries nationales du Grand Palais 12–13 déc. 1991* (Paris: Documentation française, 1994).

Arminjon, Catherine, 'Le groupe sculpté en aluminium du Musée du Second Empire au Château de Compiègne', *Cahiers d'Histoire de l'Aluminium*, vol. 10 (1992): 19–20.

Arminjon, Catherine, *L'Art du métal* (Paris: Ed. du patrimoine, 1998).

Atterbury, Paul (ed.), *The Parian Phenomenon. A Survey of Victorian Parian Porcelain Statuary and Busts* (Shepton Beauchamp: Richard Dennis, 1989).

Aubenas, Sylvie, 'La toilette de la duchesse de Parme photographiée par Gustave Le Gray en 1851', *La Revue du Musée d'Orsay*, no. 19 (Autumn 2004): 26–27.

Bailey, Brian, 'The Forgotten Art of Carrier-Belleuse', *Antique Collector*, vol. 54 (November 1983): 86–89.

Bascou, Marc, Marie-Madeleine Massé and Philippe Thiébault, *Musée d'Orsay. Catalogue sommaire illustré des arts décoratifs* (Paris: Réunion des musées nationaux, 1988).

Bascou, Marc, 'Le sculpteur, l'orfèvre, le fondeur-éditeur, Paris, 1850–1900', in Catherine Arminjon (ed.), *L'Orfèvrerie au XIXe siècle. Actes du colloque international Galeries nationales du Grand Palais, 12–13 December 1991* (Paris: Documentation française, 1994): 39–50.

Bascou, Marc, *Paris in the Late 19th Century* (Canberra: National Gallery of Art, 1996).

Beale, Arthur, 'A Technical View of Nineteenth-Century Sculpture', in Jeanne L.Wasserman, (ed.), *Metamorphoses in Nineteenth-Century Sculpture* (Harvard: Fogg Art Museum, 1975): 29–56.

Beausire, Alain and Hélène Pinet (eds), *Correspondance de Rodin, vol. 1, 1860–1899* (Paris: Ed. du Musée Rodin, 1985).

Beausire, Alain and Hélène Pinet (eds), *Correspondance de Rodin, vol. 2, 1900–1907* (Paris: Ed. du Musée Rodin, 1986).

Beausire, Alain and Florence Cadouot (eds), *Correspondance de Rodin, vol. 3, 1908–1912* (Paris: Ed. du Musée Rodin, 1987).

Beausire, Alain, *Quand Rodin exposait* (Paris: Ed. du Musée Rodin, 1988).

Beausire, Alain, Florence Cadouot and Frédérique Vincent (eds), *Correspondance de Rodin, vol. 4, 1913–1917* (Paris: Ed. du Musée Rodin, 1992).

Benge, Glenn F., *Antoine-Louis Barye, Sculptor of Romantic Realism* (University Park: Pennsylvania State University Press, 1984).

Benoist, Luc, *La Sculpture française* (Paris: Presses universitaires de France, 1963).

Benoist, Luc, *La Sculpture romantique* (Paris: Gallimard, 1994).

Berg, Maxine and Elizabeth Eger (eds), *Luxury in the Eighteenth Century. Debates, Desires and Delectable Goods* (Basingstoke: Palgrave Macmillan, 2003).

Bezucha, Robert J., 'The French Revolution of 1848 and the Social History of Work', *Theory and Society*, vol. 12, no. 4 (July 1983): 469–484.

Blanchetière, François and William Saadé (eds), *Rodin. Les Arts décoratifs* (Evian, Palais Lumière; Paris, Musée Rodin, 2009).

Blanchetière, François, 'Un franc-tireur inspiré, Rodin et la manufacture de Sèvres', in François Blanchetière and William Saadé (eds), *Rodin. Les Arts décoratifs* (Evian: Palais Lumière; Paris: Musée Rodin, 2009): 120–131.

Blühm, Andreas (ed.), *The Colour of Sculpture 1840–1910* (Amsterdam: Van Gogh Museum; Leeds: Henry Moore Institute, 1996).

Boime, Albert, 'Le Musée des copies', *Gazette des Beaux-Arts* (October 1964): 237–247.

Boime, Albert, *The Academy and French Painting in the Nineteenth Century* (London: Phaidon, 1971).

Boime, Albert, *Hollow Icons: The Politics of Sculpture in Nineteenth Century France* (Kent, Ohio: Kent State University, 1987).

Bouchon, Chantal, 'Traiter de l'ornement', *Histoire de l'Art*, no. 61 (October 2007): 7–15.

Bouillon, Jean-Paul, 'Baron Vitta and the Bracquemond/Rodin hand mirror', *The Bulletin of the Cleveland Museum of Art* (November 1979): 298–319.

Bourgarit, David and Jean Plateau, 'When Aluminium was Equal to Gold: Can a "Chemical" Aluminium be Distinguished from an "Electrolytic" One?', *Historic Metallurgy*, vol. 41, part 1 (2007): 57–76.

Braunwald, Annie and Anne Wagner, 'Jean-Baptiste Carpeaux', in Jeanne L. Wasserman (ed.), *Metamorphoses in Nineteenth-Century Sculpture* (Harvard: Fogg Art Museum, 1975): 109–143.

Brunhammer, Yvonne and Colette Merklen, *L'Œuvre de Rupert Carabin (1862–1932)* (Paris: Galerie du Luxembourg, 1974).

Bullen, J. B., 'The Sources and Development of the Idea of the Renaissance in Early Nineteenth-Century French Criticism', *The Modern Language Review*, vol. 76, no. 2 (April 1981): 311–322.

Bumpus, Bernard, 'Auguste Rodin and the Technique of *pâte-sur-pâte*', *Apollo* (January 1998): 13–18.

Bumpus, Bernard, *Pâte-sur-Pâte, the Art of Ceramic Relief Decoration, 1849–1992* (London: Barry and Jenkins, 1992).

Butler, Ruth, *Rodin in Perspective* (Englewood Cliffs and London: Prentice-Hall, 1980).

Butler, Ruth, *Rodin. The Shape of Genius* (New Haven and London: Yale University Press, 1993).

Calvignac, Marie-Hélène, 'Claude Aimé Chenavard, décorateur et ornemaniste', *Histoire de l'Art*, no. 16 (December 1991): 41–53.

Chaudonneret, Marie-Claude, *La Figure de la République. Le concours de 1848* (Paris: Réunion des Musées nationaux, 1987).

Chevillot, Catherine, 'Le socle', in Anne Pingeot (ed.), *La Sculpture française au XIX siècle* (Paris: Galeries nationales du Grand Palais, 1986): 242–251.

Chevillot, Catherine, 'Les Stands industriels d'édition de sculptures à l'exposition universelle de 1889: l'exemple de Barbedienne', *La Revue de l'Art*, no. 95 (1992): 61–67.

Chevillot, Catherine, 'Fichier des fondeurs', *La Revue de l'Art*, no. 104 (Paris, 1994): 74.

Chevillot, Catherine and Laure de Margerie (eds), *Sculpture au XIXe siècle* (Paris: N. Chaudun, 2008).

Chevillot, Catherine, 'Artistes et fondeurs au XIXe siècle', *Revue de l'Art*, no. 162 (2008): 51–57.

Chevillot, Catherine (ed.), *Leaving Rodin Behind? Sculpture in Paris, 1905–1914* (Paris: Musée d'Orsay, 2009).

Chong, Alan, 'Mrs Gardner's Two Silver Boxes by Christian Eriksson and Anders Zorn', *Cleveland Studies in the History of Art*, vol. 8 (2003): 222–229.

Cladel, Judith, *Rodin* (London: Kegan Paul & Co., 1936).

Clark, Timothy. J., *The Painting of Modern Life. Paris in the Art of Manet and his Followers* (London: Thames and Hudson, 1985).

Coignard, Jérôme, *Les Arts décoratifs, là où le beau rejoint l'utile* (Paris: Les Arts décoratifs, 2006).

Cole, Michael, W., *Cellini and the Principles of Sculpture* (Cambridge: Cambridge University Press, 2002).

Coutts, Howard, *The Road to Impressionism: Joséphine Bowes and Paintings in Nineteenth Century France* (Barnard Castle: The Bowes Museum, 2002).

Crestou, Nicole, 'Rodin à la manufacture de Sèvres', *La Revue de la Céramique et du Verre*, no.55 (November–December 1990): 22–24.

Curtis, Penelope, *Sculpture 1900–1945. After Rodin* (Oxford: Oxford University Press, 1999).

Davis, Shane Adler, '"Fine Cloths on the Altar": the Commodification of Late-Nineteenth-Century France', *Art Journal*, vol. 48, no. 1 (Spring 1989): 85–89.

Day, Ivan, *Royal Sugar Sculpture: 600 Years of Splendour* (Barnard Castle: The Bowes Museum, 2002).

De Caso, Jacques, 'Serial Sculpture in the Nineteenth Century', in Jeanne L. Wasserman (ed.), *Metamorphoses in Nineteenth-Century Sculpture* (Harvard: Fogg Art Museum, 1975): 1–28.

De Caso, Jacques (ed.), *Statues de chair. Sculptures de James Pradier (1790–1852)* (Geneva: Musée d'art et d'histoire; Paris: Musée du Luxembourg, 1985).

De Decker, Aurélie, 'Rodin et la décoration monumentale', in François Blanchetière and William Saadé, *Rodin. Les Arts décoratifs* (Evian: Palais Lumière; Paris: Musée Rodin, 2009): 72–81.

De Ferrière, Marc, 'Christofle: un pionnier de l'aluminium', *Cahiers d'Histoire de l'Aluminium*, no. 10 (Summer 1992): 7–20.

Delahaye, Jeanne Marcelle, 'Le Chanteur florentin de Paul Dubois', *La Revue du Louvre et des Musées de France*, vols 5–6 (1975): 338–343.

Devaux, Yves, *L'Univers des bronzes et des fontes ornementales: chefs-d'œuvre et curiosités, 1850–1920* (Paris: Ed. Pygmalion, 1978).

Devaux, Yves, 'Les Objets ciselés et le décor intérieur sous le Second Empire', *L'Estampille*, no. 11 (July 1979): 12–23.

Dion-Tenenbaum, Anne (ed.), *Marie d'Orléans (1813–1839): Princesse et artiste romantique* (Paris: Musée du Louvre; Chantilly: Musée Condé du château de Chantilly, 2008).

Drost, Wolfgang, 'La Photosculpture, entre art industriel et artisanat. La réussite de François Willème (1830–1905)', *Gazette des Beaux-Arts* (October 1985): 113–129.

Droth, Martina (ed.), *Taking Shape. Finding Sculpture in the Decorative Arts* (Leeds: Henry Moore Institute, 2008).

Ducrot, Brigitte, *Sèvres, Second Empire & IIIe République, de l'audace à la jubilation* (Sèvres: Manufacture nationale de Sèvres, 2008).

Edwards, Clive, 'The Firm of Jackson and Graham', *Furniture History*, vol. 34 (1998): 238–65.

Elliott, Bridget and Janice Helland (eds), *Women Artists and the Decorative Arts 1880–1935, The Gender of Ornament* (Aldershot: Ashgate, 1992).

Elsen, Albert E., *Rodin* (New York: Museum of Modern Art, 1967).

Elsen, Albert E., *In Rodin's Studio, A Photographic Record of Sculpture in the Making* (New York: Cornell University Press; Oxford: Phaidon Press, 1980).

Elsen, Albert E. (ed.), *Rodin Rediscovered* (Washington: National Gallery of Art, 1981).

Elsen, Albert E., *The Gates of Hell by Auguste Rodin* (Stanford: Stanford University Press, 1985).

Ennès, Pierre, 'Aimé Chenavard, Vase dans le style de la Renaissance', in Daniel Alcouffe, Anne Dion-Tenenbaum and Pierre Ennès (eds), *Un Age d'Or des Arts décoratifs 1814–1848* (Paris: Grand Palais, 1991): 265–267.

Exposition Rupert Carabin (Paris: Musée Galliera, 1934).

Faÿ-Hallé, Antoinette, 'La Porcelaine de Sèvres au XIXe siècle', *La Revue du Louvre et des Musées de France*, vol. 25, no. 2 (1975): 173–41.

Faÿ-Hallé, Antoinette, 'Le Décor en pâte sur pâte, une innovation du 19ème siècle', *Connaissance des Arts* (February 1994): 94–103.

Fend, Mechthild, 'Bodily and Pictorial Surfaces: Skin in French Art and Medicine, 1790–1860', *Art History*, vol. 28, no. 3 (June 2005): 311–339.

Flynn, Tom, 'Amending the Myth of Phidias: Quatremere de Quincy and the Nineteenth-Century Revival of Chrystelephantine Sculpture', *Apollo* (January 1997): 6–10.

Fortescue, William, *France and 1848, the End of Monarchy* (London: Routledge, 2005).

Frank, Isabelle (ed.), *The Theory of Decorative Art: An Anthology of European and American Writings, 1750–1940* (New Haven and London: Yale University Press, 2000).

Frelinghuysen, Alice Cooney, 'Christian Herter's Decoration of the William H. Vanderbilt House in New York City', *Magazine Antiques* (March 1995): 414–415.

Frisch, Victor and Joseph T. Shipley, *Auguste Rodin, a Biography* (New York: F. A. Stokes, 1939).

Froissart, Rosella, 'Les Collections du Musée des Arts décoratifs, modèles de savoir ou objets d'art?', in Chantal Georgel (ed.), *La Jeunesse des musées: les musées de France au XIXe siècle* (Paris: Musée d'Orsay, 1994): 83–90.

Froissart-Pezone, Rosella, 'Quand le palais Galliera s'ouvrait aux "ateliers des faubourgs": le Musée d'art industriel de la ville de Paris', *Revue de l'Art*, no. 116 (1997): 95–105.

Froissart-Pezone, Rosella, *L'Art dans tout. Les arts décoratifs en France et l'utopie d'un Art nouveau* (Paris: CNRS, 2004).

Gabet, Olivier, 'Sources et modèles d'un ébéniste au XIXe siècle: l'exemple d'Henri Fourdinois (1830–1907)', *Bulletin de la Société de l'Histoire de l'Art français* (2002): 261–279.

Gabet, Olivier, 'French Cabinet Makers and England, the Case of the Maison Fourdinois (1835–85), *Apollo*, vol. 155, no. 479 (January 2002): 22–31.

Gaborit, Jean-René, *Michel-Ange, Les Esclaves* (Paris: Réunion des musées nationaux, c. 2004).

Gardner, Albert T. E., 'The Hand of Rodin', *The Metropolitan Museum of Art Bulletin*, n.s., vol. 15, no. 9 (May 1957): 200–204.

Garnier, G. 'La carrière d'un artiste officiel à Paris', in Jacques de Caso (ed.), *Statues de chair. Sculptures de James Pradier (1790–1852)* (Geneva: Musée d'art et d'histoire; Paris: Musée du Luxembourg, 1985): 77–96.

Georgel, Chantal (ed.), *La Jeunesse des musées: les musées de France au XIXe siècle* (Paris: Musée d'Orsay, 1994).

Getsy, David J., *Rodin: Sex and the Making of Modern Sculpture* (New Haven and London: Yale University Press, 2010).

Getsy, David J., 'Refiguring Rodin', *Oxford Art Journal*, 28, no. 1 (March 2005): 131–135.

Gilbert, Christopher, *The Life and Work of Thomas Chippendale* (London: Studio Vista, Christie's, 1978).

Godden, Geoffrey A., *Victorian Porcelain* (London: Herbert Jenkins, 1961).

Goldscheider, Cécile, *Rodin, vie et œuvre, tome I, 1840–1886, catalogue raisonné de l'œuvre sculptée* (Paris: Wildenstein Institute; Lausanne: Bibliothèque des Arts, 1989).

Grappe, Georges, *Catalogue du Musée Rodin, essai de classement chronologique des œuvres d'Auguste Rodin* (Paris: Musée Rodin, 1931).

Hargrove, June, 'Carrier-Belleuse, Clésinger and Dalou: French Nineteenth-Century Sculpture', *Minneapolis Institute of Arts Bulletin*, no. 61 (1974): 28–43.

Hargrove, June, *The Life and Work of Albert Carrier-Belleuse* (New York and London: Garland, 1977).

Hargrove, June, 'Gustave-Joseph Chéret's "Day"', *Cleveland Studies in the History of Art*, vol. 8 (2003): 214–221.

Hellman, Mimi, 'The Joy of Sets: the Uses of Seriality in the French Interior', in Dena Goodman and Kathryn Norberg (eds), *Furnishing the Eighteenth Century: What Furniture can Tell us about the European and American Past* (Andover: Routledge, 2007): 129–53.

Héran, Emmanuelle and Marie-Madeleine Massé (eds), *Alexandre Charpentier (1856–1909): Naturalisme et Art nouveau* (Paris: Musée d'Orsay, 2008).

Heuzé, Michèle, 'Pradier intime, bijoux et camées', *L'Objet d'Art*, no. 380 (May 2003): 72–78.

Hirota, Haruko, 'La Sculpture en céramique de Gauguin: sources et signification', *Histoire de l'Art*, no. 15 (September 1991): 43–60.

Huard, Raymond and Pierre Maillot, *Jules Desbois sculpteur (1851–1935): une célébration tragique de la vie* (Paris: Le Cherche midi, 2000).

Hughes, Anthony and Erich Ranfft, *Sculpture and its Reproductions* (London: Reaktion Books, 1997).

Hughes, Peter, *The Wallace Collection Catalogue of Furniture*, 3 vols (London: The Trustees of the Wallace Collection, 1996).

Hungerford, Constance C., 'Meissonier and the Founding of the Société Nationale des Beaux-Arts', *Art Journal*, vol .48, no. 1 (Spring 1989): 71–77.

Janson, Horst W., 'Rodin and Carrier-Belleuse: The Vase des Titans', *The Art Bulletin*, vol. 50, no. 3 (September 1968): 278–280.

Jones, Claire, 'Rodin: la formation d'un sculpteur', in François Blanchetière and William Saadé (eds), *Rodin. Les Arts décoratifs* (Evian: Palais Lumière; Paris: Musée Rodin, 2009): 10–15.

Kenworthy-Browne, John, 'Plaster Casts for the Crystal Palace, Sydenham', *Sculpture Journal*, vol. 15, no. 2 (December 2006): 173–198.

Kjellberg, Pierre, *Les Bronzes du XIXe siècle. Dictionnaire des sculpteurs* (Paris: Ed. de l'Amateur, 2005).

La Sculpture du XIXe siècle, une mémoire retrouvé, les fonds de sculpture. (Paris: Ecole du Louvre, 1986).

Lajoix, Anne, 'Auguste Rodin et les arts du feu', *Revue de l'Art*, no. 116 (1997–2): 76–88.

Lampert, Catherine, *Rodin. Sculpture and Drawings* (London: Arts Council of Great Britain, 1987).

Lapaire, Claude, *James Pradier et la sculpture française de la génération romantique. Catalogue raisonné* (Lausanne: Institut Suisse pour l'étude de l'art, 2010).

Laurent, Stéphane, *L'Art Utile. Les écoles d'arts appliqués sous le Second Empire et la Troisième République* (Paris: L'Harmattan, 1998).

Laurent, Stéphane, *Les Arts appliqués en France. Genèse d'un enseignement* (Paris: Ed. du C.T.H.S., 1999).

Lawton, Frederick, *The life and Work of Auguste Rodin* (London: T. Fisher Unwin, 1906).

Le Normand-Romain, Antoinette, 'L'Académie de France à Rome, les envois de Rome', in Anne Pingeot (ed.), *La Sculpture française au XIX siècle* (Paris: Galeries nationales du Grand Palais, 1986): 53–57.

Le Normand-Romain, Antoinette, 'Les Ecoles', in Anne Pingeot (ed.), *La Sculpture française au XIX siècle* (Paris: Galeries nationales du Grand Palais, 1986): 28–31.

Le Normand-Romain, Antoinette (ed.), *Rodin en 1900: l'exposition de l'Alma* (Paris: Musée du Luxembourg, 2001).

Leben, Ulrich, Renaud d'Enfert, Rossella Froissart-Pezone and Sylvie Martin, *Histoire de l'Ecole nationale supérieure des arts décoratifs (1766–1941)* (Paris: Ecole nationale supérieure des arts décoratifs, 2004).

Lebon, Elisabeth, *Dictionnaire des fondeurs de bronze d'art, France, 1890–1950* (Perth: Marjon, 2003).

Lehni, Nadine and Etienne Martin (eds), *F.R. Carabin, 1862–1932* (Strasbourg, Musée d'art moderne; Paris, Musée d'Orsay, 1993).

Lehr, Robert, Joan Jones and Marilyn Karmason, 'Les Majoliques de Minton', *L'Estampille, L'Objet d'Art*, no. 270 (June 1993): 71–82.

Les Amitiés modernes de Rodin à Matisse, Carolus-Duran et la Société nationale des beaux-arts, 1890–1905 (Roubaix: La Piscine, musée d'art et d'industrie André-Diligent, 2003).

Les Epées de l'Académie des beaux-arts (Paris: Edition PC, 1997).

Lévêque, Jean-Jacques, *L'Hôtel de Ville de Paris, une histoire, un musée* (Paris: P. Horay, 1983).

Lobstein, Dominique, *Les Salons au XIXe siècle. Paris, capitale des arts* (Paris: Ed. de la Martinière, 2006).

Mainardi, Patricia, *Art and Politics of the Second Empire, the Universal Expositions of 1855 and 1867* (New Haven and London: Yale University Press, 1987).

Marsden, Jonathan (ed.), *Victoria & Albert: Art & Love* (London: Royal Collection, 2010).

Martín, Carmen Espinosa, 'La faïencerie de Choisy-le-Roi a través de los modelos de Albert Ernest y Louis Robert Carrier de Belleuse en el Museo Lázaro Galdiano', *Goya*, no. 274 (January–Febraury 2000): 35–43.

Martin, Etienne, 'Le Mobilier Symboliste de F.R. Carabin, passéiste, moderniste ou visionnaire', in Nadine Lehni and Etienne Martin (eds), *F.R. Carabin 1862–1932* (Strasbourg: Musée d'art moderne; Paris: Musée d'Orsay, 1993): 55–60.

Martinez, Jean-Luc (ed.), *Les Antiques du Louvre. Une histoire du gout d'Henri IV à Napoléon 1er* (Paris: Fayard Fayard and Musée du Louvre, 2004).

McWilliam, Neil, 'Craft, Commerce and the Contradictions of Anti-Capitalism: Reproducing the Applied Art of Jean Baffier', in Anthony Hughes and Erich Ranfft (eds), *Sculpture and its Reproductions* (London: Reaktion Books, 1997): 100–112.

McWilliam, Neil, *Monumental Intolerance: Jean Baffier, a Nationalist Sculptor in Fin-de-siècle France* (University Park: Pennsylvania State University Press, 2000).

Mercier, Jocelyn, *Jules Desbois, illustre statuaire angevin* (Longué: Editions du Vieux-Logis, 1978).

Metman, Bernard, *Documents sur la sculpture française; répertoire des fondeurs du XIXe siècle* (Nogent-le-Roi: Librairie des arts et métiers, institut national de l'histoire de l'art, 1989).

Metman, Bernard, 'La petite sculpture au XIXe siècle, les éditeurs', *Archives de l'Art Français*, vol. 30 (1992): 186–188.

Midant, Jean-Paul, 'Les Ateliers de Sèvres, un centre de recherche et d'expérimentation', *Monuments Historiques*, no. 190 (November–December 1993): 93–97.

Milande, Véronique, 'Du modèle en terre au biscuit de porcelaine. Les terres cuites du Musée national de céramique – réalisation d'un biscuit de porcelaine', in Marie-Noëlle Pinot de Villechenon (ed.), *Falconet à Sèvres ou l'art de plaire 1757–1766* (Sèvres: Musée national de céramique, 2001): 77–86.

Mitchell, Claudine (ed.), *Rodin: the Zola of Sculpture* (Aldershot: Ashgate, 2004).

Ostergard, Dereck (ed.), *The Sèvres Porcelain Manufactory: Alexandre Brongniart and the Triumph of Art and Industry, 1800–1847* (New Haven and London: Yale University Press for The Bard Graduate Center for Studies in the Decorative Arts, 1997).

Papet, Edouard (ed.), *A Fleur de peau. Le moulage sur nature au XIXe siècle* (Réunion des musées nationaux: Musée d'Orsay, c. 2001).

Pevsner, Nikolaus, *High Victorian Design: A Study of the Exhibits of 1851* (London: Architectural Press, 1951).

Pingeot, Anne (ed.), *La Sculpture française au XIX siècle* (Paris: Galeries nationales du Grand Palais, 1986).

Pingeot, Anne, Antoinette Le Normand-Romain and Laure de Margerie (eds), *Musée d'Orsay. Catalogue sommaire illustré des Sculptures* (Paris: Réunion des musées nationaux, 1986).

Pingeot, Anne, 'Carabin Sculpteur', in Nadine Lehni and Etienne Martin (eds): *F.R. Carabin 1862–1932* (Strasbourg, Musée d'art moderne; Paris, Musée d'Orsay, 1993): 22–29.

Pingeot, Anne, 'La Sculpture du XIXe siècle, la dernière décennie', *Revue de l'Art*, no. 104 (1994): 5–7.

Pingeot, Anne, 'Les Sculpteurs créent leur propre musée', in Chantal Georgel (ed.), *La Jeunesse des musées: les musées de France au XIXe siècle* (Paris, Musée d'Orsay, 1994): 259–264.

Pinot de Villechenon, Marie-Noëlle (ed.), *Falconet à Sèvres ou l'art de plaire 1757–1766* (Sèvres: Musée national de céramique, 2001).

Porcelaines de Sèvres au XIXe siècle (Sèvres, Musée national de céramique, 1975).

Portebois, Yannick and Nicholas Terpstra (eds), *The Renaissance in the Nineteenth Century* (Toronto: Centre for Reformation and Renaissance Studies, 2003).

Possémé, Evelyne, 'La Politique de reproduction à l'Union centrale des arts décoratifs au XIXe siècle', in Chantal Georgel (ed.), *La Jeunesse des musées: les musées de France au XIXe siècle* (Paris: Musée d'Orsay, 1994): 77–82.

Préaud, Tamara, *Sèvres de 1850 à nos jours* (Paris: Louvre des antiquaires, 1983).

Préaud, Tamara, 'Sèvres, la pâte sur pâte, un procédé original', *L'Estampille, L'Objet d'Art*, no. 263 (November 1992): 46–57.

Préaud, Tamara, 'La Porcelaine aux expositions universelles. Le rôle de Sèvres dans l'industrie céramique', *Monuments Historiques*, no. 190 (November–December 1993): 73–79.

Price, Roger (ed.), *Revolution and Reaction, 1848 and the Second Republic* (London: Croom Helm; New York: Barnes and Noble Books, 1975).

Purcell, Katherine, *Falize: A Dynasty of Jewellers* (London: Thames and Hudson, 1999).

Pyhrr, Stuart W., 'Recent Acquisitions: a Selection 1989–1990', *The Metropolitan Museum of Art Bulletin*, n.s., vol. 48, no. 2 (Autumn 1990): 22–23.

Recht, Roland, Philippe Sénéchal, Claire Barbillon and François-René Martin (eds), *Histoire de l'Art en France au XIXe siècle* (Paris: Documentation française, 2008).

Reff, Théodore, 'Copyists in the Louvre, 1850–1870', *The Art Bulletin*, vol. 46, no. 4 (December 1964): 552–559.

Renard, Jean-Claude, *L'Age de la fonte, un art, une industrie, 1800–1914, suivi d'un dictionnaire des artistes* (Paris: Ed. de l'Amateur, 1985).

Rionnet, Forence, 'Un Instrument de propagande artistique: l'atelier de moulage du Louvre', *Revue de l'Art*, no. 104 (1994): 49–50.

Rionnet, Florence, *L'Atelier du moulage du Musée du Louvre 1794–1928* (Paris: Réunion des musées nationaux, 1996).

Rionnet, Florence, 'Barbedienne ou la fortune de la sculpture au XIXe siècle', *Bulletin de la Société de l'Histoire de l'Art français* (2001): 301–323.

Rionnet, Florence, *La Maison Barbedienne: Correspondances d'artistes* (Paris: Ed. du C.T.H.S., 2008).

Robin, Doriane, 'L'Importance des arts décoratifs dans les premières expositions des produits de l'industrie française', *Histoire de l'Art*, no. 61 (October 2007): 39–48.

Roger Marx, un critique aux côtés de Gallé, Monet, Rodin, Gauguin (Nancy: Ville de Nancy, Editions Artlys, 2006).

Roos, Jane Mayo, 'Aristocracy in the Arts: Philippe de Chennevières and the Salons of the Mid 1870s', *Art Journal*, vol. 48, no. 1 (Spring 1989): 53–62.

Roos, Jane Mayo, *Early Impressionism and the French State 1866–1874* (Cambridge: Cambridge University Press, 1996).

Rosen, Charles and Henri Zerner, *Romanticism and Realism: The Mythology of Nineteenth-Century Art* (New York: Viking Press, 1984).

Sanders, Patricia, 'Auguste Rodin', in Jeanne L. Wasserman (ed.), *Metamorphoses in Nineteenth-Century Sculpture* (Harvard: Fogg Art Museum, 1975): 145–180.

Sargentson, Carolyn, *Merchants and Luxury Markets: The Marchands Merciers of Eighteenth-Century Paris* (London: Victoria and Albert Museum in association with the J. Paul Getty Museum, 1996).

Ségard, Achille, *Albert Carrier-Belleuse 1824–1887* (Paris: H. Champion, 1928).

Shedd, Meredith, 'Phidias in Paris: Félix Ravaisson's *Musée Grec* at the Palais de l'Industrie in 1860', *Gazette des Beaux-Arts* (April 1985): 155–170.

Shedd, Meredith, 'A Mania for Statuettes: Achille Collas and other Pioneers in the Mechanical Reproduction of Sculpture', *Gazette des Beaux-Arts* (July–August 1992): 36–48.

Shifman, Barry, 'The Fourdinois Sideboard at the 1851 Great Exhibition', *Apollo* (January 2003): 14–21.

Siler, Douglas, 'Les Années d'apprentissage', in Jacques de Caso (ed.), *Statues de chair. Sculptures de James Pradier (1790–1852)* (Geneva, Musée d'art et d'histoire; Paris, Musée du Luxembourg, 1985).

Silverman, Debora L., *Art Nouveau in Fin-de-Siècle France, Politics, Psychology and Style* (Berkeley and London: University of California Press, 1989).

Simier, Amélie (ed.), *Jean Carriès. La matière de l'étrange* (Paris: Petit Palais, 2007).

Steinberg, Leo, 'Rodin', in Leo Steinberg, *Other Criteria: Confrontations with Twentieth Century Art* (New York: Oxford University Press, 1972): 322–463.

Sutton, Denys, *Triumphant Satyr: The World of Auguste Rodin* (London: Country Life, 1966).

The Second Empire 1852–1870: Art in France under Napoleon III (Philadelphia: Philadelphia Museum of Art, 1978; Detroit: The Detroit Institute of Arts; Paris: Grand Palais, 1979).

Thiébault, Pierre, *René Lalique. Correspondance d'un bijoutier art nouveau 1890–1908* (Paris: Bibliotheque des Arts, 2007).

Troy, Nancy, *Modernism and the Decorative Arts in France. Art Nouveau to Le Corbusier* (New Haven and London: Yale University Press, 1991).

Trusted, Marjorie (ed.), *The Making of Sculpture. The Materials and Techniques of European Sculpture* (London: Victoria and Albert Museum, 2007).

Vaisse, Pierre, 'Courajod et le problème de la Renaissance', in Roland Recht, Philippe Sénéchal, Claire Barbillon and François-René Martin (eds), *Histoire de l'Art en France au XIXe siècle* (Paris: Documentation française, 2008): 95–112.

Verlet, Pierre, *Les Bronzes dorés français du XVIII siècle* (Paris: Picard, 1987).

Wagner, Anne M., *Jean-Baptiste Carpeaux, Sculptor of the Second Empire* (New Haven and London: Yale University Press, 1986).

Wainwright, Clive, 'A Barbedienne Mirror. Reflections on Nineteenth-Century Cross-Channel Taste', *National Art Collections Fund Annual Review* (1992): 86–90.

Walton, Whitney, *France at the Crystal Palace, Bourgeois Taste and Artisan Manufacture in the Nineteenth Century* (Berkeley, Los Angeles and Oxford: University of California Press, 1992).

Ward, Martha, 'Impressionist Installations and Private Exhibitions', *The Art Bulletin*, vol. 73, no. 4 (December 1991): 599–622.

Ward-Jackson, Philip, 'French Modellers in the Potteries', in Paul Atterbury (ed.), *The Parian Phenomenon. A Survey of Victorian Parian Porcelain Statuary and Busts* (Shepton Beauchamp: Richard Dennis, 1989): 48–56.

Wasserman, Jeanne L. (ed.), *Metamorphoses in Nineteenth-Century Sculpture* (Harvard: Fogg Art Museum, 1975).

White, Harrison C. and Cynthia A. White, *Canvases and Careers: Institutional Change in the French Painting World* (New York, London and Sydney: University of Chicago Press, 1965).

Wiesinger, Véronique, 'Jules Desbois (1851–1935): sculpteur de talent ou imitateur de Rodin?', *Bulletin de la Société de l'Histoire de l'Art Français* (1985): 315–330.

Wiesinger, Véronique, 'Les Collaborations. A propos du monument à Claude Gellée dit Le Lorrain d'Auguste Rodin', in Anne Pingeot (ed.), *La Sculpture française au XIXe siècle* (Paris: Galeries nationales du Grand Palais, 1986): 110–114.

Wood, Jon, David Hulks and Alex Potts (eds), *Modern Sculpture Reader* (Leeds: Henry Moore Institute, 2007).

Online Sources

Bently, Lionel and Martin Kretschmer, 'Court of Cassation on sculptures (1814)', translated by Katie Scott, Primary Sources on Copyright (1450–1900), www.copyrighthistory.org.

Bently, Lionel and Martin Kretschmer, 'French Literary and Artistic Property Act (1793)', translated by Andrew Counter, Primary Sources on Copyright (1450–1900), www.copyrighthistory.org.

McCoy, Claire Black, '"This man is Michelangelo": Octave Mirbeau, Auguste Rodin and the Image of the Modern Sculptor', *Nineteenth-Century Art Worldwide*, vol. 5, no. 1 (Spring 2006), www.19thc-artworldwide.org.

Morel, Dominique. 'The Cabinet of Alessandri and Son at the Paris Universal Exhibition of 1867', *Nineteenth-Century Art Worldwide*, vol. 6, no. 2 (Autumn 2007), www.19thc-artworldwide.org.

Index

Note: page numbers in *italics* refer to illustrations; Christian names of sculptors and makers are included where known

Académie de France à Rome 32
Académie des beaux-arts 32, 66, 115, 152
academy system 31–2
Alaphilippe, Camille 109, *110*
Alessandri and sons 158
Alexandre, Arsène 163–4, 167, 170, 185
aluminium, work in 30
André 149
antique sources 31–2, 42, 43–4, 73
Apoil, Suzanne Estelle *106*
apprentice sculptors 58, 64
Arson 62
Art Nouveau 163, 171, 184, 185
'artisan to artist' narrative 3–4, 5–6, 20, 77
artist decorators 134
Artistic Union of Sculptor-Modellers 153
Association of Masons 19
Attarge, Désiré 68, 73
Aubusson 30
auctions, *see* sale by auction
Auguste, Jules-Robert 36
Auscher, Ernest 108

authenticity 57, 136, 172, 179
authorship 23–6, 62–3, 90
 artists' signatures 62, 90, 135, 172
 identification by personal style 142
 manufacturers' marks 136
 registration of artistic models 28, 91, 154–6
 SNBA approach to recognising 135–6
Aynard 135

babies, representation of 11, 93, 101, 164
Baffier, Jean 138, 139, 140, 148, 162
Banneville, Joly de 68
Bapst, Germain 147–8
Barbedienne, Ferdinand 43–54
 in collaboration with Sévin 69–76
 copyright case brought against 63
 participation in UCAD 120
 registration of artistic models 156
 reproductions of historic sculpture 22–3, 43–4, 45
 Sévin's contract with 69–76, 193–4
 specific works
 Bookcase (1851) 45–7, *46*, 48
 Bookcase (1862) 48, *49*, 50
 Mirror (1867) 73, *74*, *75*
 work exhibited in London 90
Barrias, Louis-Ernest 108, 121, 140

Bartholdi, Frédéric Auguste 124, 136
Barye, Antoine-Louis 6, 24, 113
Beausire, Alain 119, 122
Beauvais 18, 57
beaux-arts system 31–2, 53
Becker, Edmond 156
Bertheux 62
Besnard, Charlotte 138
Blanchetière, François 114
Blondat, Max 149
Boime, Albert 95
Bonnat, Léon 158
bookcases 45–7, 48, 50, 182
Borghese collection 42
Botticelli, Sandro 97
Bouilhet, Henri 120, 152
Boulle, André-Charles 30, 35
Bourdelle, Antoine 141
Bowes, Joséphine 33
Bowes Museum 73, 74, 75
Bracquemond, Félix 3
Brateau, Jules 139, 140, 148
Bréant & Coulbeaux 159
Breton, Edouard 98
Briot, François 148
bronze
 casting 21–3, 27–8, 43–4
 chasing 21, 23, 53
 lost wax process 33–4, 138, 139, 172
 mounts for vases 92, 96
 at Sèvres 95–6
 work in 32–5, 47–8, 51, 73–6
Buhot, Louis-Charles-Hippolyte 68
Butler, Ruth 112, 113, 121

Cahieu 69
Cain, Auguste 123
candelabra 22, 35
Canova, Antonio 37
Carabin, François-Rupert (Rupert)
 182, 184–90
 participation in SNBA 138, 140
 specific works

Bookcase (1890) 182, 183
Display Cabinet for Objets d'Art
 (1895) 179, 180, 182, 184–7,
 186
Les Quatres Eléments 188–9
Carpeaux, Jean-Baptiste 21, 24, 53
Carrier-Belleuse, Albert-Ernest
 in Belgium 89, 93
 Director of Works of Art at Sèvres
 92–109
 editing his own sculpture 24
 in England 50, 90, 92, 93
 influence on revival of sculpture in
 ceramics 109
 participation in 1863 exhibition of
 fine arts applied to industry 157
 Rodin's work for 97, 98, 99, 100–2
 sale of works 27, 90
 specific works
 Buire de Blois 104, 106
 Cylindroïde Vase 95
 Le Printemps (vase et support) 158,
 160
 Les Chasses (1883) 107
 Mirror (1867) 73, 74, 75
 Pompeii Vases 97, 99, 100–2
 Saigon Vases 95–6, 97, 98, 102
 Titan Vase 8
 Vase Delafosse (1880) 104, 105
 support for Joseph Chéret 157–8
 support for Rodin 112
 work for Christofle 107
 work for Hôtel de Ville 113
 work for Minton 50, 92, 107
Carrier-Belleuse, Marie 156
Carrier-Belleuse, Pierre 152
Carrière, Eugène 140
Carriès, Jean 139, 140
Caso, Jacques de 38
Castagnary, Jules-Antoine 135
Cauchois-Morel, Charles 53
Cavelier, Pierre-Jules 108, 140
Cazin, Jean Charles 135

Cellini, Benvenuto 20, 43, 53
Central Union of Fine Arts Applied to
 Industry 54, 116
ceramic workers 59, 60
Champier, Victor 67, 69–70, 71
Chaplain, Jules-Clément 112, 113, 120
Chapu, Henri 121
Charpentier, Alexandre 138, 139, 140,
 149, 164
Chavannes, Pierre-Cécile Puvis de
 120, 121
Chenavard, Claude-Aimé 40, 41, 43, 52
Chennevières, Charles-Philippe de 92,
 116
Chéret, Gustave-Joseph (Joseph) 157,
 161
 his studio 122
 participation in 1863 exhibition of
 fine arts applied to industry 157
 participation in 1867 International
 Exhibition 158
 posthumous exhibition at Ecole
 des beaux-arts (1894) 152, 156–7,
 162–71
 representation of babies 101, 164
 representations of women 164–70
 at Sèvres 108, 157–8
 specific works
 The Quiver 164, 165
 Sleep 164, 166, 167, 188
 Vase Mounted in Silver with a
 Garland of Fine Gold and
 Enamel (1889) 158, 159
 Vase with Masks 168, 169
 submissions to the Salon 161
 work with Carrier-Belleuse 108,
 157–8
Chéret, Jules 152, 157, 167–8, 168
Chevillot, Catherine 25
Child, Théodore 22
Chippendale, Thomas 29
Choisy-le-Roi 7, 8, 9, 107
Christofle 30, 71, 107, 158

class, sculptors 11–12, 19, 150
Claudel, Camille 139, 141
Clésinger, Auguste 47–8, 63
clock designs 25, 26, 35, 47–8, 70
Clodion (real name Claude Michel)
 11, 27, 93, 101, 164
Collas, Achille 22, 43
Collin 149
Combarieu, Frédéric-Charles-Félix 55
Combarieux 62
Combetti 27
contracts 24, 155
 between Carrier-Belleuse and
 Minton 107
 between Clésinger and Barbedienne
 47
 Pradier's with manufacturers 33
 Rodin's with manufacturers 114
 between Sévin and Barbedienne 69,
 193–4
copies, see reproduction of sculpture
copyright 24–6, 28–9, 91; see also
 contracts
 disputes 24, 33, 63
 International Congresses (1878) 91
 and the law 24–5, 28
 registration of artistic models 28,
 91, 154–6
 and Rodin's non-completion of
 Gates of Hell 25
 and sale by auction of
 manufacturer's models 27, 28, 154
 transfer of property rights form
 (1894) 155
Coquiot, Gustave 142, 149
Cordier 121
Cordonnier, Alphonse-Amédée 138
Couder, Auguste 55
counterfeiting 24, 26
Coupri, Eugène 137, 140, 153–4
Courbet, Gustave 89, 90
Court of Cassation on sculptures
 (1814) 24

Crauck 121
Cros, Henry 109
Cumberworth, Charles 24
Cuvillier 122, *123*

d'Alembert, Jean le Rond 112
Dalou, Aimé-Jules 89
Dalou, Jules 109, 112, 120
 participation in 1900 International
 Exhibition 124
 participation in Commission des
 travaux d'art 121
 participation in SNBA 133, 138
Dampt, Jean 139
d'Angers, David 68
Debon, Antony 62
Deck, Théodore 108, 116
decorative arts 4, 11, 12, 13
decorative sculpture 12, 28–9
Delaplanche, Eugène 112, 113, 121
della Robbia, Luca 36, 43, 50, 107
Demessirejean 62
democratisation of art 31, 32
Denière 51, *51*
Department of Fine Arts 90, 91, 97,
 109, 111
Department of Works of Art at Sèvres
 92
Dépôt des marbres 113, 121–2
Desbois, Jules 140–52
 his studio 150–1
 La Treille (Climbing Vine) 145, *146*
 participation in 1889 International
 Exhibition 121
 participation in SNBA 138, 141,
 145–7, 148–51
 pewter ware 142–50, *143*, *144*
 recognition of his work 142
 in relation to Rodin 141
 Women and Centaurs 142, *143*
 work for Sèvres 96, 97, 141
Desfossé, Jules 39, *39*
Dieterle, Jules-Pierre-Michel 55

direct carving 139, 141, 172, 184
direct engraving, on ceramic 97
display cases 137, 140, 179–87
Doat, Taxile 100
Doré, Gustave 101
drawings, as representations of
 models 28–9, 71
Dubois, Paul
 as Director of the Ecole des beaux
 arts 152
 member of Commission des travaux
 d'art 121
 participation in 1900 International
 Exhibition 124
 participation in SNBA 135
 support for Rodin 112
 work for Barbedienne 52, 113
Duchemin, Verry and Jouanneaux
 Dubois 33
Durand-Ruel, Paul 90
Dury, William 59

Ecole des beaux-arts 31–2
 1894 Congress on Decorative Art
 153–6
 Chéret's posthumous exhibition at
 152, 156–7, 162–71
 interest in Michelangelo's work 48
 proscription of modern subjects 94
education of sculptors 31–2, 59, 65–6,
 154
Elsen, Albert 4, 114
England
 French influenced work 50, 60–1,
 99–100, 104
 French sculptors in 60–1, 68, 92, 99
 workshop system 29
engravings, as models for sculpture
 25
Ennès, Pierre 40
Eriksson, Christian 139
étain 148
Etex, Antoine 36

Exhibition of Royal Manufactures (1832) 40
Exposition Universelle, *see* International Exhibition

Falconet, Etienne 11, 93, 101, 164
Falguière, Alexandre 52, 112, 113, 120
Falize, Lucien 107, 120, 136, 142
Fannière Frères 119
Federation of Artists 90
Fenaille, Maurice 3
Feuchère, Jean-Jacques 27, 55, 57
finishes, *see* surface finish
Flaubert, Gustave 18
Ford, Edward Onslow 124
Fourdinois, Henri 182, 184
 Cabinet on Stand (1867) 179, *181*, 182, 184–7
 criticism of the government 70
 exhibit at 1851 International Exhibition 44
 at Morel's 68
 Sévin working for 69
Fragonard, Alexandre-Evariste 42, 101, *101*
Franck 121
Franco-Prussian war 89, 90
Frémiet, Emmanuel 24, 109, 113, 152
French Academy in Rome 32
French Literary and Artistic Property Act (1793) 24
Frogmore, Prince Albert's chapel and tomb 76
Froment-Meurice, François-Désiré 30, 35, *36*, 37, 120

Gabet, Olivier 68
Gagneau 157
Gallé, Emile 140, 147, 158, *159*, 172
Gallimard, Paul 188
Gallois 157
galvanoplasty 30, 68, 71
Gardner, Isabella Stewart 139

Gauguin, Paul 109
Gautherin 121
Gauthier 121
Gautier, Théophile 32, 33, 34, 47
Geffroy, Gustave 154, 187
Géricault, Théodore 36
Gérôme, Jean-Léon 152
Ghiberti, Lorenzo 43, 45, 46–7
Gibson, John 37
Gilbert, Alfred 140
gilt finishes 72
Ginsbach, Mathias 9–11, *10*, 116–19
Gobelins 18, 30, 57
Gobert, Alfred-Thompson 108
Goncourt, Edmond and Jules 93
Goodall, Walter 47
Gothic revival 40, 42, 73, 76, 183
Goujon 43, 50, 71
Grandier, Léon 121
Graux-Marly 26
Gruet 139
Guéret frères 55
guild system 29
Guillaume, Eugène 91–2, 120, 121, 124
Gustini, L. 44

Haquette family 113
Hargrove, June 108
Havard, Henry 120
Hayet 27
Hébrard, Adrien-Aurélien *143*, *146*
Heingle 55
Heuzé, Michèle 35
Hilaire *181*
Hiolle 11
historic models 42, 72–3
Hôtel de Païva 112
Hôtel de Ville 111–12, 113
Huysman 151
Huysmans, Joris-Karl 94–5

income of sculptors 64–5, 96–7
'industrial art' 12, 29–31, 54–5

industrial tribunals, *see* legal cases
Ingres, Jean-Auguste-Dominique 36, 97
International Congress on Artistic Copyright (1878) 91
International Congress on Industrial Property (1878) 91
International Exhibitions
 1851, London 20, 44–5
 Minton's majolica 107
 Pradier's *Phryné* 37
 Victor Paillard's exhibit 34, *34*
 Walter Goodall's drawing of the French Court *47*
 1855, Paris
 Denière's tobacco jar 51
 Pradier's *Pandora* 39
 Simart's *Minerve du Parthénon* 37
 1862, London 50, 137
 Barbedienne's *Bookcase* (1862) 48
 report by the French delegation of ceramic workers at 62
 report of the delegation of sculpteurs-ornemanistes at 55–9, 60–1
 1867, Paris 19, 123, 137, 158
 cabinet by Fourdinois 182
 mirror designed by Sevin for Barbedienne 73, *74*, *75*
 report of the delegation of sculptors at 61–7
 1871, London 89–90
 1878, Paris
 Barbedienne's clock by Sévin 70
 Rodin's masks for the Trocadéro fountain 112
 1889, Paris 108, 121–4
 Brateau's *Zodiac Plate* 148
 Rodin's participation in 121–4
 1900, Paris 109, 115, 124

Jackson and Graham 45, 90
Janson, Horst 7, 9
Jeannest, Pierre-Emile 92
jewellery 35, *36*
Jouhanneaud and Dubois 69

Kahn, Gustave 115
Klagmann, Jules 57, 137
 Renaissance style work 43
 report on problems of industrial artists (1852) 54–5
 Romain's sale of works by 27
 Salon's refusal of work by 119

La Païva (Esther Lachmann) 70, 76
Laborde, Alexandre de 54
Lami, Stanislas 57, 140
Lanson, Alfred 139
Lapeyre & cie 42, *Plate 2*
L'Art dans Tout 91, 149, 161–2
Larue, Jean Denis *103*
Laurent, Stéphane 65
Lauth, Charles 96, 97, 116
Lawton, Frederick 7, 9, 114–15
Lebreton, Joachim 31
Ledru 148
legal cases
 Bartholdi vs. Falize 136
 Clésinger vs. Barbedienne 63
 Pradier vs. Duchemin, Verry and Jouanneaux Dubois 33
 Robin vs. Romagnesi 24
 Vittoz vs. Royer 26
legal definitions 29
legal position of sculptors and sculpture 23–8, 90–1; *see also* copyright
Lege fils 62
Legion of Honour 20, 58, 112
Legrain, Eugène 112
Lehni, Nadine 189
Lequien, Justin-Marie 55
Levillain, Ferdinand 44
Levy frères 27
Levy, G. J. 27

Leygues, Georges 152
licked surface 119
Liénard 27, 44
Ligeret 62
lost wax process 33–4, 138, 139, 172
Louvre
 Borghese collection 42
 encompasses both the decorative
 and fine arts 134
 plaster workshops 29–30, 48
 post-1848 Revolution reforms 32
Lyon Museum 44

Maillet, Arthur 187
Maillou, Pedro Rioux de 184
Mainardi, Patricia 20
majolica 50, 107
Mantz, Paul 120
manufacturers; *see also* national
 manufactories and under the
 names of specific manufacturers
 contracts with, *see* contracts
 innovations in 1850s 30, 54
 relationship with artists 90, 135–6,
 154, 155–6, 172
 rights to models 25–8, 38, 62–3,
 155–6
 sculptors disputes with, *see* legal
 cases
Marchi, Salvator 33
Marneuf, Antoine-André 68
Marnihac, C. de 90
marqueterie en pleine 184
Marx, Roger 124, 135, 183
Masi 33
materials 33, 137–8, 171–2, 184, *see also*
 under specific materials
Mathurin-Moreau 27, 120
McWilliam, Neil 148
Meissonier, Ernest 133
Mercié, Antonin 22, 120, 121, 124
Mérigot, Maximilien-Ferdinand 98
metal workers 20, 21–3

Meunier, Constantin 139
Michel, Claude, *see* Clodion (real name
 Claude Michel)
Michel-Malherbe, Ernest 139
Michelangelo 43
 Combat des Lapithes et des Centaures
 51–2
 Last Judgment 48
 Lorenzo de Medici 46, 48
 Night and *Day* 35, 36, 46, 72–3
 Penseroso 52
 Slaves 48, 50
Michelet, Jules 40
Minton 50, 92, 93, 99, 100, 107
Mirbeau, Octave 114
mirrors 73, 74, 75
modelling 22–3
models
 drawings as representations of
 28–9, 71
 historic sources 42, 72–3
 paintings, as models for sculptors
 25
 registration of 28, 91, 154–6
 rights to 24–9, 38, 62–3, 155–6
 sale by auction of manufacturers'
 models 27, 28, 154
 sale by auction of sculptors' models
 27, 90, 156
Monet, Claude 90
Monjon 55
Moreau, Mathieu 142
Moreau-Vauthier, Paul 120, 149
Morel 68, 182
Morhardt, Mathias 117
mould making 22–3
Müller, Edouard (called Rosenmuller)
 38–9, *39*
Musée des Arts décoratifs 113, 116, 156
Musée du Luxembourg 142, 144, 149,
 150
Musée Galliera 102, 149
Musée Rodin 3

Museum of Decorative Arts, *see* Musée des Arts décoratifs
'Museum of the Night' 154

Nancy School 147
narrative expressed in work 139, 143
national manufactories 18, 30, 91; *see also* Beauvais; Gobelins; Sèvres
National Workshops 17
neoclassicism 40, 42, 72
Néviller *181*

objet d'art 12, 136, 161
objets d'art section at the SNBA Salon 133–40, 141–2, 148, 149–50, 161, 171–2
Odessa, Tsar Nicolas's tomb 76
ornamental sculptors, *see sculptor-ornamentists*
Osbach 121, 122
ouvriers sculpteurs 63–6

Paillard, Victor 27, 34–5, *34*, *Plate 1*
Paillet, Fernand 114–16, *Plate 3*
painted decoration 37, 94, 103; *see also pâte-sur-pâte*
paintings, as models for sculpture 25
Palais du peuple 32
Palissy, Bernard de 107
Parfonry & Huvé frères 122–3, *123*
Parianware 104
Paris Commune 89, 90
The Parisienne as subject matter 163–4, 167–70
Parthenon frieze 47, 48
Pasti *181*
pâte de verre 109
pâte-sur-pâte 97–101, 103
patents
 marqueterie en pleine 184
 sculpture reducing machine 43
People's Palace 32
Petite Ecole 6

Pevsner, Nikolaus 44
pewter ware 138, 140–52, 161, 163, 168, 171–2
Pezieux, Jean 122
Phenix and Joyau 68
Piat 27, 142
Pickard, C. 27
piece work 59
Pilon, Germain 43
Pissarro, Camille 90
Planche, Gustave 17
plaster, as creative medium 2, 27
plaster casts of historic sculpture 43–4, 48, 50, 154
plaster models, *see* models
polychromy 33, 36, 37, 109, *110*
Porlie 62
Potier, Victor 149
Pradier, Jean-Jacques (James) 31–9
 interest in the Renaissance 36–7
 Standing Sappho 32–5, *Plate 1*
 training 31
 Two Women with a Vinaigrette Coffer 35, *36*
 work for manufacturers 35–6, 38
Préaud, Tamara 98, 108
Premier Grand Prix 32
private enterprise, *see* manufacturers
Prix de Rome 32
professional categories of sculptors 19–20, 21–2, 154
professional status of sculptors 19–23; *see also* class, sculptors
Proust, Antonin 120, 135
Prouvé, Victor 139
Public Exhibitions of French Industrial Products 20, 44

Raffaelli, Jean-François 139
Ravaisson, Félix 42
registration of artistic models 28, 91, 154–6
Reiber, Emile 101, *101*

relief decoration, *see pâte-sur-pâte*
relief sculpture 25
Renaissance sculptural sources 35, 36,
 43, 46, 48, 51–2
Renaissance style 40–3, 57, 62, 72–3
reproduction of sculpture 21–3, 27–8,
 43–4
reproduction rights 24–7
Réunion des fabricants de bronzes
 (RFB) 25–6, 27, 28–9, 134
rights to models 24–9, 38, 62–3, 155–6
Robert 27, 120, 142
Robin 24
Rodin 109–24
 art education 6
 authorship of decorative works 9,
 108
 caricature by Fernand Paillet
 114–16
 commissions for the 1889
 International Exhibition 121–2
 commissions for the 1900
 International Exhibition 122, *123*
 early decorative work 4–5, 7, 9
 employment at Sèvres 96, 97, 101
 his 'artisan to artist' trajectory 3–4,
 5–6, 20
 jury member at the 1889
 International Exhibition 121
 jury member at the 1900
 International Exhibition 124
 jury member at UCAD's 1887
 exhibition of Fine Arts Applied to
 Industry 120
 later decorative work 123–4
 one-man show at the Place de
 l'Alma (1900) 123–4
 participation in Commission des
 travaux d'art 121
 participation in SNBA 133, 138
 participation in UCAD 119–21
 positioning as 'father of modern
 sculpture' 2–3, 5, 10

in relation to Jules Desbois 141
relocates to Belgium in 1871 89
solo exhibition at the Place de
 l'Alma (1900) 115
specific works
 Age of Bronze 109, 111, 112, 113
 Balzac 163, 167
 Buire de Blois (1883–84) *106*
 *Bust of Mrs R**** 138
 The Gates of Hell 25, 52, 111,
 113–16
 Jean le Rond d'Alembert 112
 l'Architecture 121
 masks for the Trocadéro fountain
 112–13
 models for *Bed* by Ginsbach 9–11,
 10, 116–19
 models for *Grand Dresser for a
 Dining Room* by Cuvillier
 and Parfonry & Huvé
 Frères (1889) 122, *123*
 models for *Wardrobe* by Ginsbach
 116, *117*
 Pompeii Vases, La Nuit, et Le Jour
 97, *99*, 100–2
 Puvis de Chavannes 139
 Saigon Vase, Les Eléments *102*
 Saigon Vase, Les Limbes et les
 Syrènes 97, *98*
 The Thinker 7, 9
 Titan Vase 7, *8*, 9
work experience in industry 6–7
work for Hôtel de Ville 111–12
work for Sèvres 90, 96, 97, *98*, *99*,
 100–2, *106*, 107
Roger, François 122
Roll 135
Romagnesi 24
Romain 27
Rops, Félicien 142
Roret 44, 148
Rosen, Charles 119
Rosenbaum, Kory Elisabeth 187–9

Rosenmuller (Edouard Müller) 38–9, *39*
Rothschild, Baron Alphonse de 141
Roty, Louis-Oscar 120
Roujon, Henry 152
Royer 26
Rude, François 53

SAF (Société des artistes français) 62, 133–4, 136, 156
Saint-Juirs 95
salaries of sculptors 64–5, 96–7
sale by auction
 manufacturers' models 27, 28, 154
 sculptors' models 27, 90, 156
Salon, Académie des beaux-arts 32, 66
Salon de la Société des artistes français (SAF) 62, 133–4, 136, 156
Salon des artistes de l'industrie (UCAD) 119–21
Salon des Arts décoratifs (UCAD) 119–21
Salon du Champ-de-Mars (SNBA) 133; *see also* Société nationale des beaux-arts (SNBA)
Sarrancolin marble 122
Sauvegeau 27
Sayer 26
sculpteurs-modeleurs 68, 153–4
sculptor-ornamentists 55–9
sculptors
 class 11–12, 19, 150
 education and training 31–2, 59, 65–6, 154
 income 64–5, 96–7
 legal status 23–8, 90–1
 ouvriers sculpteurs 63–6
 professional categories 19–20, 21–2, 154
 professional status 19–23
 Report by Jules Klagmann on the problems facing industrial artists (1855) 54–5

reports by sculptors at the international exhibitions 54–67
 Report by the delegation of French ceramic workers to the 1862 International Exhibition 59–61
 Report by the delegation of sculpteurs at the 1867 International Exhibition 61–7
 Report by the delegation of sculpteurs-ornemanistes to the 1862 International Exhibition 55–61
 sculpteurs-modeleurs 68, 153–4
 sculptor-ornamentists 55–9
 sculptors' organisation 19, 63, 64, 66, 153
 stone sculptors 65
 unions and organisations 19, 58, 63, 64, 66, 153
 wood sculptors 19, 64
Servant, G. 27
Servat, Albert *183*
Sevenier, E. 27
Sévin, Constant 67–76
 contract with Barbedienne 69, 193–4
 design for a mirror by Barbedienne (1867) 73, *74, 75*
Sèvres 91
 bronze mounts 92, 96
 Commission to supervise artistic works at Sèvres (Commission de perfectionnement) 91
 Department of Works of Art 92
 design for vases by Carrier-Belleuse *103, 105, 106*
 designs for 'vases, in the Renaissance style 40, *41, 42*
 Director of Works of Art 92–3, 108, 157
 experiments in the 'Gothic' (gothique) style 40

French Court at International Exhibition (London, 1851) 47
preference for repeating historic designs 59
provision of prizes to the newly established Republic 32
revival of sculpture in ceramics under Carrier-Belleuse 92–109
revival under the Third Republic 90
Vase de Phidias 42
Sigalon, Xavier 48
signing of work, *see* authorship
Silverman, Debora 190
Simart, Pierre Charles 37
Simon, Constant 6
Simonet 33
Singer, Vinnaretta 140
Siot-Decauville 149
SNBA, *see* Société nationale des beaux-arts (SNBA)
Société d'encouragement de l'art industriel 54
Société des artistes français (SAF) 62, 133–4, 136, 156
Société du Musée des Arts décoratifs 116
Société nationale des beaux-arts (SNBA)
 objet d'art section 133–40, 141–2, 148, 149–50, 161, 171–2
 Salons 145, 147, 148, 161, 182, 188, 189
Society for the Encouragement of Industrial Art 54
Solon, Marc Louis 99–100
specialisation (trades) 22, 23, 29
Spuller, Eugène 121
State; *see also* Department of Fine Arts; national manufactories
 copyright status of State acquisitions 24–5
 definition of fine art 20

intervention in design education and manufacturing 54
sculpture budget 97, 111
state manufactories, *see* national manufactories
stone sculptors 65
'style de la Renaissance', *see* Renaissance style
subdivision of labour 22, 23, 29, 66
surface finish 34, 72, 119, 171–2; *see also* bronze, chasing
Susse 24, 149
Sutton, Denys 118

taille directe, see direct carving
Taylor, Alfred 60
Thomas, Gabriel-Jules 112, 113, 121, 124
Thorvaldsen, Bertel 37
Tiffany 172
titles of works 147, 162, 163, 172
Towska, Kory (Kory Elisabeth Rosenbaum) 187–9
tribunals, *see* legal cases
trompe l'oeil designs 39, 42
Turquet, Edmond 97, 111, 112, 113, 116
two-dimensional designs
 as representations of models 28–9, 71
 of sculpture in wallpaper designs 42–3

UCAD, *see* Union centrale des arts décoratifs (UCAD)
Union artistique des sculpteurs-modeleurs 153
Union centrale des arts décoratifs (UCAD) 116, 119–21, 147
 1865 exhibition on the French and Italian Renaissance 50
 1884 Exhibition of industrial art 107
 1894 Congress on Decorative Art at Ecole des beaux-arts 153–6

criticism of 154
scheme for registration of artistic
 models 154–5
Union centrale des beaux-arts
 appliqués à l'industrie 54, 116

vases
 Carrier-Belleuse designs for Sèvres
 95–7, *98*, *99*, 100–2, *102*, 104, *105*
 in the Renaissance style 40, *41*, 42, 52
Vechte, Antoine 57
Vigoureux 62
Villa Médici 32
Viollet-le-Duc, Eugène 55
Vitta, Baron Joseph 3
Vittoz 26
Vittoz & Co. 27
Voyer 122

wages, *see* income of sculptors
Wagner *Plate 2*
Wagner, Anne 150
Waring, John B. *49*
Weiswald 26
Weisweiller, Adam 158
Wellner, William A. 188, *Plate 4*
Wièse, Jules *36*

Wiesinger, Véronique 141
Willms, Albert 68
women, representation of 11, 164–70,
 184–90
women sculptors 11
wood sculptors 19, 64
wood sculpture 62, 72, 138, 184
 Barbedienne, *Bookcase* (1851) 45–7,
 46, 48, *49*, 50
 Carabin
 Bookcase (1890) 182, *183*
 Display Cabinet for Objets d'Art
 (1895) 179, *180*, 182, 184–7,
 186
 Fourdinois
 Cabinet on Stand (1867) 179, *181*,
 182, 184–7
 Ginsbach
 Bed modelled by Rodin 9–11, *10*,
 116–19
 Wardrobe modelled by Rodin 116,
 117
workshop system 29–30

Yon 27

Zerner, Henri 119